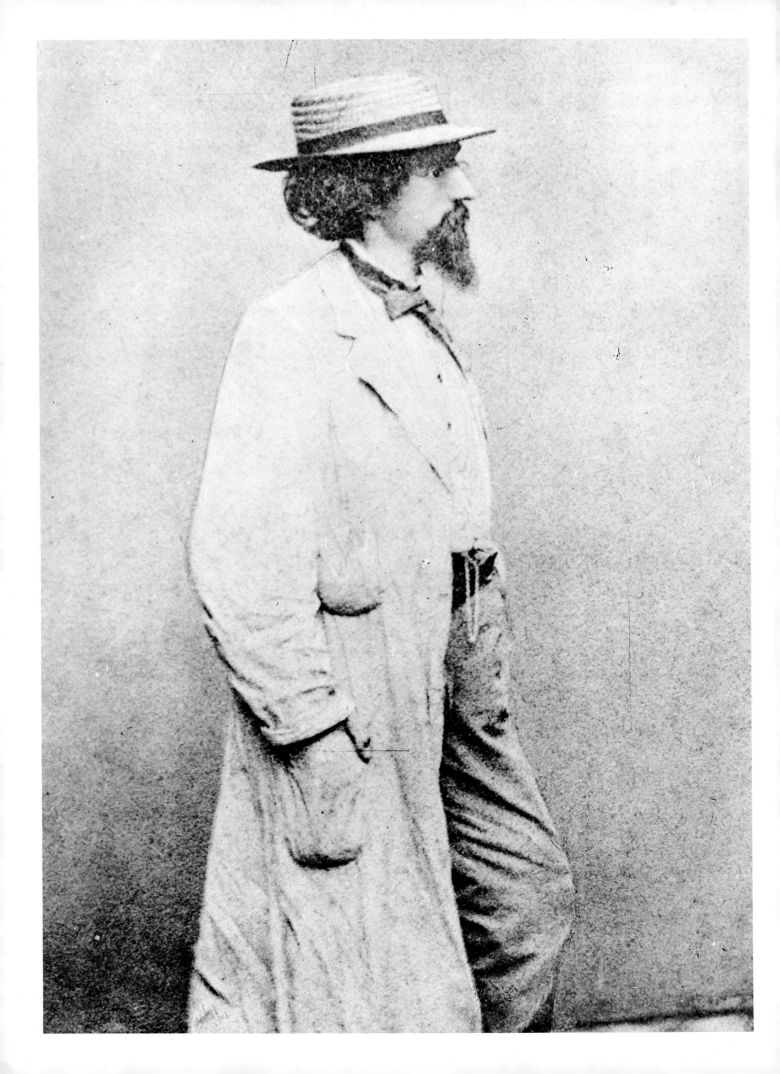

MR. LINCOLN'S CAMERA MAN

MATHEW B. BRADY

Roy Meredith

Second Revised Edition

DOVER PUBLICATIONS, INC., NEW YORK

Published in Canada by General Publishing Company, Ltd., 30 Lesmill Road, Don Mills, Toronto, Ontario.
Published in the United Kingdom by Constable and Company, Ltd., 10 Orange Street, London WC 2.

This Dover edition, first published in 1974, is an unabridged and corrected republication of the work originally published by Charles Scribner's Sons in 1946. An index of negative numbers has been especially prepared for this edition.

The publisher wishes to express his appreciation to Mr. Jerry L. Kearns and his staff in the Reference Department, Prints and Photographs Division of the Library of Congress for help in securing new photographic prints for this edition.

International Standard Book Numbers:
0-486-23021-X (paper edition)
0-486-23087-2 (cloth edition)
Library of Congress Catalog Card Number: 73-92262

Manufactured in the United States of America
Dover Publications, Inc.
180 Varick Street
New York, N. Y. 10014

TO
ANNE WHITMAN
AND TO
MY SON ARTHUR

INTRODUCTION

Mathew B. Brady was the photographic historian of the United States of his day. Little has been written of him and his contribution to our history. He was a fabulous figure of a fabulous time, as genuine a product of America as Mark Twain. The by-line "Photographed by Brady" was one that even Royalty insisted upon having on their "Imperials." In these pages I have attempted to recall this man to his proper place in the history of our nation.

There have been controversies as to just who actually took many of the pictures of the Civil War. Obviously Brady alone could not have taken a majority: he employed twenty field operators. And there was a rather free exchange of negatives and prints among the various war photographers, which has made it even more difficult to ascertain the authorship of many of the plates. But pictures that were not taken by Brady himself were, for the most part, made under his direction. His lecture book gives many clues as to what photographs he did take. In my opinion it is absurd not to give him credit for most of the war pictures. He was essentially the director. The actual operation of the camera though mechanical is important, but the selection of the scene to be photographed is as important, if not more so than just 'snapping the shutter.'

Directors of Photography on the motion picture 'sets' seldom approach a camera except to look into the 'finder,' but all the important matters of lighting, exposure, and position are entirely their responsibility. So it was with Brady. The director of photography who hires and trains a camera crew and then does the work himself, is no director. If he has to do that work because of his crew's incompetence, then *he* is incompetent.

Because it was impossible for him to move the cumbersome camera equipment quickly, Brady was usually forced to make his battle photographs after the heavy firing had ceased. But many times he was actually under fire, as at Bull Run and Petersburg, and at Fredericksburg where he nearly lost his life.

No one assistant traveled with him throughout the war. J. F. Gibson, Stanley Morrow who "volunteered" his services to learn photography, and David Laudy, a chemist and later a teacher at Columbia University, were among those who worked with him in the combat areas, as his personal assistants.

His portraits of historic figures speak for themselves as to quality, and it is doubtful if even at the present time any photographer could claim the patronage of as distinguished a clientele as Brady had. He knew he was a good photographer, and he did not hide his light under a bushel. He was the first to conceive of the idea of taking the camera to the battlefield, and his work proved the military value of photography. It was his ideal to be the photographic historian of the war, and he considered personal fortune a light thing compared to that. In a conversation with John C. Taylor shortly before his death, Brady summed up his story of photographing the Civil War in a few words. He said: "No one will ever know what I went through to secure those negatives. The world can never appreciate it. It changed the whole course of my life." He believed in something. He believed that his function was to presrve all that he could of the drama of that war through the medium of his camera. His effort was never fully appreciated.

Some of the pictures in this book, many of which appear for the first time since 1865, have been 'cropped' to allow for a better display of the figures. The unpublished photographs are from original wet plate and copy negatives made from the original albumen prints, some in a faded condition, and are presented without benefit of retouching.

I am indebted to Carl Sandburg, biographer of one of America's greatest presidents, for his friendly interest and encouragement when I started on this book several years ago, and for allowing me reference to his masterly biography, *Abraham Lincoln—The War Years*.

I extend my thanks to Archie Ogden for his interest and friendly advice concerning many details; and to Mrs. Mary Handy Evans and Mrs. Alice Handy Cox, the grandnieces of Mathew Brady, for their kindness and help in searching through their family archives for material, and for their own recollections; and to Joseph Stanley Pennell for the use of his Brady scene at Savage Station, from his fine book *The History of Rome Hanks and Kindred Matters* and Lee Lawson for the maps on pages 120 and 121.

Roy Meredith

STANZAS

Suggested by a Visit to Brady's Portrait Gallery

Soul-lit shadows now around me;
 They who armies nobly led;
They who make a nation's glory
 While they're living—when they're dead,
Land-marks for our country's future,
 Have their genius left behind;
Victors from the field of battle;
 Victors from the field of mind—

Doniphan, who trod the desert;
 Scott, who conquered on the plain;
Taylor, who would not surrender;
 Butler, sleeping with the slain;
Houston, San Jacinto's hero;
 Fremont, from the Golden shore;
Jackson, as a lion, fearless;
 Worth, whose gallant deeds are o'er—

Webster, with a brow Titanic;
 Calhoun's eagle look of old;
Benton, freedom's valiant Nestor;
 Kent, the jurist, calm and cold;
Clay, "ultimus Romanorum;"
 Cass, with deep and earnest gaze;
Wright, of yore the Senate's Cato;
 Adams, last of early days—

Pere de Schmidt, the Jesuit preacher,
 From the Rocky Mountains wild;
Tyng, Melanethon of the pulpit;
 Channing, guileless as a child;
Barnes, who pondrous themes has written;
 Bascom's eye, a gleaming bright;
Anthon, whose unceasing labor
 Fills the student's path with light—

Audubon, from out the forest;
 Prescott, from historic page;
Bryant, pilgrim of our poets;
 Forrest, vet'ran of the stage;
Inman, looking palely thoughtful;
 Huntington, with dreams of art;
Father Mathew, mild benignant;
 Jenny Lind, who wins the heart.

Lawrence, type of merchant princes;
 Colt, of our mechanic peers;
Emerson, of Yankee notions;
 Miller, of our Scripture seers;
Mott, the hero of the scalpel;
 Cooper, wizard of the pen;
Flagg, the glorious painter poet;
 Powers, of arts own nobleman—

From the hills and from the valleys,
 They are gathered far and near,—
From the Rio Grande's waters,
 To Aroostook's mountain drear,—
From the rough Atlantic's billows,
 To the calm Pacific's tide,
Soldier, statesman, poet, painter,
 Priest and Rabbi, side by side.

Like a spirit land of shadows
 They in silence on me gaze,
And I feel my heart is beating
 With the pulse of other days;
And I ask what great magician
 Conjured forms like these afar?
Echo answers, 'tis the sunshine,
 By its alchemist Daguerre—

CALEB LYON, of LYONDALE
Broadway, Dec. 12, 1850

viii

CONTENTS AND LIST OF ILLUSTRATIONS

Chapter Twenty-Two
(Pages 234-244)

Chapter Twenty-Three
(Pages 245-254)

Chapter Twenty-Four
(Pages 255-261)

Brady's Lecture Book
(Pages 263-362)

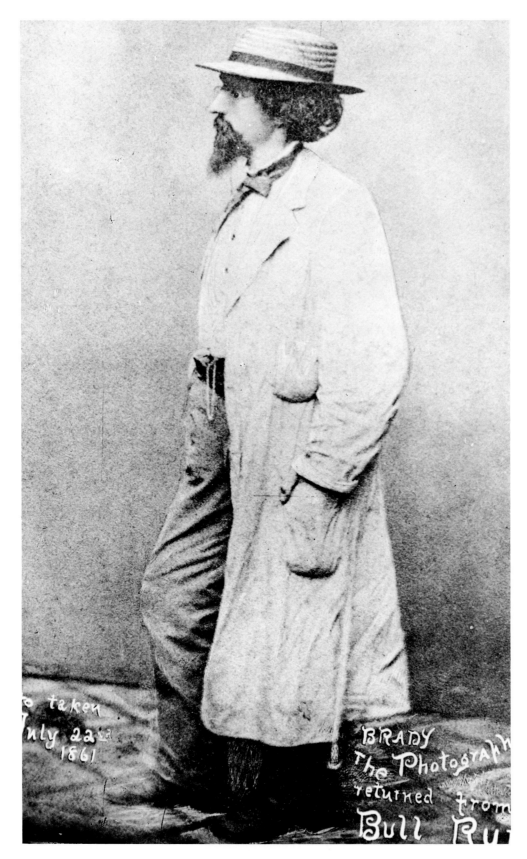

MATHEW B. BRADY

Photographed on July 22, 1861 following his return from the battlefield of Bull Run, probably by Capt.
A. J. Russell, T. H. O'Sullivan, or Alexander Gardner, who were working in Brady's Gallery at the time

CHAPTER

ONE

O N A BLAZING HOT DAY, July 16, 1861, Mathew Brady, in a white linen duster and a straw hat, with his traveling darkroom, three day's rations, and three companions, joined General Irvin McDowell's army in the march on Centreville, Virginia—reported position of the Confederate Army.

It had been twenty-five years since Samuel F. B. Morse first introduced him to Daguerreotypy; and it had been only three days since Lincoln had given his nodded consent to accompany the Army.

Mathew B. Brady—for that was his full name—no one ever knew what the 'B' stood for and in fact it meant nothing, being inserted for effect—was the preserver of the American Scene: Photographer of New York and Washington Society, poser of Royalty, the Codfish Aristocracy and the little 'Tom Cods'; of presidents, congressmen, senators, actors, actresses. And to all he was known simply as Brady of Broadway. Now in '61, barely twenty years since the opening of his first gallery on Broadway in New York, he found himself dusty and sweating on a wagon seat on his way to photograph a war.

"I felt I had to go," he had said to a friend who inquired of his riskful venture, . . . "a spirit in my feet said go, and I went."

With a blaring of bands the army had defiled before the President in high spirits, colorful uniforms adding to the martial scene. Since Charleston's leading newspapers had announced in screaming headlines, that the Union had been dissolved, the North, with Lincoln's gentle prodding, had decided on the course, 'that by force if necessary, the bond would be kept tied.'

Marching over the Long Bridge into Virginia the soldiers carried the politicians' promises on their lips, 'that the war would be over in thirty days'. Well clothed and well armed, led by regular officers, and amply furnished with the best artillery, they made an imposing array.

Long Bridge, scene of Brady's first wartime photograph, was soon left behind, and now as he rode along, he found the road choked with creaking wagons and marching men. Their march was brisk and the countryside was gay with fantastic uniforms and brilliantly colored banners.

1

Of the states that responded to Lincoln's call for troops, every regiment of volunteers mustered in for service had their own conception as to what constituted the military mode of dress. The Seventy-Ninth New York (Highlanders) marched to battle in kilts; the Eleventh New York came dressed as French Colonial Zouaves, with bright red pantaloons, blue tunics, white gaiters and kepis. Garibaldi Guards in their native uniforms of the Carabineri marched with Blenker's Eighth New York Immigrant German regiment. Michigan regiments came as lumberjacks, and one regiment from New York was even dressed in summer sports clothes and straw hats.

'Light Marching Order' was not the rule. One private carried a trunk full of fine linen shirts; others carried cooking utensils, valises, camp chairs, pillows, blankets, skillets, and sundry camping articles. 'Soft Tack' and 'Salt Pork', hard as a G.I. shoe, was the military ration, but the volunteers would have none of this fare and brought their own delicacies. Some even carried ice freezers to be able, they said, "to make 'Ices' when the going got too hot". But hidden under this pitiful masquerade was the fact that many of these men had never before fired a rifle. Some did not even know how to load one. A few regiments of 'regulars', dressed in the regulation blue uniforms, were the only professional soldiers in the whole army.

Compared to the 'regulars', these three-month volunteers were a heterogeneous mob of irresponsible yokels with a smattering of patriotism and a thirst for adventure. Yet, the majority were brave men and good Americans. They had come with no other compulsion than love of country and to restore the Union; but as the war was so much the result of political bombast and stupidity, so by the same token this amateur invasion army was sent to the field against the advices of sound military opinion.

Over the Warrenton Turnpike, ankle deep in dust, marched the army, the men full of enthusiasm. But the heat was oppressive, and before six miles had been covered the monotonous exertion of marching began to tell in the ranks. Knapsacks and blanket rolls becoming a grievous burden to the raw recruits, were carelessly tossed into the thickets or left by the roadside.

The compact array of the columns gradually became an unorganized mass of stragglers. By each brook the men fell out in large numbers to bathe their feet in the cool waters. Regiment mingled with regiment. Every blackberry bush had its knot of stragglers, shouting and heckling at one another. Some sought the cooling shade of trees in the nearby woods, ignoring the protests and threats of their officers.

But the strangest feature of this fantastic march was the accompanying army of civilians. Members of Congress, senators, their wives, pretty ladies in crinolines, on foot and on horseback, in hack and buggy, followed the invading army. They carried parasols, lunch-boxes, camp chairs, stools and baskets. There was to be a 'Big Fight'—it had been announced in Washington—and the whole affair was looked on as a sporting event. Bloodshed was yet to come.

Ambling along the dusty turnpike in the wake of the army, came the white topped wagon train, and in its midst rolled Brady's two photographic wagons. These vehicles had

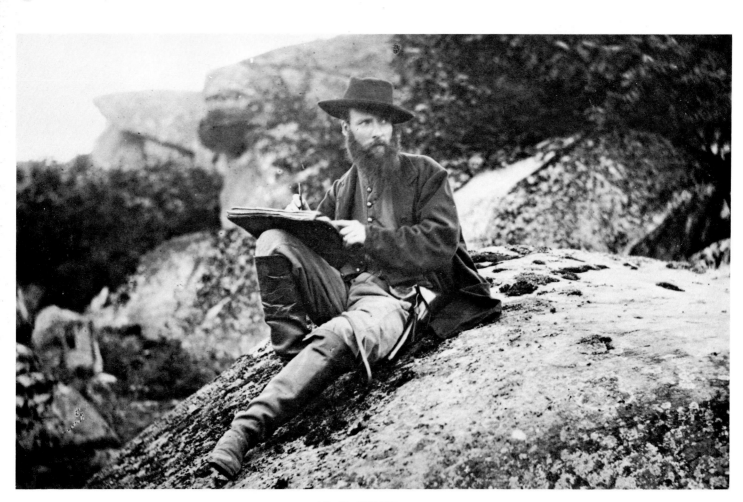

1.
AL. R. WAUD
Sketch Artist for *Harper's Weekly* and one of Brady's companions at the first battle of Bull Run

been specially built to serve as traveling darkrooms and were equipped with shelves to hold bottles of chemicals, plates, and camera equipment. They resembled delivery wagons covered by greyish white tarpaulins.

On the seat of the first wagon with Brady was Dick McCormick a newspaperman, and Al. Waud, who represented *Harper's Weekly,* and who would capture scenes of the war with his pencil sketches. Ned Hause, Brady's darkroom assistant, a slight sandy haired man, was driving the second wagon. All were covered with dust kicked up by the tramping of thousands of marching feet, dust that stuck to the sweaty bearded faces of all three as they looked down the long moving columns from the wagon boxes.

As his wagons rolled along, newspapermen, on horseback shouted recognition and rode alongside and talked of the coming battle and the heat. The sun was high, overhead, and throughout the sultry day the army, with its lumbering train, slowly and cautiously moved on Fairfax Courthouse. Frequent stops had to be made to allow for the rest and watering of the horses. One of these halts was the opportune moment for Brady to extricate his wagons and drive up to the head of the column.

The moment the leading brigades hit the town, the ranks, breaking like a string of beads, scattered in all directions. With wild shouts men ran into houses, ripped down Confederate flags, looted and carried away anything and everything that could be carried. Some of the regimental wags ran out of doorways dressed in female attire, with bustles

3

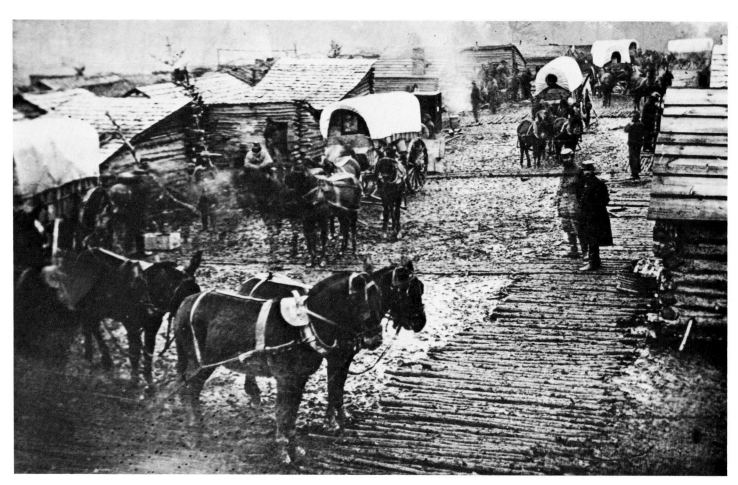

2. CAMP OF THE UNION FORCES AT CENTERVILLE, VIRGINIA
Photographed by Brady during the winter of 1861 and 1862. From an original wet plate print

and dresses stuffed to give the effect of cantaloup busts and watermellon rears, and paraded up and down the village streets.

In the midst of this hilarity, while the sorely tried officers struggled to restore order, Brady took his camera and equipment out of the wagon and attempted some pictures of the town and vicinity. When the camera with its great tube appeared, small groups of men gathered to watch the proceedings with amusement and banter, stopping their hell-raising long enough to watch this new divertisement. Brady had the devil's own time trying to keep the hellions from running through the scene while it was being exposed. Yet, they would have had to 'freeze' themselves for three minutes to make any impression on the slow plate.

"It's the Whatsit", they shouted—a term the soldiers had given Brady's mysterious looking wagon whenever it appeared on the scene. The name clung to the vehicle throughout the war, yet it was held the soldiers never knew that pictures were being taken.

As the day drew to a close Brady's photographic efforts ended. McDowell, realizing the futility of pushing the men any farther gave orders to encamp for the night. Brady, with his companions, after seeing to the equipment and the care of the horses, pitched their own tents just outside the town and despite the heat, prepared to make themselves as comfortable as possible.

By nightfall the officers had restored a semblance of order, and except for some wild

4

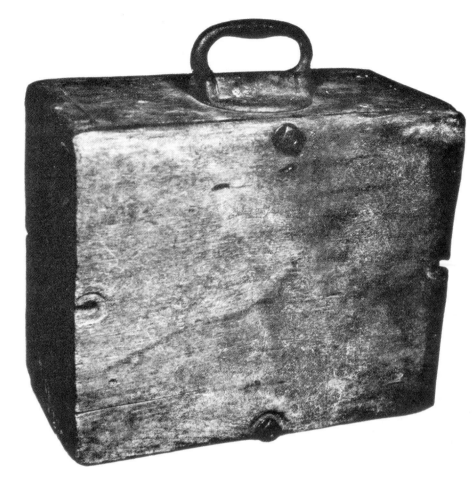

**3. BRADY'S NEGATIVE
PLATE BOX**
This cumbersome piece of equipment was used by Brady throughout the entire war. Made of heavy wood with cast iron handle and bolts, it was capable of holding fifty plates

shouts and ribald laughter, provoked when a nervous sentry fired at a drunken patriot staggering through the picket line, darkness and quiet settled over the camp.

The following morning, awakening to the notes of indifferent sounding bugles, the men broke camp and formed ranks to the shouted orders of 'fall in'. Brady and his companions gathered their things together, harnessed the teams, and fell in with the columns.

As on the day before, progress was slow and laggard. Obstructions in the form of felled trees and abatis beset the columns at every turn in the road. Finally reaching Centreville, McDowell was compelled to halt because of the delay in getting the provision wagons up to the head of the column, and again he ordered the army into bivouac.

With this delay, Brady turned his attention to the photographing of the hastily constructed fortifications the Confederates had evacuated the day before. He drove to the nearby redoubts just outside the town and there saw ample evidence that an army had been there lately. The field was strewn with rags, broken canteens, and rubbish of all kinds.

On the ground glass of his camera the countryside appeared barren and desolate, a few sparse trees entirely bereft of foliage, and a few deserted shacks, dotting the landscape. The fortifications, some of the first to appear in the war, made good camera studies. They were in the form of earthen parapets reinforced with sand-filled barrels piled in double rows. The gun embrasures were cleverly placed, as they allowed the cannon to enfilade anything coming between the redoubts. Brady placed his camera atop one of these para-

5

pets, and while some of the pickets posed in careless attitudes, he exposed his plates. While he and Ned Hause were thus occupied, Al. Waud made pencil sketches of the subjects Brady had posed.

The pleasant occupation of taking pictures was shortlived however, for McDowell, in the meantime, received orders to attack the Confederate Army. When these orders were send to McDowell, the same orders were sent to Washington newspapers for publication. By the time McDowell received them, the newsboys were hawking the intelligence of the proposed attack through the empty streets of the Capitol city.

The newsboys' shouts were heard in Confederate quarters in Washington, a female informer passed on the news, and Beauregard, acting on this intelligence, immediately withdrew his army to a position behind Bull Run Creek, throwing out his line of battle from Sudley Springs Ford on the left, to Union Mills Ford on the right.

McDowell had made his preparations under difficulties. Sightseers, unofficial and official, having caught up with the army, swarmed over the camp. They did as they pleased with no military restrictions. The camp was alive with senators, congressmen, and government officialdom. Brady, returning from his foray, probably met senators Wade, Chandler, Trumbull, Wilson, and Grimes. All were armed with large navy revolvers strapped to their portly waists and hidden under their frock coats, and all were sweating profusely. With combined expressions of discomfort, curiosity, and annoyance, they had "come to observe", they said, but spent most of the time making speeches to the soldiers.

Withal this final delay was fatal to McDowell's campaign. For in the middle of this time wasting and official foolishness Joe Johnston's army in the Shenandoah, watching the Federal General Patterson's forces, made a forced march and joined Beauregard at Bull Run;—of which McDowell was unaware.

While McDowell waited and wondered, he ordered General Tyler to make a reconnaissance in force to feel out the enemy. Brady, learning of Tyler's proposed movement, requested and received permission to accompany him. Joining the column he pushed on in the general direction of Blackburn's Ford. Over ground covered with thicket and brush Brady and his companions rocked and jolted to the clatter of glassware as the wheels of the wagon struck rock and rut of what was no road at all.

It was about noontime. The sun was high overhead, and the sounds of midsummer were mingled with those made by marching men and moving guns. Suddenly Tyler's lead column flushed a small force of the enemy near the ford and the midsummer air was torn by a blast of musketry as each side opened fire. Guns wheeled into battery and began firing into the woods on the far side of the creek. Brady being near the scene, the sudden crash of musketry and cannon caused his horses to rear and plunge, almost upsetting the wagon. He and his companions, quickly leaping out, grabbed the bridles of the terrified beasts. Throwing their jackets over the horses heads quieted them somewhat and enabled Brady to lead them to the rear.

In the meantime Tyler's force slowly advanced into the deep woods. As the men disappeared into the tangled brush the artillery ceased its firing for fear of hitting their own

6

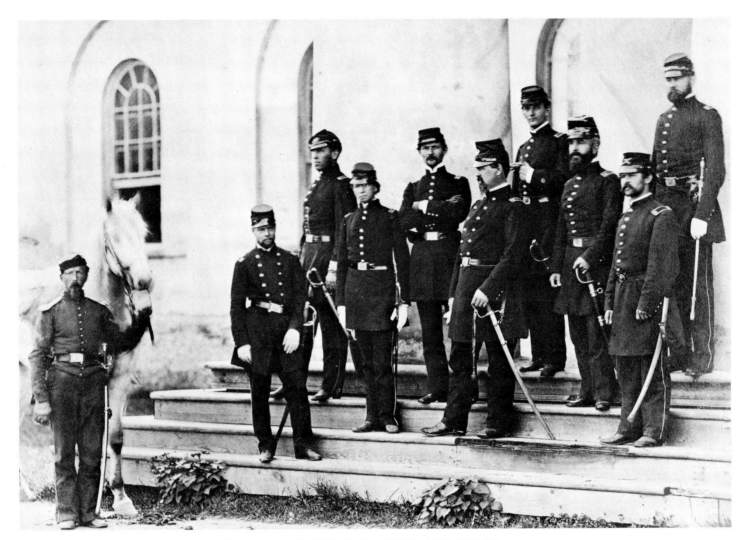

4. GENERAL IRWIN McDOWELL AND STAFF
Photographed by Brady on the steps of the Arlington Mansion, Lee's ancestral home overlooking the
Potomac, shortly after the battle of Bull Run

men. Another tearing crash of musketry echoed and reechoed, accompanied by yells and sounds of combat. Brady drove his wagon in the rear of the artillery position and was making pictures of the wrecked railroad bridge; his camera was planted on the edge of a small ravine that guided the course of the stream when desultory firing broke out heralding Tyler's frightened brigades as they emerged from the woods, forded the stream and climbed the banks close to where he was working.

Realizing his precarious situation, he and his men quickly placed the equipment in the wagon and drove a short distance back of the lines. As soon as the retreating soldiers were safely in the rear of the artillery, the great Parrott rifles opened fire. The roars of these guns signaled the opening of an artillery duel at long range with the famed Washington Artillery of New Orleans. When this ceased as if by mutual consent, Brady and his companions made their way back to Centreville with the retreating columns.

Back in camp Brady went about the routine duties of washing his plates and preparing his chemicals, and thus came to an end his first day of battle.

Despite Tyler's report on his failure, and of the behavior of his troops under fire,

7

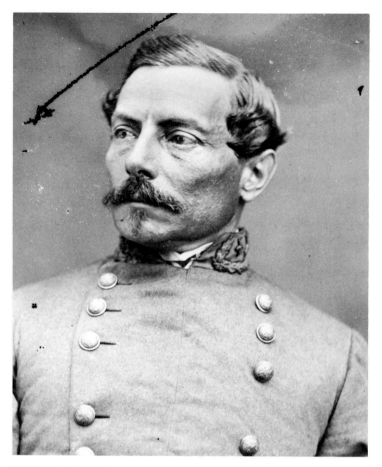

5. **GENERAL PIERRE GUSTAVE TOUTANT BEAUREGARD**
Commander of the victorious Confederate forces at Bull Run in 1861. This picture, formerly attributed
to Brady, was probably made by Vannerson, a Richmond photographer

McDowell had not abandoned the idea of delivering battle. Nightfall brought rest and sleep for Brady and his companions, while the camp buzzed with talk of Tyler's defeat.

Sunday morning, July 21, 1861, dawned hot and clear. Brady, in his white linen duster and the straw hat that was too small for his head, drove to the Stone Bridge, where, guarding it, was a thirty pounder Parrott in battery. Then men were sitting around talking and joking of the coming battle and of the prospects of getting to Richmond.

About six a.m. the gunners and officers took their positions around the gun. Suddenly one of the men pulled the lanyard. A terrific roar and a flash in the morning light signified the opening of the battle. The shell whizzed through the air and went through the tent of Beauregard's Signal Officer, Captain E. P. Alexander. Soon all the Federal batteries opened and the Confederate batteries, their guns not having the range, could not reply. The Federal skirmishers advanced and were immediately engaged. Then the masses of the Federals now swarmed to the attack, their powerful batteries on the Henry Hill having a devastating effect on the Southern troops. The battle raged from Sudley Springs all along the line.

Burnside's and Hunter's Divisions debouched from the woods into the open field in front of Evans of Stonewall Jackson's divisions. The Second Rhode Island advanced with a battery of six Parrotts, and after a few rounds were shattered by the volleys of Evan's troops, leaving dead gunners and screaming horses lying all around.

As the stray shells began bursting near the wagon, Brady drew off to a safer position

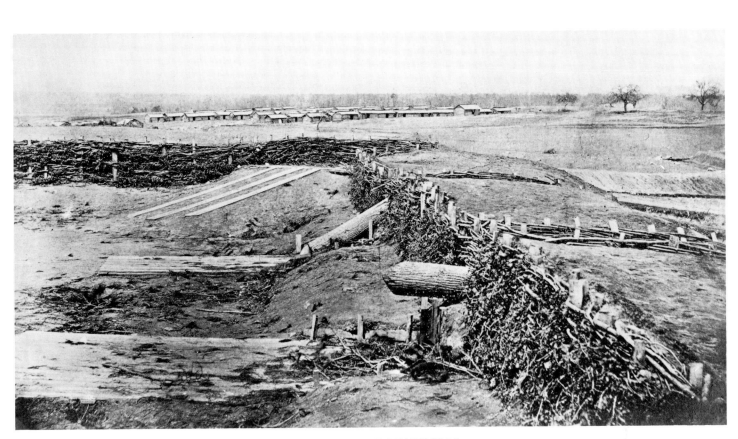

6. FORTIFICATIONS AT MANASSAS

Photographed by Barnard and Gibson, two of Brady's operators, in March of 1862. The real guns have been removed. "Quaker Guns," logs made to look like guns, have replaced the real ones

near Cub Run, a little stream that branched off from Bull Run. The battle raged all morning, and by eleven thirty o'clock seemed lost for the Confederates. Evans brigade advanced to within a hundred yards of the Federal position when heavy artillery fire opened tearing great gaps in the ranks. The Southerners, in desperation, almost carried the position, but the reinforcements of Sherman and Heintzelman came up just in time.

Evans, outnumbered, could do nothing but retire, and his men fell back in disorder behind Jackson's position, hidden below the edge of a small plateau. The Federals advanced to the crest of the hill and had just reached the top, when suddenly, Jackson's men sprang up and fired a volley in their faces. The Confederates taking advantage of the surprise followed it up with a bayonet charge.

The Federals, taken completely off guard, started a retreat that in no time at all turned into a complete rout. The officers tried in vain for some kind of order, but panic had seized the raw recruits and before long the whole Union line disintegrated. The volunteers were in the utmost confusion, and the rout was complete.

Major Sykes' regulars, aided by Sherman's brigade, making the best of a desperate situation steadily withdrew, protecting the rear of the routed volunteers and enabling many to escape by the Stone Bridge. While the battle raged Brady had taken pictures near this bridge till the avalanche of frightened soldiers rolled back upon it.

Real panic did not break out however, until a few stray shells from Lindsay Walker's battery, just arrived from Fredericksburg, firing from a high hill, began dropping in the midst of the fugitives as they fled in disorder to the shelter of the nearest woods. The air

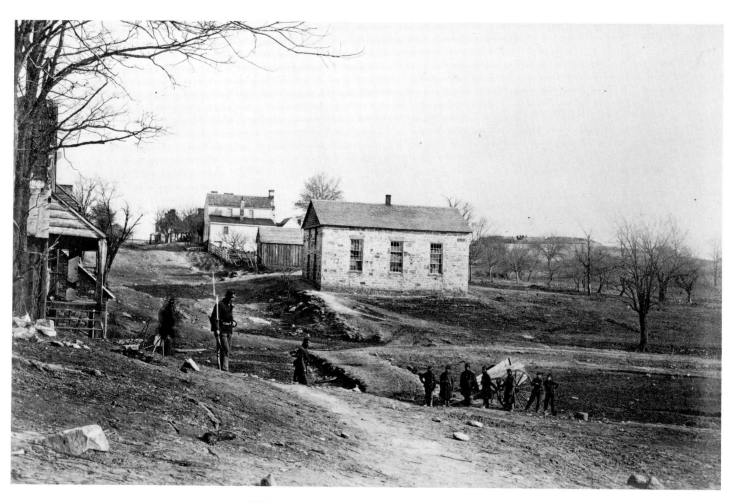

7.
THE TOWN OF CENTERVILLE, VIRGINIA
This photograph, made in March of 1862 by Brady's operators Barnard and Gibson, show the condition
of the roads. The Centerville Church is in the right foreground. Union sentries are on duty

was full of flying missiles, many landing near the mobs of congressmen and sightseers milling around the bridge. The ensuing confusion was frightful.

Brady and his companions worked furiously trying to extricate his vehicles from the melee with some success—until they reached the bridge over Cub Run. It was impassable because of an overturned wagon, and abandoned ambulances, ammunition wagons, pleasure carriages, and cannon.

Crowds milled around. Screaming women, frightened soldiers walking in a daze, choked the fields and roads. After a struggle, a group of stalwarts righted the wagon and, pulling it aside, let it roll down the embankment. Brady and his group were forced along in the panic, but the progress was slow as the roads were filled with the vehicles of civilians. Stragglers threw away their muskets, cut horses from their harnesses and made off on them.

Nightfall brought further terror, but it also brought an end to the pursuit by the Confederates. In the darkness Brady became separated from his companions. Not knowing where he was, he lead his horse into the comparative safety of the woods.

During the night it rained. Brady, exhausted, fell asleep on the wagon seat with a bag of oats for a pillow. After a short time he was startled by someone shaking his foot. He

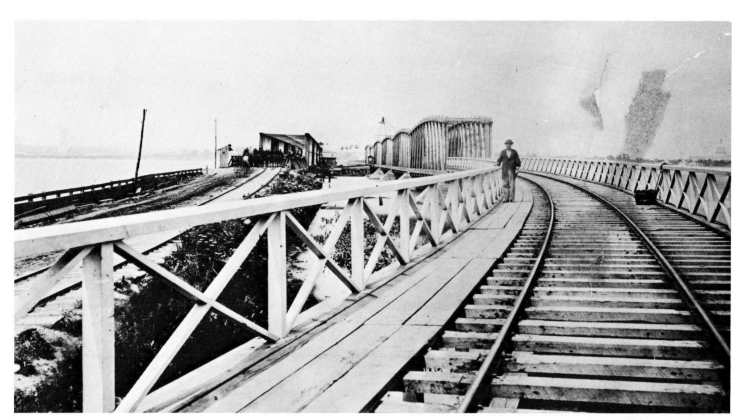

8. LONG BRIDGE, OVER THE POTOMAC RIVER
One of Brady's first pictures taken at the start of the war. For the safety of Washington the planking
was removed as a defense measure.

found it was a Zouave, a straggler from a New York regiment. The fellow seemed friendly
enough and he warned Brady that the woods were full of stragglers from both armies,
and that Cavalry patrols were out rounding them up. When he saw that Brady did not
want to separate from his wagon and go along faster on foot, and also that he was unarmed,
he gave him his broadsword for protection. Just before he disappeared into the darkness,
he announced that he 'wasn't going to stop retreating until he reached New York.'

Brady remained alone, with the sounds of the stricken battlefield filling the night,
and with the rain beating down on the wagon top. Just before dawn he continued on his
way to Washington. It was quiet in the woods with only the rustle of the night wind in
the trees and the trampled grass which had started to spring up again.

When he reached the road, he saw all around evidences of a routed army. Haversacks,
harness, broken wagons, shoes, coats, caissons, abandoned artillery, hats, and broken
muskets, all the accoutrements of the fleeing soldiers covered the roads and fields. Fences
were down everywhere, the woods were riddled with shot and shell. Here and there
were spiked guns, disabled gun carriages, blood soaked blankets, and dead horses.

Over the plain men and women were hunting for loved ones that had fallen in battle.
As he rode along the now muddy road the damp air smelled of dead things and horse dung.
He continued on to Washington through the old towns of Spindle and Old Shop, down
the Warrenton Turnpike, while the rain turned the road into red quagmires.

Terror arrived in Washington with the first mobs that rolled back over the Long

11

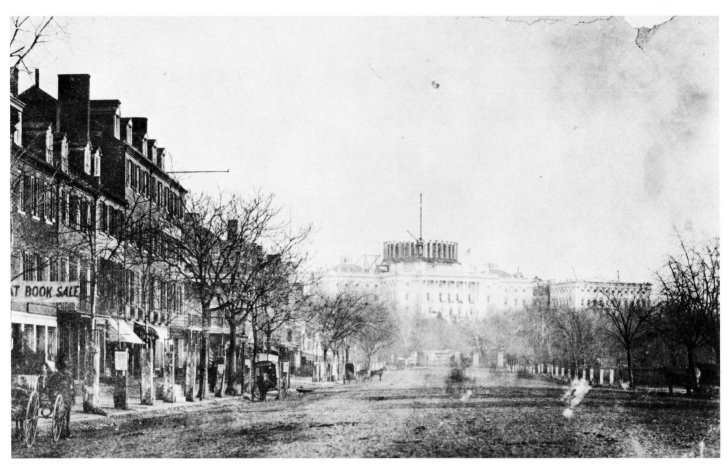

9. PENNSYLVANIA AVENUE DURING THE CIVIL WAR
The Capitol Building with its unfinished dome stands in the background. This print is believed never to have been published

Bridge. In disorderly groups, dirty, black from powder grime and dust of the road, they descended on the Capital City. Sidewalks were jammed with citizens—the 'Secesh' element —who stood and watched silently and exultantly the motley, and haggard swarm of the defeated.

Some of the men, at the limit of their endurance, fell asleep on doorsteps, their muskets beside them. Housewives placed tables on the sidewalks with washtubs of soup and coffee for anyone who wanted them. By noon the whole army was crossing the bridge into a city filled to bursting. Cavalcades of teams, artillery, ammunition wagons, carriages with wild eyed congressmen and their wives with one thought above all—safety—rode through the muddy streets. One officer in command of the arsenal remarked, "We are now in such a state, that a dog fight would cause the gutters of the Capital to run with blood."

Brady arrived late in the afternoon none the worse for his ordeal. Some of his equipment had been damaged from the jolting of the wagon, including some plates he had exposed on the field. He still had the broadsword the Zouave had given him, and his linen duster and straw hat were a little bedraggled and dampish. As he rode through the streets to his gallery he saw a city of gloom and despair. Expected momentarily was the invasion by the Southern forces, and with it Washington was preparing for a siege. Ammunition wagons and artillery rolled through the muddy streets churning them into a black gooey

12

10. *Above:* THE WAR DEPARTMENT IN 1861. The ghostly image of a horse-drawn street car can be seen in the upper left foreground. *Below:* THE NAVY DEPARTMENT IN 1861. From wet plate Brady negatives never before published

substance. Chimneys of ovens pierced the terrace of the Capitol. The basement galleries were being converted into store rooms for pork and beef. The vault under the terrace was quickly made into a bake oven turning out sixteen thousand loaves of bread a day. Men were feverishly at work erecting forts around the city itself. Heavy artillery was being dragged on stone boats through the muddy streets by tens of oxen.

As usual, the men who forced the army to take the initiative before it was ready, and who refused to follow the advice of the officers, were the first to look around for a scape-goat for the fiasco. Senators, congressmen, the press, all were looking for an out.

They first placed the mantle of blame on General Patterson, who, they said, "should have held Johnston at Winchester, so he couldn't have joined Beauregard at Bull Run, and turned the position of the Union forces". They blamed the ladies who were present at the battle for the panic. A minister of a New York Church said, "They shouldn't have started the fight on Sunday."

But the most fantastic of all excuses was in the blame placed on Brady. One correspondent wrote, "Some pretend, indeed, that it was this mysterious and formidable instrument (Brady's camera) that produced the panic! The runaways, it is said, mistook it for the great steam gun discharging five hundred balls a minute, and took to their heels when they got within focus."

What silenced most of these efforts to explain away the defeat, was the appearance of Brady's photographs in his gallery. Not many hours after his return the news about his pictures leaked out, and the fact that he had startling evidence from his experiences on the battlefield. And Washington, forgetting its fears for the moment, gaped. The anti-administration press immediately took up this topic, notably *Humphrey's Journal,* whose reporter stated, "The public is indebted to Brady of Broadway for his excellent views of grim visaged war. He has been in Virginia with his camera, and many and spirited are the pictures he has taken. His are the only records of the flight at Bull Run. The correspondents of the rebel newspapers are sheer falsifiers, the correspondents of Northern Journals are not to be depended upon; and the correspondents of English newspapers are altogether more than either." The reporter went on to say, "Brady has shown more pluck than many of the officers and soldiers who were in the fight. He went, not exactly like the Sixty-Ninth, stripped to the pants . . . but with his sleeves tucked up and his big camera directed upon every point of interest in the field. It is certain they (the soldiers) did not get away from Brady as easily as they did from the enemy. He has fixed the cowards beyond the possibility of a doubt".

By far the wisest view of the affair was written in a private letter of George William Curtis. "As for blame and causes," he wrote, "they are in our condition and character. We have undertaken to make war without in the least knowing how."

The successful result of the Bull Run affair was the determining factor that convinced Brady that tremendous success lay in making historical photographic records of the war. He believed that the public demand for 'War Views' would more than cover the costs of operation and investment; and toward this goal he would work.

CHAPTER

TWO

 ASHINGTON was in the grip of fear. Suspicion and distrust walked hand in hand through the muddy streets. Immediate invasion by the Southern forces seemed to impend. Many politicians who had clamored for the war were for ending the matter then and there and were willing to let the South go her way unmolested. They did not know that the Southern army was as much demoralized by victory as the Northern army was by defeat. After Bull Run, many Southern soldiers went home, thinking they had licked the Yankees and that the war was over.

But the fear that held Washington was to last, a fear that could not be overcome during the entire course of the war. In the eyes of the people of the North, Washington was the Union, the focal point of national existence. To maintain it, an army, unlike anything the enemy could put in the field, was to them, the answer.

Lincoln immediately called for men, money, and supplies for an army, the like of which the world had never seen. From all over the North came volunteer regiments answering the call. From July twenty-second to the middle of November the army grew from fifty thousand to one hundred and sixty-eight thousand men. A string of forts containing the heaviest ordnance formed a protective ring of metal around the Capital.

General George Brinton McClellan, a personal friend of Brady's who had participated in the minor victories in West Virginia, was given command, replacing the hapless McDowell, and the army went in for a period of training while the warehouses were being filled to overflowing with supplies for the new march on Richmond.

After his experience at Bull Run, it became increasingly evident to Brady that the photographing of full scale military operations would be a gigantic undertaking. It would require a staff of trained and fully equipped camera operators. Mindful of the cost it entailed, he reasoned with justification, that the popular sale of 'War Views' would more than cover the cost of the riskful venture. But for the present at least, the costs of organization would have to be carried by his New York and Washington Galleries.

Brady was not concerned with the politics of the time and he had never expressed any sympathies either northern or southern. He was passionately American, but patriotic

ardor was not the motivating influence. To be the photographic historian of America was his ambition. His task was mainly the working out of an idea.

To gain the necessary permission to accompany the army had taken friends in high places in the Government. And these he had in abundance. Influential people with sympathies, both northern and southern, were his intimate friends, and these warm friendships were of years' standing.

Mathew Brady had come a long way in twenty-five years. His early beginnings had been humble. Born in 1823 of poor Irish parents in Warren County, New York, he had roamed over country steeped in legend as a boy. Lake George, Fort Ann, Deer's Leap, Stone Arabia, Saratoga, Oriskany, names of places with blood on them, places that had seen and felt the wrath of Joseph Brandt the half breed and his Destructives, hirelings of the British Crown, who came down from Canada to ravage and burn the Valley of the Mohawk were familiar to him. Through forests that only a few short years before had echoed and reechoed with the war whoop and rung with the musket shot, he had played. He had probably romped on the shores of Lake George whose waters once had floated the silently moving war canoes and batteaux of red coated soldiers and Indians as they paddled toward Ticonderoga.

Undoubtedly, too, he had listened to wild stories of great-aged veterans of the Continental Army when they talked of scouting and battle, and of days never to return, while they sat out their last years in front of the country store. His parents being poor, could only give him a meager country school education, but ambition was in his heart.

In later years his conversations would seem to indicate that in his youth he had always been interested in art and painting. He was fifteen years old when, on a visit to Saratoga Springs, he met William Page the American portrait and historical painter. Page became greatly interested in the boy and forthwith gave him some instruction in painting and pastel,—instruction that in later years he used to advantage.

Page, impressed with young Brady's progress, decided to bring him to New York where he could meet and study with Samuel Finley Breese Morse at the Academy of Design. Page had been a pupil of Morse at the Academy and the two were fast friends. In 1841 Page took Brady to New York to meet and study with Morse and procured a job for him with A. T. Stewart and Company, a mercantile establishment, to work as a clerk for subsistence money while completing his studies.

Morse, also of humble beginnings, was eking out a lean existence painting portraits at starvation prices at the University rookery in Washington Square. While at Yale College Morse earned money by painting miniatures on ivory to further his education, selling them for five dollars, 'and profiles at one dollar'. Shortly after his graduation at Yale, in company with Washington Allston, the American painter, he visited England, studying there with Allston and Benjamin West. After several exhibitions of his work at the Royal Academy he returned to New York in 1815. Several years of struggle followed and in 1826 he became the first president of the National Academy of Design.

During this time he was constantly at work on commissions, among his sitters being

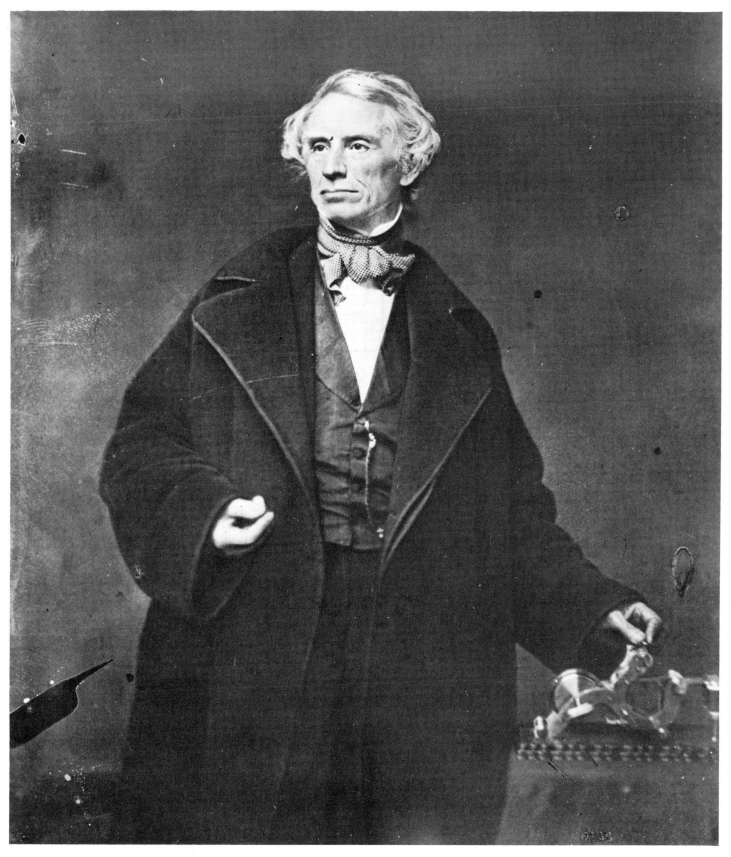

11. SAMUEL FINLEY BREESE MORSE
Inventor of the telegraph and Brady's first instructor in the Daguerreotype process. From an original
India Ink print 14x17 which hung in Brady's Washington Gallery. The odd looking instrument on the
 table is Morse's telegraph key

James Monroe, Chancellor Kent, Fitz-Greene Halleck and Lafayette. But Morse did not devote his entire time to painting, for much of it was taken up with chemical and electrical experiments. While on board the packet ship Sully, on his way from Europe to America in 1832, he conceived the idea of the electric telegraph, and before the close of the year, a portion of that apparatus had been constructed in New York.

On one of his trips to Europe he had met Daguerre, discoverer of the Daguerreotype process. Morse was fascinated with Daguerre's results in fixing a photo-image on a copper plate with the help of certain chemicals, and as a portrait painter, he thought of using the Daguerreotype process to simplify his labors, by which means he would copy the subjects to be painted, thus eliminating the need of having them pose for long periods.

On his return to New York, he set up a studio and laboratory in a loft building belonging to his brother S. E. Morse, on the corner of Nassau and Beekman streets. Morse equipped the studio for Daguerreotypy and for his telegraph apparatus that, although near to completion, was still being developed. About his experiments with Daguerreotypes he wrote, "My ultimate aim is the application of the Daguerreotype to accumulate for my studio, models for my canvas."

Morse had been previously given a professorship at the University of New York where he met Professor John W. Draper who, it seems, was also interested in the making of Daguerreotypes. Draper had been fairly successful with his experiments, and Morse and he worked in partnership for a time. But Morse soon went into business making Daguerreotypes for himself and, for the moment, laid his palette aside. He received meager remuneration from his position at the University. The photographic profession had beckoned as a lucrative field, and he was in financial difficulties.

In a letter he wrote, "I am tied hand and foot during the day endeavoring to realize something from the Daguerreotype portraits. I am at present engaged in taking portraits by the Daguerreotype. I have been at considerable expense in perfecting apparatus and the necessary fixtures and am just reaping a little from it.". . . It was in this loft that young Brady was introduced to the making of Daguerreotypes. Brady, then sixteen years of age, became deeply interested and Morse gave him instruction in the art during the next three years. In 1844 Brady left Stewart and opened his own Daguerreotype Gallery on the corner of Broadway and Fulton Street.

It was an unpretentious studio on the top floor of a building in one of the busiest sections of town, directly across the street from Barnum's Museum. Broadway, bustling with activity, was lined with shops and restaurants, their awnings reaching out almost to the curb. Horse drawn omnibuses, carriages and brewery wagons filled the streets, and from the highest buildings flew flags and pennants denoting the names of their owners.

From the rooftops could be seen the masts of hundreds of sailing ships in the harbor, and the cornice of Brady's building carried the sign 'Brady's Daguerrian Miniature Gallery'. On each side of the entrance to his gallery were small showcases containing samples in fancy frames of his early efforts, and on the wall inside the entrance was painted a great hand with a finger pointing to the stairway, and to the legend, 'three flights up.'

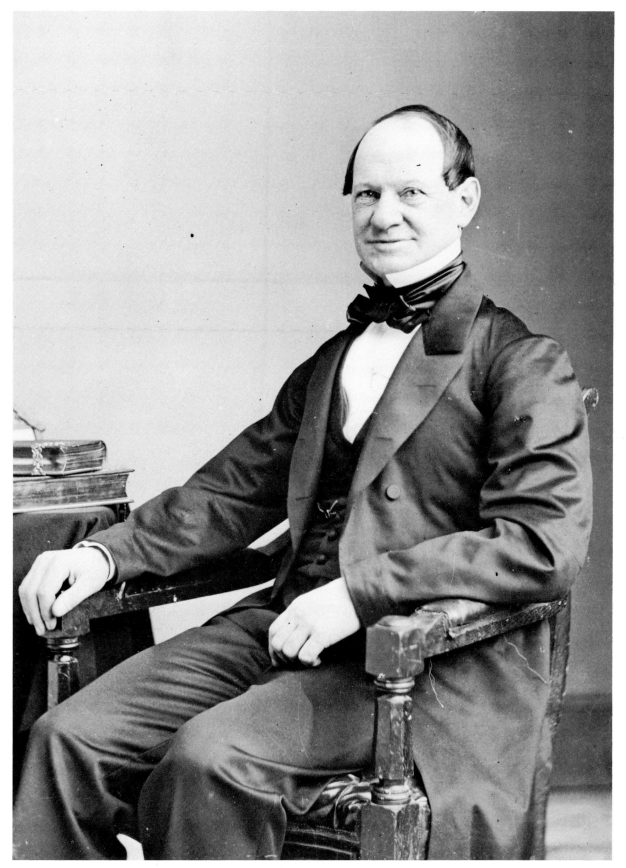

12. A. T. STEWART
Brady's first employer and benefactor. Photographed in 1856 in the New York Gallery by Brady after
Gardner's introduction of the wet plate

The gallery, an immediate success, was the beginning of prosperity for the young photographer. From the very day he opened his doors to the public, he did a thriving business. The newspapers applauded and, observing the growth of the Daguerreotype industry, declared after a survey, "that there were over ten thousand Daguerreotypists in the United States, the leading one being Brady." By this can be estimated his phenomenal good fortune. But even during the first year he faced serious competition. John Plumbe an enterprising promoter, who had quickly learned the profession also dabbled in bigger things, notably railroad promotion, and while he waited on Congress to back his railroad interests he earned a livelihood by making Daguerreotypes.

A go-getter, he opened galleries in New York, Boston, Petersburg, Saratoga Springs, and Kentucky. His New York studio was near Brady's at 251 Broadway. He too had won prizes, the Herald claiming, " 'Professor' Plumbe celebrated photographer has long been regarded as the American Daguerre". Quite a claim it was, but he was by no means reticent about his ability. Plumbe's career, however, was short lived. His business enterprises were so widely scattered and varied that they toppled of their own weight. He met financial disaster and his galleries were sold to meet the demands of his creditors.

New York was a lusty and fast growing city and with it grew Brady and the industry. He was a tireless worker. He had always shown great energy and he now had the grasp of his new profession. Always searching for new innovations in the art, he discovered a method of making Daguerreotypes in color. This was remarkable in itself. He coated ivory plaques with the sensitized emulsion and after they were exposed and developed they were hand tinted. At first appearance they were a great success and became the order and style of the day.

During these early years of the studio and the progress of Daguerreotypy, the American Institute held annual contests offering prizes for the best plain and colored Daguerreotypes. By the few professionals that constituted Brady's competitors, these were eagerly sought after. Brady realized the publicity value of these prizes, entered the competition, and was awarded a premium and honorable mention. This was late in 1844, scarcely a year after the opening of his gallery.

The following year he won first prize in two classes, and finally in 1846 was awarded the highest prize. From the very beginning his name seemed to carry magic for it brought the most distinguished clientele to his door. He had realized early that the success of his enterprise depended entirely on a reputation based on the results obtained in the sittings of famous people, and toward this object he was always striving, for the most part making his own contacts.

Brady's ambition then was to make a photographic record of all the men and women notables of the period. The selection was to be published under the flattering title of Gallery of Illustrious Americans. Brady had known John Howard Payne, the American actor and dramatist and author of "Home Sweet Home", who, like Brady, had worked as a clerk in a New York mercantile house in his youth.

Payne had been appointed American Consul to Tunis, Africa, in 1842. Three years

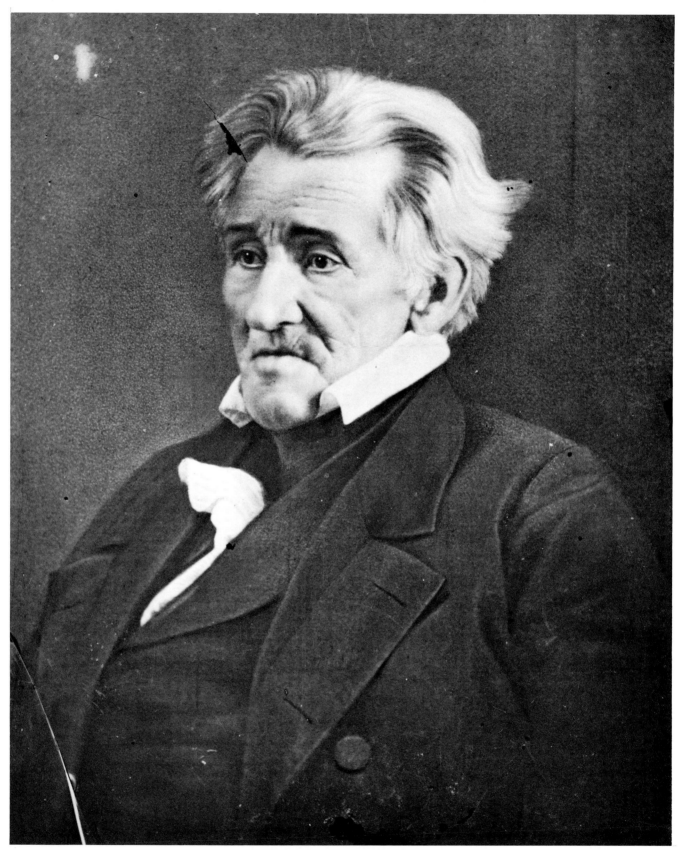

13. ANDREW JACKSON
This Daguerreotype was made at the Hermitage, Jackson's home, in 1845, against the advices of his physician, but on his own insistence.

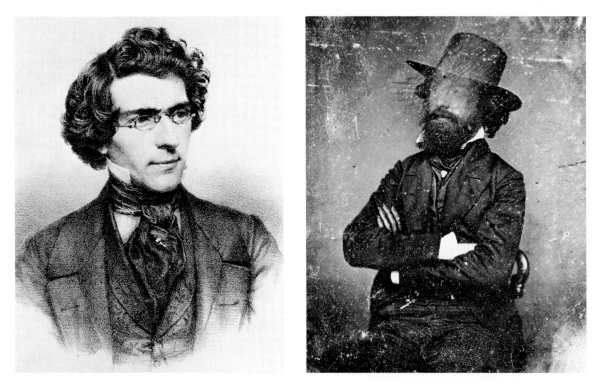

14. *Left:* MATHEW B. BRADY. From a lithograph by D'Avignon reproduced from an original Da-
guerreotype in 1845-46. *Right:* The bearded Mathew Brady. This is a rare print from an original 8x10
Daguerreotype taken about 1846. The only one of its kind in existence, it is published for the first time

later he was recalled and came to New York. It was about this time that he had gone to
visit Brady's Gallery, and it was during one of these sittings that Brady proposed that he
write the sketches for the pictures in the "Gallery."

Payne at once began to work on the assignment. He did not complete the sketches,
however, for while he was thus engaged, he was again given his diplomatic appointment
as American Consul to Tunis and relinquished Brady's project. Brady engaged C. Edwards
Lester to continue where Payne had left off.

One of the first pictures to be made for the "Gallery" was that of General "Andy"
Jackson, the famous defender of New Orleans. Just before Jackson's death in 1845, Brady
went to the Hermitage, Jackson's home in Kentucky, to get a portrait of the ex-president,
by that time a confirmed invalid, whose death was possible at any moment. It was against
the wishes of his household, who were deeply concerned for the old General's comfort,
and the positive advice of his attending physician that Jackson had persisted in gratifying
Brady's wishes. On the morning of the sitting he had himself dressed with special care and,
bolstered up with pillows and cushions, he was determined and 'would not listen to any
denial.' 'His hair,' wrote T. B. Thorpe of *Harper's Monthly Magazine,* 'once such a remark-
able steel grey, which had "stood like a mass of bayonets" around his forehead, was now
soft and creamy white, and combed away from his temples it fell upon his shoulders.

'When the moment came that he should sit still he nerved himself up with the same
energy that characterized his whole life, and his eye was stern and fixed and full of fire.
The task accomplished, he relapsed into his comparatively helpless condition. When re-
lieved from pain he was pleasant and courtly yet, "he never seemed to be entirely satisfied
with the restraints imposed upon him as an invalid."'

CHAPTER
THREE

SOON after the opening of his gallery in 1844, Brady made his residence the Astor House, a trim, fashionable hotel on Broadway directly opposite his place of business. Besides being convenient to his gallery, it afforded him excellent opportunities for contact with the many celebrities who stayed there when in New York. His social life at this period was limited to his brief meetings with the prominent people that came to his gallery. But he seemed by natural instinct to adopt a friendly attitude, and this probably was largely accountable for his growing clientele of celebrities.

Despite the depression of 1837 that lingered through the years in which he was establishing his business, he prospered. His 'Gallery of Illustrious Americans' was near completion and publication, and now, with the amount of business pouring into the gallery, he needed larger quarters. But it was not until late in 1849 that he seriously considered opening another larger and more elaborate gallery.

During the early part of that year Brady had the good fortune to have for subjects of his camera, three of the most notable of figures in American politics, Daniel Webster, Henry Clay, and the fiery John C. Calhoun. These men were at the height of their fame and well past the prime of life when they came to Brady's. Webster's arrival in New York caused no little flurry of excitement. He went directly to the Astor House on invitation from his friend Charles Stetson, Sr., an admirer and close friend of Brady.

Stetson promised Brady that he would do his best to induce Webster to come to the gallery to sit for his portrait, but he made it plain that he could not arrange a definite time, but would signal to Brady by waving a handkerchief from a window on the Vesey Street side of the Astor when he and Webster were ready to come to the gallery. With this promise Brady had to be content, and hopefully posted a 'lookout' in his gallery window to await the signal.

Stetson kept his promise. After two days of patient waiting the signal was seen in the hotel window. A few moments later Stetson and Webster were observed crossing the street by the 'lookout' who quickly informed Brady of their coming. At once the gallery was all activity. Skylights were arranged, the camera placed in position, and the plates prepared. Nothing was overlooked that might delay or impair the sitting.

Webster's entry into the gallery was pompous, if not somewhat melodramatic. In a studied and stagy manner, somewhat out of breath after climbing three flights of stairs, he announced with a booming voice, "Mr. Brady, I am here sir! I am clay in the hands of the potter! Do with me as you please sir! I am at your service sir." And he offered his hand. Brady was astonished by this theatrical manner, but still more astonished were Brady's workmen, who acted as if paralyzed with awe.

While the sitting was being arranged Webster took his position in front of the camera, 'submitting with greatest good nature'. Shades under the skylight were adjusted, one rolling back with a snap, causing all to look upwards. Backdrop curtains were arranged, with Webster sitting quietly, mild amusement showing on his face at all the activity going on around him. And all the while the room smelled of iodine crystals, burning candlewick, and the smoke from Stetson's cigar.

Brady pointed the camera, studying the upsidedown image on the groundglass as he did so, noting that Webster's large dark eyes, set deeply in cavernous sockets in the massive head, seemed to 'hide mysteries in their depths'; and while Brady's assistant stood behind Webster adjusting the 'immobilizer', Brady noted too, that when tightened it seemed to make Webster's thin lips compress tighter with each turn of the thumbscrew.

Finally at a word from Brady, Webster riveted his eyes on the lens of the camera and the plate was exposed. Two more pictures were made, and on being told that the sitting was over, Webster's face brightened with an expressive smile, prompted undoubtedly, by relief at being released from the jaws of the headclamp. Without further demonstration, except for a formal bow, he left the gallery.

It was the request of a child who desired the picture for her locket that brought John C. Calhoun, the eminent statesman and arch opposer of Webster and Clay, to Brady's. He arrived promptly in accordance with his appointment, accompanied by his devoted daughter Mrs. Klempson.

It was a cloudy, rainy day, and none too favorable for the sitting. Calhoun seemed conscious of this fact, and while he attended to the necessary details, he continually made remarks about the inclement weather, seeming concerned as to what effect it might have. This was natural, for the sole source of light was the skylight of the gallery, and the success of any sitting depended entirely on the whims of nature, as far as the light was concerned. Brady put him at his ease, however, explaining that apparent poor light conditions could be overcome by a longer exposure in the camera. Brady in racking the image on the groundglass was struck by Calhoun's appearance of great age. His hair, which in his younger days had been dark, and had stood so frowningly over his broad, square forehead, was now long, and thin and combed back, falling behind his ears. The most outstanding of his features, Brady recalled later, was his eye. He said "that Calhoun's eye was startling, and almost hypnotized me".

When all was ready Brady made the exposure. But owing to the floating clouds and murky atmosphere, it had taken a full half minute for Calhoun's image to burn itself on

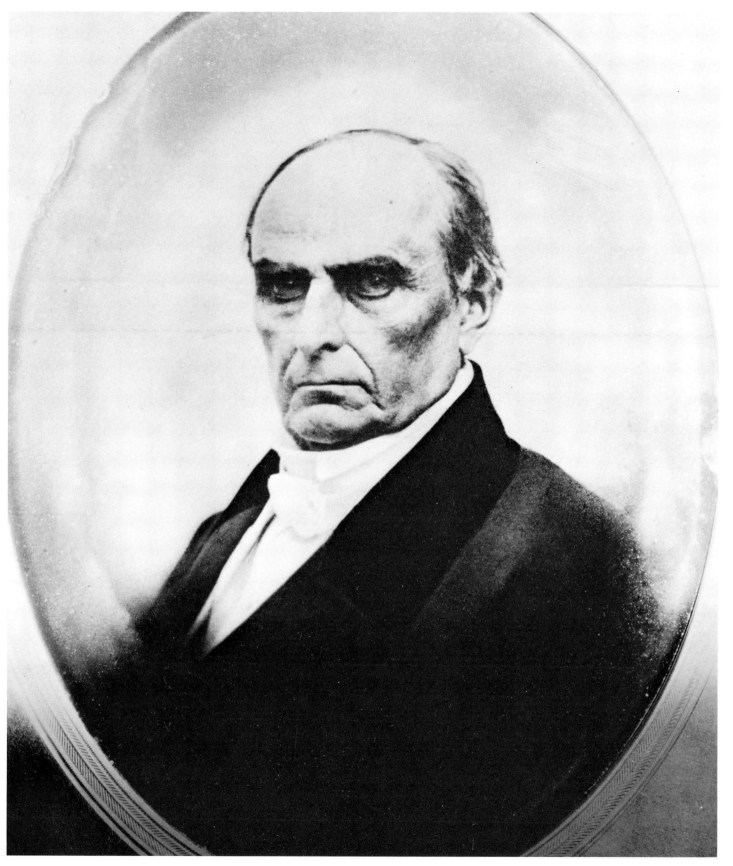

15.
DANIEL WEBSTER
After an original Daguerreotype, this portrait was probably Webster's last, by Brady

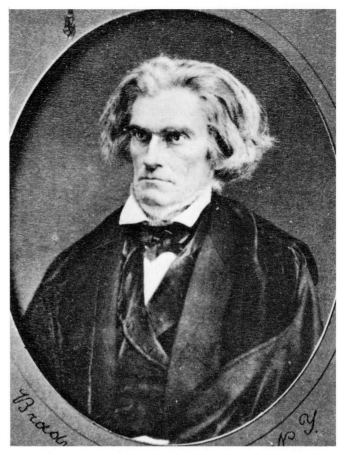

16. JOHN C. CALHOUN
This Daguerreotype portrait of the aged Southern statesman, made at the request of a child for her locket, was taken by Brady on a cloudy day in the Fulton Street Gallery, in 1849

the sensitized plate. To the elderly statesman this appeared to be a long time in a standing position, and with some weariness he remarked upon it. Brady, altogether dissatisfied with this first attempt, asked Calhoun if he would pose again. Calhoun was very obliging and readily consented.

Brady attempted the picture again and this time it was successfully accomplished in ten seconds. Calhoun's daughter, during the intervals of posing, delicately arranged her father's hair and the folds of his coat, and expressed her surprise at the length of time the first picture had taken. She asked her father: "How is it that your first picture consumed so much more time than your second?" Calhoun, resuming his seat while the plate for a third picture was being prepared, replied that he did not feel qualified to explain the exact method, but proceeded to give an enlightened explanation of the process of Daguerreotypy that fascinated and astonished the workers in the gallery.

Calhoun sat for the third time, and after expressing extreme pleasure at Brady's announced success of the visit, and calling the attention of his daughter to some of the pictures that looked down from the gilt frames on the wall, he left the gallery.

It wasn't long after Calhoun's visit that Henry Clay came to New York. And unlike the ease with which Brady obtained Webster's and Calhoun's presentments, Brady must have had some difficulty in getting Clay's, for he said at one time, in speaking of Clay's sitting, "It requires a good deal of diplomacy and influence, to obtain sittings from the eminent men, for when they are in New York they are usually in the hands of Municipal committees or their political friends."

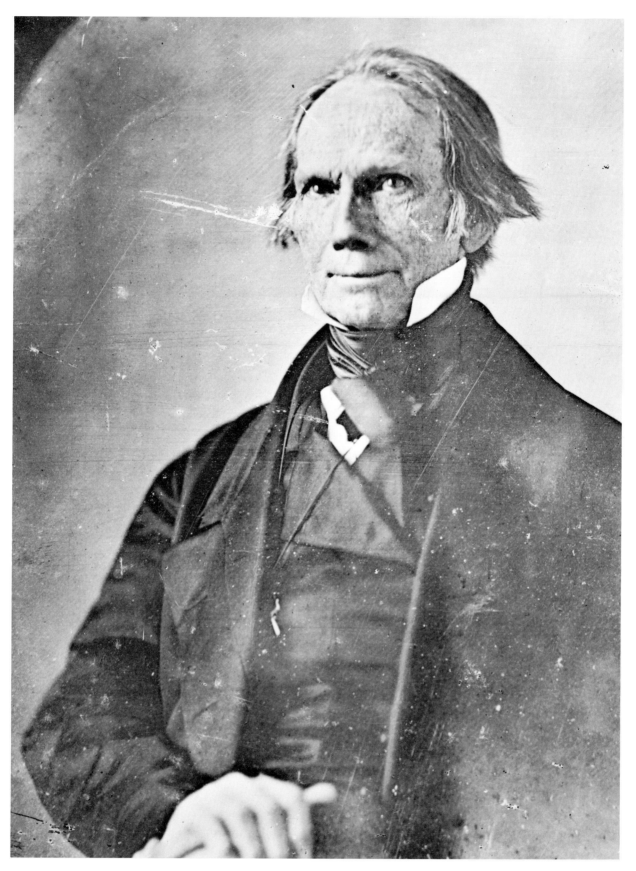

17. HENRY CLAY
This portrait made by Brady at the Fulton Street Gallery in 1849, is shown in its entirety for the first time

Clay was a popular man, who enjoyed everything in life. He drank with some moderation—something that could not be said for Webster, who liked his glass. A horse fancier, he was a heavy bettor, and was not above placing a bet on a cockfight. An excellent card player, he had many times held all night card games in his rooms. Nor did he draw the line at the Code Duello, for in 1826 he exchanged shots with John Randolph of Roanoak on a supposed slight, both missing, and Randolph refusing to fire again.

It was in the late Spring of 1850 that Henry Clay sat for a Brady portrait. Clay's health had been on the decline and when Brady approached him about the sitting he flatly declared that he was overwhelmed with demands upon his time, and that it would be impossible. Brady, surprised and disappointed at the blunt refusal, discovered shortly after, that Clay's personal friends, Mayor Brady, Joe Hoxey, Simeon Draper, and Moses Grinnel wanted pictures of Clay for themselves. Together with Brady, they contrived to have Clay sit for his 'counterfeit presentment', as Calhoun put it.

The time appointed was for the morning of the day that Clay was to be given a public reception at the City Hall. Somehow, word had gotten out that he was to have his portrait taken at Brady's Gallery and would arrive precisely at twelve, noon. Crowds gathered and milled around Broadway hoping to catch a glimpse of the celebrity as he entered the Gallery.

But they waited in vain, as did Brady, for Clay never arrived. He was besieged at the City Hall by the Aldermen and the thousands of admirers that thronged the park to greet him. Shortly afterward, a policeman brought Brady word that he was to bring his apparatus and come to the Governor's Room in the City Hall.

Brady gathered up his cameras, and with his assistants, aided by a police escort, pushed a way through the dense crowds that surrounded the City Hall. Chief of Police Matsell assisted Brady and his operators to the room where the picture was to be taken where Brady attended to the placing of the camera while his operators tacked up curtains and attended to other details. When Clay entered the room he walked over to Brady, saying very cordially, "Well, here I am Mr. Brady". Brady shook hands with Clay and showed him to the chair in which he was to sit. Meanwhile the hammering continued, and when it ceased Clay remarked at the sudden quietness of the room with some relief.

But the relief from noise was short, for crowds of people outside the building became demonstrative, and the corridors resounded with the noise. At the very moment when Clay was to pose, a committee of ward healers, gladhanders, and political hangers-on burst open the door into the refreshment room where a lunch was spread, and began to gorge themselves;—from the lunchroom they pushed and crowded into the Governor's Room.

Clay had dressed with particular care,—for he had set apart an hour that day for the special reception of the ladies—in a black satin suit with a long swallow tail coat. Around his neck was a high satin stock with a standing collar, which gave the appearance of stiffness to the whole costume. The large high vault of his head was covered with long stringy greying hair that hung around to his jaw, covering his ears. Slight irritation was apparent on his face, for the room by this time was filled with the spectators' cigar smoke.

This gave Brady a very uneasy feeling as to the probable result. But he nevertheless resolved to make the picture, and when everything was ready, Clay took his seat once again, saying, "Well, I am ready Mr. Brady,"—but before Brady could direct the pose, Clay's host of followers surrounded him as he sat waiting for instructions. The crowd almost obscured the statesman from Brady's view, and for a moment it looked as though no picture would be taken at all.

While Brady stood at his camera waiting for the crowd to move aside, Clay suddenly raised his hand, commanding immediate silence, and caused his admirers to step out of the way of the camera. Clay assuming his pose, dropped both hands before him, one grasped within the other,—and at that moment Brady exposed the plate.

When the click of the drop shutter announced that the sitting had ended, a subdued but enthusiastic demonstration was made by the spectators. Clay gracefully arose, and bowing, put everyone at ease by conversing with those nearest him. In a few moments Brady's workmen relieved the crowded room of cameras and paraphernalia, and the doors were then thrown open to the public.

Brady was dissatisfied with the sitting, and before Clay left the room, received his promise that he would come to the gallery for another, before he returned to Washington.

These early years were filled with as many dramatic and amusing incidents as the gallery was filled with pictures. For the most part, even at this early stage, Brady's clientele were colorful figures of the period, and to Brady it was an education in itself, this mingling with the learned men of the time. But all the sittings did not go smoothly, for the crude facilities with which Brady had to work sometimes caused mishaps and embarrassment. Such was the case with Thomas Hart Benton's sitting.

Benton was a man of many contradictions and convictions. Known in political circles as 'Andy Jackson's lieutenant', he had bitterly criticised President Polk's policies and was censured for it. He had once killed a man in a duel, and for a time tiring of politics, he went to St. Louis and started a newspaper, the *Missouri Enquirer*, there having to fight a duel for every editorial he ever wrote.

In a strange encounter that started with a three-sided argument involving him, his brother, and Andy Jackson, his brother shot Jackson in the shoulder and was thrown downstairs. But time healed the breach between him and Jackson and he later became United States Senator, serving for thirty-six years.

Benton had been engaged, so to speak, in the electioneering canvass of the year that Brady had 'waited on him with influential friends', receiving Benton's promise to visit the gallery. He had come and had taken his place in front of the camera, seated, the 'clamp' holding his head. The shade overhead to control the light, which was raised and lowered by pulley, had been fixed in position for the picture. Brady had gone into the rear darkroom for the plate when he heard a crash, followed by Benton's shouting, frantically, "Brady, come here at once!"

This brought Brady into the studio on the run. The frame was resting on Benton's

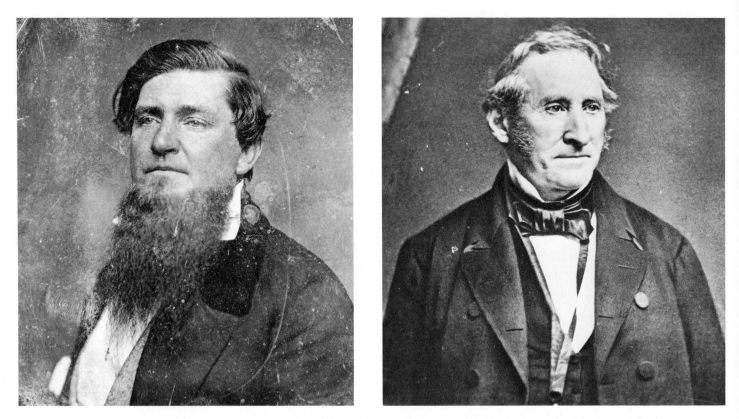

18. *Left:* BRIGHAM YOUNG, Governor of Utah, President of the Church of Latter Day Saints. From an original Daguerreotype by Brady never before published. *Right:* THOMAS HART BENTON, Editor, Statesman, and "Andrew Jackson's Lieutenant"

shoulders with his head protruding through the shade. A cloud of dust brought down with the shade almost obscured him, covering his clothes from head to foot. Brady quickly lifted the fallen frame from around Benton's shoulders and released him from the head 'clamp'. He then called in his assistants who helped clean up the debris while Brady brushed Benton's clothes.

Benton, seeing Brady's embarrassment, good naturedly laughed away the incident, and after the workmen restored the setting Benton once again took his place in front of the camera.

Edgar Allan Poe came strolling unexpectedly into the gallery one day during the latter part of May of that year, accompanied by a friend, Ross Wallace, a poet. Wallace wanted a picture taken of himself, making a point of paying for it. Wallace introduced Poe to Brady, who expressed his pleasure upon having such distinguished visitors.

Brady noticed that Poe seemed in a melancholy mood,—that his appearance spoke of suffering and mental torment. From his attire it was obvious that he was in abject poverty. He was dressed in a seedy black coat, tightly buttoned across his emaciated frame, with little linen showing. A swath of black necktie encircled his throat in a mass of wrinkles, carelessly twisted around and around many times 'like a bandage on a fracture.'

His hair, long and unkempt, hung down to his collar, covering his ears, and in his dark eyes showed the indelible marks of desperate grief brought on by the death of his devoted wife just two years before. His strong face was pale tending to puffiness around the eyes, and the dark circles under them told of excesses in drink.

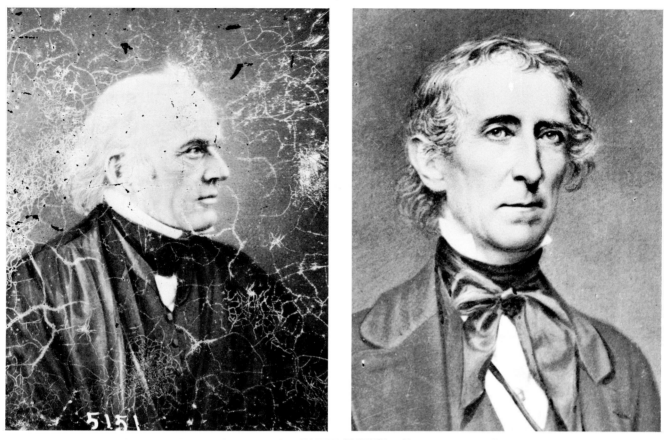

19. *Left:* JUDGE JOSEPH STORY. *Right:* JOHN TYLER. Daguerreotypes by Brady in 1845

While Brady's workmen were preparing for Wallace's sitting, Poe stood near the camera taking a curious interest in the proceedings, but through it all he remained strangely quiet. After having made several pictures of Wallace, to his satisfaction, Brady asked Poe if he would also like to sit for his portrait. But Poe, with a slight trace of a smile, declined with a shake of his 'wild loose locks'.

Brady, quick to sense the reason behind the curt refusal, gave the penniless Poe—with as much diplomacy as he could muster—to understand that there would be no charge for the sitting as he was an admirer of Poe's works, and wanted the picture for his gallery. But Poe was adamant.

Finally, after persuasion on the part of Wallace, Brady won out, Poe taking his seat in front of the camera without even as much as a tug at his tie. He responded to Brady's posing instructions gracefully, and without comment, but the gloomy look would not leave his face.

Brady made the picture, and while the plates were being processed he showed Wallace and Poe around the gallery, pointing out familiar persons whose portraits hung on the walls. Shortly afterward they left, Poe never to return.

It was barely two weeks after the sitting at Brady's that Poe went to Richmond, a sick man. In the southern city he stayed with friends in an effort to regain his health. His stay lasted until early fall and he greatly improved with abstinence. But the weight of his distress overcame his fortitude, against which the habit won the struggle. For on the return trip to New York he suddenly disappeared. After a week of frantic searching by his friends, he was found in a notorious drinking place in Baltimore intoxicated to the point

31

of unconsciousness. He was taken to a hospital where he succumbed four days later.

The odd intervals on Brady's studio calender were interspersed with incidents not of his own choosing. Another experience with the writing fraternity came about when James Fenimore Cooper consented to having his picture taken.

Brady, being otherwise engaged, entrusted one of his operators with the job of making arrangements for Cooper's appointment. The operator obtained Cooper's somewhat reluctant consent to sit for a portrait, and while in the act of posing him and preparing a plate,which required a few moments, the operator tried to make himself agreeable to Cooper.

It so happened at this particular time that Cooper was having some trouble over a disagreement with his publisher, and was a little out of sorts. The operator seemed well informed on the controversy, and expressed his personal views in sympathy with Mr. Cooper. The operator's remarks at this juncture seemed to strike a sour note, for suddenly, for some unknown reason, Cooper jumped up from the chair in which he was sitting, and without a word rushed from the gallery. Brady upon returning that day was told of the unfortunate incident, and immediately went to see Cooper. But Cooper refused to see him. It was sometime after the occurrence that Brady, armed with a letter from William Cullen Bryant, called upon Cooper who was at Bixby's Hotel on the corner of Broadway and Park Place. Brady was shown to Cooper's rooms, and, though expecting another refusal, he determined to use 'all his powers of persuasion' to induce him to again come to the gallery. His knock was answered by Cooper himself, and to Brady's astonishment he was received very cordially. After greetings were exchanged, Brady handed Cooper the letter, and after a quick perusal, he surprised the photographer by saying that he would 'dress immediately and go to the gallery'. A few moments later, calling a hansom, they drove there, and the long sought picture was soon made.

Brady's 'Gallery of Illustrious Americans', now complete, was ready for publication. For the Lithography Brady hired an expert, Frances D'Avignon, to make copies of the selected Daguerreotypes, for which he paid twelve hundred dollars for the lithographic stones. The 'Gallery' was henceforth published, and being an elaborate and expensive publication, it was not a financial success. But this did not seem to cause Brady much concern for that same year he completed plans for a branch gallery in Washington D. C. He reasoned that as Washington was the gathering place of the country's statesmen, it would offer splendid opportunities. By now he had a staff of well-trained and able technicians and his own time was, for the most part, taken up with business matters concerning his enterprise.

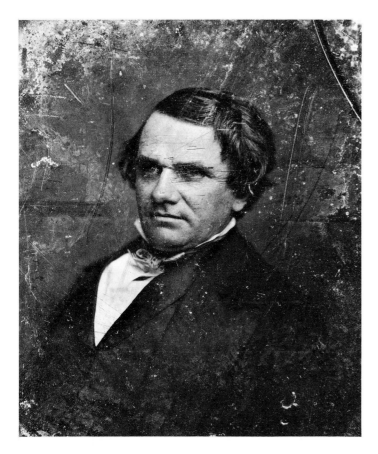
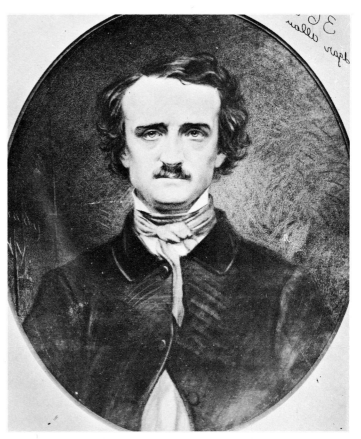

20.　　　　　AN ORATOR, A POET, A PRESIDENT, AND A WRITER
Upper Left: STEPHEN A. DOUGLAS. *Upper Right:* EDGAR ALLAN POE. *Lower Left:* JAMES
KNOX POLK. *Lower Right:* JAMES FENIMORE COOPER.

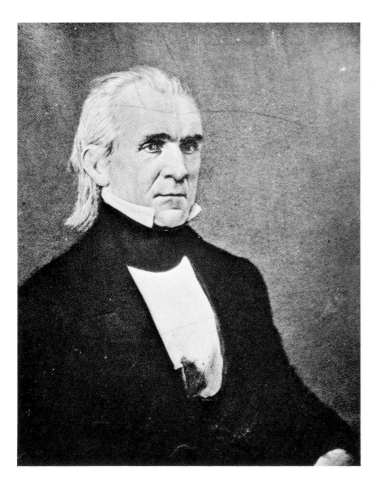
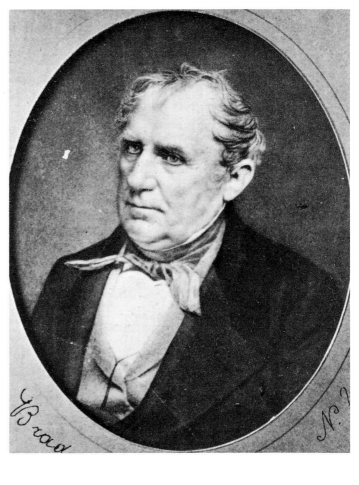

CHAPTER

FOUR

BY MARCH of eighteen forty-nine Brady opened his first Washington gallery. For the purpose, he rented a house near the National and Brown's Hotels;— and although this new edition of the branch gallery in the Capital City gave early indications of being a profitable investment, it was nevertheless in the nature of an experiment. It was not as elaborate as the gallery in New York, but the equipment and fixtures and darkroom layout were of the best obtainable. It was mainly operated during the sessions of Congress where its location would be easily accessible to the country's statesmen, when they felt inclined to sit for their portraits.

Just a month previously, on February fourteenth, Brady photographed James Knox Polk, the first president to sit before his camera. For the sitting Brady came to Washington, a short time before Polk's term of office expired. Brady went to the White House on the day set for the portrait with his Daguerreotype outfit, accompanied by an assistant. This was evidently at Brady's request, for Polk later told about it in his diary. He wrote, "I yielded to the request of an artist named Brady of New York by sitting for my Daguerreotype likeness today. I sat in the large dining room."

Washington was by no means virgin territory to Daguerreotypists, for two of Brady's biggest competitors had opened studios almost five years before. Thomas H. Benton had then been chairman of the Senate Military Affairs Committee, and he had loaned the committee room to Edwards and Anthony to carry on their business—rent free.

Quincy Adams, had written earlier that he too, posed for the Anthonys. "I sat in their rooms," he wrote, "while they made three larger Daguerreotype likenesses than they had before," and Adams further recorded,—"President Tyler and his son John came in;—but I did not notice them."

Edwards and Anthony had a lucrative field in Washington, and until the time Brady decided on opening his gallery in the Capital City, they had succeeded in photographing all the most prominent people, including all the congressmen whose terms of office overlapped those years of Brady's beginnings. And it is evident that Brady had stepped into a veritable hornet's nest of competition. For Edwards and Anthony, to make sure of their clients, moved into the Capitol.

Brady had by now photographed John Quincy Adams, the sixth president, a school-boy at the time of the Declaration of Independence, Andrew Jackson, and James Knox Polk, and he would in time, photograph them all up to McKinley, with one exception—William Henry Harrison, who died in office in 1841, three years before Brady started on his career.

While in Washington on one of his visits, Mathew Brady met Julia Handy. She was the daughter of Colonel Samuel Handy of Somerset County, Maryland, and the grand-niece of Levin Handy, a Commodore during the Revolutionary War. Her father, a distinguished lawyer, had come to Washington at the request of President Jackson to act in a government capacity, and with him he brought his daughter, then four years old.

President Jackson seeing her for the first time, was so 'struck with her' that he wanted to adopt her for his own.

As a young girl she attended the best schools of Maryland and Georgia. Her alertness and spontaneity had gained her many friends and brought her much admiration and attention. She had no personal ambitions but delighted to share in the experiences and confidences of her intimates. Her mother, having died when she was very young, Julia undertook her father's care with sympathy and understanding.

Brady when in Washington, always stayed at the National Hotel, and it was here that he met her while attending a dinner. Their interest in each other was immediate, she being impressed with this quiet, serious young man who had achieved so much in so short a time. Their courtship was short and no other woman ever became more a part of her husband's life than did Julia Handy Brady. Her background and personality helped lay the foundation for his future successes.

They were quietly married in the old "E" Street Baptist Church in Washington, D. C. by the Reverend Sampson who had married many members of the Handy family. The wedding was attended by members of both families and their close friends. There followed a gay reception at the National Hotel after the nuptials; they later entrained for New York with their hosts of friends seeing them off at the station. Arriving in New York the newlyweds drove directly to the Astor House where they would make their home for the next few years.

Brady appeared with his bride in all the fashionable theatres and restaurants. For the general run of business that came to the gallery daily, he had operators that ably handled the work. It was mainly with the celebrities that he concerned himself, for their portraits were a matter of importance to him and he personally conducted and photographed them, —or at least he directed the sitting, lighting and posing if not actually participating in the darkroom itself.

These appointments were frequent, but the intervals allowed him leisure for relaxation. On holidays he and his wife went for drives in the country. They were always entertaining guests in their suite, and many times Mrs. Brady came to the gallery bringing her friends with her.

Brady was always delighted by her visits, and on one occasion she herself sat for a

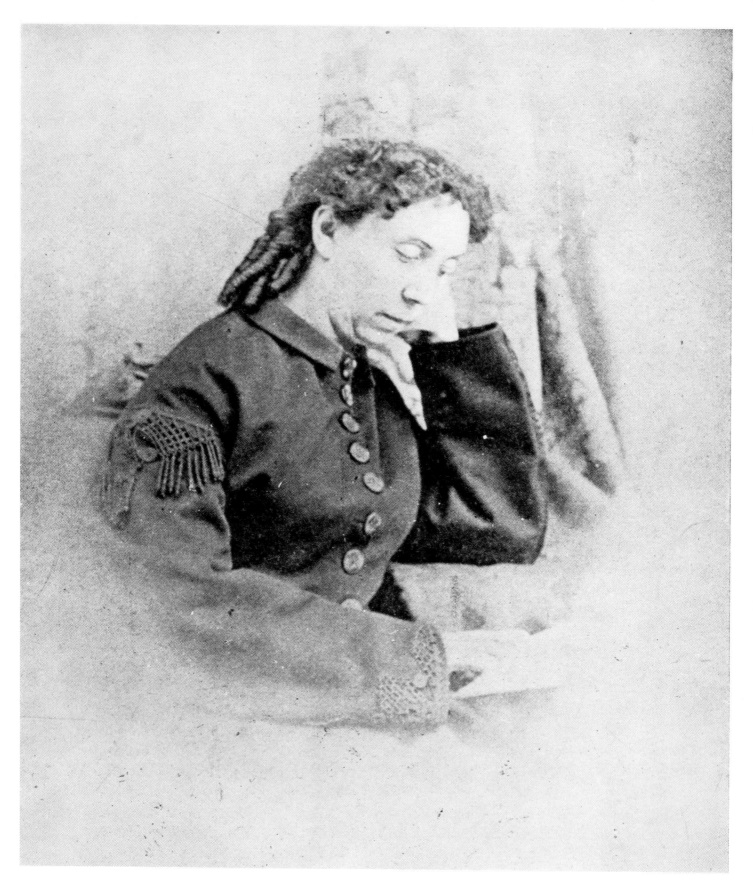

21. **JULIA HANDY BRADY**
Wife of Mathew Brady. A hitherto unpublished portrait, made in the Washington Gallery shortly
 after their marriage

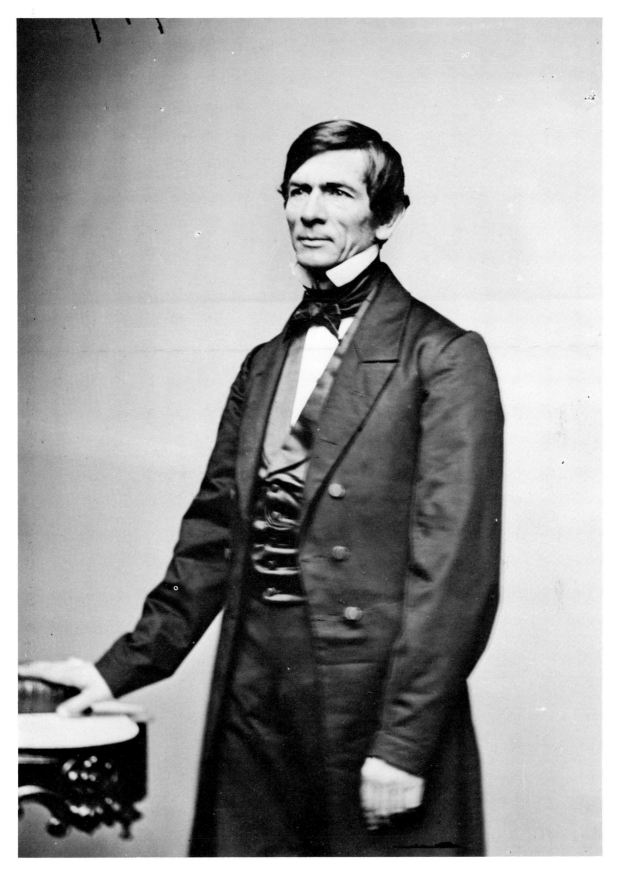

22.
REVEREND WILLIAM SAMPSON
As minister of the E Street Baptist Church, he married Julia Handy and M. B. Brady. From the **Brady** family bible, never before published

'Brady' portrait. These were prosperous and happy times, and it was fortunate that the happy couple could not see into the future, for after a few short years her health was impaired by a heart ailment and the last years of her life she spent as an invalid.

It was two months later, on May sixth, that Brady again came to Washington to make Zachary Taylor's portrait. President Taylor came to the new studio, where Brady made three large size pictures, one at full length, standing. He also made a picture of Taylor and his Cabinet a few hours later. The group comprised Reverdy Johnson, William M. Meredith, and Preston, flanking him on the right, and John Middleton Clayton, George Washington Crawford, Thomas Ewing, and Jacob Collamer on the left. This was a typical Brady grouping, a type he excelled in, and would later use to advantage.

While Brady was in Washington he consumated arrangements for the engraving of these pictures, the actual engraving of the lithographic stones to be executed by D'Avignon and Hoffman, the final printing by Nagle and Weingaertner, a printing firm in New York. Of these pictures the Washington press said: "The success of Mr. Mathew Brady in taking Daguerreotype portraits is truly remarkable,—and when it is remembered, too, that the president was never in better health than at the present time, the value of these portraits is greatly enhanced."

Brady soon after, returned to New York, and his photographic duties in Washington were taken over by his operators. The public received the 'General Taylor and his Cabinet' portraits with enthusiasm. One paper, after reviewing the picture, said: "We have no doubt but that Mr. Brady will receive a handsome income from the sale of this magnificent picture. At least we hope so, for he is a man of industry and enterprise and deserves it."

The Daguerreotype by this time had come into its own, for it was now justly ranked among the greatest discoveries. In the city of New York alone there were, it was stated, "about ninety-six Daguerreotypists, the most celebrated being Brady." And with the annual amount of business coming into his galleries it was a continual topic for the speculation and wonder of his competitors.

Until this time Brady's camera subjects were mainly in political circles, but early in 1850 Jenny Lind, the Swedish Nightingale, Europe's singing sensation, arrived in New York. She had retired early in 1849 from the operatic stage, and now was devoting herself to concert singing. She was then thirty years of age and at the height of her career.

Of all theatrical celebrities that graced the American theatre, Jenny Lind was by far the most 'Daguerreotyped'. And for the portraits that were solicited of her in the various cities in which she appeared, the Daguerreotype operators received anywhere from five to twenty-five dollars, depending entirely upon how great the sensation was that she created by her appearances.

P. T. Barnum, the American showman, who sold Bibles and exhibited Negro dancers at the same time, became her manager, and in his managerial capacity Barnum's generosity probably overcame his better judgment. For the great showman,—he who exhibited the Japanese Mermaid, a monstrosity composed of a fish and a monkey; a 'White Negress',

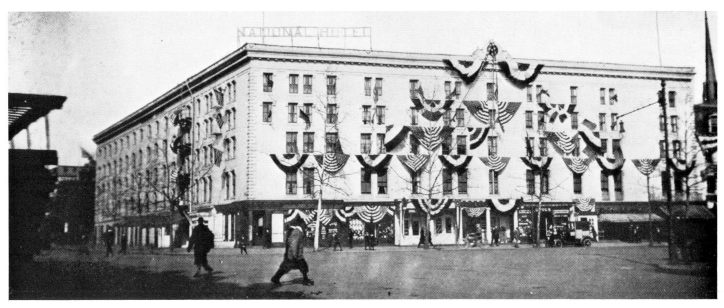

23. THE NATIONAL HOTEL, WASHINGTON, D. C.
One of the most fashionable of the Capitol City's hotels

and a dwarf that answered to the name of General Tom Thumb—gave the Nightingale almost ninety per cent of the income derived from the concerts which he had arranged. A fact which even surprised and mystified the songstress herself!

Barnum gave the Nightingale one thousand dollars a night for concert appearances, the tickets being sold at auction. And for the season of ninety concerts the gross income was seven hundred thousand dollars! Brady was intimately acquainted with Barnum, whose museum was just across the way from Brady's gallery on Broadway. Brady went to see Barnum to make arrangements for a portrait sitting of the Nightingale, but for some unknown reason, Barnum was indifferent to Brady's proposal,—and speaking as the singer's manager, he politely but strongly refused.

But Brady was not to be outdone by this, for quite by chance he happened upon an old schoolmate of the Nightingale's who now lived in Chicago. The young man, on a visit to New York, had come to the gallery for a portrait sitting. While the sitting was in progress, the conversation had got around to the Nightingale. The young man casually mentioned that he was a childhood friend and had gone to school with her back in Sweden.

Brady told him of the difficulty he was having in getting a picture of the singer and that Barnum her manager had refused to help him. The young man promised Brady that he would write to her at once and ask her to come to the gallery for a sitting.

The young man was as good as his word, for shortly after, Brady was informed that she would be at the gallery within the week. A few hours before the appointed time, crowds began gathering in front of the Broadway entrance of the gallery. The studio was prepared for the sitting. When the Nightingale's carriage arrived the crowds jammed the entrance so thickly that it was only through the efforts of her driver and a few policemen that she was able to reach the doorway safely.

After a very pleasant and successful sitting in which a number of plates were made, the gracious songstress was shown around the gallery by its owner. When this pleasant interlude came to an end and it was time for Miss Lind to leave, Brady suddenly realized that she would have difficulty in getting through the dense crowds outside. He managed to have

39

her carriage brought around to the Fulton street entrance, but the crowd followed the carriage. The driver had great difficulty in forcing his way through, and the horses almost trampled some of the excited onlookers.

How did the crowds learn of the Nightingale's coming to Brady's? It was never mentioned thereafter—but Barnum liked publicity, and he was, after all, her manager—and for that matter so did Brady like publicity—?

The results of the Nightingale's visit to Brady's did not go unnoticed by the press, for it was stated, "One of the most beautiful specimens of art that we have recently seen, is a portrait of the Swedish Nightingale, which for perfect correctness of expression and beautiful execution stands unrivaled".

Making portrait sittings did not comprise the major part of Brady's photographic business, for the copying of Daguerreotypes and other subjects was a large department in itself. The Operating Department of the gallery he had arranged in a scientific manner and it was directed by outstanding artists of known skill. It contained equipment for copying, painting, and engraving, along with facilities for photographing statuary. The light source and the instruments used were especially designed for this purpose, several cameras being used, and this studio was large enough for more than one operator to work at one time.

On one occasion Mrs. Alexander Hamilton visited the gallery at the age of ninety-three, for a portrait sitting. She was dressed in a costume of the past, and on her head was a plain snug-fitting cap. Brady about that time had been experimenting with the restoration of Daguerreotypes, and during Mrs. Hamilton's sitting the conversation had turned to this subject. Brady told her that it was possible to make copies of Daguerreotypes, and speaking of this later Brady remarked, "She loaned the framed miniature in profile of her illustrious husband made on ivory, which was to be found on the Treasury notes;—the same from which I made a copy."

Another department that Brady inaugurated as an addition to the gallery, was the Daguerreotype College of which he was president. Although the school was an innovation, it only lasted a few short years, for the Daguerreotype now at its peak of popularity would, before long, fade into obscurity with the coming of 'wet plate' photography.

Brady's publication, the 'Gallery of Illustrious Americans', that he had spent so much time on, finally appeared in the leading bookstores of the city that year. It was a unique publication in the sense that the pictures and biographical sketches it contained were detachable and could be bought separately or as a whole unit. The book was large in size and was in the finest format of the period. It was not sectional in its scope, for the names of the men whose portraits it contained were those whose talents and public services had gained 'honorable fame throughout the nation.'

The book sold in its complete form of twenty-four portraits for twenty dollars, or single portraits could be had for one dollar each. Upon its appearance in the bookstores it received wide acclaim from the press. It was yet to be seen, whether the sale would be popular. But the press said, "Brady's Gallery of Illustrious Americans has now established for itself a substantial reputation and we are glad to learn that the circulation is rapidly increasing."

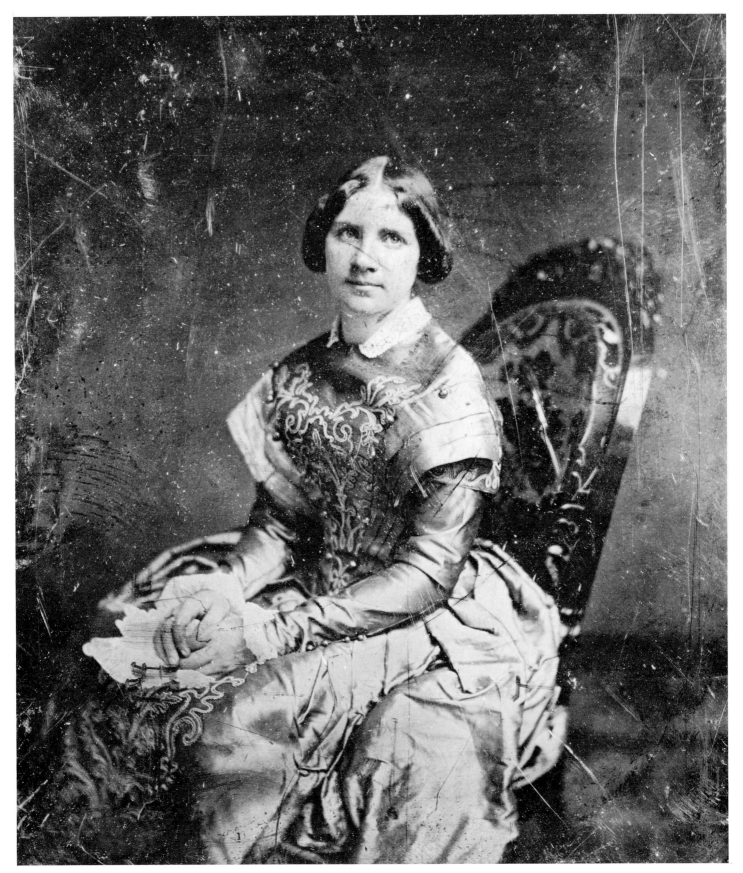

24.
JENNY LIND, THE SWEDISH NIGHTINGALE
This Daguerreotype of the famous Swedish Coloratura was made at the Fulton Street Gallery by Brady in 1850. From an original Daguerreotype

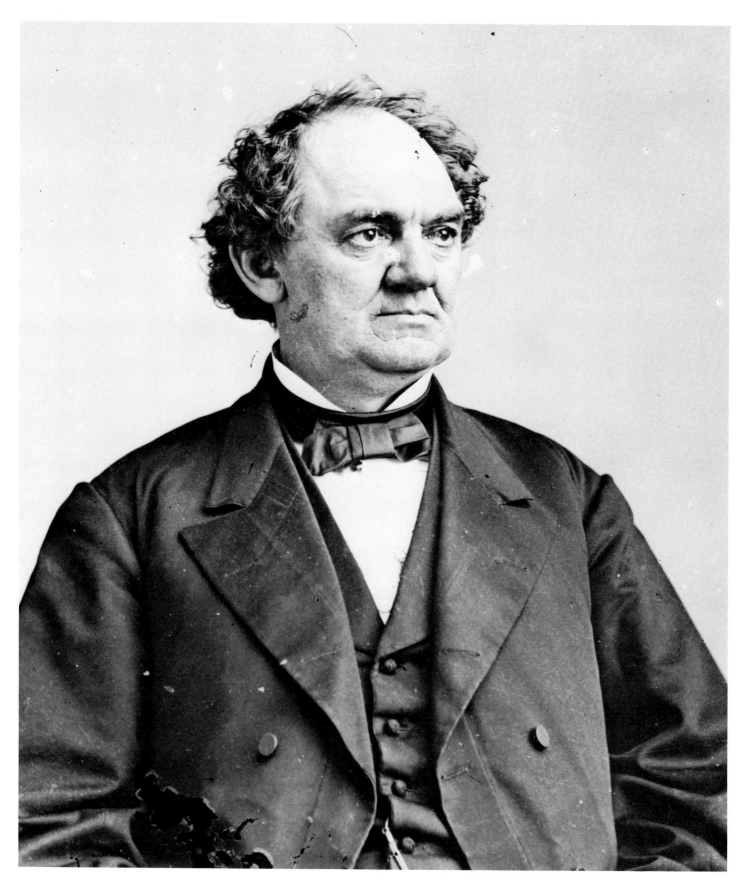

25. **PHINEAS TAYLOR BARNUM**
American showman, founder of the "Greatest Show On Earth," the traveling circus. From an original
wet plate negative hitherto unpublished

26. **MAGGIE MITCHELL**
This American actress famous for her role of Jane Eyre was photographed by Brady in the Tenth
Street Gallery in New York.

27. MADAME LYDIA SIGOURNEY
American poet and philanthropist. Photographed by Brady in 1859 in the Tenth Street Gallery in New
York. After an India Ink print from an original wet plate negative and never before published

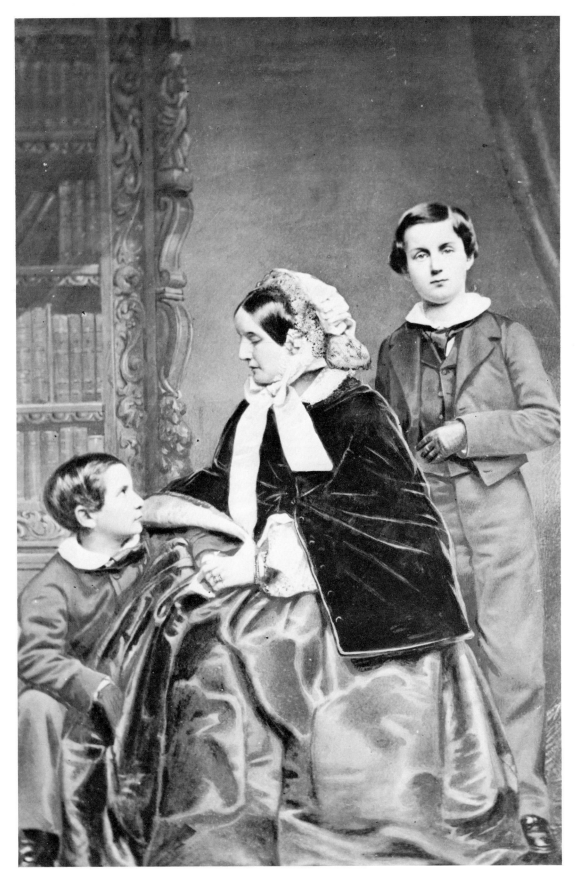

28.
LADY NAPIER AND HER SONS
This India Ink portrait made by Brady in the Tenth Street Gallery in New York, hung in the Washington Gallery foyer. From an original wet plate negative by Brady

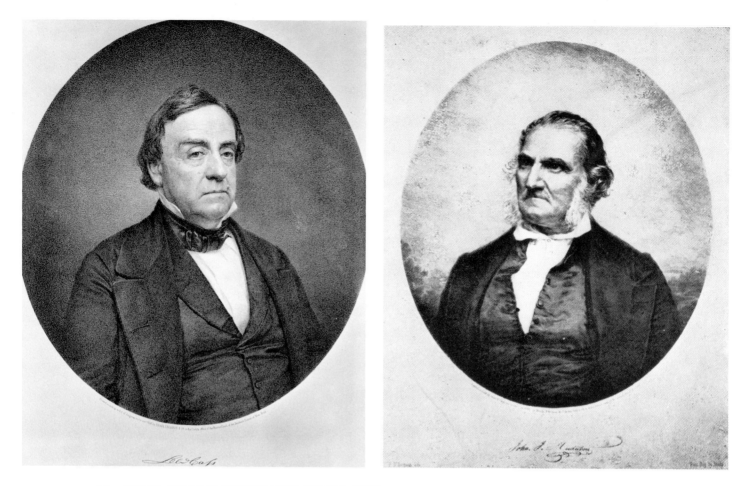

29. SOME BRADY PORTRAITS FROM THE "GALLERY OF ILLUSTRIOUS AMERICANS"
Left Above: LEWIS CASS. *Right Above:* JOHN J. AUDUBON. *Left Below:* GENERAL WINFIELD
SCOTT. *Right Below:* WM. E. CHANNING

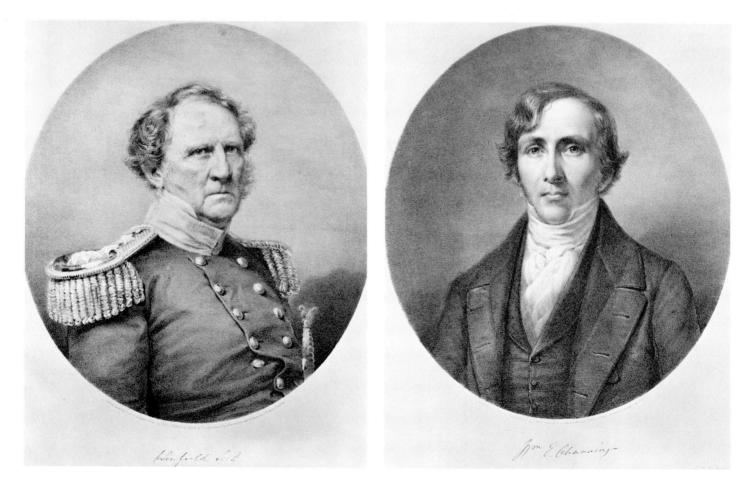

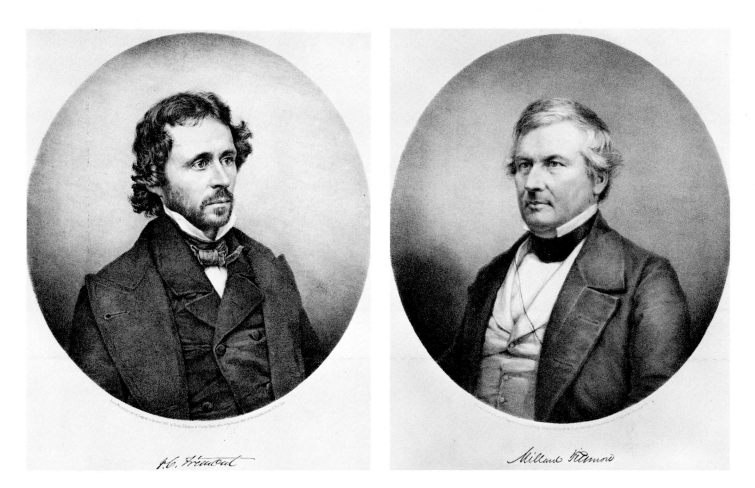

30. SOME BRADY PORTRAITS FROM THE "GALLERY OF ILLUSTRIOUS AMERICANS"
Left Above: JOHN C. FREMONT. *Right Above:* MILLARD FILLMORE. *Left Below:* WM. H.
PRESCOTT. *Right Below:* SILAS WRIGHT, JR.

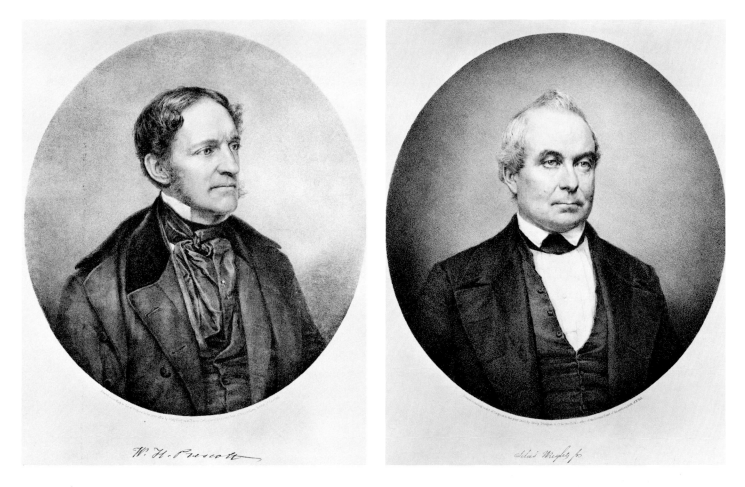

CHAPTER

FIVE

I
N 1851 the great London World's Fair, first and largest of its kind in the world, opened
in all its sparkle and lavishness. It had as one of its main features, an edifice in the
Hyde Park district of London, named the Crystal Palace. Devoted to the Arts and
Sciences, it was built entirely of glass supported by iron framework. Costing upwards
of $5,800,000 dollars, its wooden flooring covered a total area of twenty-one acres.

Included among its many exhibits was one of the largest photographic displays ever to
be seen up to that time. It was a competitive display, where the leading Daguerreotypists
of the United States and the countries of Europe would vie for the honors the judges would
bestow on their pictures.

It was only fitting that Brady of Broadway, one of the leading, and most certainly best
known, Daguerreotypists of America, would be one of the three men to represent the Amer-
ican Union at the London Exhibition. Also scheduled to exhibit were M. M. Lawrence,
a competitor of Brady's from New York, and John A. Whipple of Boston, both capable
technicians and portraitists. To Brady, it not only presented an opportunity for capturing
more professional honors but it would mean a belated honeymoon as well. He selected his
best pictures, forty-eight in all, including his recent publication, Gallery of Illustrious
Americans, and formally entered them for exhibition.

It was a pleasant ocean voyage, and to Brady, worn down by overwork and over exer-
tion, it was undoubtedly a relaxing and hard-earned vacation. His health had not been of
the best during recent weeks, and the trip to Europe was a welcome respite from his labors.
It was in fact his first real vacation in over seven busy and eventful years, and the energy
he had expended during this period of struggle needed replenishing, and the sea-voyage
was a tonic.

As the steamer churned Europeward, Brady met many people on board that he knew
intimately. Among the passengers were Mr. and Mrs. James Gordon Bennett and their son
John. Brady was no stranger to the Bennett family, for he had at one time made a portrait
of Mrs. Bennett. He had also tried tempting the noted editor into coming to the gallery,
but Bennett would have none of it, saying, that he would not permit himself to be photo-
graphed, as he was, he said "shy of the camera."

After their arrival in London the Bradys became the guests of the Earl of Carlisle. Brady's duties during his stay in London were, for the most part, giving demonstrations of his camera technique at the Crystal Palace. His letters of introduction to Cardinal Wiseman, Lamartine, the French poet, statesman, and extravagante, who at that time was on the verge of bankruptcy, and Victor Hugo, the noted writer, were requests that they grant him the pleasure of photographing them. These letters of introduction brought quick response and these three distinguished personages came to the Crystal Palace, where Brady made portraits of them.

Mrs. Brady, who in a great degree possessed the rare qualities of well-bred women, maintained her social rank as much by courtesy and sweetness as by tact and birth, and was always present at these functions, taking great interest in them. She shared her husband's honors and triumphs to the full. Together they entered the social life of literary London during their stay, and they entertained and were guests of many of Europe's notables.

For his pictures on display at the Crystal Palace, Brady was awarded the first prize by the Fair's judges, and he also received one of three medals given only for the best Daguerreotypes. Lawrence, Brady's New York competitor, and Whipple of Boston were awarded the remaining two. Lawrence received commendation for 'clear definition and general excellence of execution,' and Whipple 'for an unusual departure from the portrait trend,' received his medal for a Daguerreotype of the moon!

In the face of all European competition the American practitioners of the Daguerreotype art came away with top honors, but not without sharp reproach in another direction, from the English press. The papers were unanimous and emphatic in their praise, though not altogether without disappointment. But without exception they admitted that the Daguerreotypes from across the Atlantic were unquestionably the best. Yet, unanimous as the London critics and judges were in their decisions as to America's Daguerreotypes, one could not resist administering a rap on the knuckles. This came from the critic of the *Illustrated London News* who found no fault with the pictures themselves, but with the method and manner in which the Americans contracted for space at the Crystal Palace for displaying them. He wrote: "After a very minute and careful examination we are inclined to give America the first place. Whether the atmosphere is better adapted to the art, or whether the preparation of Daguerreotypes has been congenial with the tastes of the people . . . Certain it is that the number of exhibitors has been very great and the quality of production super-excellent. The likeness of various distinguished Americans by Mr. Brady are noble examples of this style of art."

The critic went on to say, "The family of Mr. Churchill is a very pretty group, and the series of views illustrating the falls of Niagara are very appropriate examples of American industry by Mr. Whitehurst of Baltimore. The large specimens by Mr. Harrison are also excellent. In fact the American display of Daguerreotypes in some degree atones for the disrespect with which they have treated all other nations, in having applied for so large a space, and yet at last having left their space comparatively unfilled." This last statement was undoubtedly a rebuke to the other American Daguerreotypists who had evi-

dently applied and contracted for more space than they could use, and then at the last moment cancelling the contracts too late for other nation's exhibitors to take advantage of the vacancies.

The opinions of the juries judging the photographic entries were unanimous in their decisions for a London correspondent of the *National Intelligencer* wrote: "The American Daguerreotypes are pronounced the best that are exhibited." But back in America Horace Greeley blatantly announced, "In Daguerreotypes we beat the world."

Brady and his wife stayed in Europe that year, touring the countries of the old world and visiting their principal cities. They traveled as far as Rome and Naples, and it was a pleasant surprise to Brady to find his pictures exhibited in all the leading galleries everywhere he went.

When Brady visited the Pitti Palace in Florence one day during his trip, the custodian, upon learning that he was the celebrated Daguerreotypist from New York, showed Brady one of his own pictures. He told Brady that his plate was kept there as a 'specimen of the excellence that the Daguerreotype had attained in America!' The custodian also stated that the particular picture had traveled much, and that it had been sent as a specimen to Rome, Vienna, and other European Capitals.

But by far the most important event of Brady's visit abroad, aside from winning the Fair's prizes, was his meeting with Alexander Gardner, the English Daguerreotypist.

Frederick Scott Archer, another Englishman, some months before had discovered a new process that was soon to become known as the 'wet plate'. Archer's discovery was revolutionary. It had been practiced for several months in England, but it was not, until that time, perfected to a point where it could be used for exhibition purposes. It was simple in the fact that a glass plate was coated with an emulsionized mixture of collodion and iodine, and dipped in a bath of silver nitrate for sensitivity, and allowed to dry until tacky. All plate preparation was done in darkness, and when this same coated plate, still tacky, was exposed in the camera and developed while still wet, the result was a negative image. Any number of original prints could be struck from this negative without harming the original in any way. Moreover, being more sensitive to light almost 'instantaneous' exposures could be made, and more important, smaller lens diaphragm openings could be used. And with the wet plate process from a commercial standpoint, there was no comparison. The Daguerreotype was a direct positive picture image, and none other than the original could be had without a process of copying.

Brady recognized at once what this process would mean to photography, and undoubtedly he further realized, too, that when this method became known generally to the profession it would sound the death knell of the Daguerreotype and its counterparts. And it also implied that the camera and laboratory equipment and technique would have to be revised somewhat.

Alexander Gardner, some months before Brady's visit to London and the Fair, had been experimenting and working with this method and had become quite proficient in its use. Brady met him at the Fair, and it is reasonable to suppose that Brady in his con-

versations with the English photographer made the proposal that he come to the States and work in his galleries. Just what arrangements, if any, Brady made with the 'wet plate' expert or whatever his reactions to the proposals are unknown. In any event Gardner did join Brady in New York, but not until four years later.

Brady returned from Europe in May of 1852 after having been away on the continent exactly one year less one month. The change of scene and the rest had been beneficial, for his health was greatly improved. Encouraged by his showing at the Fair, and with his old zest and energy returned, he went to work on business matters that needed his immediate attention. He began to form plans for his contemplated new gallery, which was to be the largest operating unit of his enterprise. During his absence the studio was ably operated and his business had never been better.

Other episodes of moment that took place at Brady's that year, though minor, are worth noting. Ex-president Martin Van Buren sat for Brady sometime during that spring. He was then engaged in supporting Franklin Pierce for the Presidency. He had come to the Fulton Street gallery with his son John, 'Prince John' as he was familiarly known in former years while he was Attorney-General of New York. They came to the gallery on a pre-arranged appointment during a terrible storm, and it was with some consternation that Brady asked Mr. Van Buren why they had not postponed their visit. The ex-president replied, "Mr. Brady, never in my life would I break an engagement if it were at all possible to keep it."

But in marked contrast was the 'enforced' appointment of Governor William Learned Marcy of New York. When Marcy was Secretary of State in President Polk's cabinet, Brady had completed a set of pictures of all the cabinet members, with the exception of the indifferent Marcy. While in office he had always pointedly refused Brady's numerous requests, flatly saying that, 'he had no time'.

Marcy was an individual of many contradictions. Associated with the saying, 'To the victor belong the spoils', he himself was a firm believer in the 'spoils system' philosophy and of the 'every man for himself and the devil take the hindmost' school. A former newspaperman, while Secretary of State, he had 'scooped' the New York Herald, his pet hate. During his term of office he and the Herald were not exactly on what could be called good terms, because he said, "The Herald always seemed to know everything that went on in the State Department." Brady had given up all hope of ever completing the cabinet of Mr. Polk until one day Mrs. Polk was a visitor to the gallery. During the preparations for her sitting Brady said that he needed Mr. Marcy's picture to complete the portrait of her husband's former cabinet members. She exclaimed, in a tone that brooked no patience, "Leave that to me!"

Mrs. Polk's 'leave it to me' approach to Marcy evidently had the desired effect, for the reluctant Governor three days later came to the gallery. But it was with no little impatience that he sat for his portrait.

New York City was a lively and bewildering place even in June of 1853, the year Brady opened his new Gallery at 359 Broadway to the public. It occupied the extensive premises over Thompson's Saloon and was elaborately fitted out with the finest furniture and equip-

ment available. On the walls were hung hundreds of portraits taken of all the celebrities that had come to the old gallery since his initial start in the profession in 1844.

It immediately caught the public favor, and following the opening Brady exhibited his pictures at the Crystal Palace in New York and 'carried away top honors'.

After the establishment of this most elaborate of his galleries, Brady advertised extensively in all the leading newspapers in the city. There had been a lot of competition along the lines of the cheaper type of picture and to offset this in his 'address to the public' he stated:

"New York abounds with announcements of twenty-five cent and fifty-cent Daguerreotypes. But little science, experience, or taste is required to produce these, so called, cheap pictures. During the several years that I have devoted to the Daguerreotype Art, it has been my constant labor to perfect and elevate it. The results have been that the prize of excellence has been accorded my pictures at the World's Fair in London, the Crystal Palace in New York, and wherever exhibited on either side of the Atlantic.

"Being unwilling to abandon any artistic ground to the producers of inferior work, I have no fear in appealing to an enlightened public as to their choice between pictures of the size, price and quality which will fairly remunerate men of talent, science, and application, and those which can be made by the merest tyro. I wish to vindicate true art, and leave the community to decide whether it is best to encourage real excellence or its opposite; to preserve and perfect an art, or permit it to degenerate by inferiority of materials which must correspond with the means of price."

Whatever effect this announcement had on the public and the proprietors of the low-priced galleries is unknown. But it does point out unmistakably Brady's motives and efforts toward the uplifting of the profession, and his sincerity in his professional practices, though it may be questioned on grounds of business solicitation. Yet the fact remains that he did, from the very beginning of his career, bring to the profession the stamp of quality and dignity that he knew it justly deserved.

It was about this time that the Ambrotype, invented by James A. Cutting of Boston, a photographer who had contributed much, came into its short-lived prominence. It was actually almost identical with the wet plate in some respects, but differed in that although the glass plate was coated with collodion and exposed in the camera and developed and fixed, it remained a negative image until a piece of black paper was placed behind it for viewing. This caused the white areas of the plate to become black and the black areas to reflect light by contrast, hence producing a positive image. In some cases dark glass was used as backing cemented to the image plate with Canadian Balsam,—a compound in use today for cementing optical elements of lenses and filters,—and then placed in fancy gilded frames.

But of all the confusing and various 'types' developed during the then growing period of photography, the Ambrotype became the forerunner of the wet plate method that would soon grow into popular use in America. And with the advent of the Ambrotype, wet plate, and the 'Imperial' photograph, the Daguerreotype would slowly go its way into obscurity, and by 1858 would be almost entirely gone from the photographic scene.

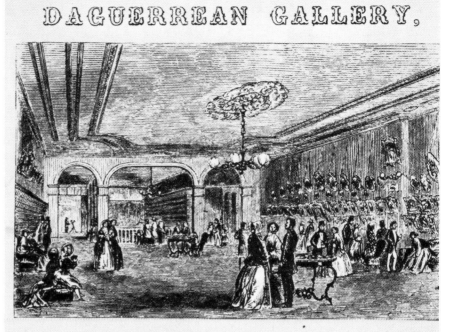

BRADY'S
DAGUERREAN GALLERY,

359 BROADWAY, over Thompson's Saloon, New York.

This New and Extensive Establishment

Has been recently completed, and the public are invited to view the many improvements combined in this MAGNIFICENT GALLERY. *The proprietor has*

31. *Right:* One of Brady's advertisements. *Below:* BRADY'S GALLERY ON BROADWAY AND TENTH STREET. Facsimile of an engraving of a Brady advertisement showing interior of the 'Broadway Valhalla' as it was known

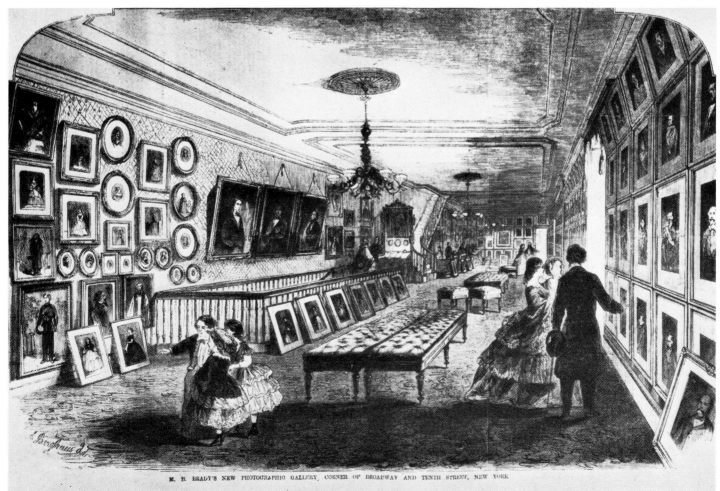

M. B. BRADY'S NEW PHOTOGRAPHIC GALLERY, CORNER OF BROADWAY AND TENTH STREET, NEW YORK

The Ambrotype became very popular for a time, and it was 1854, a year after the opening of his largest gallery, that Brady introduced the process. In a letter to the press, a person styling himself 'A Lover of Art,' wrote,

"Messrs., editors;

"I have seen frequent compliments in your paper paid to Brady, the renown Daguerreotypist, 359 Broadway, New York. I stepped into or rather (up to) his gallery, the other day and was actually taken by surprise at the magnificent specimens of Daguerrean art at present gracing his walls.

"The world may differ as to the merits of Brady, compared with the artists, in his particular line, but, for my part, I candidly and honestly believe him to be the first Daguerreotypist in the World, and his triumph over 'all comers', at the World's Fair in London is pretty conclusive evidence that I am not alone in my estimate of Brady's talents. I see he is commencing in the photographic line, and mark my prediction, and it will not be long before he is 'at the top of the tree' in this branch of the art. His photographic specimens are even now, splendid. He deserves a call.

"Yours,

A Lover of Art."

This would tend to show that Brady was already experimenting with the new wet plate process, as indeed he was, and in fact soon after it was introduced all the New York Daguerreotypists would adopt it as an additional attraction.

Two years later, in 1856, Alexander Gardner finally joined Brady in New York, and with him came the process of 'enlarging'. Brady placed Gardner in charge of his new gallery and that year introduced the 'Imperial Photograph' to his patrons. These 'Imperials' were paper prints of large size. They ranged in size from 14″ by 17″ to 17″ x 20″ and were printed from wet plate negatives.

The novelty of these large size pictures caught on almost at first appearance, and New York society was attracted by the fact that the 'Imperial' exclusiveness lay in being above the price range and pocket-book of the average person. Society swarmed to Brady's doors for their 'Imperials' and they were not deterred by cost, for some of the pictures went as high as seven hundred dollars.

He had truly earned the title of "fashionable photographer" for with most that were able to afford it, none but a 'Brady' would suffice. He had always shied away from the cheaper type of picture and as a result his 'exclusiveness' plus the quality of the work that came out of his galleries always attracted the notice of the press. And to judge by the quantity of his unsolicited press notices it would seem that reporters made his gallery a daily 'must'. And the papers commented on the 'Imperial', writing, "the Imperial, first produced by him seems to be the ne plus ultra of the art. His gallery being filled with an unequaled collection of portraits of the lions of the town, is itself one of the lions. To see the elephant one must go elsewhere".

Hardly a day went by without some notice, article or story concerning the activities in his gallery appearing in the papers, or some well known columnist of the day writing

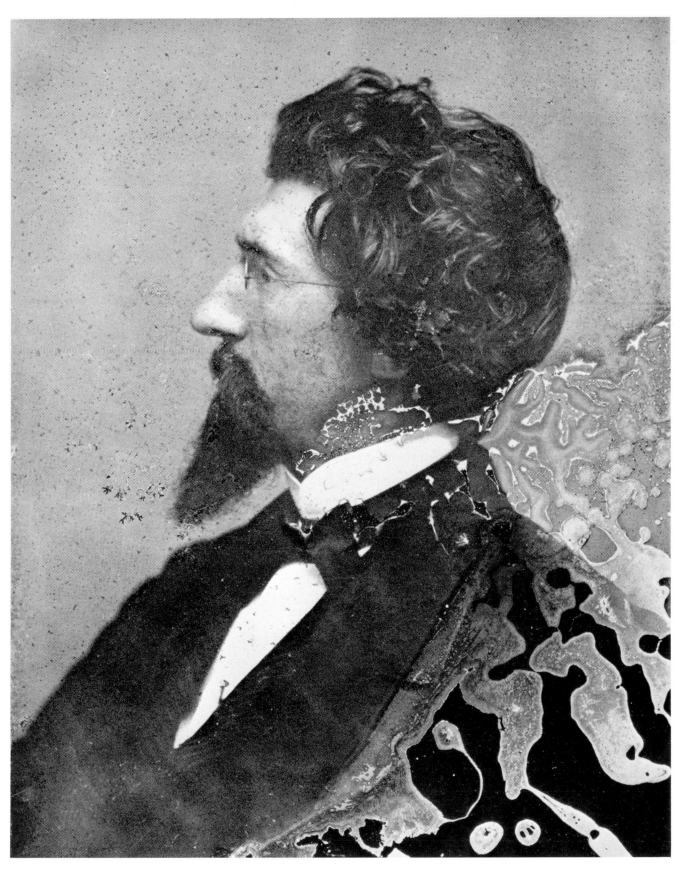

32.
MATHEW B. BRADY
A print from an original Ambrotype used as a negative and made in the New York Tenth Street Gallery in 1855. A rare unpublished print

anecdotes connected with the sitting of some celebrity of the times. 'From a Photograph by Brady' was in fact becoming a household word, for *Harper's Weekly, Frank Leslie's Illustrated Newspaper* and a host of others were using Daguerreotypes of Bradys to make their line-cuts and engravings almost exclusively, and so helped to keep his name before the public.

Some idea of the magnitude of Brady's annual business in taking Daguerreotypes can be gathered from the fact that, during the previous year, thirty thousand portraits of all types were taken at the Fulton Street gallery. On the opening of his new gallery he had evidently come down in price for sittings, for the press commented: "We perceive that yielding to the pressure of the times he has cut down his prices one-half. This is certainly the time to obtain likenesses."

The styles in which these portraits were executed were varied, and the prices ranged from one to thirty dollars apiece. The latter price was for the most exact and splendid photographs. He also specialized in life sized photographs, made on sensitized canvas and finished in oils. There were also life-size medallions, which had once cost sixty dollars and now thirty. And there were the popular crayon vignettes, that were, said the press, "particularly adapted for ladies and children so delicate is the execution".

Oddly enough for such an elaborate establishment, the gallery was over Thompson's Saloon, as the "ad" mentions without embarrassment. But it is doubtful whether the frequenters of Thompson's were in any way spellbound by the dazzling splendor over their heads. Still, it is a safe guess that many of the 'eminent men' fearless in debate and in battle fortified themselves before facing the horrors of the 'headclamp' and the staring eye of the camera.

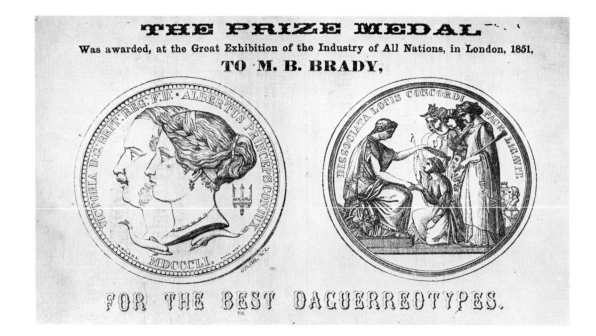

THE PRIZE MEDAL
Was awarded, at the Great Exhibition of the Industry of All Nations, in London, 1851,
TO M. B. BRADY,
FOR THE BEST DAGUERREOTYPES.

CHAPTER SIX

RADY opened the greatest and most magnificent of his galleries in January of 1860 and named it the National Portrait Gallery. It was on the West corner of Broadway and extended down Tenth Street for about one hundred and fifty feet. Lorillard's house was above it on the North; Grace Church, the resort of 'pious fashionables', opposite to the East; the new store of A. T. Stewart, Brady's early benefactor, faced it directly South. It was in the then heart of the city, and for the business of 'Fashionable Photography' surpassed all others as to location.

The new gallery was fitted-up in admirable taste and was richly and handsomely furnished. The artistic gas fixtures were specially designed and manufactured by a Mr. Morgan L. Curtis of 141 Elm Street. The heating apparatus, consisting of Littlefield's Heaters, was installed by Tibbetts and Company of 690 Broadway. Brady had them installed to promote the health and comfort of his visitors, a consideration that was unusual in those days.

A costly carpet covered the entire area, soft velvety green pile sprinkled with spots of gold. Green was the predominant color; the walls were of emerald, and the chairs, sofas, and luxurious divans were all of the same color decorated with gold. The glass ceiling gave a cool emerald light.

Adorning the walls of the gallery were sparkling gold-framed photographs. These were of various styles that included life size portraits photographed on canvas and finished in oils, crayon portraits, ambrotypes, and photographs that resembled water colors.

The 'operating rooms' were complete with modern equipment. One of the improvements was the use of colored glass which Brady had found by experiment to have an advantage in creating certain effects. The great glass skylight was of an emerald color or tint to cut glare, daylight being used exclusively.

Another feature was the 'Private Entrance' on Tenth Street for the use of ladies coming in formal dress. This entrance led directly to the 'operating rooms' to 'obviate the necessity of passing through the public gallery.'

Brady opened his new gallery with a reception and private preview for members of the press, invited guests, and leading art connoisseurs of the city. There in the deep-tinted room they gathered and pored over and praised the portraits of people whose fame ranged over two continents. Magnificently attired ladies leveled their lorgnettes at the 'unconscious

senators' and representatives whose portraits graced the deep green walls. "How the lucky fellows would blush and arrange their mustaches", commented one member of the press, "if they were any more than pictures, at the gaze of so many bright eyes."

The guests that evening could view the leading lawyers, millionaires, orators, actresses, actors, statesmen, dillettantes, and authors. As the guests wandered through the spacious lounge they saw the Grinnels, Taylors, Aspinwalls; the Presidents Buchanan, Van Buren, Polk, Tyler, Pierce and Fillmore.

And the ladies were represented. There was Miss Hosmer, the New England sculptor, whose likeness brought forth the remark, "That woman should have been a man," fierce Charlotte Cushman, in Gypsy garb, and the present lady of the White House, a too plump, rosy cheeked, Harriet Lane, with her unintellectual face and her English 'embonpoint' of whom the press remarked, "How quietly she looks down on you, just as her eyes rolled over the crowded hosts on 'Levee Nights' in her Uncle's saloons"...

But the Belle of Brady's was Ada Douglas, lovely queen of American beauty. And the guests gathered around this picture. "It was scarcely less beautiful than the fair original," said one reporter, "with her soft hazel eyes and her dewy lips, . . . sweet Ada Douglas!" The voice of gossip proclaimed her vain, heartless, and ambitious, and charged that she married only for wealth and station. But one female reporter wrote, "I covered my face with my hands and cried like a child". . . , and she admonished . . ."These slanderers should have heard, as once I did, the child-like simplicity with which she spoke of being present at one of Douglas's greatest efforts in the United States Senate . . ."

The evening was a complete success, 'flattering to the proprietor as it was satisfactory to his friends'.

That year, 1860, was an election year, and there were rumblings of unrest and dissatisfaction in the South and of complaints against Buchanan, 'the Autocrat in the White House' —the kind of talk that goes with elections. But the hustle and bustle of Broadway went on just the same. Political controversy raged on street corners or wherever men gathered.

Abraham Lincoln of Illinois, making speeches that were supposed to be oil on troubled waters, was momentarily expected in New York, the city of slums, powerful newspapers, railroad terminals, steamship lines, where the talk was of Brady, Beecher, Greely, Vanderbilt, Astor, A. T. Stewart; the city of prize fighting, German brass bands, Barnum's Museum, Organgrinders, that swung the balance of power in politics. President Buchanan, the 'Autocrat in the White House', was 'crying bitter tears' about the state of things in general, but did nothing but 'stare at the floor and weep some more'.

Apparently Brady was too engrossed in the handling and operation of his photographic enterprises to pay much attention to the trend of affairs, for his business was never better, indeed being on a landoffice scale. Threats and loud talk, Secession, States Rights, and other questions were making lively and timely conversation, but until the shot was fired at Sumpter the newspapers were still filled with stories of Brady and his Galleries.

It was on February 27, 1860, just a month after the opening of the Tenth Street gallery, when Abraham Lincoln arrived for a speech at Cooper Union. This was the result of the

Douglas Debates. A few hours after his arrival in New York, Lincoln, accompanied by three members of the Young Men's Republican Committee, came to the gallery. They made an odd looking group as they entered. The young men were of slight build and small in stature, and Lincoln, tall, angular, with an extraordinary show of neck, made his companions appear as dwarfs.

After introductions, Brady began arranging the apparatus for the sitting. While thus engaged he considered the difficulty he would have in trying to make this strange quiet man 'impressive.' Brady studied his subject as he adjusted his camera, and saw him as Ward Hill Lamon saw him. 'Over six feet four inches in height, his legs out of all proportion to his body. His head was long and tall from the base of the brain to the eyebrow. His ears were large, his nose long and blunt, the tip of it rather ruddy, and slightly awry towards the right-hand side; his chin, projecting far and sharp, curved upward to meet a thick lower lip which hung downward; his cheeks were flabby, and the loose skin fell in wrinkles, or folds; there was a large mole on his right cheek and an uncommonly prominent Adam's apple on his throat.

'His countenance was haggard and careworn, exhibiting all the marks of protracted suffering.' If ever a photographer was presented a problem, where all his experience and artfulness had to be called on, that man was Brady.

Lincoln's low shirt collar and the loose necktie that was nothing more than a black ribbon, had to be arranged before the picture could be made. "I had great trouble," Brady said, "in making a natural picture. When I got him before the camera I asked him if I might not arrange his collar, and with that he began to pull it up. 'Ah', said Lincoln, I see you want to shorten my neck.' 'That's just it', I answered, and we both laughed." When Lincoln stepped before the camera another problem presented itself. The 'immobilizer' or head-clamp when it was extended its full height did not reach Lincoln's head, and a small taborette had to be placed under the stand. Brady took the pictures, and after Lincoln's speech at Cooper Union the following day they were in great demand. The press made woodcuts from the photographs and published and distributed them,—among the publishers were Currier and Ives and *Frank Leslie's Illustrated Weekly*.

It was in October of that year that Brady would reach the peak of achievement and popularity. The Prince of Wales' visit was occupying general attention and New York was all agog. Anyone having anything to show and worthy of being seen was preparing in some fashion to exhibit it to the Royal visitor. The leading photographers were waging a silent battle to determine who would be the favored photographer to the Royal Party.

None was more determined that he would be the privileged one than Jeremiah Gurney, Brady's foremost competitor who also had won prizes, and owned a pretentious gallery on Broadway. The press announced, "There is a tremendous struggle between Brady and Gurney as to who will have the honor of being photographer to Royalty."

When the Prince arrived in New York he was greeted by immense throngs of people. Nowhere, during the Prince of Wales' tour of the Continent, was he welcomed with greater acclaim and popular enthusiasm. A torchlight procession of New York's Firemen marched

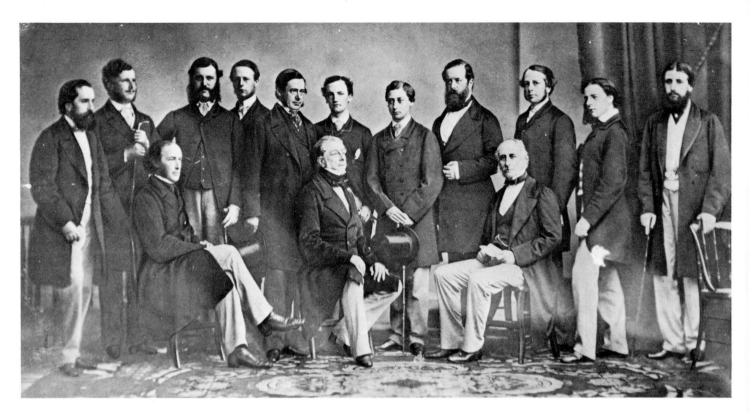

33. THE PRINCE OF WALES AND SUITE

Photographed by Brady at his Tenth Street Gallery in New York in 1859. *Left to Right:* William Brodie, Major Teasdale, Doctor Ackland, Captain Gray, Charles Eliot, Lord Lyons, Earl St. Germains, Hinchinbrook, the Prince, Duke of Newcastle, General Bruce, G. B. Inglehart, G. F. Jenner, and Frederick Warre

past the Fifth Avenue Hotel where he was staying, with blaring bands, acrobatics, and demonstrations of fire-fighting, while the Prince watched from the balcony. A great Diamond Ball, with all its dazzle and glamour, was given in his honor and was attended by hosts of the socially prominent men and women of New York's elite. The Ball lasted until the small hours, and it was five o'clock in the morning when the Prince reached his hotel and retired.

That morning, October 13, 1860, a noisy and eager crowd assembled around the entrance of the hotel and waited to catch sight of the Royal visitor. About ten o'clock the Prince sent for Brady to come to the hotel in order that he might make arrangements for a visit to the gallery. Brady arrived promptly and the Prince discussed with Brady the desirability of closing the gallery to the public during his visit. Shortly before noon the Prince and his party left their hotel, entered their carriages and drove down Fifth Avenue amid cheering crowds. Brady had closed his doors to all comers for the day, and even his most intimate friends were denied admission, but news of the Prince's intentions leaked out and a fashionably dressed crowd gathered before the Private Entrance "to the Gallery".

By twelve noon the crowd had increased to such an extent as to impede the passage of vehicles on Broadway. At twelve-thirty, the Royal Party was seen approaching from the direction of Fifth Avenue. As the carriages drove up the Prince acknowledged the cheers and passed through the gauntlet of admirers into the gallery entrance. He expressed amazement at the magnificent studio, and as Brady escorted his visitors through the

60

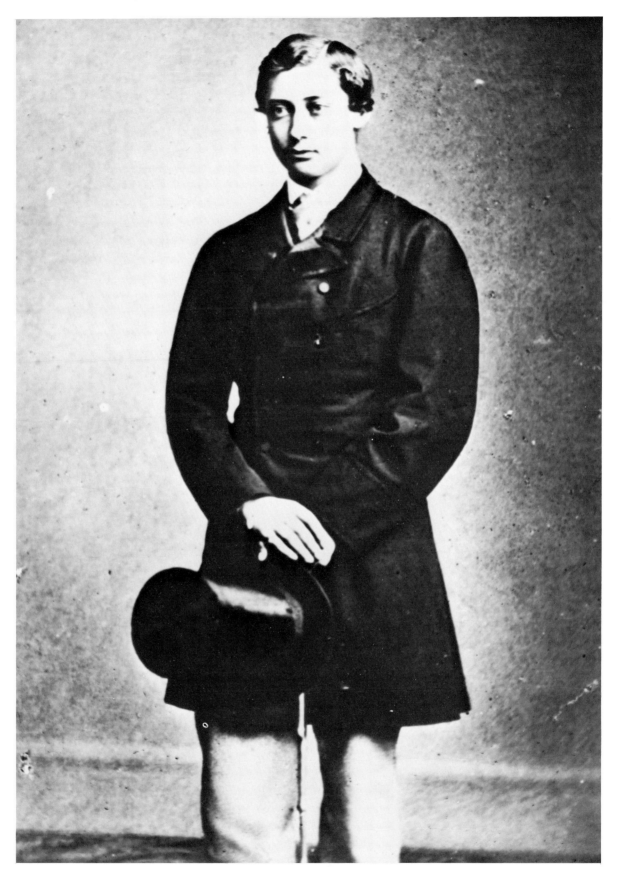

34. EDWARD, PRINCE OF WALES
A full length portrait taken by Brady at the time of the Prince's visit to the Tenth Street Gallery

gallery, he inspected the portraits of leading statesmen, and other American celebrities, 'pointing out to his followers those that were familiar to him by reputation'.

After due time had been spent on this the party settled down to the business in hand, and Brady 'instructed his operators in preparation for the sittings'.

First to be taken were three 'Imperial' groups of the whole party with the Prince as the central figure. Next, Brady made a full length 'Imperial' of the Prince 'standing alone' and a number of miniature photographs of the Prince and his suite, singly and in groups.

The day being bright and favorable for the taking of pictures, when the proofs were shown to the Royal Party, 'they were loud in their praise as to the perfection and the accuracy of the apparatus used in the gallery.'

After the sittings, Brady inquired of the Duke of Newcastle, one of the Prince's party, why he had been selected from all the photographers in New York. The reply was, "Are you not THE Mr. Brady, who earned the prize nine years ago in London? You owe it to yourself. We had your place of business down in our notebooks before we started." Before leaving the gallery the Royal Party inscribed their autographs on the visitors' book, 'October 13—60. Albert Edward, Lyons, Newcastle, St. Germaine, Robert Bruce, C. Teesdale, Hinchinbrooke, Charles G. L. Eliot, G. O. Englehart, Hugh W. Ackland, G. F. Jenner.

Brady's success, and the adroit way in which he handled the affair was immediately taken up by the press. "Brady managed his cards well," they said. "He did not make any preparations to secure the 'Youthful Guelph' as soon as he was advised of his intended visit—modest man—not he. And how immensely surprised he was when the Prince sent for him and merely intimated his intention to visit Brady's splendid gallery, whose praises had occupied columns of our city's newspapers. How very fortunate that the Prince should have selected him of all others; particularly when he had not the slightest idea of being so distinguished; but Brady is evidently a lucky man; he knows how to trim his sails—Brady does; he succeeded admirably with His Royal Highness—took some pictures of Prince and Suite, and came off with flying colors.

"We suppose that his fortune is made now. Of course 'Upper Tendom' will have to visit Brady's. Of course the Cod-fish Aristocracy will go nowhere else to get photographs of the little 'Tom-Cods'. Nothing but a veritable 'Brady' will hereafter answer for the parvenu set who could not make the floor strong enough to hold up the Royal Party when engaged in Terpsichorean exercises."

35. *Above Left:* Ebony Escritoire or writing desk presented to Mrs. Brady by the Prince of Wales after his visit to the Gallery. Embossed with mother of pearl, the inside is lined with green velvet and solid silver furnishings. *Above Right:* Walking stick of Honduras Rosewood with a carved ivory handle embossed with gold. The gold band at the base of the handle bears the inscription: "M. B. Brady from Edward, Prince of Wales." *Lower Right:* A typical Brady advertisement. A three-page throw-away folder of orange colored paper, printed in the ornate style of the period

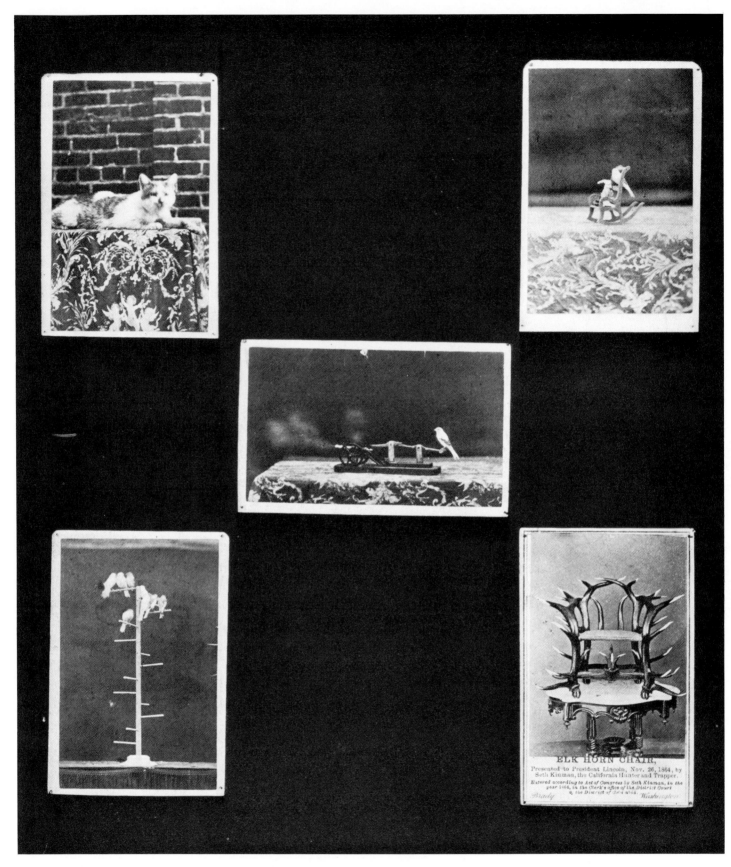

36.

BRADY'S FAMOUS CARTES DES VISITES
Published for the first time

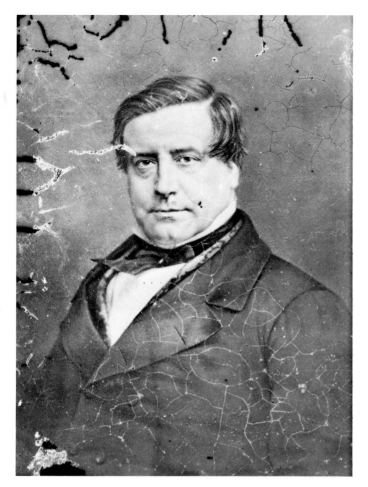

37. WASHINGTON IRVING
After an original Daguerreotype by Brady, prob-
ably made in 1846. Irving expressed dissatisfaction
with this likeness and refused to sit for another

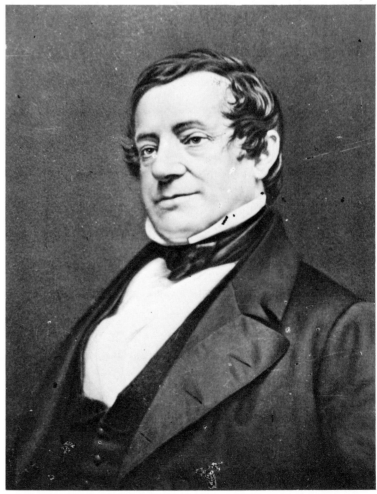

38. WASHINGTON IRVING
This Daguerreotype taken by Plumbe shortly be-
fore Irving's death, was later copied by Brady on
wet plate, enlarged to life size and finished in oils.
It hung in the Brady Gallery for years

CHAPTER

SEVEN

HEN BRADY opened his Washington Gallery in 1858, the Capital City was nothing more than an overgrown country village. Aside from the Capitol with its unfinished dome, there was nothing to indicate the nation's seat of government. There were wide unpaved streets that started from a common center like the spokes of a wheel, and the Capitol, Patent Office, Treasury, and other public buildings were in marked and classic contrast with the tumble-down tawdry look of the average red-bricked homes, stores, saloons, and other buildings.

Brady's Gallery was in a two-story house of a type in which Washington abounded, on the corner of Pennsylvania Avenue and Seventh Street near the fashionable National and Brown's Hotels. It was now operated by Alexander Gardner, but from the start Brady had been making frequent trips to Washington to conduct the business of the gallery. His decision to make Washington his permanent place of residence came that year of 1861 when he engaged a suite of rooms in the National Hotel. He desired to be near the center of Governmental activity where he could angle for the political clientele that the new Administration would bring to the city.

Washington was now making ready for the Inauguration of Abraham Lincoln, an event not looked upon with much enthusiasm in political circles. Divided political feeling had been running high. States Rights, the spectres of Secession and Slavery, were fomenting hatred and fear, and these explosive topics were on all tongues.

Talk, bombast, threats, following the establishment of the Confederate States of America and the subsequent seizure of U. S. mints, arsenals, forts, custom houses, post offices, and warehouses provoked a situation where rebellion and war hung by a thread.

President Buchanan, confused and bewildered, with not the slightest idea of how to cope with this alarming turn of events, did nothing, content to let the new President shoulder the burden. Lincoln was about to take office. What would he do? Washington and the world wondered.

The young artist, George H. Story had taken a studio for himself in the same building with Brady's Photographic Parlors in 1859. And he was in Brady's Gallery on

Saturday, February 23, 1861, when Abraham Lincoln walked into the studio to have his first official photograph taken. Brady and Story had become good friends, and Brady often asked him to come in and help pose some famous person. In Story's opinion the 'Napoleonic' pose, a more or less accepted posture for appearance before the camera was ridiculous. "In those days", he, Story said, "the photographer knew but one pose for a man to assume who was having his picture taken. He had to stand bolt upright with one hand thrust into the breast of the coat and the other hand on a table;—it was laughable, but it was the custom of the day".

On the afternoon of February 23, Story had come down to the gallery to help pose Abraham Lincoln, who had arrived only that morning at Willard's Hotel to prepare for the inaugural ceremonies. Story was delighted at the opportunity, "I was very pleased at the prospect of meeting him", he said, "and I hurried down to Brady's".

Ward Hill Lamon, City Marshall of Washington was close to Lincoln and had traveled the entire route of the Presidential party with Allan Pinkerton, Chicago's first official detective, who strangely enough, had been 'engaged for years in the business of running slaves from where they were legalized property to places where they were not!' Lamon and Pinkerton were intrusted with Lincoln's personal safety. During the trip from Springfield to Washington they were beset by sinister murmurings of violence and assassination. And it was in the shadow of the rumors of disaster that Lincoln came to Brady's Gallery.

When Story walked in, Lincoln and Lamon had already arrived, and Lincoln was seated at a table waiting to be posed. His dress as the *Washington Evening Star* reported: "was his plain black clothes, black whiskers,—and how well trimmed",—a different man entirely from the hard-looking pictorial representations seen of him . . ."some of the ladies say he is almost good looking."

His depression was manifest, but he said nothing to expose his thoughts, and this mood of Lincoln's was not lost on Story, who noted: "He did not utter a word, and he seemed absolutely indifferent to all that was going on about him;—and he gave the impression that he was a man who was overwhelmed with anxiety and fatigue and care".

While Brady and Gardner were preparing the lighting and other details, they took Story aside and asked him if he would pose him. The artist who had been studying Lincoln and who had caught his mood, recognized at once that as he was, would make a great picture. Surprising both Brady and Gardner he exclaimed, "Pose him?". . . No! . . . "Bring the camera at once!"

The camera was hurriedly placed in position, and, while Lincoln pondered, the plate was exposed. In his recollection of the incident Story stated: "As soon as I saw the man I trusted him. I had received private information that undoubtedly there would be a war, and I knew that Lincoln was the man to handle the situation. There was a solemnity and dignity and a general air about him that bespoke of weight of character. At first meeting that was convincing. Honesty was written in every line of his face. In dress and appearance, he was elegant, his clothes being made of the finest broadcloth. Nor was he awkward despite his height. His hands and feet were small and shapely . . ."

When the sitting came to an end, Ward Hill Lamon said, "I have not introduced Mr. Brady". And while introductions went the rounds, Lincoln extended his hand and 'answered in his ready way', "Brady and the Cooper Union speech made me President".

In the midst of all the excitement and controversy that was now going on in Washington, Brady and Gardner were busy with the portraits of the prominent men and women who were to figure in the coming Inaugural. The Gallery was crowded daily. All over the nation the atmosphere was tense, and in Washington, a sense of expectancy and impending disaster affected everyone.

During the Inaugural preparations, Brady was engaged to photograph Mrs. Lincoln. At her sitting two pictures were made for one of which she wore the Inaugural Ball dress of pink silk, and for the other, a striped silk dress 'elaborately trimmed with lace'. The *Washington Star* noted: "The peep afforded at Mrs. Lincoln in passing from the carriage to the hotel presented a comely, matronly, lady-like face, bearing an unmistakable air of goodness, strikingly opposite of the ill-natured portraits of her by the pens of some of the sensation writers".

On the second of March, leaving Gardner in charge of the studio, Brady went to see his friend General Meigs, engineer officer in charge of building operations of the unfinished Capitol, to arrange for permission to photograph the coming Inaugural. Probably, the fact that this was the first time in the history of the country that an Inauguration could be photographed and so recorded for all time, prompted General Meigs' decision, in spite of the tense situation. Trouble was anticipated 'from almost any quarter.' The precautionary measures, were strict; but Meigs made the necessary arrangements and full permission was granted.

On the afternoon of the third of March, General Winfield Scott held a conference at his headquarters, and the program of the procession was arranged. President Buchanan was to drive to Willard's Hotel and call upon the President-elect. The two were to ride in the same carriage between double files of a squadron of the District of Columbia cavalry. A company of West Point Sappers and Miners were to march in front of the presidential carriage, and the infantry and riflemen of the District of Columbia troops were to follow it. Riflemen were to be placed on the roofs of certain commanding houses along Pennsylvania Avenue, with orders to watch the opposite side 'and to fire upon them should any weapon appear in any of the windows'. The small force of 'Regular cavalry, which had just arrived was to guard the side streets and crossings of Pennsylvania Avenue, and to move from one to another during the passage of the procession. A battalion of District of Columbia troops was to be placed near the steps of the Capitol and riflemen were to be stationed in the windows of each wing. On the arrival of the Presidential party at the Capitol, the troops were to be stationed so as to return in the same order after the ceremony.

During the night of the third of March it was suspected that an attempt would be made to blow up the platform on which the President-elect would stand to take the oath of office. Soldiers were placed under the steps, and at daybreak a trusted battalion of District troops formed a semicircle and prevented all entry from within and without.

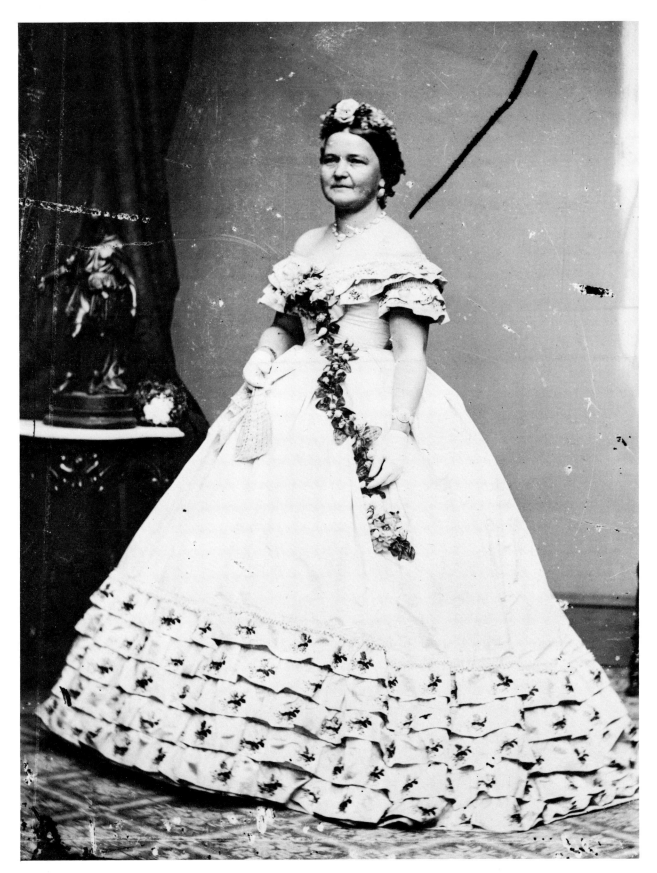

39. **MARY TODD LINCOLN**
A photograph of the first lady made in the Washington Gallery by Brady a few days before the
Inaugural Ball

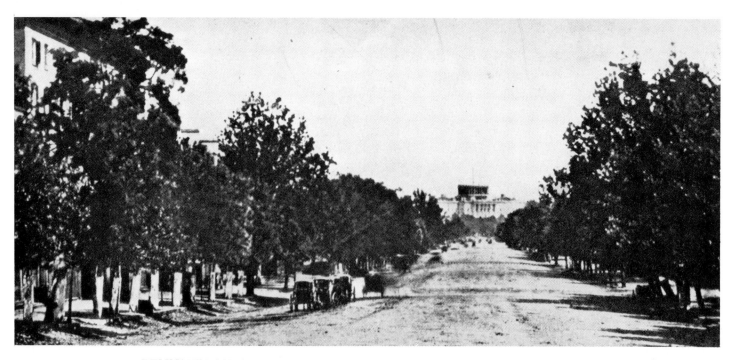

40. PENNSYLVANIA AVENUE AS IT WAS WHEN LINCOLN RODE TO THE CAPITOL FOR
HIS INAUGURATION
Probably never published before

At dawn the crowd began to assemble in front of the portico. A large number of policemen in plainclothes were scattered through the mass, to observe closely, to place themselves near any person who might act suspiciously, and to strike down any hand that might raise a weapon.

During all this preparation, Brady and Gardner, who had been at the scene at dawn, were making arrangements for the location of their camera and darktents, and for the platform that had been built for the purpose. All this was done under the careful and watchful eyes of the Pinkerton men, some of whom were posted on the stand during the ceremony to protect the men of the press in case of violence.

Spring is usually kind to Washington, and in March the grass begins to turn green and the magnolias and redbuds take on new life. It was so on this March fourth, 1861, which dawned clear and pleasant. Hotels and boarding houses were crowded to capacity. Lobbies, halls of public buildings, even the sidewalks were taking the place of comfortable beds for those who would get a glimpse of the new president to be. Twenty-five thousand people filled the streets of Washington, and a great crowd filled the street near the Willard Hotel, hoping to be near when the procession started.

It was around noon when the barouche bearing President Buchanan arrived at the Willard. The President alighted and disappeared into the doorway, returning a few moments later with the President-elect to escort him to the carriage.

They were flanked on either side of the doorway by policemen who kept the path open through the surging crowd. The two leading men of the country climbed into the barouche and the procession led by Major French, Chief Marshall, with ministers, the Diplomatic Corp, the Army, Navy, Marines, Members of Congress, even veterans of the Revolutionary War, guarded by units of the Army and trusted squadrons of picked cavalry started up Pennsylvania Avenue to the Capitol.

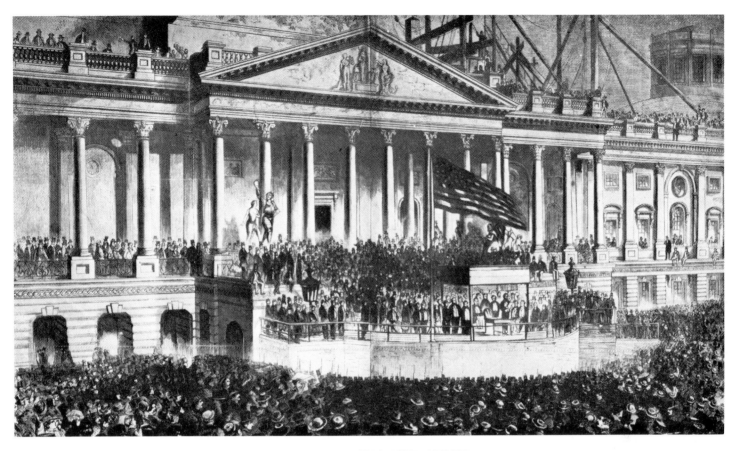

41. LINCOLN'S FIRST INAUGURATION
This engraving from a photograph by Brady shows Lincoln taking the oath of office as President of the
United States. *Harper's Weekly*, as late as 1868, calls it Grant's Inauguration "From a photograph
by Brady and Gardner"

The procession reached the Capitol and the principal members of the party took
their places on the platform. On the lawn in front of the platform there was a crowd of
about ten thousand people. Brady's darkroom tents, dotting the lawn, made it look like a
Nomad encampment. He and Gardner worked feverishly, taking pictures as quickly and
efficiently as their cumbersome apparatus permitted.

On the platform the Senator from Oregon, Edward D. Baker, walked forward and
announced, "Fellow citizens, I introduce to you, Abraham Lincoln, President-elect of the
United States." A little applause, and Lincoln drew from his pocket a piece of paper and
read the Inaugural speech. Near the conclusion are the words: "I am loathe to close." At
about this point Brady and Gardner must have made their plates for in the pictures some
of the crowd can be seen starting to leave—During the remainder of the speech there was
an interruption. 'A spectator fell out of a tree,' and landed with a crash and a struggle en-
sued. Lincoln regained the composure that he had lost for a moment and continued to the
end.

Artillery roared a salute to the sixteenth President of the United States. Newspaper-
men rushed to get their stories on the crowded wires to an eager nation, and Brady and
Gardner packed up their equipment, their work finished, loaded their carriage and drove
back to the gallery. The day had been successful and had ended without violence. General
Scott had done his work well.

71

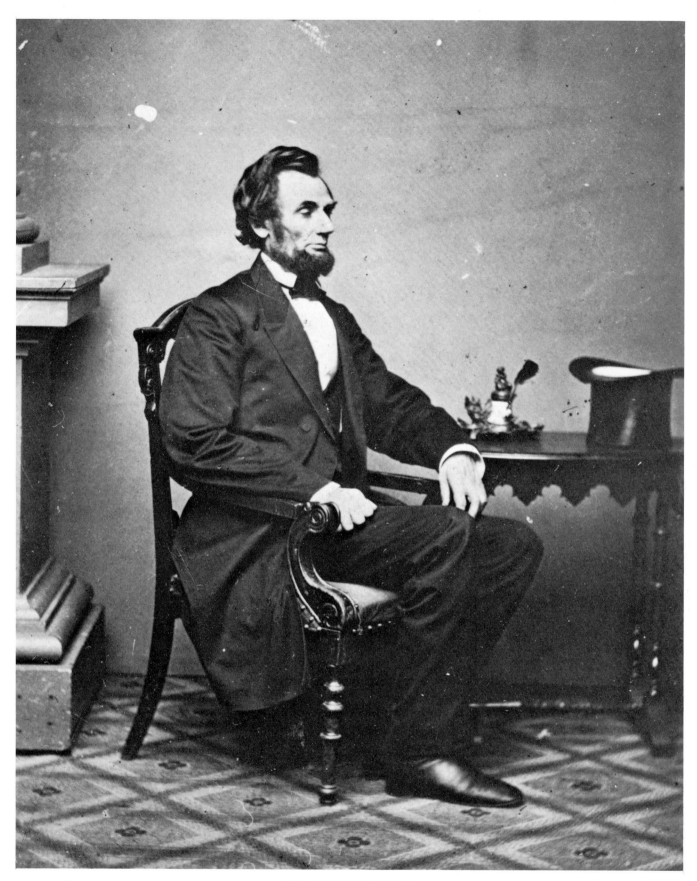

42.
ABRAHAM LINCOLN
This picture posed by George H. Story, Curator-Emeritus of the Metropolitan Museum of Art in New
York on February 23, 1861, was taken by Brady in the Washington Gallery

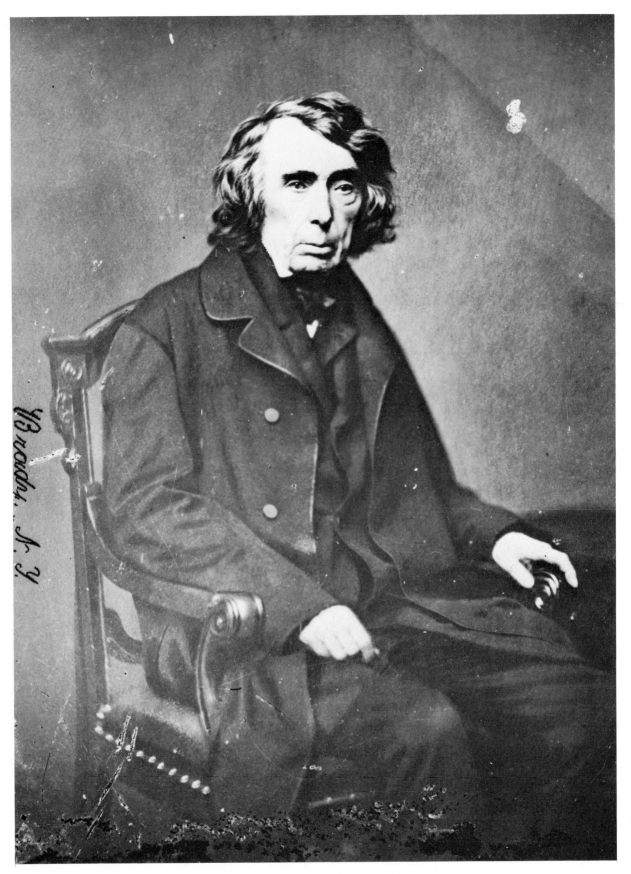

43. **CHIEF JUSTICE ROGER BROOKE TANEY**
Photographed by Brady in the Washington Gallery at about the time he took the Lincoln portrait on the opposite page

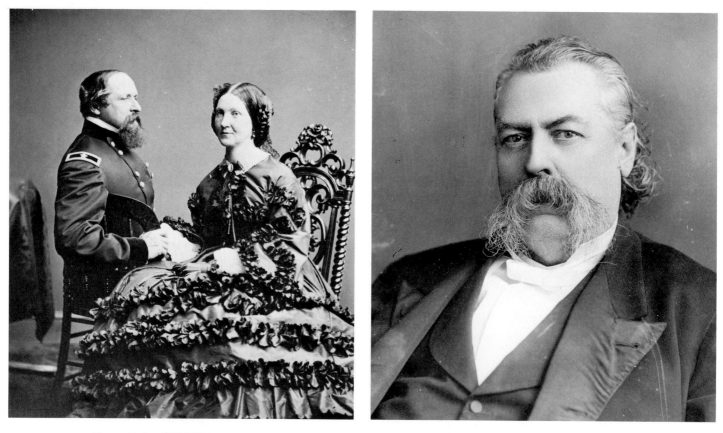

44. *Above Left:* GENERAL JAMES B. AND MRS. RICKETTS. From an original wet plate negative made by Brady in the Washington Gallery. *Above Right:* WARD LAMON, Marshal of Washington City. From an original wet plate negative by Brady and published for the first time. *Below Left:* HENRY KIRK BROWN. A rare print of the sculptor who made the statues of Washington and Lincoln in Union Square, New York. *Below Right:* CLARK MILLS. Sculptor and personal friend of Brady. From original negative and never before published

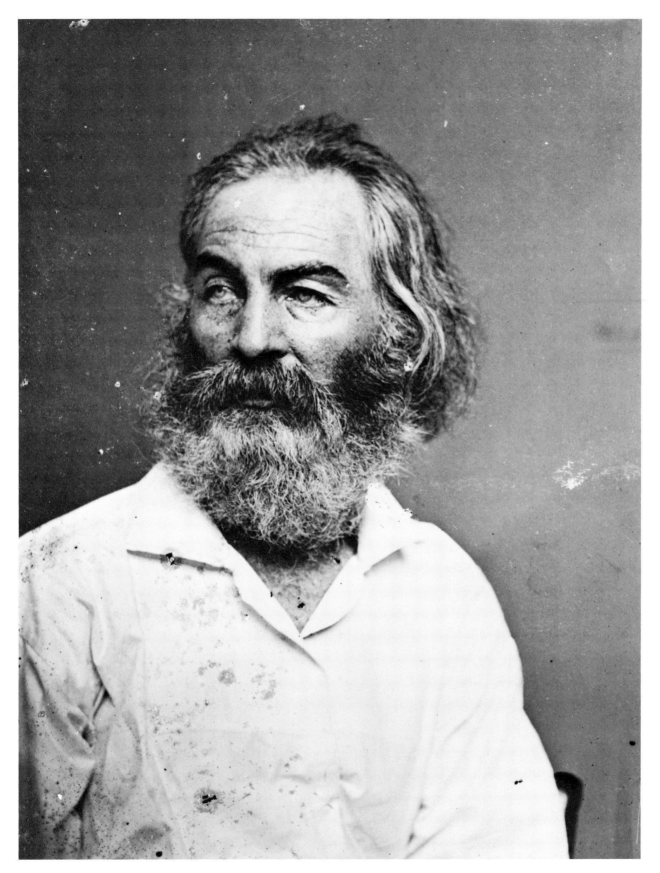

45. **WALT WHITMAN**
This rare and unpublished portrait is from an original wet plate negative by Brady made in the
Washington Gallery in the sixties

CHAPTER

EIGHT

F OLLOWING quickly on the heels of Secession came the South's seizure of all
U. S. arsenals, customs, shipyards, and Post Offices in her territory. Then, sud-
denly, all eyes were turned on Fort Sumter in Charleston harbor, last of the
U. S. outposts in Southern waters and still in Federal hands. A drama was
being enacted there. The people of the North and South watched the fearful
scene unfold around Major Robert Anderson, commandant of the garrison of forty men.

Anderson anxiously reported that he was surrounded by breaching Confederate bat-
teries on Morris and Sullivan Islands flanking the fort, and from the mainland. He added
that his supply of food, originally enough to last three weeks with care, was running low.
He warned that massed Confederate forces were awaiting orders to shell him into sub-
mission, and that General Beauregard had demanded surrender, which he had refused.
He then waited for orders from Washington.

Would Anderson evacuate? And with this question yet to be answered, the world
watched and waited breathlessly. The answer was not long in coming, for the Northern
Government decided to reinforce Anderson and send supplies for a siege. Consequently,
on April 12, 1861, at 4:30 in the morning, the first Confederate cannon was fired on Fort
Sumter, a shot that began one of the fiercest and bloodiest civil conflicts the world has
ever witnessed.

The news of the assault on Fort Sumter caused tense excitement in Washington.
The war, so long smoldering, was now a reality. Trade was suspended, and thousands of
men and women filled the streets walking aimlessly around talking, questioning, and
gathering in little groups on street corners. Night and day the people thronged the streets,
newspaper offices, and Government buildings eager for scraps of information.

Then came the worst news of all. Major Anderson had surrendered the Fort after a
heavy bombardment, and evacuated the garrison with flags flying and drums beating.

With the attack on Sumter, Lincoln called for 75,000 volunteers to put down the
rebellion. Recruiting offices in all cities were opened on the public squares, and men left
their businesses and stepped into the ranks. In Washington, it first appeared that Lincoln's
call for troops had gone unheeded, but a few days later volunteer regiments began to

stream in. Every train brought its picturesque regiments in their own conceptions of military dress. The Capital was crowded to bursting, and there was not a foot of sidewalk left to walk on.

Even Pennsylvania Avenue, with its sidewalks "was extremely dirty", as one volunteer noted, and the cavalcades of teams, artillery caissons, and army baggage wagons with their heavy wheels, "stirred up the muddy streets into a stiff batter for the pedestrian". Officers in their tinsel and gold trappings were so thick on the avenue one soldier noted, "that it was a severe trial for a private soldier to walk there." One private declared that he, "after a half hour's walk, had saluted two hundred officers," and declared that "the Brigadiers were more numerous on Pennsylvania Avenue than ever he would know them to be at the front."

With the volunteers came hoards of 'office seekers' and civilian patriots in quest of fat war contracts. They descended on the government offices with one purpose, 'selling the government something'. Over night the once overgrown country village had become a vast military base of operation. Every once in a while a regiment or two would pass through the streets on the way to camps in the outskirts of the city, surging along Pennsylvania Avenue, their bayonets flashing in the sunlight, and their brightly colored uniforms adding to an already colorful scene.

The climate of Washington is usually genial, but in those days of '61 the winter rains and snows caused the mud to be fearful in the streets, and it was no uncommon sight to see teams of straining horses and oxen trying to pull heavy cannon or wagons that had sunk to the axles in the morass that held to the wheels like glue. But this condition was accepted as one that no one could do anything about.

The following months were a time of preparation for the army and during this period of military training, Brady's gallery enjoyed what amounted to a landoffice business. It was filled with soldiers of every rank who wanted their pictures taken for the popular *cartes des visites*, a type of small photograph slightly larger than an ordinary visiting card. This photographic novelty had become popular around the time of the Prince of Wales' visit to Brady's just a year before, and was now one of the main features of the Washington wartime gallery.

Something akin to mass production was used to make these *cartes des visites*, for a camera with six lenses mounted in front took six negatives at a time at one sitting, and on one plate. When finished with the name of the sitter lettered on the card below the picture they sold a dollar and a half for six prints. But the lowly private was not the only visitor representing the army, for officers in blue uniforms and gold buttons, with trousers that never seemed to be pressed, ('political brigadiers',) came into the gallery with their muddy boots, smelling of strong cigars and whiskey, and with their swords and accoutrements clanking, and sat for Brady. Almost every general officer had his picture taken, at one time or other, by Brady.

Brady's sitters at that time, particularly Lincoln's cabinet members, and mainly the unpopular members, elicited unflattering comments from the press whenever their pic-

tures appeared. Edwin McMasters Stanton, Lincoln's Secretary of War, was heartily disliked by members of the press who caricatured his beard,—which immense facial adornment they said, "he always perfumed". This was the same Stanton who had once said, speaking of Lincoln, "that he would not associate with such a damned, gawky, long-armed ape as that".

Gideon Welles, Lincoln's Secretary of the Navy, came in for his share of press invective. When Brady's picture of him appeared it was said, "he looked like Marie Antoinette on her way to execution." But these remarks were not criticisms of Brady's photographs, which the press said, 'was remarkable for their fidelity and likeness'.

It was only under 'official pressure' that Secretary of State Seward consented to sit for Brady, for he hated to have his picture taken. Of him it was rumored that 'Mrs. Lincoln intensely disliked him and wished her husband would replace him with someone she did like'.

And of 'Fernandy' Wood and Thurlow Weed, one commenting on their pictures, pointed out that if you wanted to see the real thing and not a photograph, the White House was the place to find them for that was where they 'were on file'. It will be remembered that Fernando Wood, a short time before Mayor of New York City, conceived the idea of a Free City seceded from the United States, and wanted to try the experiment with New York. And of the other personage, Thurlow Weed, much could be said,—a journalist turned politician, once prominently identified with the Anti-Masonic Party, and now the leading figure in 'boss politics'. Last of the three was Seward, Secretary of State, of the 'political firm of Seward, Weed, and Greeley' who admittedly controlled New York State politics, and now was attempting to dictate just who would get government jobs in the Lincoln Administration.

Brady and his wife liked hotel life, and they entertained and gave many gay parties and receptions. Their most intimate friends were among the most prominent people in Washington artistic and political circles,—among them Danby, who had painted Brady on a retouching plate and whom Brady had photographed, Neagle, and the celebrated cartoonist Thomas Nast. There were well known Army officers who attended many of these parties. Winfield Scott, General Ben Butler, who would years later present Brady's case before Congress to induce the purchase of his vast collection of War Views, and General George Brinton McClellan, soon to become head of the Army of the Potomac, were all close friends of the Bradys;—and on many festive evenings these distinguished guests lifted the gatherings from the commonplace.

In February of 1857 there had been a change of chairs in the House of Representatives, new ones replacing the old which were shipped out of town. Just what became of the old chairs is not known, except for one, this being Lincoln's when he served the 30th Congress as Representative from Illinois.

Lincoln was a great admirer of Brady and his work. "Brady and the Cooper Union speech made me president", he had said, and as a token of friendship and admiration he presented Brady with the chair. Brady gratefully accepted the gift and it was henceforth

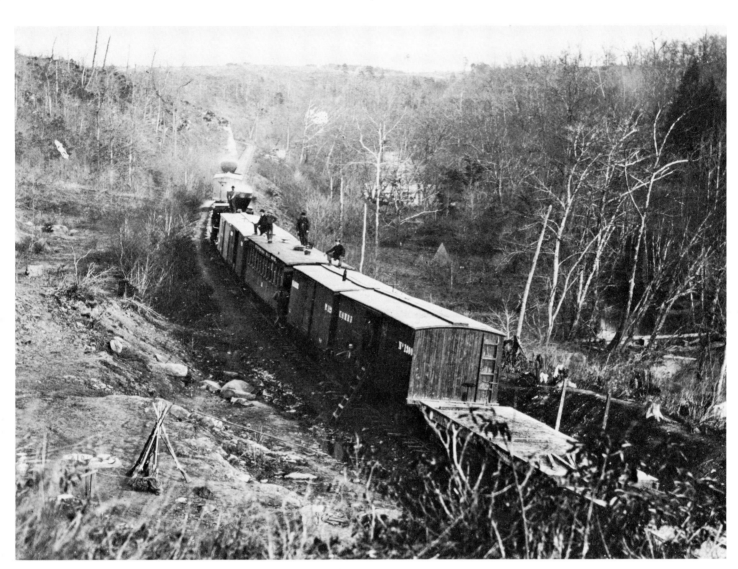

46. AN ARMY'S SUPPLY LINE
A section of the Orange and Alexandria R.R. near Union Mills, Virginia

taken to the gallery where it became one of the most familiar 'properties'. This chair was destined to serve for hundreds of sittings before the camera,—was to become in effect the signature of a 'Brady Photograph'.

Another distinguishing 'property' like the marble-topped table, was the massive, filigreed gold-leafed clock, with the words M. B. BRADY on its face. These three articles of studio furniture, went to make up the settings for most of Brady's photographs, and invariably they were used either singly or together to dress the background of all the portraits taken either by him personally or by his operators.

During the war, and until 1868 Brady, when he was not on the battlefields, photographed his most important clients. It was his policy to leave the daily routine work of the gallery to his operators. For his own prestige he handled the most prominent of his sitters, and any celebrity who wanted a 'Brady Photograph', naturally expected to be photographed by him and not by one of his operators. There has been much controversy as to which is and which is not a Brady photograph, but there is a distinct style to the posing, grouping, and general handling of his picture that is not in any others.

And of course a genuine Brady gallery photograph is not hard to distinguish from the work of a competitor because of certain marks such as the details of design in the carpet pattern, the table and the clock. If the chair is visible, that is positive identification.

So Lincoln's chair took its place among the familiar gallery's 'properties', to remain for the next thirty years. Unlike the homely furniture of the time, it had the appearance of being massive. Actually, the round, heavy, carved legs gave the massive look. The back legs that reached to the curved and carved backrest, gave it a curve and sweep similar to that of modern furniture. It was of dark oak which was in contrast to the leather that bound it all together and made up its dress. The arms, also of mahogany with leather arm rests, had the look of being uncomfortable, yet it is one of the most comfortable of chairs,—a chair that was built for durability.

During the early part of May, 1861, Lincoln came to Brady's gallery for another portrait sitting. After an exchange of pleasantries Brady ushered the President into the 'operating room'. Alexander Gardner was probably busy making preparations,—for it seems he attended to these details when an important sitter was expected,—such details as arranging the lighting by adjusting the shades under the skylight, and their accompanying reflectors,—and of having the darkroom assistant prepare the plates and load the holders.

The President walked across the floor of the operating room in front of the big Anthony and Company camera, and seated himself in his chair for the first time since it had left the Hall of Congress. He had purchased the chair in 1860 and given it to Brady, 'because the chairs in Brady's studio were considerably smaller and with lower backs;—and were probably not to his liking for a comfortable pose'.

While Brady moved the big red varnished camera with the C. C. Harrison Optical Company cannon-like lens over the linoleum floor—the lens measured two feet in length with a five and half inch diameter—he probably took note of Lincoln's melancholy expression as the image came into focus on the ground-glass when he racked the great tube into its final position. Robert Lincoln had noted this peculiarity: "When any attempt was made to photograph my father," he wrote, "or to paint his portrait, he relapsed into his melancholy mood".

Walt Whitman, some time before had seen it. "... I saw very plainly the president's dark brown face, with the deep cut lines, the eyes ... always to me with a deep latent sadness in the expression ..." But there was good reason for Lincoln's depression. Martial law had just been declared and the war drums were beating louder. The Capital was in turmoil. Fighting had broken out in Baltimore against regiments of soldiers trying to reach Washington; Virginia had seceded;—with these matters weighing on his mind, Lincoln sat for his photograph in a chair that was once his in the Hall of Congress.

When the camera was ready, Brady made the first exposure of the six that he would make that day and slipped the black slide into the holder preparatory to taking it out of the camera for processing. And the image that the rays of the North light carried to the ground-glass of the Anthony camera as Brady saw it was the impression John G. Nicolay, Lincoln's trusted secretary, later described:

"Large head, with high crown of skull; thick, bushy hair; large and deep eye caverns; heavy eyebrows, a large nose; large ears; large mouth; thin upper and somewhat thick lower lip; very high and prominent cheekbones; cheeks, thin and sunken; strongly developed jawbones; chin, slightly upturned; a thin but sinewy neck, rather long; long arms; large hands; chest thin and narrow as compared with his great height; legs of more than proportionate length, and large feet," and Nicolay continued, "The picture was to the man as a grain of sand to the mountain, as the dead to the living."

Brady and his photographer-manager worked quietly and efficiently. Unlike the previous sitting when Story was there they took more liberties in the posing. Lincoln said little. Yet he was agreeable and obliging, readily complying with Brady's suggestions as a newly loaded plate holder was placed in the intricate wooden receptacle for the next exposure.

Lincoln had come to the camera-sitting without any special regard to his dress. His hair, after the fashion of the time, was long;—it was brushed with little care, and at one time, he ran his fingers through his hair before the photographic plate was exposed. The sitting drew to a close when the sixth plate had been drawn from the back of the camera receptacle and handed to the darkroom assistant for the inevitable processing, and shortly after Lincoln left the gallery.

In June of that year George Story was asked by Mr. Gardner, Brady's studio manager, to fill an order for a painted portrait of Lincoln from a photograph. Mr. Story replied that he must have sittings. Gardner told him that the President could not give time for these, but that he might sit in Lincoln's office while the President transacted business.

Mr. Story went to the White House and was admitted to a large room on the second floor. The President, who was seated, nodded to him and beckoned to a chair. As Story studied the President's face he noted that it was in shadow, and that he was constantly in motion. For this very reason it was difficult for him to make sketches. One afternoon though, he got a mental sketch of the President, and with the help of Brady's photograph he was able to paint the portrait. In due course the painting was delivered.

"Graphic art was powerless", said John G. Nicolay, "before a face that moved through a thousand delicate gradations of line and contour, light and shade, sparkle of eye and curve of lip, in the long gamut of expression from grave to gay, and back again from the rollicking jollity of laughter to that serious faraway look with prophetic intuitions... There are many pictures of Lincoln; there is no portrait of him."

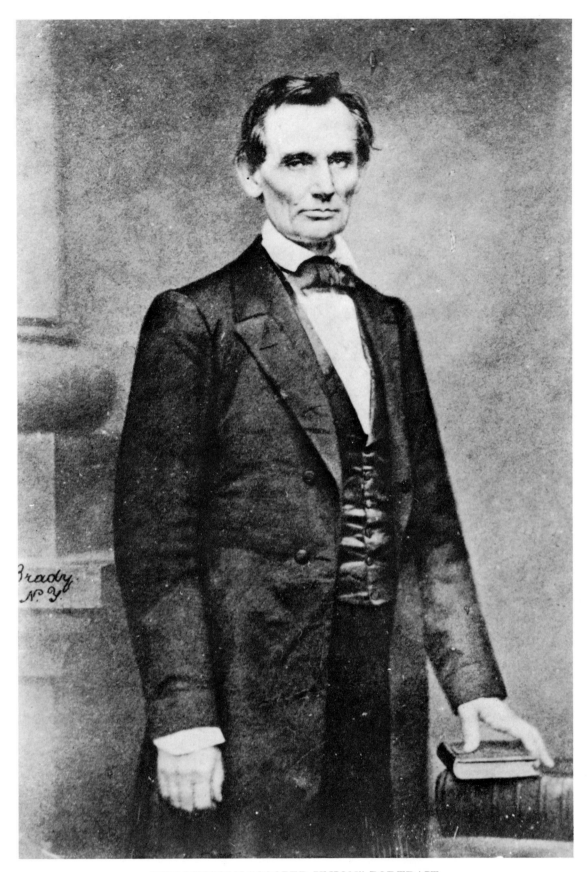

47. THE LINCOLN "COOPER UNION" PORTRAIT

This portrait, the second of three, was made at the Tenth Street Gallery in New York on February 27, 1860. It was the first time Brady ever photographed Lincoln, and was made following the Cooper Union speech at the request of the Young Men's Republican Club

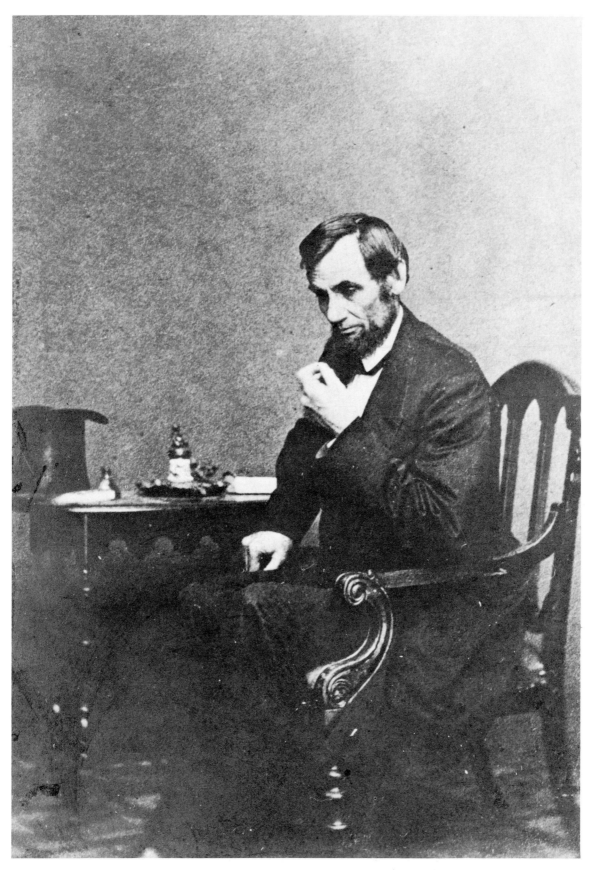

48. **ANOTHER BRADY LINCOLN**
This picture was one of seven plates made sometime during May of 1861, in the Washington Gallery

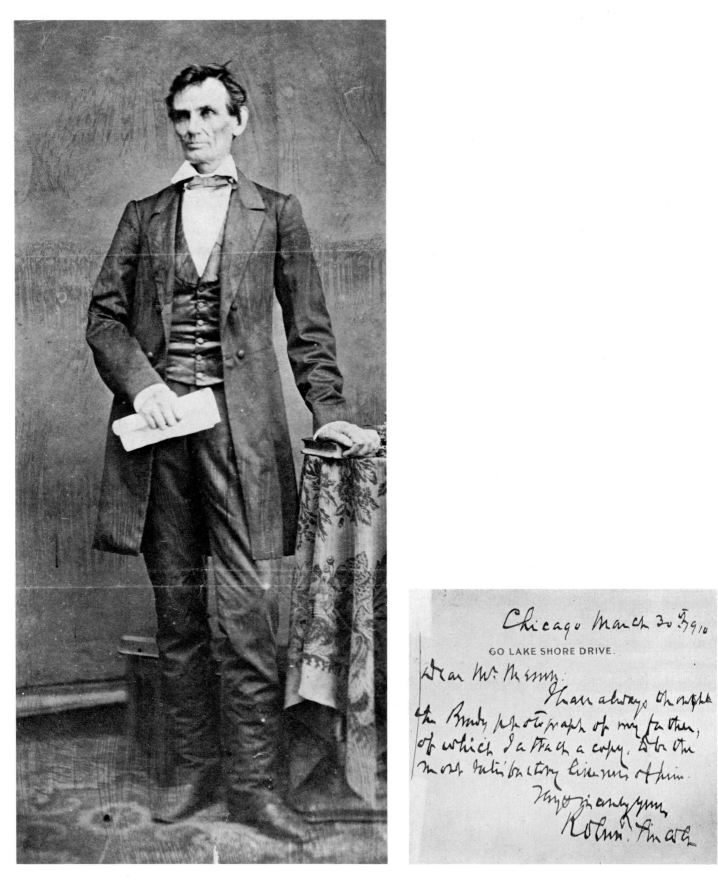

Chicago March 30th 1910

GO LAKE SHORE DRIVE.

Dear Mr. Meserve:

I have always thought the Brady photograph of my father, of which I attach a copy, to be the most satisfactory likeness of him.

Very sincerely yours,

Robert T. Lincoln

49. **ABRAHAM LINCOLN**
Portrait made by Brady for Henry Kirk Brown for his statue of Lincoln. There has been some controversy about this picture but it is believed to have been made about the time of the Cooper Union portrait

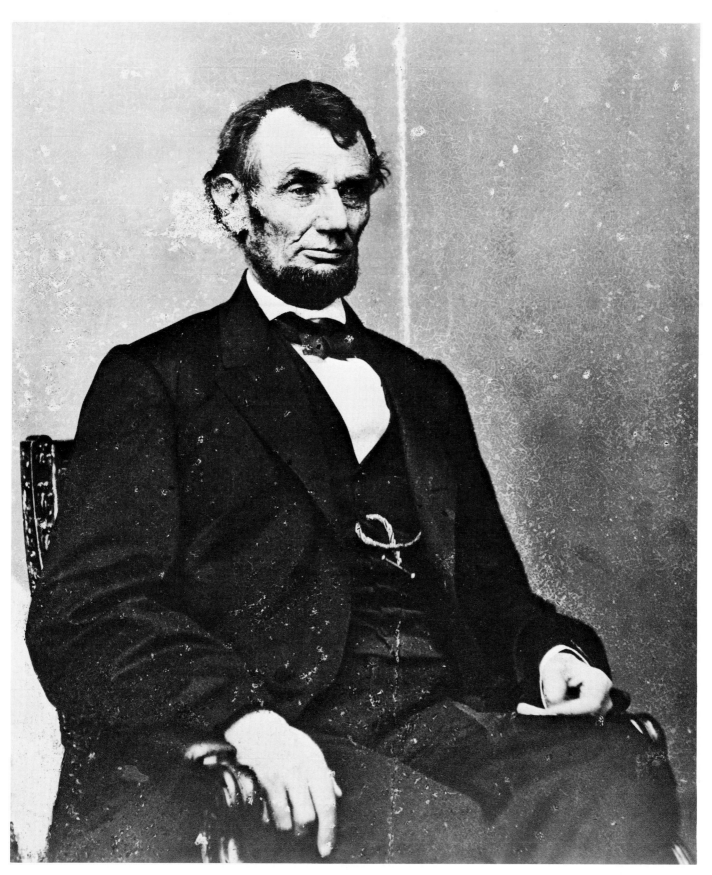

50.
THE FAMOUS "BRADY LINCOLN"
This unretouched photograph is from the original negative in the Brady collection and is owned by
Mrs. Alice Coxs. It is the photograph used for the engraving of the Lincoln head on the Five Dollar
note and the one Robert Lincoln spoke of as being the best likeness of his father

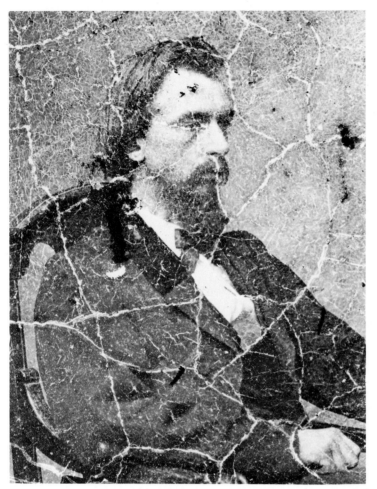

51. JOHN J. NICOLAY
Secretary to President Lincoln and one of his many
biographers. Photographed by Brady in the Wash-
ington Gallery in 1861

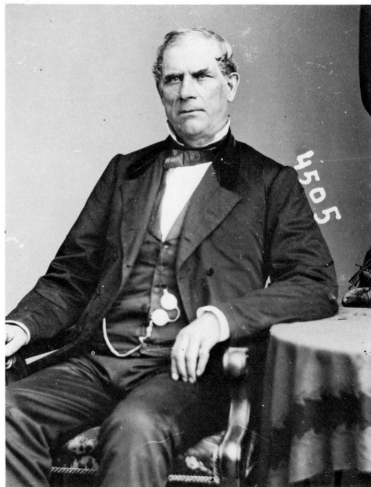

52. THURLOW WEED
Politician, Newspaperman, and friend of Lincoln
Photographed in the Washington Gallery in 1861

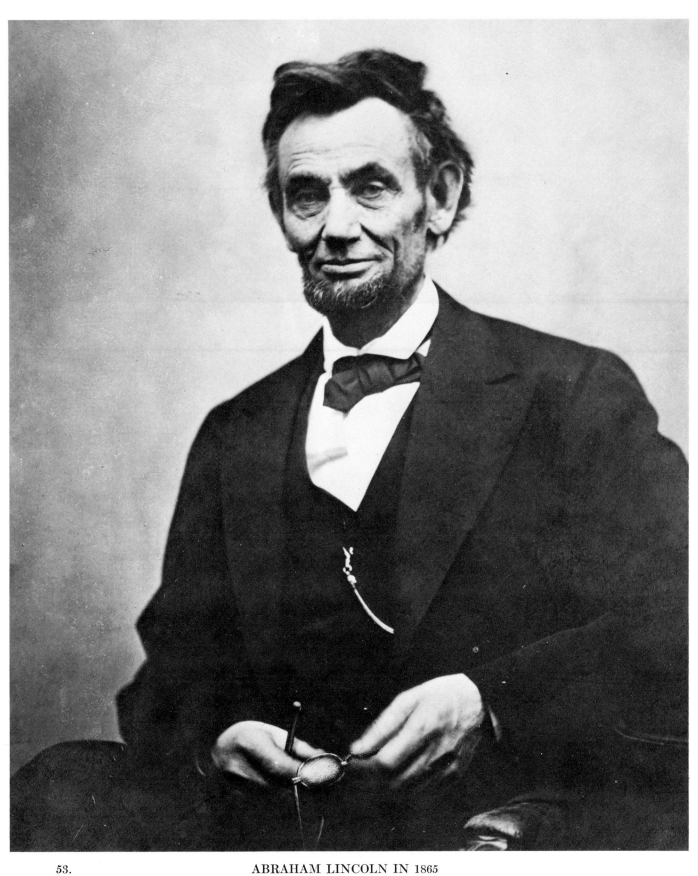

53. ABRAHAM LINCOLN IN 1865
This portrait is accredited to Alexander Gardner

CHAPTER

NINE

BY JULY SIXTH 1861 there were over 58,000 volunteer troops, including twelve hundred regulars in the base camps around the Capital, and it was rumored that before long a battle would be fought somewhere near Washington. These rumors had caused a hurried exodus of the government employees of Southern sympathies, and for several days the city was almost empty. The soldiers made up for any lack of business caused by the hurried departure of the citizenry for they crowded the gallery daily. Every conceivable military dress was to be seen on the soldiers coming for their *cartes des visites,* and Brady and photographer-manager Gardner worked until the last rays of light filtered weakly through the North skylight.

With the field equipment he had improvised for the inauguration, on days when the weather was suitable, Brady photographed scenes in camps, and military activity around the city. It seems that he encountered no official objection to this—something that would be impossible today, military secrecy being what it is—for in 1861 photography was considered a harmless novelty,—and until after Bull Run the war was in the musical comedy phase. There were rumors of impending battles and Brady's imaginative and active mind, stimulated by these rumors, gave him the idea of taking the camera to battle. It would be the first time in history that photography could play a part in war, he perhaps reasoned, and he would be the first photographer to make the attempt. It was a daring conception, and the more he considered it the greater seemed the possibilities.

He consulted his wife, unfolding his plan before her. She listened attentively, but she was not in wholehearted accord and the risk was great. She believed that he was to be a great man in his work, and that the management of his galleries was the most important thing of all. "My wife and my most intimate friends," he said, "had looked unfavorably upon this departure from commercial business to pictorial war correspondence".

Despite the counsel of his wife and friends he was determined to carry out his plan. With the actual details, technical and otherwise to be worked out later, but with the idea firmly planted in his mind, Brady went to see his friend, old General Winfield Scott, Chief of the Army. "I had long known General Scott", he said, "and in the days before the war.

it was the considerate thing to buy wild ducks at the steamboat crossing of the Susquehanna, and take them to your choice friends, and I often took Scott his favorite ducks. I made my suggestion to him in 1861 . . . He told me he was not to remain in command".

To Brady, Scott could give no encouragement, although he was impressed with the idea and quick to see its possibilities. "Mr. Brady, no person but my aide, Schuyler Hamilton, knows what I am to say to you," he said. "General McDowell will succeed me tomorrow, he and Col. Whipple are the persons for you to see." Looking toward the window of his office he continued a little sadly, "I am too old—; this will be a great war, and needs younger men to conduct it, I therefore cannot give you any help. You ought to be with the topographical engineers, well up to the front, I will give you a letter to General McDowell." Scott had seen at once in Brady's suggestion the value photography would be to military topographers;—something that would not be realized by other officers until two years hence.

Armed with Scott's letter, Brady went to see General McDowell the following day. McDowell was courteous and somewhat impressed. Evidently Brady received his permission, Scott's letter having the desired effect. "Destiny overruled me", he said to a friend. "Like Euphorion, I felt I had to go, a spirit in my feet said go, and I went—!"

Just before General Winfield Scott resigned as Commander-in-Chief of the U. S. Army, Brady received an order from sculptor Henry Kirk Brown to photograph Scott stripped to the waist. Brown had been commissioned to make a statue of General Scott. It was to be placed in Scott Square and Brown needed the picture for a model.

When Scott and his valet arrived at the studio Brady hurriedly arranged the cameras. While the valet was in the act of removing the General's shirt, Scott pointed to a scar on his shoulder and told Brady that he received the wound in the battle of "Lundy's Lane." The picture was to be a standard full length pose and when Scott, in his 'undress uniform' as Brady called it, stood up for it, he almost put his head through the skylight. The general towered above any one who had ever been in the studio before, and Brady, apprehensive, reminded him of his height and warned him about the skylight. While he was occupied with Scott's sitting, he was informed that Mrs. Fanny Kemble, the renown English actress and author and the Reverend Doctor Bellows were in the Gallery waiting to see him. Brady had been trying to get a picture of Mrs. Kemble. Dr. Bellows had brought Mrs. Kemble to the Gallery as he had promised Brady he would, but with General Scott in his undress shouting in his loudest voice, "Brady, don't leave me," all he could do was to look over the banister and see his long-sought subject go out with her escort. He never again had an opportunity to have her sit for him. She left for England that day.

Bull Run was fought and lost, and two raw, young armies separated after their first pitched battle, one as demoralized by victory as the other by defeat. But to Brady it had proved something. The first trial for the camera in the field was a complete success and the press declared: "Brady has fixed the cowards beyond a doubt . . ."

The records now show that the stinging defeat given the Army of the Potomac at Bull Run caused McDowell's removal, he being replaced by General George Brinton McClellan.

McClellan trained the army, watched empty forts for six months that held 'Quaker Guns', made of logs painted to look like guns,—and although he outnumbered the Confederate Army by three to one, seemed afraid to force battle. Finally, being pushed into action by the press and the insistence of Lincoln, he marched his army into Virginia in a pouring rain and a sea of mud, only to march back again, much to the disgust of the soldiers, the press, and the government—and the war went on from there.

Mathew Brady's success at Bull Run determined him to photograph the war on a large scale, but he could not begin until a system and an organization were devised. Undoubtedly his visions of the possibilities were checked by sober realities of cost, procedure, and equipment; and there was the question of government permission to follow the armies—for most assuredly there would be more than one to follow if photographic operations were to be conducted on a large scale. The actual military operations would cover thousands of square miles of hostile territory, and men would be needed to operate the cameras. He realized that if the job were to be done properly, a trained crew of operators would be needed.

These, and many other perplexing problems obtruded themselves during the months after Bull Run, yet, during these months of military inactivity, while McClellan drilled and put on parades, and stalled, Brady worked and formed plans for his field organization.

The first thing needed was War Department sanction, and this he set about to obtain. To Lincoln, Brady went with his proposal. But Lincoln, almost driven to the point of insanity by crackpots, office seekers, and incompetents, was not much impressed. But he did refer Brady to his new Secretary of War, Edwin McMasters Stanton.

Stanton was an enigma. A man of many sides and contradictions, irrascible, arrogant, and erratic,—a self-made man, he had worked his way through Kenyon College as a clerk in a bookstore to become a successful lawyer. To get a private interview with Stanton was the next thing to impossible—'he had to have witnesses.' At all interviews someone was always present. He had an ungovernable temper: many callers were heard to say, "He went at me like a tiger".

Brady had more than a passing acquaintance with Stanton having made portraits of him several times, and to Stanton, Brady made his proposal. Stanton was not easily convinced and Brady evidently exhausted his arguments. "By persistence and all the political influence I could control", Brady wrote, "I finally secured permission from Stanton, the Secretary of War, to go onto the battlefields with my cameras".

Stanton took the shortsighted view. The provision placed on Brady by Stanton was that he would have to finance the venture himself; that the government could not see enough merit in the proposal to warrant War Department financial support. But it was agreed that he would have the protection of the newly organized Secret Service under Allan Pinkerton. Pinkerton saw great possibilities in the venture and agreed to whole-hearted cooperation. This settled the matter of government sanction.

The odds against him were still great, for it was left to him to formulate methods of financing and operation. Brady realized that the investment the venture would entail

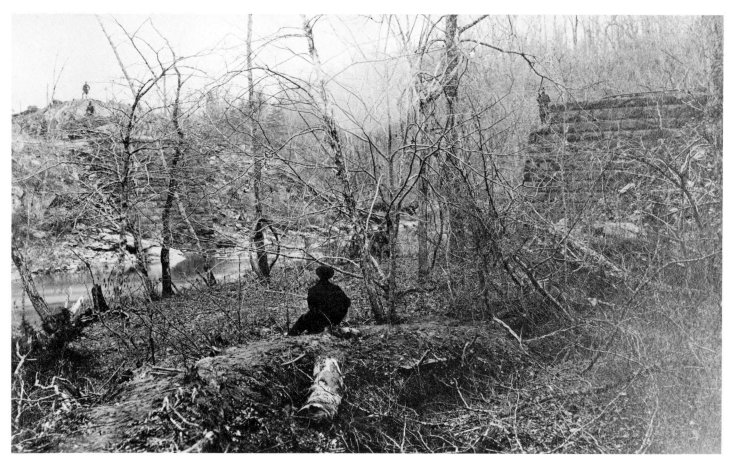

54. *Above:* An original print of Brady's, showing destroyed railroad over Bull Run Creek near Blackburn's Ford. *Below:* Another original print of Brady's showing the repairs made to the bridge and the hastily constructed railroad trestle

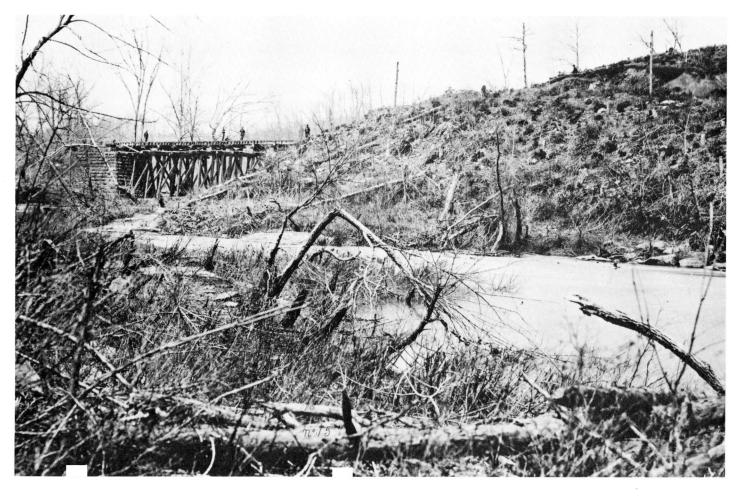

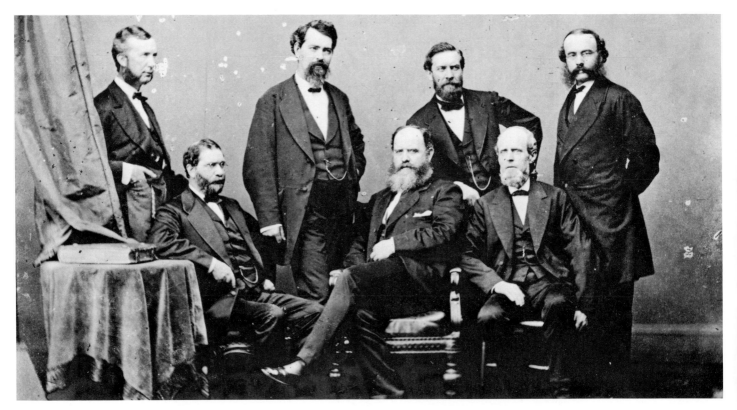

55.　　　　POSTMASTER GENERAL JAMES A. R. CRESWELL AND GROUP
A rare unpublished print showing the mechanics of photography in Brady's Washington Gallery.

would make the investments of his other enterprises seem trivial;—they had, almost at once, more than repaid the original outlay. But this one great ideal, to be America's photographic historian, was paramount in his mind. He considered that this innovation, 'War Views', would, as did the 'Imperials', and other of his galleries' novelties that had caught the public fancy, more than cover the cost of making them.

With Alexander Gardner managing his Washington gallery, Brady set about organizing his field units. From January to April of '62 Brady trained his crews and made his plans for the campaigns that were to come with the Spring, when the roads were in condition for military use.

His first problem was to get cameramen, and this was apparently the most difficult of many problems, judging from Brady's conversation with John C. Taylor, whom he told of his 'difficulty in finding men to operate (his) cameras'. Men now realized the dangers of the field, and the boredom of life in bivouacs in all kinds of weather. Yet, it can be assumed that although little is known of the men, they were recruited from his own galleries. He knew them and their capabilities, and they in turn, were familiar with his methods. The men chosen were T. H. O'Sullivan—who would, more than any other of Brady's men, make the war pictures—William R. Pywell, J. B. Gibson, George Cook, David Knox, D. B. Woodbury, J. Reekie, Stanley Morrow, H. Moulton, and one Wood.

These capable men were assigned to different territories in the war theatres by Brady, and operated from bases set up in these localities. For the equipment, Brady had recourse to Anthony & Company, the New York Photographic Supply House, whose customer he had been for many years for chemicals and supplies.

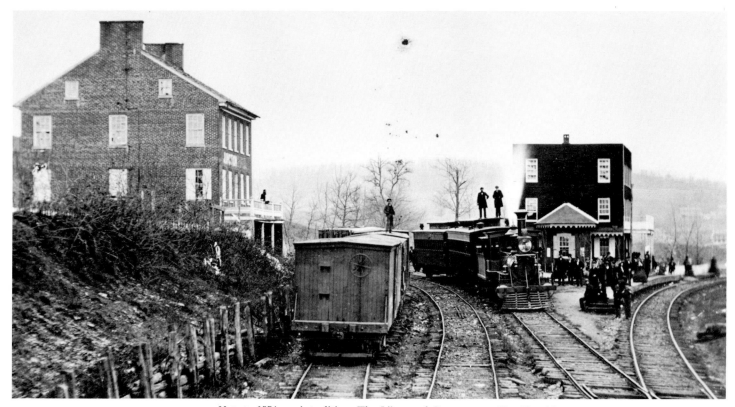

Note to 1974 reprint edition: The Library of Congress now identifies this as Hanover Junction, Pennsylvania.

56. BURKE'S STATION ON THE ORANGE AND ALEXANDRIA RAILROAD
This photograph was made by Brady sometime in March of 1862 near Alexandria, Virginia

Horses, and wagons specially designed for field work were purchased for the traveling darkrooms, which had built-in receptacles and shelves for the chemicals and plates to guard against breakage, with additional compartments for the several types of cameras carried. These cameras were of different sizes ranging from the large 16″ x 20″ type, to the small 4″ x 4″ Stereoscopic camera used to make pictures for the popular parlor Stereoscope Viewer. Chemical tanks for each camera were also a part of the unit, and each Darkroom wagon had a full supply of glass plates, plate holders, heavy negative boxes, and several tripods. Thus was the 'WHATIZZIT WAGON' born,—forerunner of the modern newsreel truck and camera unit in use today.

Public opinion and Lincoln's prodding were now forcing McClellan into the field. In April of 1862 his much vaunted Peninsula Campaign was begun. It was to last four months with the Confederate Armies roughly handled but still victorious.

During mid-April a large photographic exhibition was held in London, and the only American to enter was Brady. He had prepared his prints during the preparation for the coming military campaign. The prints were entered and sent to London. His work was unfavorably compared to the French and English entries. But this view was not taken by a London correspondent of the *New York Express*, who wrote: "The three best and best known experts in this money-making art are Brady of New York, Silvy of London, and Nadar of Paris".

It would be two months before the armies would march into Virginia, and for the time being at least Brady had to content himself with the work in the gallery.

93

57. MATHEW B. BRADY Print from an original negative in the National Archives made with a multi-lens camera. Presumably never published before. *Left Below:* THOMAS NAST, the celebrated artist, caricaturist, and political cartoonist. From an original Brady negative never before published. *Below Right:* MATHEW B. BRADY: A print from an original negative in the National Archives in Washington. The negative was made in the Washington Gallery, presumably by Alexander Gardner shortly before the war

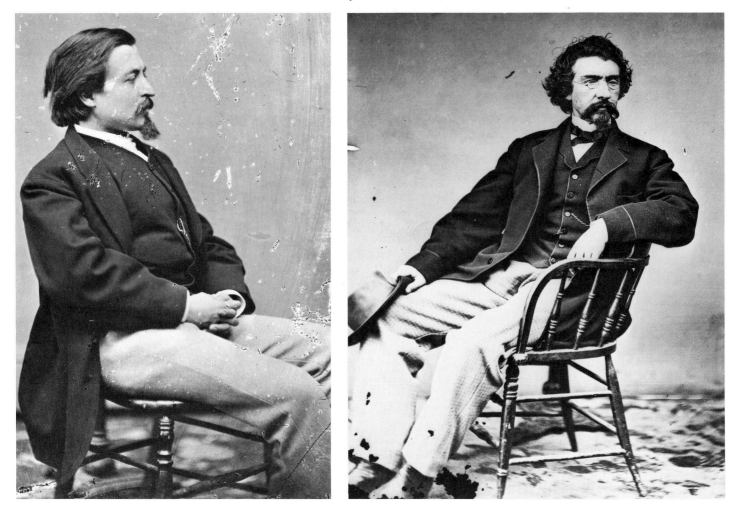

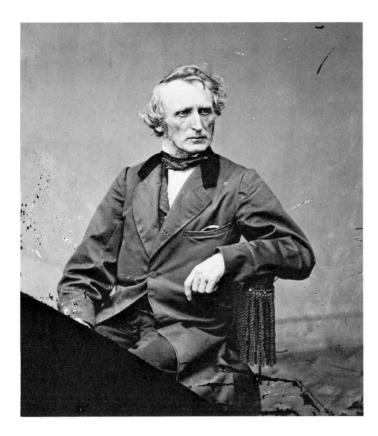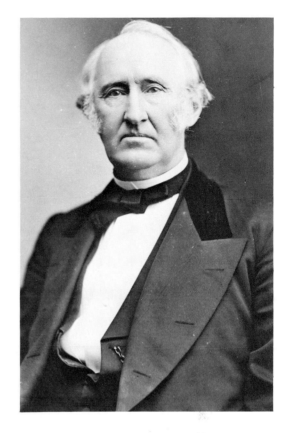

58. AN IMPEACHMENT MANAGER, AN ORATOR AND REFORMER, A JURIST AND A VICE-PRESIDENT. *Above Left:* JOHN ARENDE BINGHAM. *Above Right:* WENDELL PHILLIPS. *Below Left:* JEREMIAH BLACK. *Below Right:* HANNIBAL HAMLIN

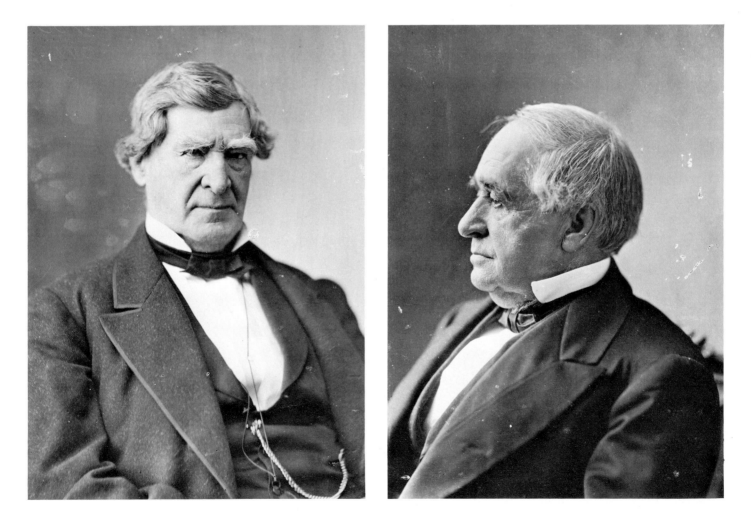

CHAPTER

TEN

TO accompany him on the Peninsula Campaign about to be opened, Brady chose D. B. Woodbury, J. B. Gibson, an operator in his Washington gallery, and Wood. In the field, Wood and Gibson would work together;—their picture credits read that way—and Brady and his personal assistant, Woodbury, would work for a time as a team;—and when not actually handling the camera, Brady would direct the taking of many of the pictures when he chanced to be in the vicinity of either of his camera crews.

T. H. O'Sullivan, a very capable photographer, who would cover most of the war theatres, was assigned the area from Harper's Ferry down through the Shenandoah Valley, operated in the vicinity of Culpeper, Warrenton, and Bealton, Virginia, and was to be on hand for the great battle of Cedar Mountain.

With the assignments made, and all details completed, Brady and his men, Woodbury, Gibson, and Wood, departed in their traveling darkrooms for the wharves on the Potomac where military supplies were being loaded aboard the transports and barges for the trip down the river. Arrangements had been made for the inclusion of the darkroom wagons and horses on the transports, and it was not long before they were taken aboard with the baggage wagons of the army. At last the transports moved down the Potomac bound for Fortress Monroe. Brady's first full scale photographic operations had begun.

The strategy of McClellan's campaign of '62 was, roughly, a three pronged advance on Richmond, the Confederate Capital. McClellan's own army of the Potomac was to advance up the Virginia Peninsula, while the divided, smaller, armies of Generals Banks, Shields, Fremont, and Milroy, were to march down the Shenandoah Valley to Richmond. McDowell was to advance with his army from the North and join McClellan by marching East, to form a junction at Richmond. McClellan made his base on the York River where he would have a railroad for his supply line and deep water to float his gunboats.

The Virginia Peninsula is divided in its upper reaches by the turbid Chicahominy River that passes a little over four miles North of Richmond, emptying into the James River below Westover Landing. The Chicahominy is narrow, swift, and sensitive to rains

which raise it out of its banks. The land on either side was swampy, and covered with a heavy growth of pine and white oak, laced together by dense underbrush and thick trailing vines. The roads of the region were little more than woodlot traces, narrow and obscure;—and it was only by these roads, almost bottomless after rains, that army wheeled transport could move,—for to move, off the roads, was impossible. The foliage and branches of the dense trees of the forest obscured the sunlight, even during the brightest part of the day, making the thick woods dark and dismal. This, then, was the theatre selected for the spearhead of McClellan's Army,—a miasmal wilderness of malarial swamp, mosquitos, and mud.

Under the protection of Fortress Monroe, McClellan landed his Army of the Potomac at Old Point Comfort on the tip of the peninsula. Barges loaded with military supplies, baggage wagons and horses, that had been towed by the troop transports, were lined in rows alongside makeshift wharves for unloading. All along the shore stood row on row of artillery, parked ambulances, baggage wagons, and pontoon trains all facing the Fort. Some of the pontoon boats had been filled with hay and grain by the army mule drivers, the mules using the boats as feed troughs.

The scene was as busy as it was colorful. Zouaves in red caps, white leggings, blue tunics and red baggy trousers, mingled with the blue-uniformed infantrymen, the blue, yellow-trimmed cavalrymen, and the dark blue and orange-trimmed engineers, and the ragged black laborers and teamsters—'Butler's contraban' darkies'—all busy at something and puzzled at being free and still having to work.

Such was the lively scene before Brady and his men as they supervised the unloading of their darkroom wagons and horses from the transports. Farther back from the landing, on drier ground were the crowded tents of soldiers, with scattered groups of men talking, frying bacon, and making coffee. Following the unloading of their equipment, Brady and his group made their camp near those of the soldiers, pitching their tent and attending to the care and feeding of their horses and the parking of the wagons.

During the two day stay at the Fort, Brady had many opportunities of making photographs much to the amusement of the soldiers, who gathered in groups to watch the strange operation. The photographing of one group deserves mention.

General McClellan, because of his friendship for Brady, brought his whole staff out to pose in front of the massive, red-bricked wall of Fortress Monroe. In this picture of the eleven general officers, Brady used exactly that number of standard poses. The whole gamut of expression 'for the instrument that could take you from yourself' was struck, from the 'napoleonic pose' that McClellan affected, with the right hand thrust into the breast of the coat, to those affecting gaiety, determination, resolution, audacity, impatience,— the third officer from the left moved while the cap was off the lens — and benevolence.

But the stay at the Fort was short, for at dawn break on April fourth, a bright Spring day, the advance up the peninsula began. Following the white-topped ammunition wagons with the stencilled U. S. on their canvas sides that moved with creaking, straining wheels through the soft dirt tracks, came Brady's traveling darkrooms. The weather was clear,

bright, and pleasant and the buds on the trees were beginning to burst into leaves. The grass was green, and in the woods the birds were singing. But soon it began to rain. Wagon teams at the head of the columns soon churned up the soft red-dirt roads into a quagmire that slowed the rear columns almost to a standstill.

After a short march the columns reached the little village of Hampton where evidences of war were plain in the shell-blackened ruins. The only building standing intact was the old Episcopal Church where Washington had once worshipped. By the time the columns reached another small village, Big Bethel, the rain was coming down in torrents. As the trek continued Brady discovered that he was in Hooker's column which had landed at Ship's Point, and that the objective of the advance was Williamsburg.

The army continued slowly on parallel roads until a halt was caused by a burning bridge, set afire by the retreating Confederates. Darkness came before the fire was put out and the troops bivouacked for the night.

To Brady and his men, who tried to make themselves as comfortable as wet clothes and a hard wagon box would allow, sleep was impossible; for all through the night they heard the axes of the engineers repairing the bridge. At dawn came the shouts of the teamsters and orders to 'fall in', and the men shook themselves into ranks and plodded on through the mire.

Soon after the columns left Big Bethel the men began to discard their knapsacks and soon along the route could be seen overcoats, blankets, and shoes. Many times during the march the double-teamed baggage wagons had to be unloaded so that they could be pulled out of the mud. But Brady's darkroom wagons, each drawn by one team, were lighter and had higher wheels and so had little trouble.

On the afternoon of April fifth the columns were brought to a standstill and formed in line of battle with the right of the line in front of Yorktown and the left near Lee's Mills, almost within sight of the enemy's works. Then the Army of the Potomac settled down to a month of siege. Brady and his operators pitched their camp on Wormely Creek near the Moore House and the York River, in plain sight of the enemy's water batteries on Gloucester Point.

The weather was unfavorable for photographic operations, but on clear days Brady took many scenes of Camp Winfield Scott, as the men had named it, and of the elaborate fortifications that the cautious McClellan was constructing. McClellan had placed the camp about a mile from the enemy's fortifications, along a four mile front, in which was some of the heaviest artillery ever used up to that time. In one of these redoubts Brady came under fire, in the act of taking a photograph.

It was on one of the rare clear days, when the sun was high overhead. Brady and Woodbury were making photographs of the two-hundred pounder Parrott rifles in the first parallel of Battery One, a short distance from the York River. The portable darkroom, a square black tent about four feet high and four feet wide, in which the men took turns at coating and developing the plates, had been set up on planking inside the redoubt.

While the photographers were at work General McClellan was escorting the Prince

de Joinville on a tour of inspection. McClellan and de Joinville, peering through field glasses across the river at the rebel fort, drew the attention of a Confederate battery which at once opened fire. The first shot, whistling over their heads, was followed by another that struck the parapet and exploded with a deafening roar. The crash brought Woodbury out of the tent, and Brady, ducking instinctively, saw the Prince jump and look nervously around. But, McClellan quietly, and without a sign of nervousness, knocked the ashes from the cigar he was smoking. And only when Woodbury dropped a plate holder in his excitement did McClellan look around.

Then, while Woodbury went about putting the camera away, McClellan introduced de Joinville. Later, in camp while the Prince and his party were at dinner, Brady and Woodbury made some negatives of the group, who were seated on camp stools at a crude plank table resting on two tree stumps.

During the rest of April camp life for the photographers, although rugged, was leisurely and pleasant. On the most inclement of those Spring days the men sat around playing cards, smoking, and talking, but on clear days Brady and his men made many plates around the camps and forts. McClellan's gunboats would occasionally throw a shell into the enemy's works and get a few in return, and on the sixteenth of April there was a sharp skirmish on the left of the line near Lee's Mills.

But the engineers had not been idle. Every road had been corduroyed and all heavy ordnance placed in position. Finally the great Parrotts of Battery One opened fire on the enemy's forts. There was little return fire, only some light sporadic shelling. The enemy it turned out had abandoned their works, and McClellan ordered the immediate advance of Hooker's and Smith's forces in support of Stoneman's cavalry.

Brady and his operators proceeded to break camp, and as soon as the teams were rounded up and harnessed, fell into place behind the baggage wagons. Hooker and Smith continued slowly up the peninsula on parallel roads until forced to halt by another burning bridge. This led Smith's column to turn into the road by which Hooker was marching and caused delay and confusion. It was near sunset and rapidly growing dark, and Brady and his men partook of what little food there was, after seeing to the care of their horses. No fires were permitted and the men in the ranks ate only what food they had in their haversacks. Most of them fell asleep on their arms, and Brady and his crew spent another night on the wagon boxes. Toward morning it began to rain, and before a gleam of light appeared in the Eastern sky there was a steady downpour. Just before dawn Brady and his operators were aroused by the shouts of officers and noncoms, giving commands to 'fall in'. Bedraggled and miserable, Brady and his group prepared to move once again. Up ahead, the slowly moving column suddenly broke into a clearing, in the middle of which was Fort Magruder, a large redoubt of earth, protected in front by a wide ditch and a system of rifle pits. As soon as the leading Union column broke into the clearing it met a hail of rifle fire. The sector between the Union army and the fort had once been a dense forest. Now, the trees, felled to make the clearing, formed a tangled abattis almost impossible to penetrate. Skirmishers were at once sent out with orders to advance as far as

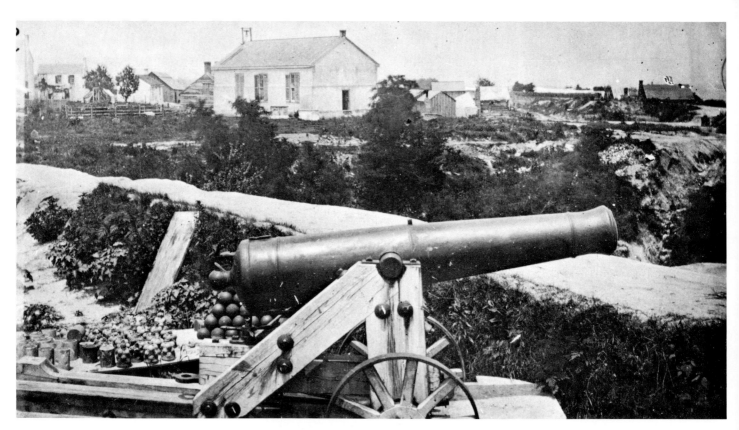

59. CONFEDERATE WATER BATTERY
Photographed near Nelson Church Hospital by Brady during the siege of Yorktown, July 1862

possible and to try to silence the fire from the rifle pits. But then the heavy guns of the
fort opened fire on the blue columns.

Back in the train Brady and his followers could not extricate their wagons, and all
around big shells tore through the underbrush throwing great showers of dirt, and rocks.
The terrified horses reared, almost tearing themselves out of the traces.

The din was terrific. Musket balls with the whistle of sudden death—personal shooting
they called it in that army—ricocheted from tree to tree, snipping off leaves and twigs. All
through the morning the sound of battle continued and shells burst in a rapid succession.
It was manifestly impossible to break out a camera, and neither Woodbury, Brady, nor
the rest could do anything but await the outcome and hope that a stray shell would not
land in their midst. Soon the walking wounded began to stream past them, dirty, bloody,
some limping on the arms of comrades, going to the rear.

Bramwell's and Weber's batteries rushing into position, shelled the fort with telling
effect, and by eleven o'clock the Unionists were skirting the edge of the wood to the left
of the fort, when suddenly they flushed a covey of Southerners who came, yelling, out into
the clearing, pouring a steady stream of fire into their ranks. Gathering the momentum of
a charge and topped with the rebel yell, they forced the Federals back into the woods
where they took advantage of every tree and stump to try and stem the rebel advance.

The surprise and momentum of the charge forced Hooker to retire leaving a battery

100

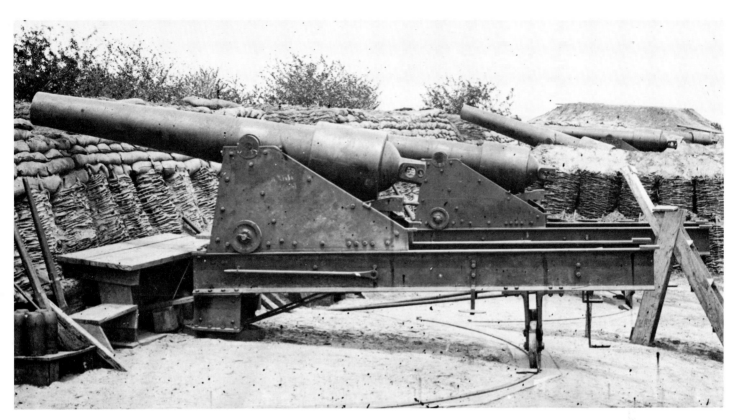

60. BATTERY NUMBER ONE, YORKTOWN, VIRGINIA
Photographed by Brady's operators Wood and Gibson during the siege of Yorktown, Virginia. This
print appeared in Gardner's "Sketchbook of the War" in 1865

on the field. Taking advantage of this, D. H. Hill, with Early's brigade quickly rushed forward. Hancock's infantry opened fire and followed up the volley with a counter charge, driving the Confederates back. The brigades of Berry and Birney recovered part of the ground lost by Hooker's retirement. Here the battle ended with the firing slowing down and dying out like a spent string of fire-crackers. That same day the Confederates evacuated Williamsburg.

As soon as the enemy withdrew, Brady and his operators were on the field. Taking their big cameras out of the wagons they went to work photographing the field and the fort before the burial parties arrived. All over the ground were scars of the fierce battle. The trees were riddled with bullets. Many bodies were lying along the road, having been placed there by stretcher parties in order that the burial parties might find them easily.

Near the fort where Wood and Gibson were taking pictures, one soldier in grey seemed to be aiming in their direction, resting the rifle on a stump. Going closer they saw that the man was dead, shot through the head. The end had come so quickly that his hands still grasped the musket as in the act of aiming. These and other scenes just as ghastly were taken, and then Brady and the others loaded the equipment into the wagons and continued on up the road toward Williamsburg.

They had gone but a short distance when a lieutenant came riding up. The officer warned them to be careful where they drove as there was a danger of 'subterranean shells'

which the Confederates had buried to delay the advance, and that they would explode at the slightest disturbance. It was quickly decided that they had better all get out of the wagons, as their additional weight would more than likely set one off.

Walking alongside their wagons the photographers finally reached Williamsburg, where they found the army in bivouac just on the edge of town. Over fires of Virginia fence rails the photographers cooked their rations of coffee and bacon, and talked about what the morrow might bring.

The most interesting and unusual photographic opportunities offered Brady during the Peninsula Campaign occurred with the first experiment in aerial military observation. Brady had learned, while the army bivouacked at Williamsburg that Professor T. S. C. Lowe had been making day and night observations of the Confederate forces now massing in front of Richmond, using the military telegraph to transmit his findings to McClellan's headquarters.

McClellan had ordered Lowe to proceed with his outfit, including all the balloons, gas-generator, the balloon-inflating boat, gunboat and tug, up the Pamunkey River, to White House, the army's objective.

Seven miles East of Richmond, where the Williamsburg 'Old Stage Road' meets the intersection of the Nine Mile Road, is an area called Seven Pines;—and where the Nine Mile Road crosses the York River railroad is a little station called Fair Oaks. It was into this watery wilderness of swamp and bog, that McClellan pushed his Army of the Potomac on the march for Richmond.

The right of his army lay on the north bank of the muddy Chicahominy near Mechanicsville. His center and left he had moved across the river ascending the South bank, with the far left aiming for, but not quite reaching the James. McClellan thus straddled the river. This was the situation in the early part of May 1862.

While Brady and his photographers were bivouacked at Williamsburg, it was evidently decided to go separate ways for the sake of greater coverage. With Brady and Woodbury remaining with the main Army, Wood and Gibson, with their equipment would push on to Cumberland Landing and White House.

Mechanicsville, only about four miles from Richmond, was selected by McClellan and Lowe for an aeronautic station. The balloon, Washington, was hauled there and Lowe then took observations to ascertain the best crossing of the Chicahominy for the army. His main station and personal camp was on Gaines Hill overlooking the bridge where the army was to cross, and where he had two other balloons, the Constitution and the Intrepid.

Upon learning of Lowe's aerial activity, Brady and Woodbury drove toward Mechanicsville, a position now held by Fitz-john Porter's Corps. Over a road, soft and spongy, lined with dense woods and thick undergrowth, matted with tangled vines, they drove their darkroom wagon.

A short distance back of Mechanicsville and Porter's lines, behind a clump of woods, Brady and Woodbury went into camp. On May thirtieth fell a heavy rain, raising the

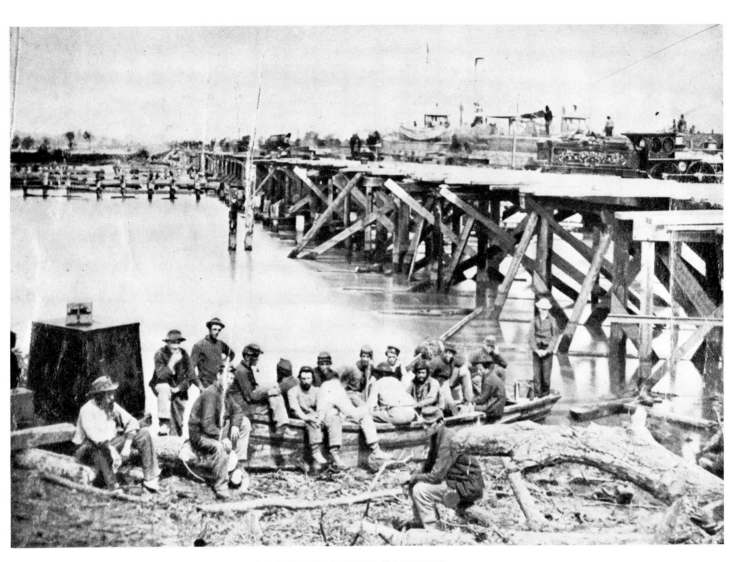

61. AT WHITE HOUSE LANDING
Copy of a rare print by Brady taken at White House Landing on the Pamunkey River. The photographer's outfit is in the black, box-like tent on the extreme left

Chicahominy to flood level and washing out some of the bridges. The next day was clear, the sun lighting up the roads. In the meantime, Silas Casey's Division of Keyes' Corps had forded the Chicahominy despite the rushing water, and entrenched itself at Fair Oaks. Heintzleman's Corps was entrenched at his rear with Kearney's Division guarding the railroad at Savage Station, and the approaches to White Oak Swamp.

By eight o'clock of the thirty-first of May the sound of heavy firing was heard in the direction of Fair Oaks. Within a few hours a battle was raging, and by afternoon the Confederate Army was driving the Federal soldiers through the woods in disorder.

That same morning Lowe had telegraphed his assistants hurried orders at Balloon Camp on Gaines Hill to inflate the balloon Constitution, in the event anything should happen to endanger the other two. Lowe, meanwhile, in the Washington, was making a reconnaissance of the Confederate Army in and around Richmond. While he was thus observing, Confederate rifle and artillery fire opened on him. Shells passed through his rigging and burst a short distance away.

This did no damage, however, and he continued his observations, soon discovering columns of troops with artillery moving toward Heintzleman's position in force. This information he at once conveyed to headquarters.

Brady and Woodbury, preparing to make pictures of the aerial observations, learned from Lowe that he was returning to his camp at Gaines Hill, six miles away, to observe the battle at Fair Oaks. The photographers hurriedly loaded the cameras and equipment into the wagon and started back on the six-mile drive. The battle at Fair Oaks was at its height, and Sumner's Division was desperately trying to find a crossing over the swollen Chicahominy to reinforce the hard pressed Keyes and Casey.

When the photographers arrived on the scene, Lowe was trying to get the balloon into the air. It was soon found that the added weight of the telegraph apparatus kept it from gaining the necessary altitude. Lowe, at once, ordered that gas be transferred from the Constitution. "To carry my telegraph apparatus, and cables to this higher elevation," he wrote, "the lifting force of the Constitution proved to be too weak. It was then I was put to my wits end as to how I could best save an hour's time . . . As I saw the two armies coming nearer and nearer together there was no time to be lost. It flashed through my mind that if I could only get the gas that was in the smaller balloon, Constitution, into the Intrepid, which was then half-filled, I would save an hour's time . . ."

While Lowe and his men worked feverishly at the hose connections and gas-generator tanks, Brady and Woodbury, their cameras already set up and focused, were busily photographing the operation of the gas transfer, as the gas rushed through the improvised hose-line to the Intrepid, hanging in the air like a limp jelly-fish. The Intrepid began to fill out slowly while the soldiers held the ratlines.

At noontime when both armies were in deadly conflict, Lowe, observing the battle, from time to time, allowed the balloon to be hauled down in order to send a dispatch. Brady and Woodbury, in the midst of this excitement, brought their camera up and made a picture while Lowe, in the balloon, was writing.

This done, the men again payed out the lines allowing the balloon to slowly rise. When the balloon was about twenty-five feet above the ground, Brady made another plate. This took about ten minutes. The balloon then continued rising, and when it reached the height of two hundred, looking over the tree-tops, it was greeted with a hail of shell and shrapnel from the Confederate batteries on the opposite side of the river. But the balloon continued the ascent until it reached an altitude of three hundred feet where it was comparatively safe from shell-fire.

Lowe reported that a crossing could be effected about a mile from where Sumner's Corps was already trying to cross.

The battle continued with savage intensity for two days. On the morning of June second, Sumner was able to get part of his troops across the Chicahominy as reinforcements. Here the battle ended with the Confederate Army falling back on the Richmond defenses. Such was the Battle of Fair Oaks, both sides suffering heavy casualties.

Soon after, Brady and Woodbury crossed the Chicahominy, over the Grapevine

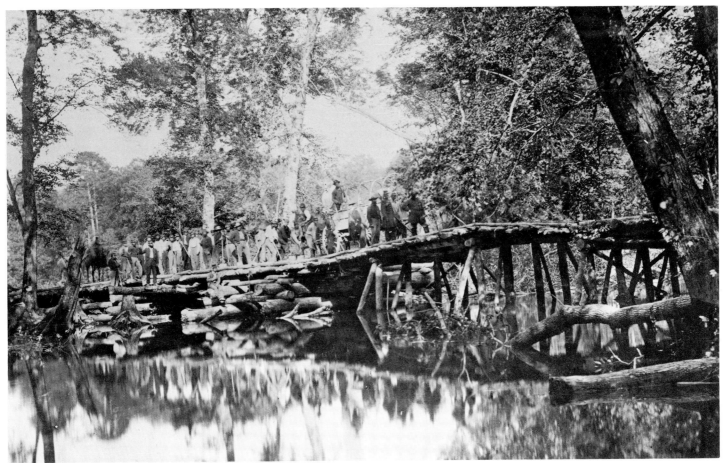

62. GRAPEVINE BRIDGE OVER THE CHICAHOMINY RIVER
This photograph was made by D. B. Woodbury working with Brady before the battle of Fair Oaks.
Below: McCLELLAN'S FORTIFICATIONS AT YORKTOWN. Photographed by Brady during the
Peninsula Campaign of 1862

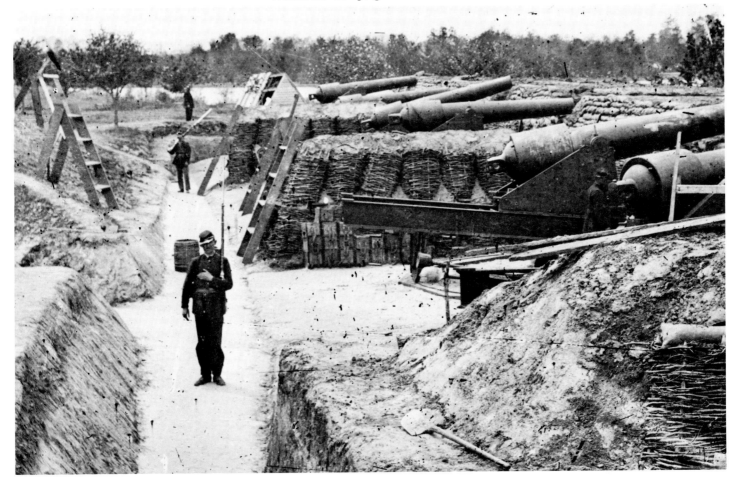

Bridge where Sumner had crossed, the slowly plodding horses' hooves making hollow sounds as they hit the dirt-covered corduroy approaches. After a drive of a mile and a half over the soft road, they reached the field of the battle of the day before.

They drove over a vast graveyard. The trees were shattered and torn as if by a mighty tempest. The open graves had been sprinkled with chloride of lime but the stench was sickening. The ground was very swampy and the graves were shallow, some of the bodies being partly and others wholly exposed to the sun's rays.

The scene can be conceived in a moment. The sun was bright, the air balmy, with a sickish, sweetish smell. Farther back in the distance, were the Twin Farmhouses, surrounded by redoubts bristling with heavy guns, the gunners lolling around.

The photographers halted their wagon, jumped out, and after a glance around the field, began setting up their cameras. Some of the gunners came over to watch as the big Anthony camera and its smaller counterpart, the Stereoscopic camera, were placed upon their tripods. Brady and Woodbury, once the scene was selected for recording, worked fast and efficiently. The warm weather made speed necessary. The effect of the rising temperature on the fugitive character of the chemicals compelled them to coat, sensitize, expose, and develop the plates within a space of ten minutes.

In the stuffy 'Well' of the darkroom wagon Brady and his assistant took turns at developing the plates. The stench of the battlefield, wafted by a light breeze, was at times, unbearable. Even the smell from the chemicals could not overpower the sticky, sweetish smell of death that brought out swarms of little green flies in the early Summer heat.

Some of the soldiers came closer to the wagon to peer inside, curiously watching the antics of the photographers as they aimed their camera, took out the black plate holder from its receptacle on the camera's back and rushed into the depths of the 'Well' of the darkroom wagon, closing the little door with the two yellow eyes behind them.

Later that day pictures were made of the redoubts, and of the soldiers manning them. And it was of these soldier groups that Brady 'displayed his best candid attitudes', the press said. With the approach of sunset the photographers went into camp where they attended to the washing, drying and varnishing of the plates exposed that day.

After the battle at Fair Oaks, during the latter part of June, two great armies watched each other, entrenched, and prepared to stage the next scene of the drama. Then an ominous silence reigned.

CHAPTER

ELEVEN

O N JUNE TWENTY-SIXTH at two p.m. the silence was broken by the boom of a cannon heralding the opening attack on Fitz-John Porter's position on Beaver Dam Creek. Then did the 'ball open', as they said it in that army on the first of the Seven Days Battles.

The intelligence delivered by General J. E. B. Stuart and the Confederate Cavalry, after a phenomenal ride around the whole Union Army, that Porter's right flank 'hung in the air,' precipitated the Confederate attack.

Robert E. Lee, in command since the wounding of Joseph E. Johnston, framed his battle on Stuart's information. His plan was simple. A. P. Hill's divisions were to attack Porter in front while 'Stonewall' Jackson was to deliver his attack on Porter's weak flank and roll up the line. Both attacks were to be delivered simultaneously.

Porter's position in itself was strong. His left was on the Chicahominy;—facing his front was Beaver Dam Creek, a deep, muddy stream. He had eighty heavy guns in position hub to hub, and his infantry was strongly entrenched. A. P. Hill viciously attacked Porter in front, and had Jackson's attack coordinated as planned, Lee's design would have been successful. But Jackson was late in arriving, even though within earshot of Hill's battle. A message had been sent Hill to withhold his attack until Jackson should come up. Not receiving the message, Hill attacked at the appointed time over an open plain, exposed to the murderous fire of all arms, and an almost impassable stream.

A. P. Hill's brigades dashed themselves to pieces while Jackson pondered; and the best blood of the South was spilled in the swamps of the Chicahominy that day. By night-fall Porter discovered that Jackson was behind his right flank. Taking prompt measures he withdrew under the cover of darkness taking up his position between New Cold Harbor and the Chicahominy. Darkness brought an end to A. P. Hill's sacrificial battle, and by the light of lanterns the men who survived helped bring in the wounded.

Since Fair Oaks, Brady and Woodbury had had their camp near Savage's Station, a depot for the unloading and storing of military supplies for the Union troops. On the North side of the railroad was a cleared field of several acres of land. This was filled with hospital tents placed in rows, each tent accommodating fifteen to twenty men.

The wounded from Porter's battle began to stream in on trains of flat-cars and in ambulances. The railroad passed close to the southside of Savage's house, barn, and negro cabins, which were being used by the Sanitary Commission as hospitals. On the lawn, and in the yards were lying hundreds of wounded soldiers enduring the torment of hordes of flies, attracted by the bloody bandages and the refuse strewn about the ground.

Here is the scene as recreated by Stanley Pennell: *

"We're gonna git our pictures took. Look pleasant and watch the birdie! yelled a boy with a bloody bandage around his shoulder.

"A little, knotty man with a big cavalry sabre strapped underneath a muddy linen-duster was shading the lens of his camera tentatively as he prepared to remove the lenscap.

"Colonel, the man said, in thickrich Irish tones, to Captain Ames, will ye ask the men to stay quiet whilst I photograph them.

"Ames, still bending over Tom, said shortly: They won't move. They can't move very much. All right, men—you can keep still for a moment? Your picture's wanted for your sweethearts.

"It's Brady and his Whatsit. I got my picture took at Bull Run, someone said.

"I'll bet it was your assend runnin' like a bat outa hell, someone answered.

"Tom rose up on an elbow and looked at the small Cork Irishman, the great Washington society photographer, the Lincoln-snapper, the Preserver of the Senatorial Stare, the Poser of the FFV's. Brady removed the lenscap, and, for a long instant, all was quiet and still: the instant was freezing in collodion as the light burnt the bromides and iodides of Brady's wetplate. Everyone within the eye of the lens had struck an attitude as if he were a statue in a public square of his home town. Wooden faces grew on the boyfaces, the beards petrified. The dead grew deader before Brady's camera. Tom watched the Irishman's lips silently tell off the seconds of frozen time. Time stretched to the breaking point like a bit of rubber; the buzz of thousands of flies only locked the paralysis of the minutes. Brady returned the velvetlined cap to his shining lens. The camera was blind again. But in 1912 the moment would be there even to the ladder against the house.

"Thank ye, gentlemen, Brady said, putting on his battered brown strawhat which he had used to shade the lens. Time continued, men unposed—slipped down off the instant's edge.

"When can we get one of those pictures, Brady? someone yelled. I want to show my girl how brave I am. But Brady was already on his way, trotting a phantom bog, toward the little tarpaulin-covered buggy to develop the wetplate, the sabrescabbard clacking against his heels. The flies whirred on, living out every moment of hypnotized existence in the sun."

The day was hot and sultry and wore away slowly. Wounded continued to stream in, in increasing numbers. A signal officer reported the advance of the whole Confederate army. Porter had lost his battle, and the Union generals, their initiative. Then began the great retreat of the Federal army to Harrison's Landing.

*From The History of Rome Hanks and Kindred Matters, by Joseph Stanley Pennell, Charles Scribner's Sons, 1944.

During the remainder of that day Brady and Woodbury made many pictures in the vicinity of the hospital, and at night they worked by the light of a lantern preparing their chemicals and washing their plates. Later that night a general retreat was ordered and everything was confusion as the soldiers broke camp. The following morning, while Brady and Woodbury were getting their equipment together, the Confederates began shelling the area. Franklin's Corps, sullen at the retreat order, was assigned to cover the withdrawal and had to fight all morning.

By noon the order was given to destroy all supplies that could not be taken away. The photographers were taking pictures of the destruction, their wagon parked near the station, when a roaring noise came from the direction of the woods. The next moment an engine with a train of blazing cars plunged down the track at a fearful speed. It sped on until it reached the ruined bridge and so great was the momentum that the locomotive leaped across the first span, struck the second tier of the bridge and plunged into the river followed by the burning cars.

To add to the confusion, back of the station where Brady was at work, a detail of soldiers were throwing boxes of ammunition into a raging fire. Explosion followed explosion and some thought the enemy had already attacked in force.

With all the violence that was going on around them it was impossible to continue photographic operations so Brady and his partner joined the wagon train that was making ready to leave as soon as the teams were harnessed and a cavalry escort arrived. Opposite the station was a clearing of several hundred acres, on the farthest line of which ran the Williamsburg Road. Beyond was a dark pine forest. This field gradually ascends from the station to the road, and in it were twenty thousand of the determined soldiers of Franklin and Sumner forming the rear guard of the Army of the Potomac. For hours these men had been standing in line of battle, waiting for the Southerners to appear.

By five in the afternoon rising columns of dust signalled the approach of the Confederate army. In a few minutes the Union videttes were driven in by enemy skirmishers. Brady, in the meantime moved his impedimenta to the vicinity of the field hospital. The late afternoon shadows had fallen when the Confederate batteries opened fire. Shells began bursting all around the hospital.

The battle now raged on all points in front. The firing was furious. Dust and smoke covered the field. The long lines of muskets poured forth streams of fire, while the flashes of the artillery looked like lightning behind a cloud. Suddenly there would be a lull succeeded by an instantaneous tearing discharge of ten thousand muskets coupled with the roar of heavy cannon.

Near the hospital where Brady and Woodbury had their wagon was what remained of the wagon train. It was ordered to proceed to the rear. Brady got his wagon into line with the rest and the column set out through White Oak Swamp, leaving the road to avoid troop movements.

They pushed boldly through the tangled forest lighted by torches that made weird, dancing shadows. Soon rain began to fall, and before long it came down in torrents. The

MR. LINCOLN'S CAMERA MAN: MATHEW B. BRADY

darkness by now had become almost impenetrable so that it was barely possible to see the file leaders, though lightning illuminated the pine forest every few moments.

At last there was a halt, and it was whispered down the line that the column was lost. A few moments later the march was resumed. Before long was heard the muffled sound of wheels rolling over muddy ground. Was it the enemy? None could answer. The column turned in the direction of the road and in doing so was discovered by a soldier who gave an alarm. In a few moments Brady and his companion could hear the sounds of unlimbering cannon. Running feet told of infantry getting into position to fire. Fortunately a voice was heard and recognized by one of the officers of Brady's column just in time. Explanation followed; the column returned to the road and at midnight reached White Oak Creek.

Finding an abandoned barn the photographers parked their darkroom wagon and succumbed to exhaustion; but they were soon awakened and told by a cavalryman that they must leave immediately. By daybreak the enemy had caught up with them and opened with artillery. Brady and his companion hurried to the rear as Franklin's men again turned about and formed up in line-of-battle.

The fight raged all day with the Southerners held in check. Franklin kept his guns firing until midnight and then the retreat continued. The supply column along with Brady's wagon flanked by a cavalry patrol, marched through the dark woods in silence. Sometimes the column halted while brush was being cleared, so that the wagons could pass. All night the march continued with the men expecting to be cut off at every turn in the road. Panic struck the column with the first of Jackson's shells. The wagon train, of which Brady's wagon was a part, had been stalled by the clogged condition of the roads. The teamsters, for the most part 'contraban' darkies, were just beginning to hitch up when a hail of hissing metal burst all about them. The frightened darkies ran for the woods, leaving the unharnessed, terrified horses to mill about in the road. A cavalry officer, seeing the darkies break for cover, drew his pistol and galloped to a point between them and the woods. He herded them back to the wagons and forced them to their work despite the bursting shells. The slow march was resumed. The white covers of the wagons made perfect targets for the Confederate gunners,—bent upon destroying the whole train. A shell struck the third wagon in front of Brady's.

At the explosion Brady's terrified horses reared and plunged almost overturning the wagon. The glassware rattling inside warned of the ruin of weeks of painstaking work. But when Brady investigated he found that only a few unused plates had broken and some chemicals had spilled.

Malvern Hill is a small plateau rising slightly above the forests surrounding it. Being an ideal spot for defense, Porter utilized it to the best advantage. It was here that the Federal Army determined to make a stand against the relentless pursuit of Lee's Army of Northern Virginia. The powerful artillery of Porter was put in position on the crest of the hill, hub to hub, covering the sloping fields.

The whole battle area was flanked by Union gunboats on the river. At the base of the hill was marshy ground, thickly wooded, making it difficult for the Confederates

110

to move their troops and practically impossible to bring up artillery. All in all the Union army had a stronghold that defied assault. The Southerners had to advance over a terrain cleared of trees, and, enfiladed by Federal artillery.

At about three o'clock in the afternoon D. H. Hill's brigades suddenly broke through the surrounding forests in an irregular line and charged against the Federal front. The Federals opened fire at once with all they had. The Southerners went down by the hundreds. When those who got through the hail of metal came within range of musket fire regiment after regiment jumped up and poured withering blasts into the ranks. The brigades of Huger and Magruder arrived too late to be any real support. They were turned back by artillery fire. With their repulse the battle ended.

Brady's column had been halted in the rear of the fighting Union army. He and his companion could not extricate their wagon from the others, and while they waited for the column to move, they listened to the din of the nearby battle. With nothing to eat but hardtack, they spent a sleepless night on the wagon seat, while the way lit by torches, the caissons and cannon rumbled to the rear.

Next day near Turkey Creek, a squadron of cavalry caught up with them and ordered them off the road to make way for artillery and ambulances. Finally the last ambulance rolled by, the photographers continued on with the masses of infantry and reached Harrison's Landing on July third.

For Brady the Seven Days had been a harrowing experience. The night marches and constant fighting of an army pursued by a relentless foe all added to the difficulties of picture-taking. But he was able to obtain scenes of the fortifications at Yorktown, Fair Oaks, Grapevine Bridge, Savage's Station, and of Lowe's attempts at aerial observation at Mechanicsville. During the weeks that followed at Harrison's Landing Brady and Woodbury busied themselves photographing activities at the base.

The monotony of camp life was relieved by many varieties of amusement. During inactive periods and on holidays the soldiers indulged in foot races, baseball games, cricket, and sometimes on special occasions, horse racing. These activities were occasionally photographed by Brady when the participants could be induced to 'hold the pose' long enough to make an impression on the 'slow plate'.

After completing the portfolio of the Peninsula and the Seven Days, Brady returned to Washington. On his arrival the plates were printed on albumen paper and given a platinum-sepia tint—a bromide developing bath that seemed to bring out definition. They were then mounted on cards with printed titles for use with the Stereoscopic Viewer. All his galleries placed them on sale at seventy-five cents, and a dollar. The leading bookstores also carried them and advertised them extensively.

Here is a typical newspaper comment:

"Mr. Brady has done something to bring home to us the terrible reality and earnestness of war. If he has not brought bodies and laid them in our dooryards and along the streets, he has done something very much like it ... Crowds of people are constantly going

up the stairs; follow them, and you will find them bending over photographic views ot the fearful battle field taken immediately after the action".

For the less grim of his pictures Brady enjoyed a tremendous patronage, particularly those of soldier groups, "as some would be recognized by relatives and the pictures immediately bought". It is certain, however, regardless of the type of photograph Brady presented, they did not come under Ambrose Bierce's definition of, "Something painted by the sun without instruction in art. It is a little better than the work of an Apache, but not quite so good as that of a Cheyenne".

63. *Below:* Lt. Colonel Albert V. Colburn, Aide-de-Camp of McClellan, and despatch-bearer during the Seven Days Battles

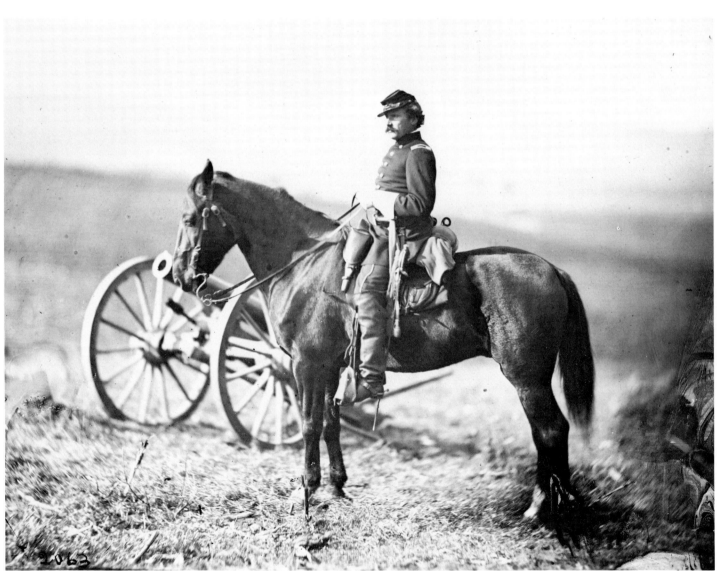

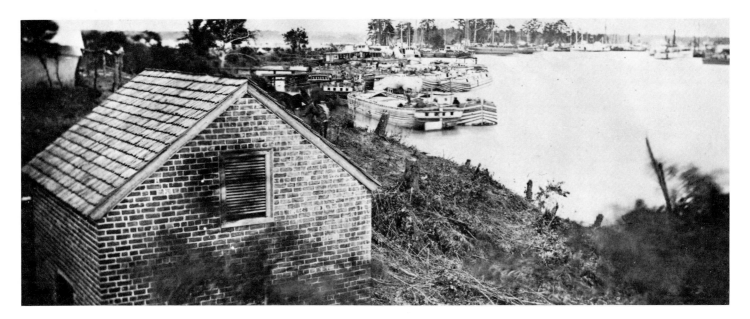

64. *Above:* WHITE HOUSE LANDING ON THE PAMUNKEY. Supply base of the Union Forces photographed by Brady during the Battles of the Seven Days. *Below:* A closer view showing the Army barges loaded with supplies. Photographed by Brady at about the same time as the one above

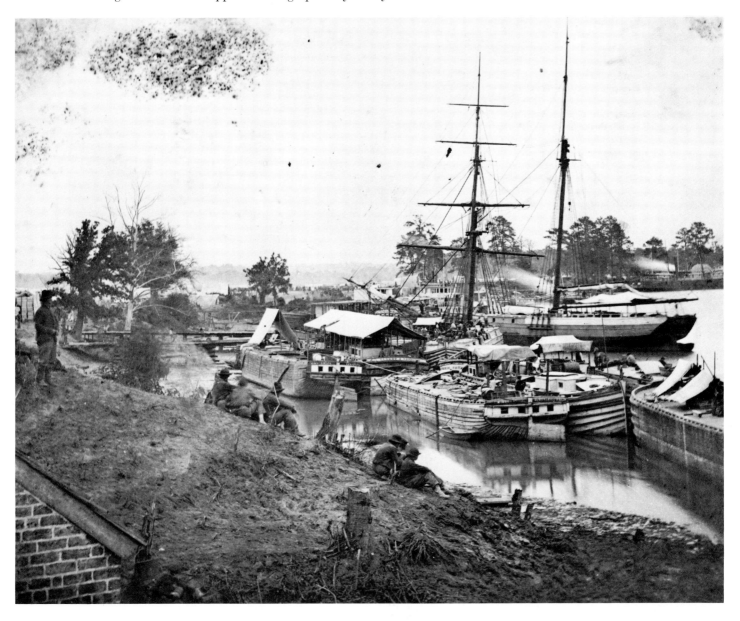

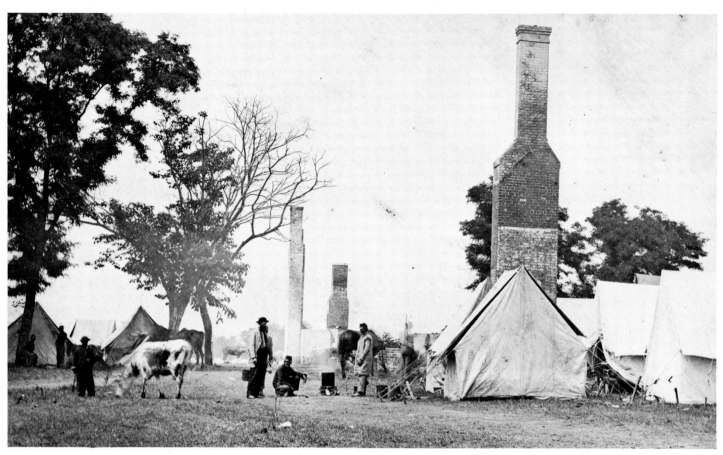

65. *Above:* RUINS OF WHITE HOUSE PHOTOGRAPHED BY BRADY DURING THE BATTLES OF THE SEVEN DAYS. The man with the felt hat is believed to be either Gibson or Woodbury. *Below:* WHITE OAK SWAMP IN McCLELLAN'S LINE OF RETREAT during the last days of June 1862. Photographed by Brady

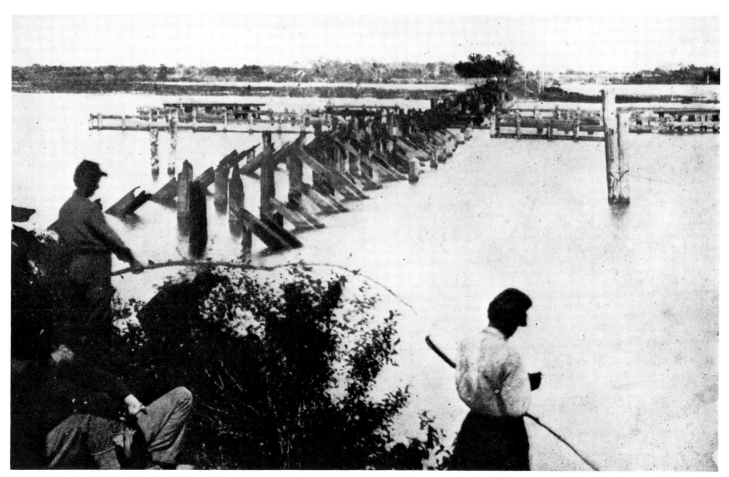

66. *Above:* RUINS OF THE BRIDGE ACROSS THE PAMUNKEY. Union soldiers fishing from the bank. *Below:* MILITARY BRIDGE ACROSS THE CHICAHOMINY. Photographed by Brady during the retreat of the Union Army

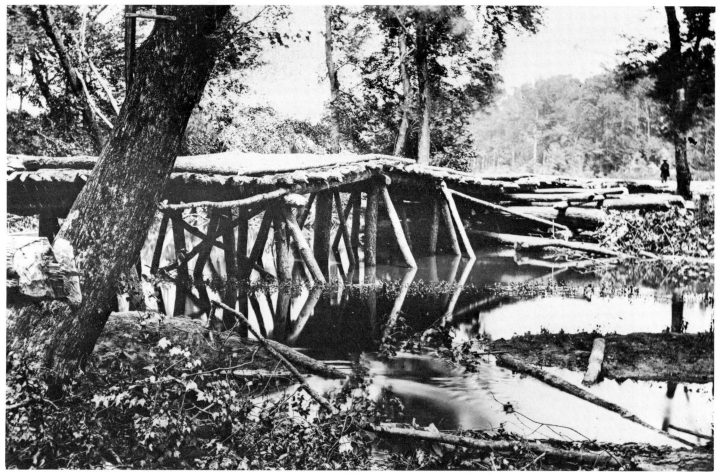

Note to 1974 reprint edition: The Library of Congress now identifies these photos as (above) Battlefield of Resace, Georgia; (below) Blackburn's Ford.

67. *Above:* MALVERN HILL. Scene of the last stand of the Union Army and last of the Seven Days Battles. Photographed by Brady shortly after the battle of Malvern Hill. *Below:* WRECK OF THE RAILROAD AT WHITE OAK SWAMP. This bridge, destroyed by McClellan's Army in its retreat to Malvern Hill, was photographed by Brady shortly afterward

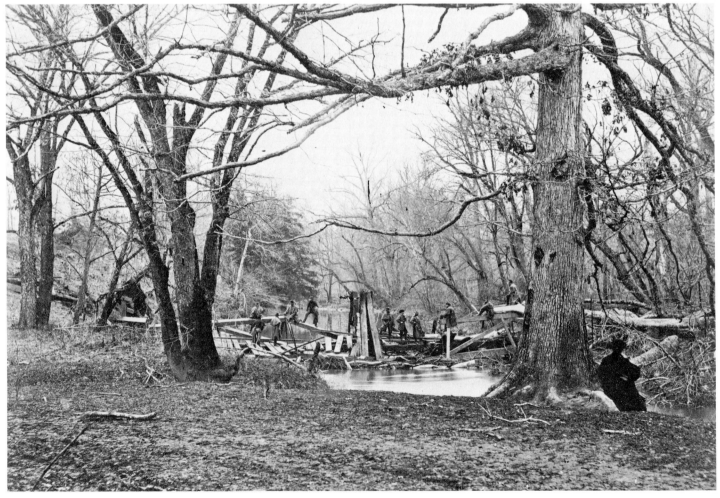

CHAPTER

TWELVE

B Y AUGUST SIXTEENTH of eighteen sixty-two, Brady had thirty-five bases of operation in the war theatres. In the East, West, and in the South his personally trained operators were at work photographing the military operations. "I had men in all parts of the army," he said, "like a great newspaper". This was no exaggeration; and it presented a staggering problem of management. These bases, usually built of logs, with a log roof covered with canvas, had to be supplied with plates, chemicals, camera equipment, feed for the horses that drew the traveling darkrooms about, and many other supplies for work in the field. The units were placed at strategic locations near the armies in the field and presented to Brady a problem in logistics.

Financing these photographic supply depots was also a staggering problem, and the burden had to be carried by his studios in New York and in Washington. It must be remembered that Brady expected the sale of 'War Views' to pay for these investments. Although tremendously popular and a novelty of the moment, 'War Views', up to this period was a speculation.

Brady, on his own account, has assumed the role of photographic historian. This was his primary object from the start of the enterprise. Hampered by the restrictions of government officials, who would belatedly recognize the importance of his achievements, he was forced into commercialism for photographing the war. On the face of it, the necessity for big sales of his 'War Views' is manifest.

It was these sales alone that would open the way toward the goal he had set for himself. While photographic coverage would go far beyond what he could possibly have encompassed, and while he was responsible for only a part of the vast number of pictures taken of the war, it can be said that he alone fathered the idea. This fact gave Brady the singular advantage his competitors could not overcome. It was necessary that they print in large quantities to enable their sales at least to equal the cost of production.

The studios, financially successful almost from the start, enabled Brady to enjoy the fruits of his labors and to finance new ideas and innovations. At the beginning of the war, when he first got the idea of photographing the conflict, it was reasonable for him to assume that the sale of pictures would more than compensate for the cost of production.

With all this, and even without serious competition in the field, if the sale of 'War Views' fell short of expectations, the result would be disastrous.

But soon competition began to appear. It was even encouraged. "Mr. Brady intends to take other photographic scenes of our armies," stated *Humphrey's Journal*, "and of battle scenes, and his collection will undoubtedly prove to be the most interesting yet exhibited. But why should he monopolize this department? We have plenty of other artists as good as he is. What a field there would be for Anthony's Instantaneous Views and for Stereoscopic Pictures! Let other artists exhibit a little of Mr. Brady's enterprise and furnish the public with more 'Views'. There are numerous photographers close by the stirring scenes which are being enacted, and now is the time for them to distinguish themselves." This last statement was in error, for the men in the field covering the war at this period were Brady's own. During the war Brady had twenty operators in his employ and all under his personal direction. Anthony & Company, suppliers of photographic chemicals and equipment to Brady, were, however, supplying him with some competition. Stereoscopic Pictures (with an illusion of third dimension) were the most popular. For a time they almost equaled the popularity of amateur motion pictures today.

The Anthonys had an able operator in the field, Thomas G. Roche, working on his own making photographs for his company's popular 'Instantaneous Views'. Apparently, Roche was just as active in the war theatres as Brady and his leading photographer, T. H. O'Sullivan; and there were others, but only meager records were kept of their activities.

In the Southwest there was a partnership between George Armstead and Albert White who followed the Western armies. George Armstead was an excellent photographer, 'almost rivaling Brady at his best'. In Corinth, Mississippi, the partners had a shack decorated with a signboard that read "Armstead and White—Photographers". During the occupancy of the Union and Confederate armies they did a land-office business in pictures of soldiers, but little else is known of them.

According to *Humphrey's Journal* the 'Views' were popular; the public could not get enough of them. They stimulated other photographers to take chances and go into battle to get more pictures to satisfy public demand.

More important was the point of view of the military authorities as to the use of photography in the army. Brady clearly demonstrated its value at Bull Run;—now they saw the importance of photographic records of the achievements of the army engineers. Some of the greatest feats of military bridge building were accomplished during the Civil War. The Army Engineers performed miracles of building and repairing of bridges which had been partially or wholly destroyed by both armies in advance and retreat. Photography was becoming an important factor in military operations.

After Brady had shown the way, others received army appointments, men with far less ability and experience. He could have turned his whole staff over to the government and completed a systematic job of covering the war for the official record.

Brady pioneered. The development of military photography was not given serious thought until almost a year after Bull Run. It was in fact, frowned upon as unpracticable until Brady brought back results from the battlefield.

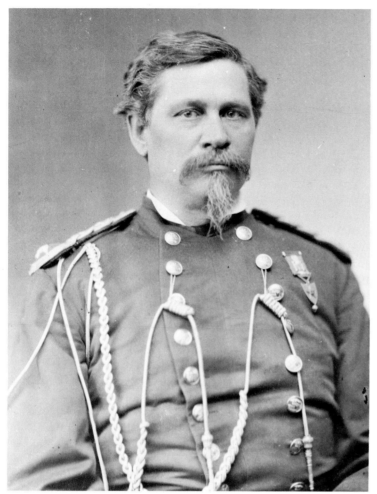

68. CAPTAIN ORLANDO METCALF POE
Engineer Officer, Army of the Potomac on Grant's
Staff. Photographed by Brady in the Washington
Gallery

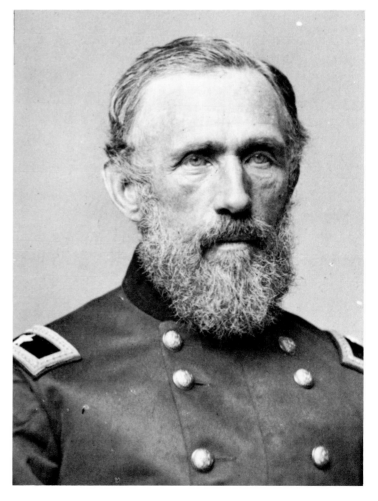

69. GENERAL GEORGE GROSS BARNARD
Chief Engineer of the Army of the Potomac and in
charge of the Washington defenses. Photographed
by Brady in the Washington Gallery

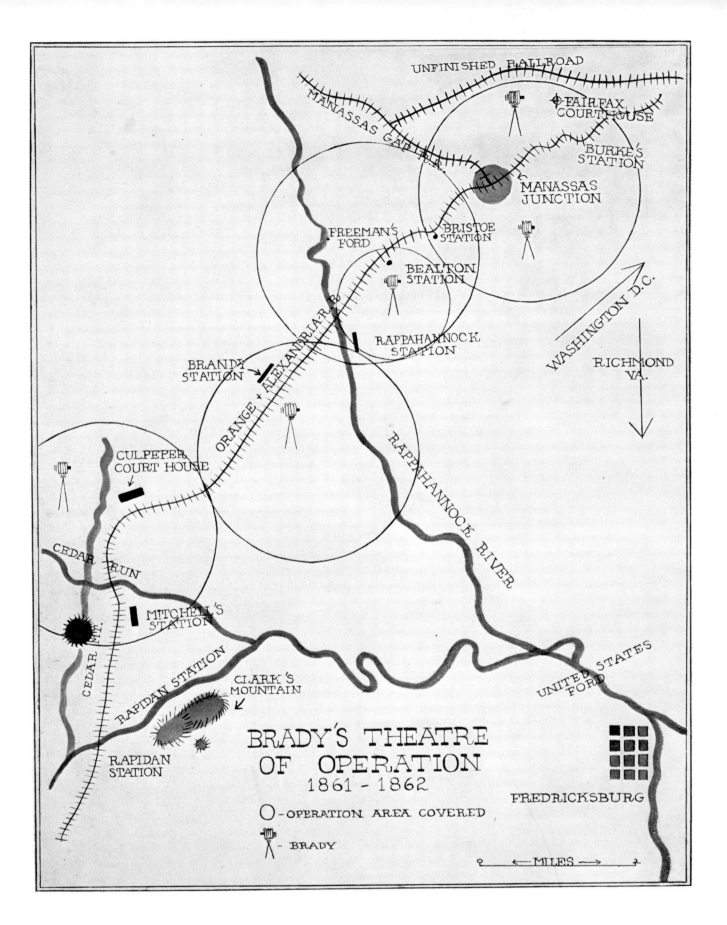

UNFINISHED RAILROAD

MANASSAS GAP R.R.

FAIRFAX
COURTHOUSE

BURKE'S
STATION

MANASSAS
JUNCTION

FREEMAN'S
FORD

BRISTOE
STATION

BEALTON
STATION

WASHINGTON D.C.

RICHMOND
VA.

RAPPAHANNOCK
STATION

BRANDY
STATION

ORANGE + ALEXANDRIA R.R.

RAPPAHANNOCK RIVER

CULPEPER
COURT HOUSE

CEDAR RUN

MITCHELL'S
STATION

CEDAR MT.

RAPIDAN STATION

CLARK'S
MOUNTAIN

UNITED STATES
FORD

RAPIDAN
STATION

BRADY'S THEATRE
OF OPERATION
1861 - 1862

FREDRICKSBURG

○ — OPERATION AREA COVERED

— BRADY

←— MILES —→

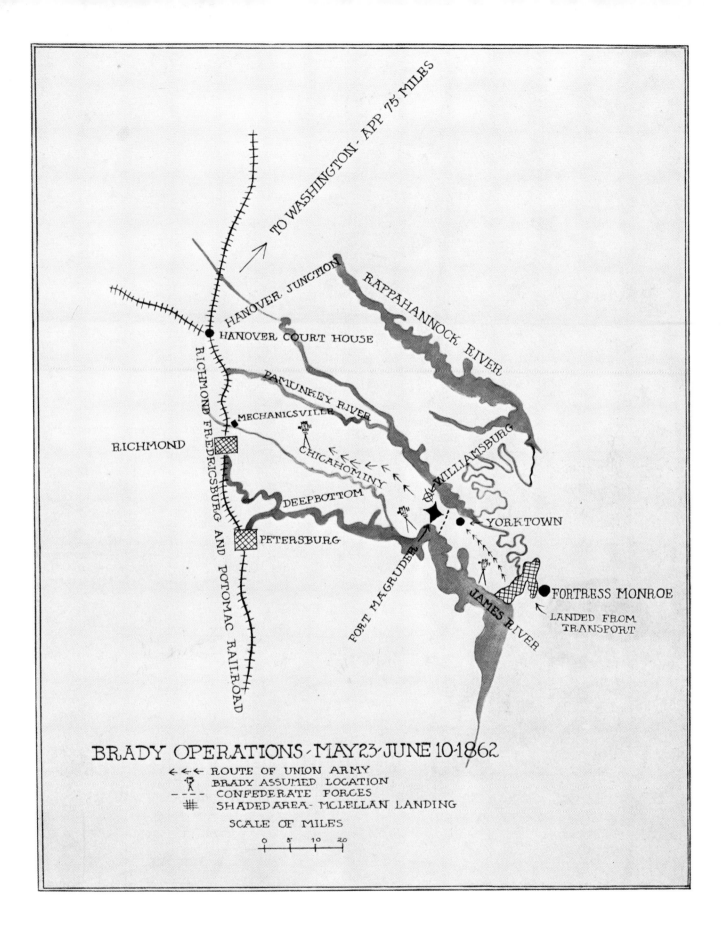

TO WASHINGTON · APP 75 MILES

HANOVER JUNCTION

RAPPAHANNOCK RIVER

HANOVER COURT HOUSE

PAMUNKEY RIVER

RICHMOND FREDRICSBURG AND POTOMAC RAILROAD

MECHANICSVILLE

RICHMOND

CHICAHOMINY

WILLIAMSBURG

DEEPBOTTOM

YORKTOWN

PETERSBURG

FORT MAGRUDER

FORTRESS MONROE

JAMES RIVER

LANDED FROM TRANSPORT

BRADY OPERATIONS · MAY 23 JUNE 10 1862

←←← ROUTE OF UNION ARMY
BRADY ASSUMED LOCATION
- - - - CONFEDERATE FORCES
SHADED AREA - MCLELLAN LANDING

SCALE OF MILES

0 5 10 20

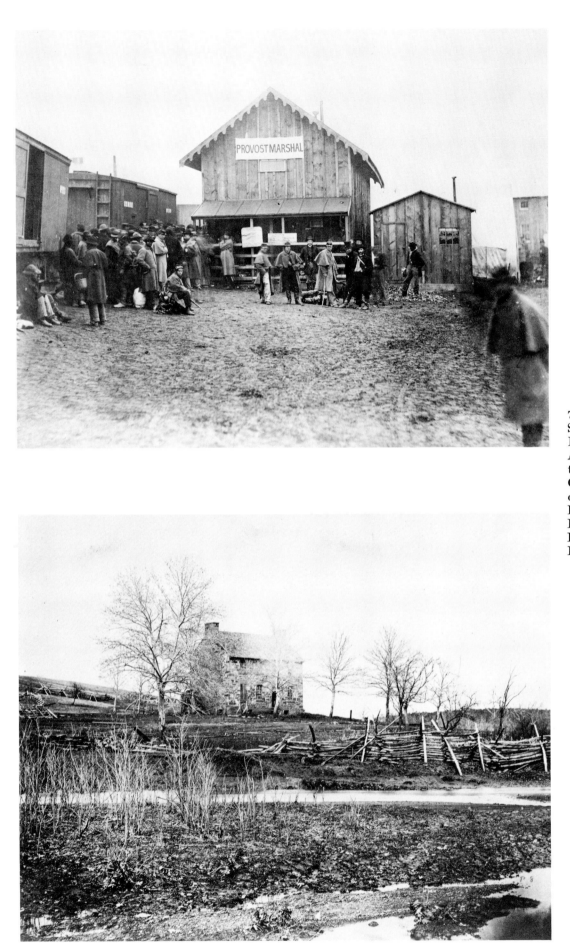

70. PROVOST MAR-
SHAL OR MILITARY
POLICE OFFICE AT
AQUIA CREEK: Pho-
tographed by T. J.
O'Sullivan in February
of 1863. *Below:* MAT-
HEW'S HOUSE ON
FIELD OF BULL
RUN. Photographed by
Barnard and Gibson in
March of 1862

CHAPTER

THIRTEEN

IT WAS SEPTEMBER and the trees were already donning their Autumnal raiment when Lee started on his march of Northern conquest. After the disaster of the battles of the Seven Days, Lincoln had removed McClellan from command, replacing him with John Pope. Lee and Jackson outguessed, outmarched, and outfought the hapless Pope at the battles of Cedar Mountain and the Second Bull Run.

Brady had one of his bases at Bealton, Virginia, along the Orange and Alexandria railroad, which originated in Lynchburg and terminated in Alexandria. It was a comparatively easy matter for his men to reach any point along this line almost as far as Brandy Station, outside the Confederate lines, when transportation was available.

T. J. O'Sullivan, Barnard and Gibson, it appears, were joined by Brady at Bealton, and between them the smoking battlefields of Cedar Mountain and the Second Bull Run were photographed. After Stonewall Jackson had destroyed all of Pope's supply depots and railroad facilities at Manassas Junction there was plenty of wreckage to be photographed, and this operation took several days. Nothing had been overlooked by either Jackson or the war photographers;—the pictures of Jackson's systematic military destruction gave loud testimony to Pope's utter defeat.

Desperate from the incompetence of his officers, and having no one better, Lincoln again returned McClellan to command, and the war went on from there.

When Lee began his march into Maryland, McClellan had no idea of his whereabouts, so well screened were his movements. Jackson and his columns had successfully captured Harper's Ferry with its booty, but at this point fate took a hand.

A copy of Lee's General Orders Number 191 wrapped around three cigars was found by a Union soldier. This order showed the disposition of his troops. More important, however, the order disclosed that they were on the march and separated. The soldier thinking it would be of interest to the commanding General took it to McClellan forthwith.

Then everything changed. For unlike his usual self McClellan took immediate action, and Lee found himself pursued by the whole Federal Army. With his divisions scattered, Lee hurriedly retired his army to the banks of the Antietam near the village of Sharpsburg with the Potomac River at his rear. There he determined to make a stand.

The distance from Washington to Sharpsburg, Maryland, is roughly forty-five miles by the shortest route, and the photographers rode together over the Hagerstown Pike through the little towns of Rockville, Darnestown, and Urbanna, crossing the Monocacy River, heading in the general direction of Hagerstown.

Their darkroom wagons swayed as they rolled through the Maryland countryside over the dusty road. Brady and the men occasionally stopped for rest and a refreshing drink from a roadside spring, and to rest and water the horses.

Just before dark on September sixteenth they reached Frederick, Maryland, where they spent the night. Weary as they must have been from the long ride from Washington, they rose before dawn the next morning, harnessed up and continued on their way.

The cannon were already thundering when they approached Hagerstown on the morning of September seventeenth. The Confederates had just evacuated the town and the people, aroused early by the cannonade, were standing in the streets in small groups listening to the sound of the guns rolling down the valley from the battle seven miles away.

As Brady, Gardner, and O'Sullivan drove up the road in an effort to reach McClellan's headquarters, they encountered the stragglers and drifters from the Union Army. Ammunition trains, coming up the hill and going to Keedysville, forced them to strike across the fields, hurrying their weary horses as much as they could without danger to their equipment.

Soon they came upon a farm selected for a field hospital. The grounds about the farmhouse were covered with the wounded, and hospital corpsmen were throwing straw on the ground for them to lie upon. Passing this they ascended a hill and came upon the men who had been the first to meet the Confederate Army at dawn that morning. As they drove past a line of batteries along a ridge Brady and the others were hailed by a Union soldier crouching under a fence. "Hold on", he said, "where do you think you're going?" "To McClellan's headquarters," answered Brady. "That's over yonder", he shouted pointing toward the rear, "This is the picket line, and if you know what's good for yourself, you'll skedaddle mighty quick!"

Brady and the others were quick to act on this advice, and a moment later shells burst all around them. Getting away from the vicinity of the batteries that were drawing fire as quickly as they could, they rode down the line at a respectful distance, forded the Antietam, and ascended the hill East of the river to McClellan's headquarters at the Pry Mansion. McClellan had selected a commanding position. The panorama seen from this location covered three-quarters of the whole battlefield, from the Dunker Church, southwest to the hills below Sharpsburg.

When the photographers arrived McClellan was sitting in an armchair in front of the Pry House. His staff officers were standing about talking and occasionally peering through large telescopes that had been strapped to stakes driven into the ground.

Brady, Gardner and O'Sullivan were no strangers to McClellan or the other officers. The traveling darkrooms were now familiar and they roused only passing notice as they got down from the wagons.

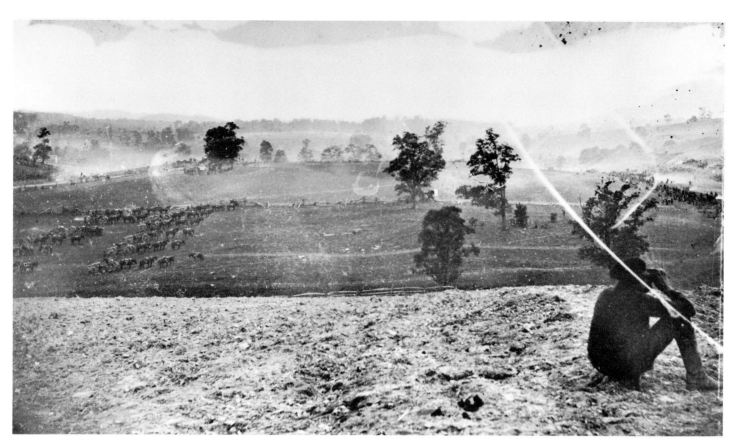

71. *Above:* BATTLE SMOKE. This photograph of the battle of Sharpsburg is believed to be the only actual battle picture of the whole war. Photographed by Brady in September. *Below:* WHAT THE TIDE OF BATTLE LEFT. The dead of D. H. Hill's men in the Sunken Road at Sharpsburg. Photographed by Brady immediately after the battle, probably in the late afternoon

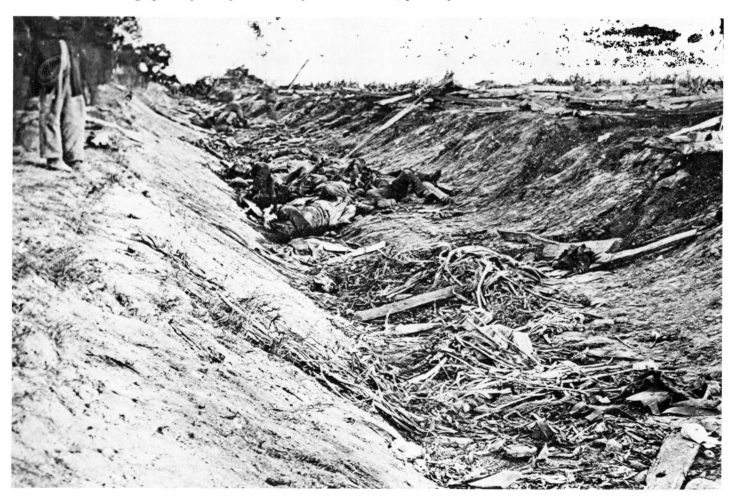

The village of Sharpsburg lies in a little peninsula flanked by the Antietam and Potomac rivers;—the Hagerstown Pike runs North out of Sharpsburg along the top of a ridge. The countryside has a number of little sloping valleys that drop eastward to the banks of the Antietam;—ridges of limestone covered by thickets three feet in height run parallel with the Pike. These afforded protection from rifle fire.

As the photographs show, there is a large patch of scrub oak slightly in the rear of the Dunker Church and this wooded section also gave natural protection.

The whole countryside is divided by little lanes and ravines, and the open fields in front of the town are outlined with walls of fieldstone. Little valleys caused the battle to be fought in three separate engagements,—for the men in one valley were unaware of what those in the others were doing.

Hooker opened his attack against Jackson before the light of the morning star flickered out. The desultory firing of the pickets worked into a rolling roar of battle. Jackson's right brigade under Lawton was covering the East Wood and the Nicodemus Farm. The right brigade had only fence rails for protection. Between the Red Hill and the Antietam was the army of McClellan in battle array.

Under the protection of the woods the Federals advanced in force with the divisions of Meade and Doubleday. Rickett's division was in support, and the attack was made with dash; but the Confederates put up a desperate and stubborn resistance.

So heavy was the firing that the corn was cut down clean as by a giant scythe. McClellan's numerous batteries plastered the southern lines with everything they had, but by eight o'clock that morning Hooker had been repulsed. It was this engagement that Brady and his men had heard while on the road.

As they watched from McClellan's headquarters the desperate character of the battle was evident. While Lawton retired after repulsing Hooker, Hood's Texas brigades made a dashing attack across the cornfield against Meade and Rickett, forcing them back on their artillery and shooting down the gunners.

Gordon, of Mansfield's Corps, struck the Texas brigades in front, while Greene attacked D. H. Hill firing at duelling distance, and Hood's men were forced back on the Dunker Church. Hill's brigades were also forced back on the town, and here the battle ended in this sector after three hours duration.

As the photographers watched French's and Richardson's divisions of Sumner's Second Army Corps deploying East of Roulette's and Mumma's farms, the clouds that had hung low all morning, lifted, and the rays of the sun broke through to bring life and color to the scene, and draw murmurs of admiration from those who saw it.

On a hill behind McClellan's headquarters Brady and O'Sullivan set up their camera and pointed it where Sumner's Corps was in line of battle. This was in clear view of an artillery reserve park immediately below. The lens of the camera commanded a sweeping view of that end of the line. Probably for effect, one of Brady's men or one of the sketch artists on the field, was sitting on a rock in front of the camera when Brady exposed the plate, to take the only picture of an active engagement taken during the whole war.

At the moment Brady took the cap from the lens the firing was terrific. As he operated the big Anthony camera, his head under the focusing cloth, a shell exploded nearby, throwing dirt and stones over everything. He calmly picked up the broken plates and continued his work.

While the photographers watched, Sumner's Corps advanced east of Roulette's. Suddenly isolated puffs of white smoke appeared and then came the crash of artillery. Again the cornfield was a stage for a terrific struggle, but the enfilading fire of numerous batteries was too much for the Southerners and they sullenly withdrew.

French advanced on Greene's left, over the open farm lands, and after a fierce combat about the Roulette and Clipp Farms drove D. H. Hill's divisions from them. Richardson's division, came up on French's left soon after, and foot by foot, field by field, from fence to fence, the Southerners were pressed back till, after three hours of fighting, the Sunken Road, since known as the "Bloody Lane", was in Federal hands.

At this road, fortified by fence rails, five of D. H. Hill's brigades had repulsed three Federal attacks.

It was now a little past mid-morning. Brady and one of his men drove past the smoking ruins of Roulette's barns to the Sunken Road. As they drove across the fields they could see that the sloping hillside was dotted with men contorted in violent death.

The Road itself was filled with the bodies of D. H. Hill's men. Scattered all about were broken muskets, cartridge boxes, broken fence rails, rags, belt buckles, jackets, and shoes. As many as fifteen bodies would be lying together in a fence corner and among the corn rows on the hillside.

Brady took the camera from the wagon. Soon he had it mounted and studied the scene before him. The mid-morning sun was bright overhead and flocks of crows and buzzards were soaring in black silhouette against the blue sky. Swarms of little green flies buzzed and hummed around him.

Brady took the cap from the lens and the camera again did its work, seizing the gruesome scene to fix it in collodion. While Brady worked on this end of the line, far to the left the batteries were still pounding away.

Later, when the site near the Dunker Church was accessible, Brady brought his camera, and with the shell pocked Dunker Church for a background he aimed at a windrow of dead artillerists lying in front of an empty caisson with its shaft lying across the body of a dead horse. Before he raised the lenscap for the exposure, he placed a pair of shoes in the foreground. Why he did this is unknown, but other pictures also have these little "signatures", such as the skull of some unfortunate soldier tossed in the foreground, as in a picture made at Gaines Mill.

About the time Brady and the other photographers were working, Burnside made his attack at the Stone Bridge on the extreme Union left. This attack was delivered at one o'clock in the afternoon in force, and was an attempt to cross the bridge and turn Lee's right flank. Burnside's men crossed the bridge and three Union divisions were forcing Longstreet's right flank back through the town in confusion. It almost seemed as though

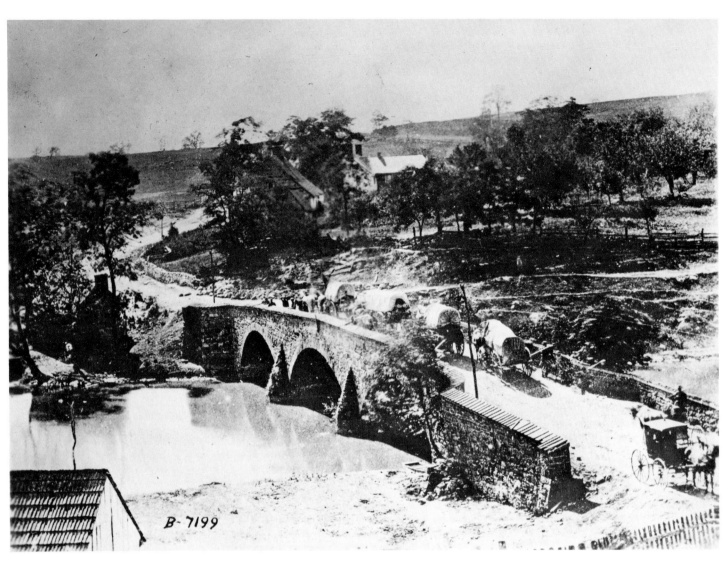

B-7199

72.　　　　　　　BURNSIDE'S BRIDGE OVER THE ANTIETAM
Scene of the action in which Burnside tried to affect a crossing of the river. This beautiful photograph
was made by Brady several days after the battle

victory was in the offing, when A. P. Hill, after a forced march of seventeen miles from Harper's Ferry attacked Burnside without waiting for orders.

Burnside's men were swept down the slopes and back to the bridge. Here at sunset the battle ended.

The sun went down; the thunder of the guns died away, and bivouac fires gleamed out as if a great city had lighted its lamps.

When the soldiers are seeking rest, the work of the war photographer begins. As darkness fell the photographers drove to their camp near McClellan's headquarters. Under the light of lanterns they washed, dried and varnished the negatives and prepared their chemicals and equipment for the next day. Long afterwards they sought sleep.

MR. LINCOLN'S CAMERA MAN: MATHEW B. BRADY

Dawn found both armies in line of battle. But all that day there was a tacit truce and the burying parties passed freely between the lines.

The photographers worked all about the field that day. Working with Brady was F. H. Schell, an artist for *Harper's Weekly,* busily sketching scenes of the farmers watching the burial parties as they dug great slit trenches for the dead.

That night, under the cover of darkness, Lee's battered army recrossed the Potomac.

After the battle McClellan was inactive for two weeks. Lee and his army, unpursued, were safe across the Potomac. Lincoln had shown impatience at McClellan's lack of initiative, when he learned that he had allowed Lee to 'get away'.

On October second, Lincoln decided to pay his wavering General a visit. Accompanied by some government officials and staff officers, he quietly left Washington for the field.

Probably McClellan, being a friend of Brady's, told him of the expected visit of the President. McClellan and his officers rode to Harper's Ferry where they met Lincoln and his party. Directly afterwards they rode to camp headquarters at the Pry House.

The next day Lincoln went to McClellan's headquarters tent for a conference. Brady seeing an opportunity of photographing him and his field commander together, hurriedly arranged his equipment and made negatives. He placed the camera just outside the tent. In the picture taken, is a captured Confederate flag, carelessly thrown under the cot at the left of the tent, and on the camp table draped with an American flag, lies the President's top hat flanked by two half-burned candles.

Later the President posed for Brady with Brigadier-General John McClernand and Allan Pinkerton, Secret Service chief. The day before his return to Washington, Brady accompanied him on a short trip to Frederick, Maryland, where he was to review the veterans of the battle. Here Brady got another negative of the President as he watched the soldiers march by. After the review the troops were drawn up to hear the President's message. He thanked the soldiers for their devotion to the Cause. To the citizens of Frederick he said, "I also return thanks, not only to the soldiers, but to the good citizens of Frederick, and to the good men, women and children in this land of ours for their devotion to a glorious cause, and I say this with no malice in my heart toward those who have done otherwise."

After Lincoln had returned to Washington, Brady drove to Shepardstown which he photographed from a hill on the Maryland side of the Potomac. He also took pictures of the place where Lee had crossed into Virginia. He then returned to Washington with Gardner and O'Sullivan. The pictures of Antietam were at once printed in quantity and shipped to the New York Galleries for sale and exhibition. They caused wide comment. *The New York Times* reported; "The living that throng Broadway care little perhaps for the 'Dead of Antietam,' (Brady had so entitled it) but we fancy they would jostle less at their ease were a few dripping bodies fresh from the field, laid along the pavement. There would be a gathering up of skirt and a careful picking of the way; conversation would be less lively and the general air of pedestrians more subdued."

129

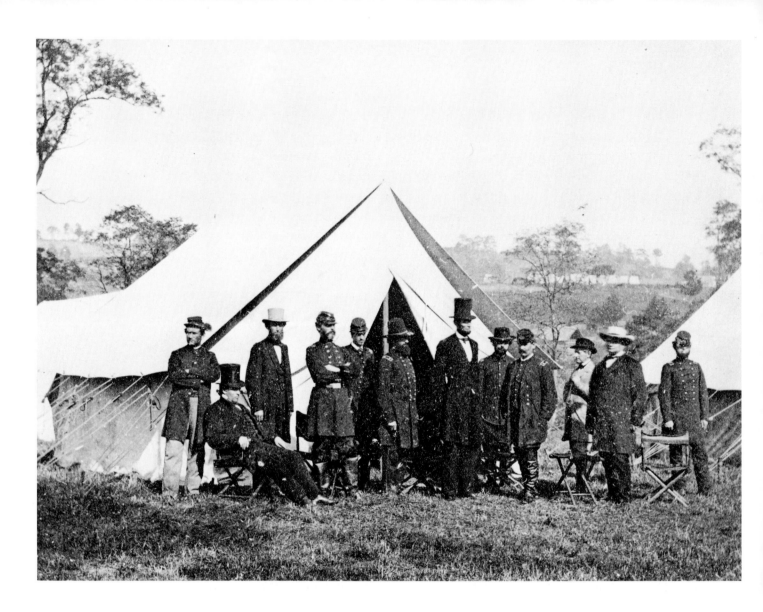

73. *Above:* A PRESIDENT VISITS HIS GENERAL. This photograph made by Brady in October 1862, previous to a review of the troops, two weeks after the battle of Sharpsburg. *Below:* Facsimile of the reverse side of the above photograph with Lincoln's inscription "Presented by the President to Capt. D. V. Derickson, October 27, 1862

BRADY'S ALBUM GALLERY.

No. 605.

Group of President Lincoln, Gen. McClellan, and Suite,

At Headquarters Army of Potomac, previous to reviewing the troops and the Battle-Field of Antietam, 3d Oct., 1862.

☞ The Photographs of this series were taken directly from nature, at considerable cost. Warning is therefore given that legal proceedings will be at once instituted against any party infringing the copyright.

Presented by the President to Capt. D. V. Derickson, Oct 27, 1862.

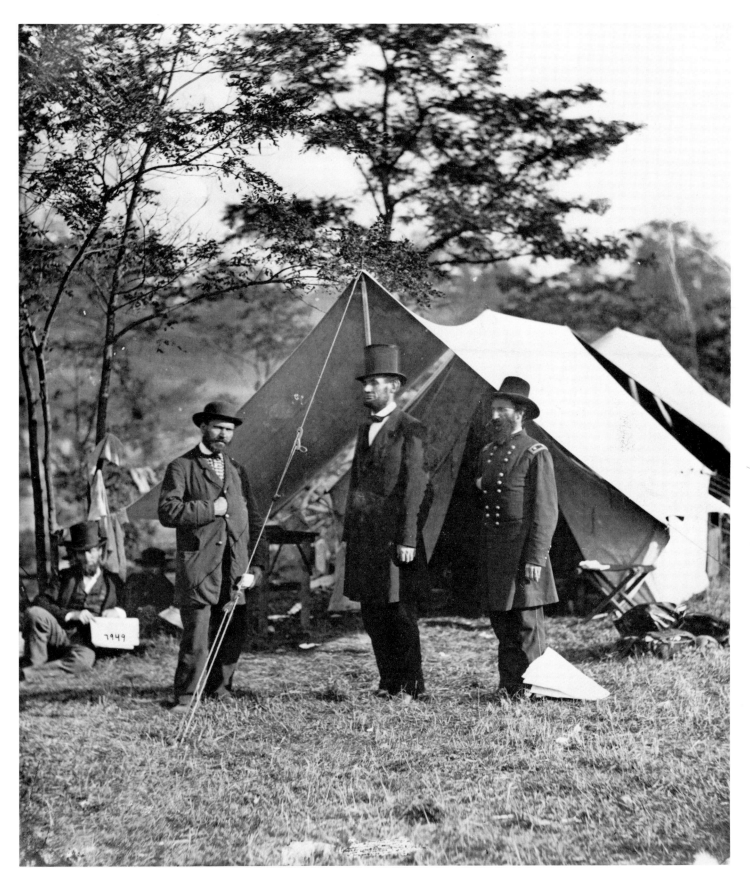

74. PRESIDENT LINCOLN AT SHARPSBURG
Photograph made by Brady in October of 1862. On Lincoln's right is Allan Pinkerton, Secret Service
Chief. On Lincoln's left is Major General John A. McClernand

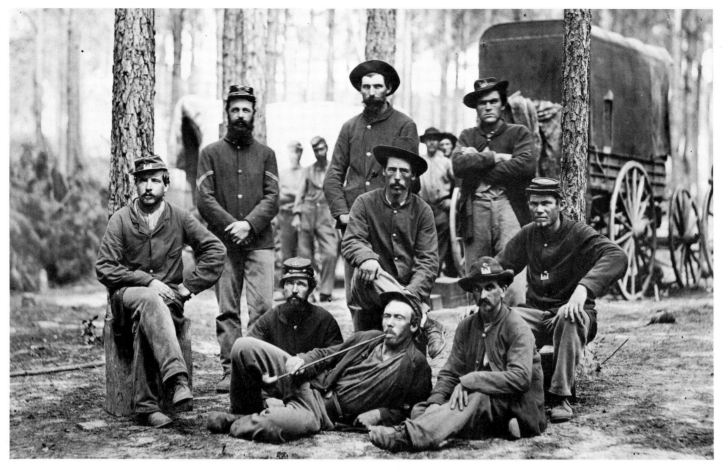

75. *Above:* SOLDIER GROUP SHOWING THE 'WHATIZZIT WAGON'. In the background of this group can be seen the 'Whatizzit Wagon', Brady's Darkroom Wagon. *Below:* ALLAN PINKERTON photographed by Brady at Antietam shortly after the battle. Pinkerton is the bearded man holding the cigar

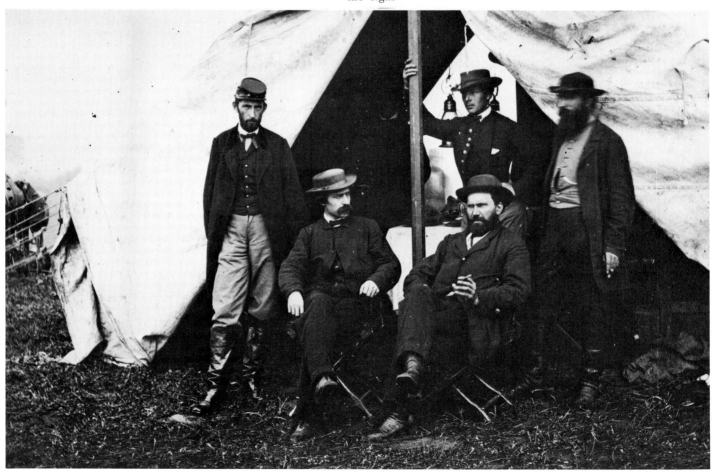

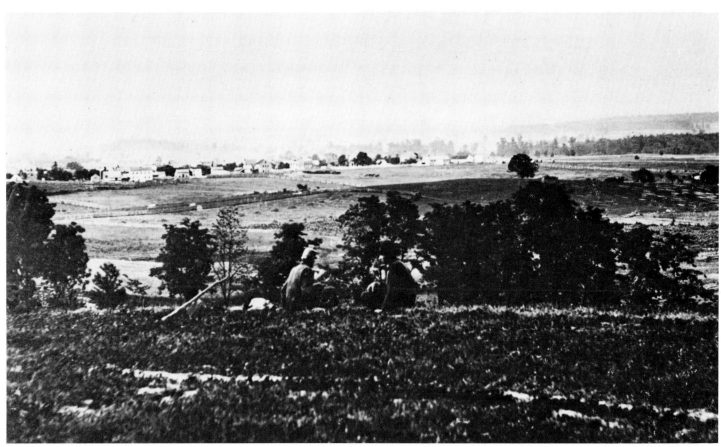

Note to 1974 reprint edition: The Library of Congress now identifies this as Chancellorsville.

76. *Above:* CULPEPER COURT HOUSE, VIRGINIA. One of Brady's bases of operation was in this town during the valley campaigns. *Below:* A Company of Union soldiers drilling on Maryland Heights. Photographed by Brady during the Sharpsburg campaign

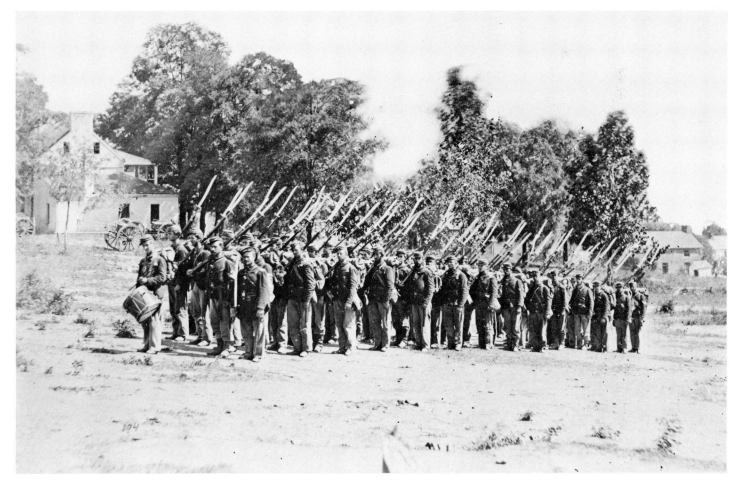

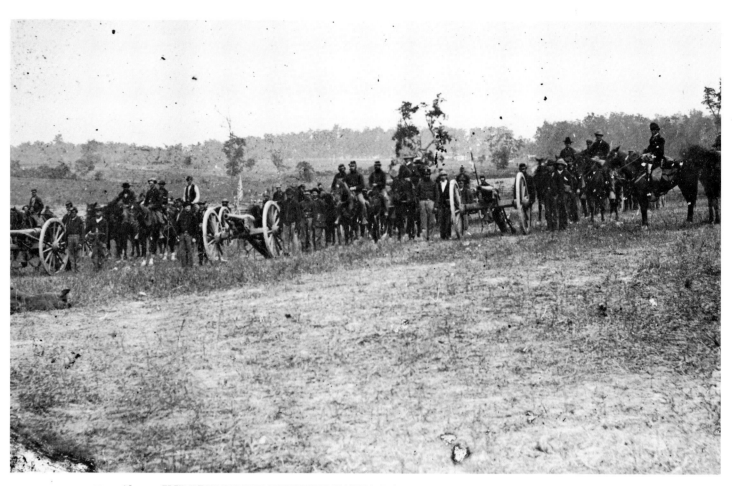

77. *Above:* INDEPENDENT PENNSYLVANIA BATTERY "E." Knapp's Battery of the Army of the Potomac photographed by Brady immediately after the battle of Sharpsburg. *Below:* SMITH'S FARM AT ANTIETAM. Used as a hospital by the Union Army. Brady passed it on his way to the battlefield. Photographed by Brady during the battle.

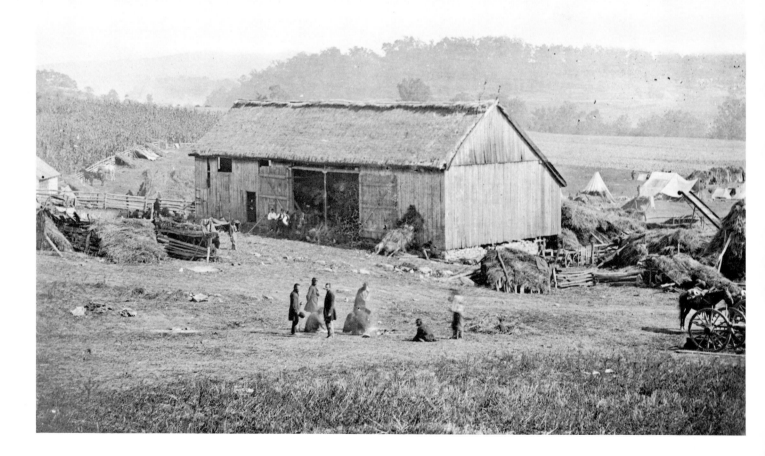

CHAPTER

FOURTEEN

O N THE NIGHT of October ninth General J. E. B. Stuart was at Darkesville with his troopers. By dawn of the following morning he crossed the Potomac at McCoy's Ford, scattered the pickets and wrecked the Union signal station at Fairview where Brady had one of his bases. Although the records do not mention the details, it may be assumed that none of Brady's equipment escaped destruction. Following this raid, on October tenth, at seven in the evening, Stuart reached the Union supply depot at Chambersburg, destroying loaded cars, machine shops, clothing and ammunition. Finally, after parolling some wounded prisoners, he left. Boldly riding around the Federal rear, he recrossed the Potomac at Whyte's Ford two days later. This latest exploit of Stuart's resulted in McClellan's final removal. The command was given to General Ambrose Everett Burnside.

Upon assuming the command, which he did not want, he changed McClellan's whole plan of campaign; and in order to keep his communications clear of Jackson's raids, his army was marched along the Rappahannock River to Falmouth, opposite Fredericksburg, establishing a new supply base line to Aquia Creek Landing on the Potomac.

Burnside's campaign preparations went on through the month of November, and during this period Brady remained in Washington. A winter in Washington during the sixties was anything but pleasant. The fabulous mud of the Capital's streets had reached a new high; the newspaper reports of McClellan's removal made a leading topic. Bickering, hate, and dissension and severe criticism of the army were being voiced on all sides.

The Capital had become one vast hospital. The transports arriving at every hour brought to the city their loads of wounded men. The wharves on the Potomac were lined with the dying and the dead. Through the muddy streets rolled the ceaseless procession of ambulances, and pedestrians were startled by the shrieks of the sufferers they carried. Churches, halls, houses, and schools were turned into hospitals, and every train entering the city brought fresh troops to take the place of those who had returned.

During these weeks business matters concerning the New York galleries occupied Brady's time for the most part. Some sittings were conducted, but most of the time was spent in preparation for his return to the field.

It was on or about the second of December that Brady and T. H. O'Sullivan left for Aquia Creek Landing on one of the heavily loaded army transports from Washington. Except for occasional snow flurries and light rains the trip down the Potomac was uneventful. Docking at Aquia Landing six hours later, the photographers supervised the unloading of their equipment from the transport. Shortly afterwards the equipment was placed on a flat car of the U. S. Military Railroad, for the last fifteen mile lap of the trip to Falmouth.

Upon reaching Falmouth Brady and his companion went into winter quarters with the army, probably taking one of the small log huts the soldiers had built after the fashion of warfare at that time. That winter of '62 and '63 was severe, and there was much suffering among the soldiers of both armies. Snow covered the ground, and it was cold indoors as well as out. It was during these next few months that Brady and his men undertook photographic operations under almost impossible conditions, and the camera and the "wet plate" had to undergo winter trials.

One fact discovered was that the collodion coated plates deteriorated less rapidly at lower temperatures than during those of summer, and allowed "almost as much as an hour's time on either side of the exposure" instead of the usual five minute interval between coating, exposing, and developing.

Although this slow chemical reaction allowed more leisurely operation it did not diminish the physical discomforts with the wet plate during the winter months. But to Brady and his operators these were something to be borne and forgotten.

After establishing themselves in their winter quarters, the photographers, with the army, waited on events.

Fredericksburg, Virginia, lies along the west bank of the Rappahannock. Beyond the town is a great rolling plain that gradually slopes upward toward a ridge of hills called Marye's Heights. Atop the ridge of the plain is a sunken road that runs almost parallel with the river for a short distance, and which is lined by a stone wall four feet high. This stone wall runs almost the entire length of the road and faces toward the river and the foot of the slope. Across the river on the Eastern bank at Falmouth, was the Federal Army. The Confederate Army was solidly entrenched behind the stone wall and the sunken road. The position was spotted with rifle pits and artillery redoubts; and except where rooftops concealed some part of the river the Confederate position commanded an unobstructed view of the town and the whole plain.

To attack the Confederate Army the Federals had to cross the river, fight through the town, cross a deep canal, and ascend the heights.

The weather had become very cold, the temperature hovered around zero, and the soldiers of both armies waited and shivered around their fires. Since their arrival at Falmouth, Brady and O'Sullivan, on clear days, took many pictures around the camp, including some of the placements of the great Parrotts on siege carriages on Stafford Heights.

On the gray cold morning of December eleventh, before the sun's rays penetrated the morning mist, Federal engineers were at work on pontoon bridges. The pontoons, hauled to

78. *Left:* Type of negative identification used by Brady in his gallery and on the field. From an original in possession of the author. *Right:* Photograph by Brady belonging to the negative card

the water's edge on their own carriages, were quickly launched and anchored parallel with the current. The quiet of morning was broken only by the sounds of hammering, and the coarse voices of the soldiers as they swore at the mules when the wheels of a pontoon carriage got mired in the mud of the river bank.

Because of the dense fog that hung over the water, there was no opposition to the bridge building from across the river. But from the windows of the houses on the edge of the town, Barksdale's Mississippians, a brigade of sharpshooters sixteen hundred strong, stared in the direction of the sounds coming over the water.

In the weird, clammy atmosphere of the fog, Brady and his assistants placed their big Anthony camera near the abutment of the destroyed railroad bridge, awaiting the morning light to break through the haze. It was too dark for photography, but they went about their preparations. Dust-proof plate boxes were placed within reach, chemical tanks examined, and all and sundry made ready.

It was bitter cold working in the darkroom wagon, and the mixing of chemicals had to be done with bare hands.

Alongside the abutment of the bridge on the opposite side of the river was an old mill in which the Confederates had placed a light field piece along with a few sharpshooters. When the rays of the sun began to filter through the mist, other eyes on the opposite bank were eagerly waiting and watching.

As the fog began to lift, Brady took out his handkerchief and wiped the mist from the lens. Then, his head under the focusing cloth, he racked the great brassbarreled Harrison lens into focus. This done, his eyes studied the scene before him as they had done a

thousand times before, as the sun shone out and revealed the Confederate position.

But when the sun's rays struck the great sixteen inch brass barrel of the Harrison lens it must have seemed to the Confederates the brass barrel of a cannon. The bridge-builders were, for the moment, forgotten, and the Mississippi sharpshooters directed their fire at the camera. Suddenly rifle bullets sang and spattered about Brady. A shell from the cannon in the mill exploded near, throwing up mud and rocks, upsetting the camera, and causing the horses to run away with the darkroom wagon.

Brady, unhurt, coolly retired to a safer place, leaving the camera to its fate, for the moment, while O'Sullivan ran after the runaway horses. The Mississippians then directed their attention to the Federal bridge-builders, and their fire was so intense and accurate as to halt momentarily the work of the Union engineers' activities.

Brady ran back at this opportunity, and retrieved the camera, which was not seriously damaged;—but the darkroom wagon did not fare as well; Brady and O'Sullivan found broken plates and chemical bottles all over the floor of the wagon box.

They had plenty of supplies though, and quickly cleared away the damage out of range of the sharpshooters.

Meanwhile Federal engineers were attempting to complete construction of the bridge, but were driven off over and over by the accurate fire of the Southeners.

Then the Federals brought up strong detachments to cover the bridge builders, even running a cannon to the water's edge; but the Mississippians, strongly entrenched, could not be silenced until Burnside, impatient at the delay, ordered a rolling barrage that shattered historic houses, blasted streets, and started numerous fires. Any further attempt at making pictures was thus rendered impossible and the photographers could only watch the contest unfold.

For nearly three hours the battle for the pontoons continued. By this time noon had almost passed. Finally General Hooker, seeing an impossible situation developing, called for volunteers to cross the river in pontoons boats and cover the bridge builders. Two regiments, the Seventh Michigan and the Nineteenth Massachusetts, responded and took to the boats and poled across under heavy musketry fire from Barksdale's "Hornets".

Reaching the opposite bank they immediately became severely engaged, and deploying as skirmishers, fought through the town from house to house and street to street until dusk brought an end to the fighting.

Nothing more was done until the next morning, Friday, December twelfth. When the pontoon bridges were completed the Federal Army started crossing in force, swarming into the town, to meet severe resistance in the streets.

As soon as the crossing was established, Federal soldiers, drunk and out of hand, ran wild and began sacking the houses and looting. Breaking into wine cellars, they rolled casks into the streets and poured into the gutters what wine they could not drink. Costly furniture and mirrors were thrown through windows. Handsome homes of generations of grace and beauty were put to the torch and burned down.

The fighting moved on to the edges of the town and later that morning, when it was

safe to do so, Brady and his companion drove their darkroom wagon across the bridge to find the town was a ruin.

They set up their camera and attempted to take pictures of the destruction, working all day until the winter light became too feeble for their "slow plates". That night Brady and his associate, bivouacked in the streets among the soldiers.

No fires were permitted and the photographers shared the same cold rations as the soldiers and got what sleep they could until morning.

The sound of shelling awakened them, and while the troops filed past toward the plain, they hurriedly harnessed their horses and drove as closely as possible to the edge of town which the Confederates had evacuated.

It was now past nine o'clock and the heavy fog from the river still covered the field. Brady saw that weather and battle conditions made photographing impossible, and so, driving back through the streets the photographers selected an abandoned house that overlooked the battlefield. After securing the horses in the yard, they entered the house and climbed to the roof from where, except for the smoke and haze, they had a fairly good view.

The fog was still heavy, but as they stood there, suddenly, like a gigantic spotlight, the sun broke through and revealed the left wing of the Army of the Potomac under Franklin and Sumner advancing on Jackson and Longstreet. Then, from across the river on Stafford Heights, came a roar of fury from massed Union batteries shelling the ridge, as three great lines of battle, which stretched for over a mile and a half, moved forward with flags flying as though on parade.

Burnside, under the delusion that Jackson was at Port Royal, had given orders to Franklin to take the ridge with one division. Meade's Pennsylvanians, 4500 strong, advanced to attack against the whole Second Army Corps of the Army of Northern Virginia, covered by the artillery that shelled the woods where Jackson's men were hidden. Meade advanced to within eight hundred yards of the Confederate center when suddenly the concealed Confederate batteries came into action. Fifty guns plastered the advancing blue lines in front and flank, tearing great gaps in the ranks. Surprised and dismayed they broke in disorder and fell back under cover of their artillery to the Richmond Road.

Then began an artillery duel of over 400 guns that lasted almost two hours, while Franklin brought up three divisions to Meade's support, and Sumner's Division advanced from the ruins of Fredericksburg to attack Longstreet.

At one o'clock Jackson's guns ceased fire for the moment. Under support of the fire from 51 guns on the Richmond Road, Meade's men rallied and advanced once again under the support of Birney and Newton with Gibbon's division covering the right. A strip of swampy woodland which separated the brigades of Lane and Archer, overlooked when the line had been formed, became the objective of Meade's advance.

A fierce struggle took place and the Confederates, being unsupported, gave ground. The second brigade of Meade's, coming in contact with Archer's left, took the Confederates by surprise. Attempting to form a line, they were forced back by a charge and had to give way.

Jackson, hearing that the Federals had broken through Archer's line, ordered the brigades of Early and Taliaferro to attack with the bayonet. Meade's brigades, unsupported and reduced to less than two thousand men, were struck with such force in front and flank by the Confederate reinforcements that they broke and fled across the plain. Burnside then ordered Franklin to attack once again. But Franklin refused, having no stomach for it and 'having lost all confidence in his superior'.

The battle still raged on the Confederate left, where, behind the stone wall, the Confederate infantry were massed, supported by numerous cannon.

Sumner's troops advanced over the plain and up the hill to within a hundred yards of the stone wall, only to be mowed down. The dead and wounded were left in windrows as each wave receded. Longstreet had repulsed each advance in turn with fearful slaughter, leaving only the remnants of a proud army to return to their lines.

The battle raged all afternoon, and from their vantage point the photographers observed the holocaust through field glasses, in constant danger.

The field was littered with the wrecks of men and horses. The dead were "rolled out for shelter for the living"; dead artillery horses were breastworks for little groups of blue-coated men.

As Brady and his companion watched, the fiery sun began to set, shining through the smoke that rose from the field. Soon against the darkening sky, shells traced their courses with comet tails from the burning fuses. With the dark came the end of the battle, but Jackson opened a cannonade and the flashes of the guns scorched the night sky.

When the shelling had ceased, Brady and his companion left their observation post. Driving back toward the center of town, they again prepared to bivouac in the streets. But there was to be little sleep for them that night.

Union soldiers were barricading streets on the edge of town and fortifying houses. Medical corpsmen were helping those of the wounded, behind the lines, they were able to reach, and wounded men were streaming back toward the center of town.

That night a red glow appeared in the northern sky. Many at first thought that a roving cavalry band had set fire to a supply depot. It was Aurora Borealis,—an awesome spectacle of the Northern Lights flickering over the wounded and the dead.

The day dawned foggy and cold. Brady and his companion put away their blankets and gathering wood from the piles of debris that littered the streets, they kindled a fire and made coffee in a black tin, and frizzled some bacon on the end of a stick.

When they had eaten, they again drove expectantly to the edge of town. But there was to be no repetition of the day before. The Federal army, now behind their hurriedly made breastworks, seemed content to stay there. Burnside had given in to his officers and did not renew the attack.

For the rest of the day the two armies watched each other.

Finally, on the morning of the fifteenth, Burnside asked for a truce for a few hours to collect his wounded and bury his dead, to which the Confederates agreed. The truce allowed Brady and his companion an opportunity to photograph the stricken battlefield.

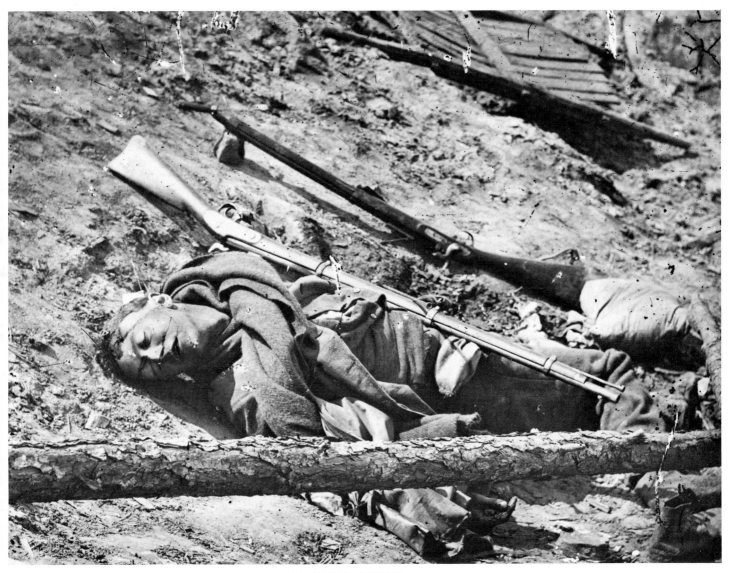

79. MACABRE SCENE

Dead boy in the road at Fredericksburg. Photographed with a stereoscopic camera by Brady on the morning of May 3rd, 1863

Thousands of bodies in blue were lying in all kinds of stiffened, contorted postures. The photographers had to take care lest they stumble over some poor soldier while carrying their equipment about. Bodies near the stone wall in front of the Confederate lines had been stripped of their clothing by the "rebel" soldiers. They lay naked and white on the ground. A woman who lived in one of the houses near the stone wall noted that, "the morning after the battle the field was blue; but the morning after the Federals withdrew the field was white".

Brady and his companion kept at work. It was a gruesome job, this battlefield photography.

When the truce was almost over, the photographers replaced their cameras in the wagon and drove back into town to the rear of the Union lines. The weather began to change for the worse. When they reached headquarters, the army was breaking camp. That night under cover of a terrific storm the Grand Army of the Potomac recrossed the Rappahannock to the camp at Falmouth.

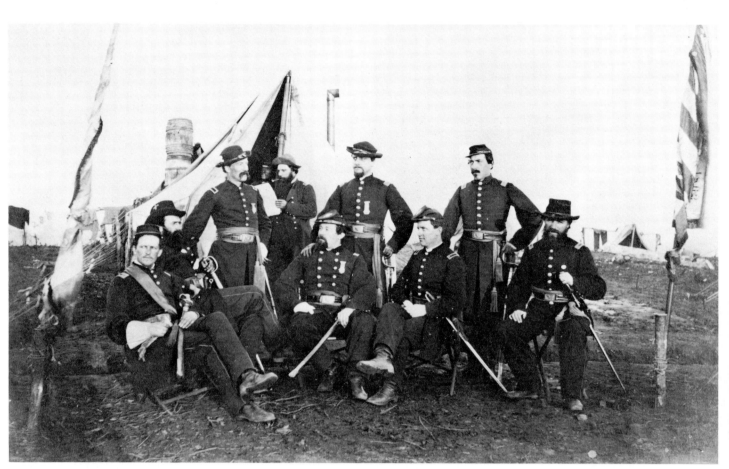

80. *Above:* OFFICER GROUP OF THE 139th PENNSYLVANIA REGIMENT AT FREDER-
ICKSBURG. Photographed by Brady shortly after the battle of December 13th, 1862. *Below:* BATTLE-
FIELD OF FREDERICKSBURG showing Hanover Street and Marye's Heights in the distance. Both of
these illustrations are reproduced from Brady's own prints

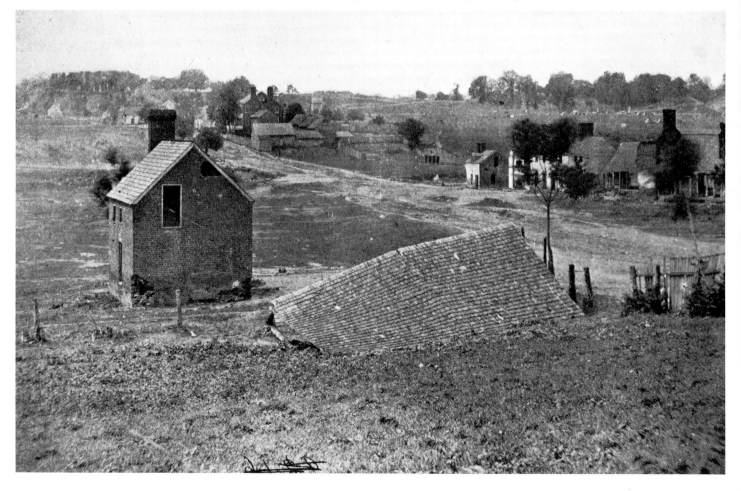

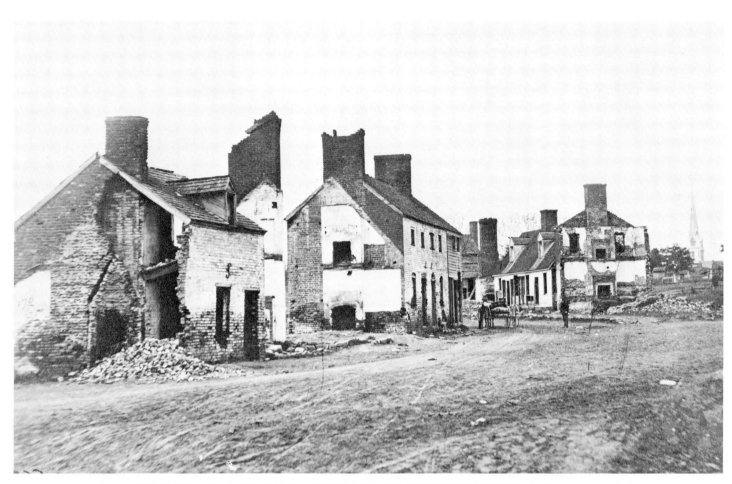

81. *Above:* EFFECTS OF THE BOMBARDMENT ON FREDERICKSBURG. Photographed by Brady after the occupation by Union troops in December of 1862. *Below:* RUSH'S PENNSYLVANIA LANCERS. Photographed by Brady in May of 1863 near Fredericksburg. This photograph is a copy of an original print, the only one of its kind in existence. Note the Darkroom wagon in the rear

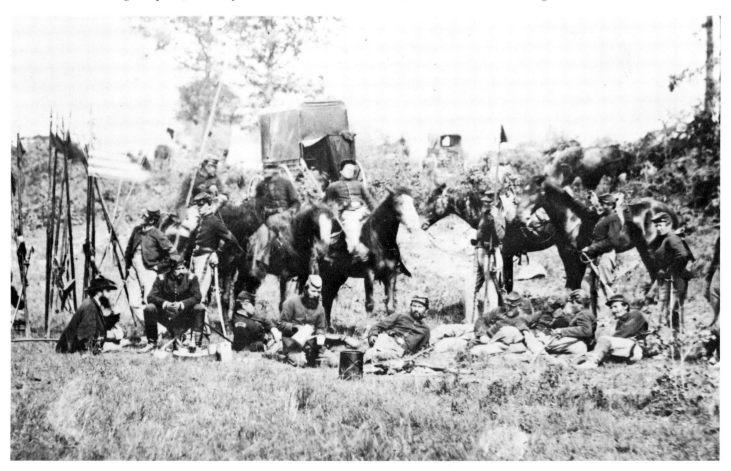

CHAPTER

FIFTEEN

ON JANUARY 26 Burnside made an attempt to outflank Lee's fortifications at Fredericksburg. This campaign, known as the "Mud March", soon came to an end—in mud up to the axles. And thus ended Burnside's career.

General Joseph Hooker, "Fighting Joe," who had distinguished himself at Sharpsburg was given the command, and the Army of the Potomac went back into winter quarters at Falmouth. Here "Joe" Hooker went to work to bring back the old fighting spirit to a disgusted and demoralized army.

At about this time, shortly after Brady returned to Washington, Alex Gardner, manager of Brady's Washington studio, decided to go into business on his own. He secured a Federal appointment as Official Photographer of the Army Secret Service and took his son James with him as his assistant.

This must have been a shock to Brady, for Gardner was probably more familiar with the inward workings of Brady's Galleries and photographic business than any other man in his employ. He had been with Brady almost from the very start, and his reasons for leaving, he never made known.

Gardner was entrusted with the preparation of maps and photographic copies of existing diagrams of the territory in which the Army of the Potomac was operating.

Heretofore, copies of the maps that were distributed to the field commanders were made by hand, a tedious process. But by the photographic method, a negative could be printed any number of times and quickly distributed among the Divisional commanders for immediate use in the field.

The method of copying was similar to that in use today, except for the use of the sun as the source of illumination. The copy stand consisted of a table with an easel on one end, and a camera of large proportions on the other. The map to be copied was tacked to the easel and the camera focused by means of tracks, fastened to the table which made possible the extension of its bellows to the limit. The whole table could swing in any direction so as to permit the sun's rays to light the easel without casting shadows across it.

Gardner was also employed in taking pictures for the purpose of recognizing and

detecting military spies. He and his men would set up their camera in a camp where it was thought there was a spy. Groups of soldiers would be photographed. The pictures would then be studied for recognition, based on descriptions of Yankee operatives who had worked as spies or with Confederate spies in Southern territory. The pictures enabled the Army Secret Service to know the spy at sight without his being aware that his identity had been discovered.

'Avoid the camera' was the advice given to operatives of both sides, but vanity frequently got the better of prudence,—after which came court-martial and the firing squad. It has been stated that in spite of the elaborate preparations of the Secret Service Photographers, very few if any, of the thousands of soldiers in the Union Armies knew that the photographs taken of them, were for the purpose of spy detection. It was not until after the war that the pictures were released.

As a rule the operational bases for the Army photographers were at or near the Signal Stations or Telegraphic Field Headquarters, so that the photographers could be easily informed of the Army's operations in the different theatres. This enabled them to get to the scenes of action quickly.

Gardner worked with the Army Secret Service for four months before he opened his new gallery a short distance from Brady's on the corner of Seventh and D Streets, over Shephards and Riley's Bookstore, directly opposite the offices of the *National Intelligencer*. During this period he made a 'hobby' of photographing soldier groups. These 'candid' photographs were made in great numbers not only by Gardner but by other Army Photographers for the soldiers who wished to send them home to their relatives. Taking of these pictures was a sideline with Gardner as military photography now occupied the greater part of his time. But he managed also to train his son, Jim, in the operation of the camera, and it was not long before he was acting as an operator for his father. Gardner and his son continued with the work of the Secret Service and engaged several more assistants.

Brady's problem was to fill Gardner's place. This he did, apparently, by recalling J. W. Gibson from the field,—for on the Gallery circulars Gibson's name suddenly appears. It will be recalled that Gibson was Wood's associate at Cumberland Landing during the recent Peninsula Campaign. He was a capable man as his work proves.

What Brady's feelings were on the matter of Gardner's leaving him, he never told anyone. Unquestionably Gardner was now in direct competition with him. Their personal relations may have been strained, for competition soon grew keener in the small town that Washington was in the '60's, but neither Brady nor Gardner ever spoke of it, then or in later years.

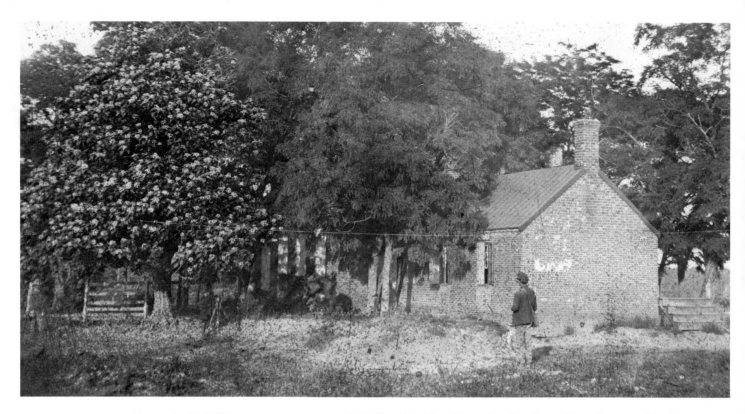

82. *Above:* A Civil War cameraman at work, believed to be Alexander Gardner. The photographer is making his plate beside Fairfax Courthouse, in Virginia. *Below:* CIVIL WAR PHOTOGRAPHERS HEADQUARTERS. Copy of a rare print made by Brady at Port Royal, Virginia in 1864. Note portable darkroom outfit on extreme lower right

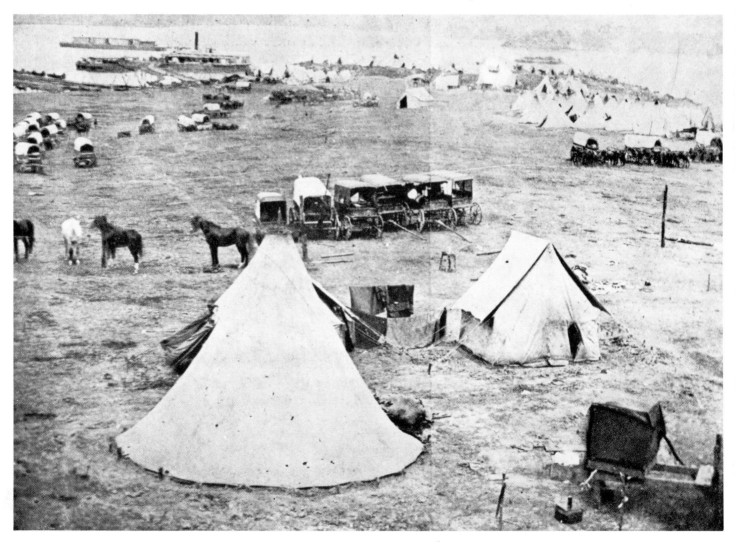

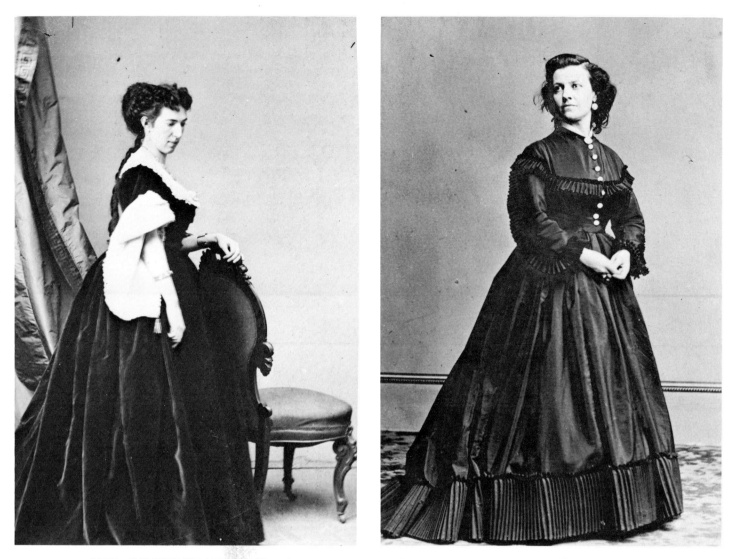

83. TWO CONFEDERATE SPYS. *Above Left:* BELLE BOYD. *Above Right:* PAULINE CUSH-
MAN. *Below:* Alexander Gardner's Photographic Gallery in Washington, D. C. on 7th and 'D' Streets
N.W. near Brady's. Photographed by Gardner in 1863

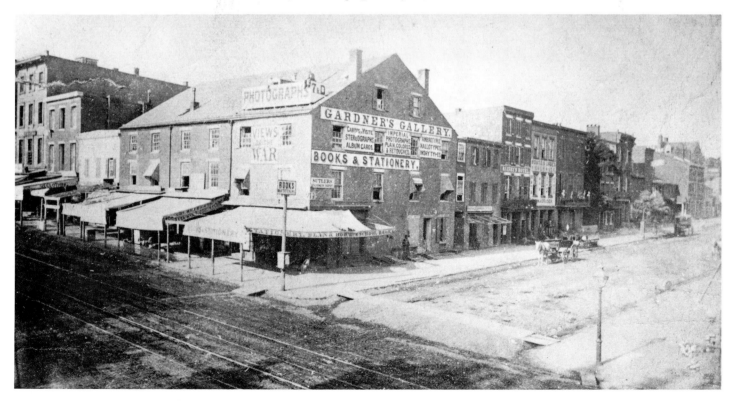

CHAPTER
SIXTEEN

ONCE WHEN BRADY was busy photographing the ruined town of Fredericksburg, in the Spring of '63, his camera and portable darkroom tent were placed far out on the end of the destroyed railroad trestle, just a stone's throw from the other abutment. It was a bright, sunny, spring day, ideal for his purpose. On the town side of the river a group of "Johnny Rebs" with one of their officers crowded out on the bridge sleepers, showing keen interest in the photographer's activity. Brady, seeing a chance for a picture, shouted across for them to pose. They were willing enough, but while he was adjusting the camera they began to shout taunting remarks relative to the trouble and hard going the Union Army was having in getting into Richmond. "Before you get to Richmond", they yelled, "you have a 'longstreet' to travel, a big 'hill' to climb, and a 'stonewall' to get over."

These remarks brought howls of laughter in which Brady joined. But as he completed the exposure he shouted: "We'll get there just the same."

Now the weather began to improve, and "Fightin' Joe" Hooker, now in command, determined on a new plan of campaign. After Fredericksburg, the army had suffered very badly in morale; and Hooker, an energetic officer, went to work to restore confidence in his officers and men. In this he was astonishingly successful.

Finally, on April 27th, 1863, Hooker's grand movement on Chancellorsville began. His strategy was as daring as it was ingenious. It was, in effect, to sever a part of his army from the main body to play the part of a decoy to the Confederate forces in their old entrenchments in front of Fredericksburg, while the army moved secretly to Chancellorsville to concentrate on Lee's left flank. The plan was well devised; and if the movement were successful it would turn Lee's position and compel him to leave his defenses.

Hooker left Sedgewick's corps on the Fredericksburg front to demonstrate. Under cover of darkness he moved his main army to Chancellorsville. Lee hurriedly moved his army from Fredericksburg to Chancellorsville, leaving General Jubal Early to face Sedgewick with ten thousand men.

On Saturday, May 2nd, Sedgewick received orders from Hooker to advance on Fredericksburg. Under the curtain of night Sedgewick marched on the rear of the town. In

their darkroom wagon Brady and his companion rolled quietly along in the wake of the Federal soldiers. Except for the jingle of accoutrements and the sound of feet, and the brushing of the branches against the sides of the wagon, the procession was silent and ghostlike. The horses picked their way along, guided by their own instinct.

The advance was contested at intervals during the night, and many times Brady and his companion had to get out and lead the horses by their bridles when the ping of minie balls broke the silence and frightened the animals. Suddenly up at the head of the columns a fusillade of shots would ring out, continuing sporadically for a few moments. Then, from his place on the wagon seat, Brady heard shouts, quickly followed by a roaring flash that lighted the blackness—the roll of musketry—silence and darkness again. Then the column would again continue quietly on up the road. In this manner the night passed and the columns cautiously neared their objective.

At dawn the columns reached the rear of the town. On that morning, Sunday, May 3rd, after exercising great caution in marching through the deserted streets, Sedgewick's Corps came on the scene of the battle of December. The sun was high and the air clear. Sedgewick prepared at once to attack the heights, but his advance was impeded for awhile by the destroyed bridges over the canal and by heavy artillery fire. To quote Sedgewick, "Nothing remained but to carry the works by direct assault."

This he at once set about to do. Under Newton, two columns in fours, were formed on the Plank and Telegraph roads, supported by some infantry of the "Light Brigade". That morning at eleven o'clock the advance began. Behind the stone wall Early's men waited, prepared to meet the attack.

Brady and his assistant watched from the yard of a brick residence on the outskirts of the town. When the Federals came within two hundred yards of the Confederate position, the stone wall exploded. Their batteries opened, throwing deadly missiles at almost point blank range. Shells burst in the blue ranks, tearing great gaps and leaving writhing groups of men on the ground. It began to look as though there was to be a repetition of Burnside's disaster.

Many men fell, but the columns surged forward and in spite of the murderous musket fire the wall was breached. The Federals, quickly climbing over it, engaged in a hand-to-hand combat. The fighting was savage and bloody, with bayonet, musket butt, fist, and revolver. The enemy suddenly became panic-stricken. Their ranks broke; and in the rout that followed, the Confederate soldiers, streaming across the plain, threw down rifles, blankets, swords, pistols, and anything that could hinder their flight. The broad plateau in front of the Marye House became a millrace of fleeing soldiers, riderless horses, artillery, and wagon trains.

Brady watched from his post of observation. Not long after it was carried by the Union troops he and his companion headed for the stone wall the Confederates had just evacuated. Driving their wagon across the plain, past huddled groups of dead soldiers, they reached the sunken road. Hitching the horses to a sapling, they moved the big Anthony Camera and tripod from the wagon.

The sun was high. In the warm spring air there was the smell of death. Swarms of little green flies were buzzing around the bodies lying in the ditch behind the wall.

In the immediate foreground, just under the lower edge of the great Harrison lens, was the body of a Confederate soldier. Dried blood covered his face and lips, and his fists were tightly clenched. The end had come from a musket butt.

From the foreground of the scene to the infinity point of the lens the road was filled with the bodies of Early's men, lying in the ditch behind the improvised firing step in the contorted positions of violent death.

Brady, his head under the focusing cloth, racked the big brass-barreled Harrison lens into focus. He set the "stop" by inserting a brass aperture disk in the slotted lens barrel. The coated wet plate was dropped into the receptacle, the slide and lenscap were removed, and the ghastly scene etched itself on the wet plate. Then Brady toured the field, and plates were made on Willis' Hill, in the vicinity of Marye's Heights, and on the Confederate fortifications. But his photographic activities were short for on that day the whole military situation changed with dramatic suddenness.

Hooker, who was to turn Lee's flank—the over-confident "Fightin' Joe", whom Brady had once described as "rather boyish, with red hair, always laughing and in high spirits", lost his head. At Chancellorsville he was attacked in force by Stonewall Jackson, who rolled up his whole flank, routing his forces in one of the greatest military achievements of the war.

Sedgewick's position at Fredericksburg was perilous. Lee, leaving Jackson's corps to pursue Hooker, marched his forces against him. The next day, Monday, May 4th, Lee drew up in line of battle and at six o'clock attacked, to cut Sedgewick off from Bank's Ford.

In the meantime, T. H. O'Sullivan was operating in the vicinity of Brandy Station, a little over twenty-four miles by indirect route. For several weeks previous he had been engaged in photographing army repair shops, carpenter shops, harness makers, blacksmiths, wheelwrights, wagon builders, and the like.

News of a battle travels fast, and probably receiving word of the engagement, O'Sullivan, in company with his assistant, hurried toward Fredericksburg, a half day's ride over indifferent roads. He arrived on the field on or about the late afternoon of May 4th.

In the vicinity of Bank's Ford, near the ruins of the Mansfield House, he found Battery D, 2nd United States Artillery in battle array. His darkroom wagon nearby, he was in the act of taking a picture of the gunners as they applied rammer and shot. As he removed the lenscap, the gunners called to him to get out of the way "unless he was anxious to figure in the list of casualties". O'Sullivan made his negative as quickly as he could, hurriedly collected his equipment and moved his wagon to the rear. In a matter of minutes the battery opened fire and the ground shook with the vibration as the heavy guns jumped and rolled back from the recoil.

During the barrage, O'Sullivan developed his plates.

That night Sedgewick recrossed the Rappahannock River at Bank's Ford and took up a position to protect his supplies. The Confederate army did not pursue or attack him.

Brady, O'Sullivan, and their assistants remained in camp with the army, working in and around Falmouth for the next three weeks. Probably because of a rumor of a visit from Lincoln, they drove to Aquia Creek Landing. It was then that they learned that the base was to be evacuated. Steamers and transports and barges began to arrive at the wharves, and preparations for transferring military stores to the transports began at once.

Several hours before the abandonment of the base, Brady and O'Sullivan, with their assistants, were busy working with their cameras. Since Burnside had occupied Aquia Landing as a base, a small town had sprung up around the army buildings, and there was much activity.

While the photographers were at work, the greatest disorder prevailed. In apprehension of an attack by Confederate cavalry, civilians and sutlers crowded onto the steamers at the wharves. Lincoln had been expected to visit the army that day, but word had come of the advance of the Confederate army into Pennsylvania and General Hooker that afternoon telegraphed Lincoln not to come.

That night Brady prepared to leave for Washington on one of the army transports, while O'Sullivan, to all indications, remained with the army, joining the Second Corps of Sedgewick which arrived at Aquia Landing on June 16 from near Falmouth.

At daybreak on June 17th O'Sullivan with his darkroom wagon followed the Second Corps on its march from Aquia through Dumphries, Wolf Run Shoals, Centerville, Gainesville, Thoroughfare Gap, across the Potomac at Edward's Ferry, to Poolesville, Frederick, Liberty, and Uniontown.

When Brady returned to Washington the plates exposed that winter and spring were printed and catalogued. It was during this period, previous to his sojourn to Gettysburg, that James McHenry gave him an order amounting to $15,000 for pictures of all the distinguished men whom he had photographed since the beginning of his career,—the largest order he had received since the visit from the Prince of Wales. Brady said he "believed this was the largest order for photographs ever given to date".

For the next two or three weeks he was busy at the gallery, filling McHenry's order, and remained in Washington.

On June 28th, after a march of thirty-two miles from Frederick, Maryland, to Union Town, O'Sullivan arrived with the Second Corps from Aquia. At Union Town it had been learned that Hooker had been removed and General George Gordon Meade was in command, much to the relief of the officers and men. Then ominous and confusing rumors began to trickle into the capital city. Lee was reported in Baltimore, in Philadelphia, on the march to Washington, at Harrisburg.

Meade wasted no time. Realizing the strategic importance of Gettysburg, in that it was the center of many converging roads, and hearing that Buford's cavalry had flushed a force of the enemy near the town, Meade determined to seize it. Buford engaged at once, and a sharp battle developed. Meade then rushed support to Buford.

At about this time Brady, and probably Gardner also, left Washington for the vicinity of Gettysburg. The distance was roughly seventy miles. Brady probably reached Taneytown, Meade's headquarters, somewhere around the last day of the month.

On July first, the two armies collided and came to death grips on the farm lands of Pennsylvania. For two days the Army of the Potomac and the Army of Northern Virginia sparred for position for the battle that each believed would decide the war.

The first day's battle was sanguinary. The Union Army was pushed back through Gettysburg after a feeble resistance and retired to a rocky, wooded ridge. Here the army was drawn up in a line of battle somewhat resembling the shape of a fish-hook. The line extended for perhaps a distance of five miles. Round Top, a high rocky hill, was on the extreme left of the line, with Little Round Top a short distance away to the north. At the other end of the line was the cemetery south of the town. The line ran through the cemetery and some of the batteries were among graves and monuments, which were used for field works. From this ridge the ground below falls away gradually across the Emmettsburg road, covered with pastures, peach orchards and cornfields, boxed with stone fences. Beyond, along a lower ridge, the Confederate Army took position, its line running through Gettysburg.

Brady probably joined O'Sullivan and his old friend and former associate, Gardner, somewhere near the Taneytown Road, where General Meade had his headquarters in an old shabby farmhouse a little more than five hundred yards in the rear of the position held by the Second Corps. Back of the line was feverish activity. Surgeons were busy hunting for wells and springs, for hospital sites. Ammunition wagons were being parked. Pack mules with boxes of cartridges on their backs were being driven in.

The photographers found everything quiet. No sound of a gun disturbed the silence. Along the crest of the Union position were long rows of heavy Parrott field guns, and a hundred thousand men waited, arms stacked, smoking, making coffee and passing the time according to their humor.

On July second came the disastrous movements of Sickles' Third Corps, and a furious battle on the left of the line. Attack after attack by the Confederates was repulsed with much slaughter. But the entire Third Corps was swept from the field.

Then, a strange silence fell. The ambulances commenced their work of picking up the wounded. Under the late afternoon sun the photographers went about the field with their wagon and cameras.

There is no better account of the scenes that the photographers witnessed, than that by Lieutenant Frank Aretas Haskell, aide-de-camp to General Gibbon. He wrote: "And how look these fields? We may see them before dark—the ripening grain, the luxuriant corn, the orchards, the grassy meadows, and in their midst the rural cottage of brick or wood. They were beautiful this morning. They are desolate now—trampled by countless feet of the combatants, plowed and scored by the shot and shell, the orchards splintered, the fences prostrate, the harvest trodden in the mud. And more dreadful than the sight of all this, thickly strewn over all their length and breadth, are the habiliments of the soldiers,

the knapsacks cast aside in the stress of the fight, or after the fatal lead struck; haversacks, yawning with the rations the owner will never call for; canteens of cedar of the rebel men of Jackson, and of cloth-covered tin of the men of the Union; blankets and trousers, and coats and caps, and some are blue and some are gray; muskets and ramrods, and bayonets, and swords, and scabbards and belts, some bent and cut by the shot or shell; broken wheels, exploded caissons, and limber-boxes, and dismantled guns, and all these are sprinkled with blood; horses, some dead, a mangled heap of carnage, some alive, with a leg shot clear off, or other frightful wounds, appealing to you with almost more than brute gaze as you pass; and last, but least numerous, many thousands of men—and there was no rebellion here now—the men of South Carolina were quiet by the side of those of Massachusetts, some composed, with upturned faces, sleeping the last sleep, some mutilated and frightful, some wretched, fallen, bathed in blood, survivors still and unwilling witnesses of the rage of Gettysburg."

These were the scenes presented to Brady and the other photographers as they aimed the big Anthony cameras over the stricken field. As darkness closed they went behind the lines to wash, dry and varnish their plates. They set about boiling their coffee and eating their rations, smoking, and talking of the day's battle, and what the morrow might bring.

At about noon on July third, while the photographers were dozing in the heat, with their horses hitched to the trees, munching oats, the silence was broken by the sharp report of a cannon. This was followed by the booming of gun after gun in rapid succession. Shells burst all around. Brady and the other photographers hurriedly hitched their horses and drove to safety at the rear. Then began one of the heaviest bombardments of the war.

Brady, O'Sullivan, and Gardner, having nothing to do but look after their equipment, became observers from a safe distance. Shells from two hundred and fifty guns of all calibers, hissed and crashed all around.

While the Union artillerists returned the fire, grimly applying ramrod and ignition spark, the shells struck among them. Solid shot would strike the Parrotts, and their iron and oak gun trails would snap like twigs. For over two hours the fire never slackened.

Then the Rebel batteries ceased. The divisions of Pickett and Pettigrew in a line that extended for over a half a mile—eighteen thousand men—advanced over the field toward the Union Army. In perfect order, bayonets flashing in the sunlight, rank on rank, red banners waving, the lines advanced in magnificent array.

Then the Federal's great Parrott guns opened fire, their shells bursting in the rebel ranks. The Confederate advance reached a grove of trees, and hand to hand fighting began. The Federal soldiers poured a steady fire into the Confederate ranks as they tried to take a portion of a stone wall. It seemed like Fredericksburg in reverse.

Savage combat raged around that clump of trees. The lines swayed back and forth for a few minutes, and it seemed as though the Union line would crack under the pressure. But suddenly the Confederate line broke and trickled back down the slope.

Thus ended Pickett's charge and the battle of Gettysburg—with twenty thousand killed and wounded on the field.

At dawn on July fourth while the heavy morning mist hung in the sultry air, Brady and the other photographers went to work. The scenes were appalling. One soldier wrote, "The sights and smells that assailed us were simply indescribable—corpses swollen to twice their original size, some of them actually burst asunder with the pressure of foul gases and vapors . . . The odors were nauseating and so deadly that in a short time we all sickened and were lying with our mouths close to the ground, most of us vomiting profusely".

Stillness pervaded the field where Brady worked. His scenes were evidence of violent conflict. At the Devil's Den, his camera at the foot of the slope, he made plates of the bodies of Union soldiers among the rocks and trees. Gardner, working near the cemetery gatehouse, was making plates of the defenses. Until dusk they were busy on the field moving their darkroom wagons and cameras to places where the fighting had been the hottest.

That night and the next day it rained, miring the roads and drenching the countryside. But by dawn of July sixth, Brady, O'Sullivan, and Gardner were again on the field. All was still while Brady worked with the camera, where not so many hours before cannon had thundered. As he went about his duties, he needed no guide to follow the course of battle. Broken canteens, caps, trousers, both blue and gray, cartridge boxes, broken wheels, smashed limbers, shattered gun carriages, were scattered for miles over the field. While he worked, civilians, even boys and girls, searching for mementoes, paid little attention to the camera. Just before Brady left Gettysburg, he went to the home of John Burns, a hero of Gettysburg. Burns, on the first day of the battle had volunteered his services to the Iron Brigade and had fought until he was wounded three times. When asked by Lieutenant Haskell whom he had fought with, he said, "Oh, I pitched in with them Wisconsin fellers."

He was probably a little surprised when Brady in his darkroom wagon drove up to his place. When asked to pose he consented, sitting in an old rocker with a pair of crutches and a musket leaning against the wall just behind him.

For two more days Brady remained in the vicinity of Gettysburg and in the town which had become a hospital for blue and gray alike. He made many plates, and with these tucked safely in his plate boxes, he returned to Washington.

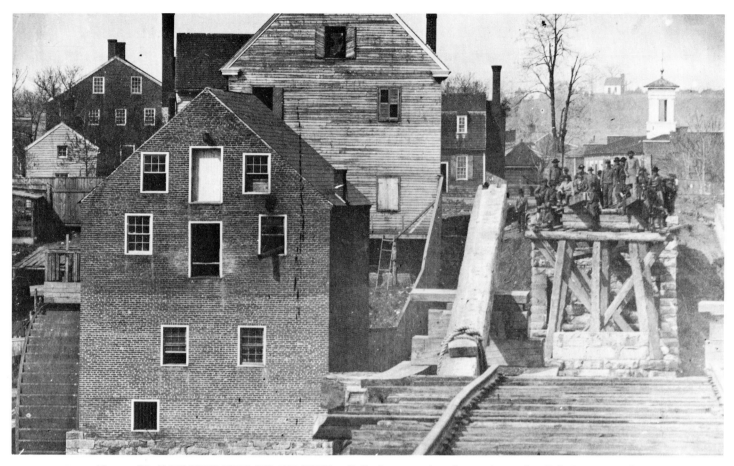

84. *Above:* "A LONGSTREET TO TRAVEL—!" Such were the shouts from the Rebels across the river when Brady made this picture from the wrecked Mayo's Bridge at Fredericksburg after the battle of December 13th, 1862. *Below:* Union guns on Stafford Heights. Photographed by Brady at Fredericksburg on May 3, 1863. This picture is often credited to Captain A. J. Russell, but is from an original print from the Brady Album Gallery

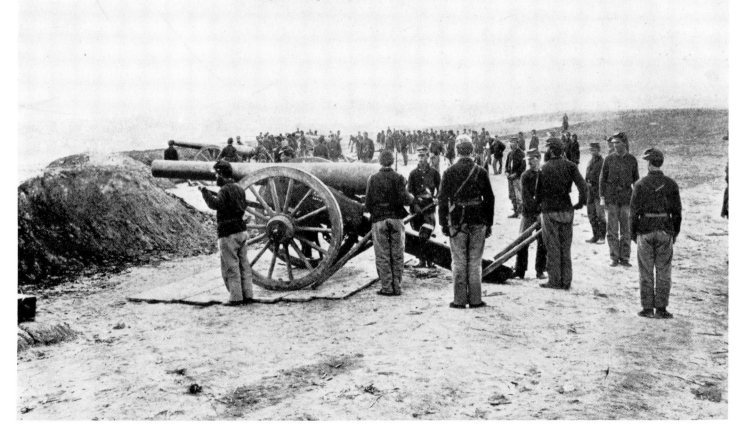

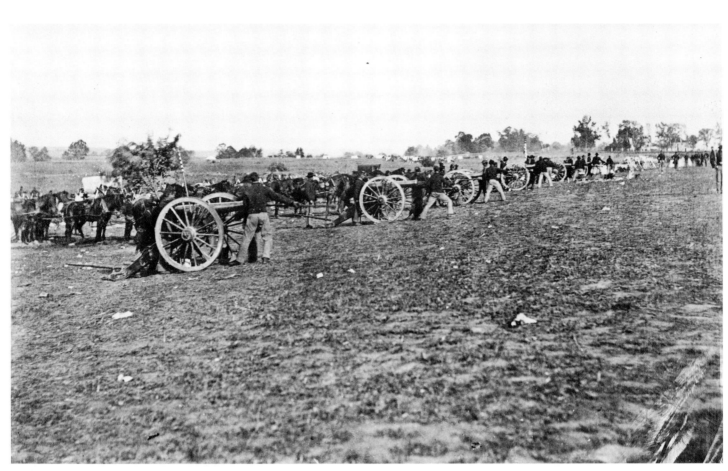

85. *Above:* BATTERY 'D' FIFTH UNITED STATES ARTILLERY. An action shot taken by T. H. O'Sullivan during the Second Battle of Fredericksburg, May 3rd, 1863. *Below:* BUZZARD'S ROOST. Dismounted Coehorn-type mortars at Fredericksburg, Virginia. Observation Post in the background was known as the buzzard's roost. Photographed from a low angle by Brady sometime in May of 1863

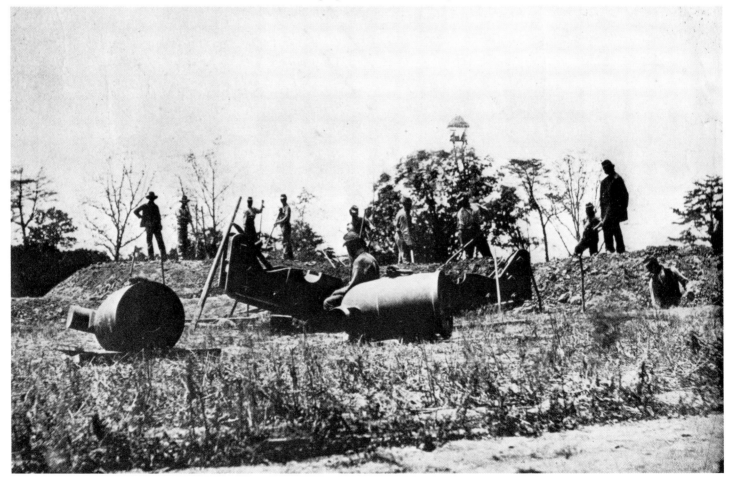

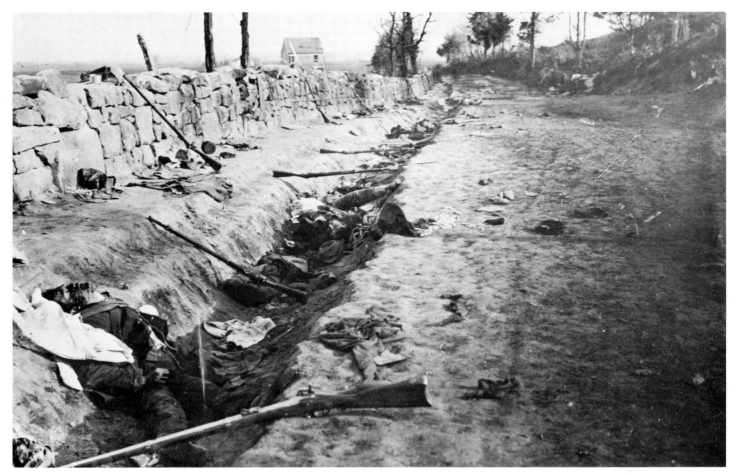

86. *Above:* WHAT EARLY LEFT BEHIND THE STONEWALL ON MARYE'S HEIGHTS. Pho-
tographed by Brady immediately after the battle of May 3rd, 1863. *Below:* Battery 'D' Fifth United
States Artillery in action at Fredericksburg, Virginia, May 3, 1863. One of the few action shots during
an engagement. From an original albumen print probably by O'Sullivan

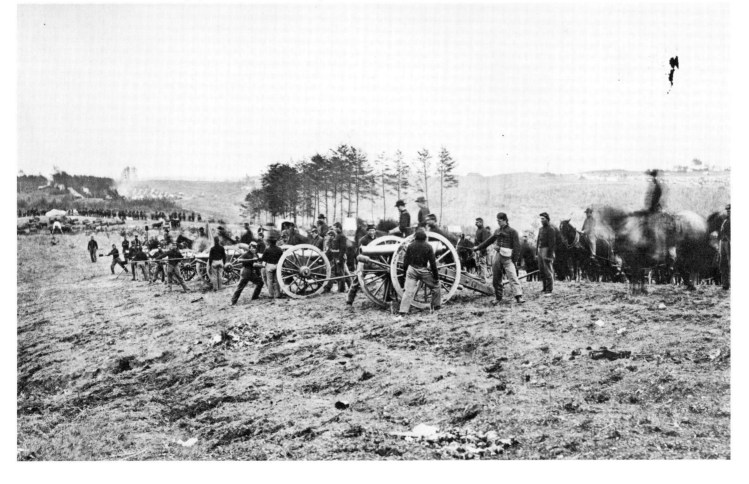

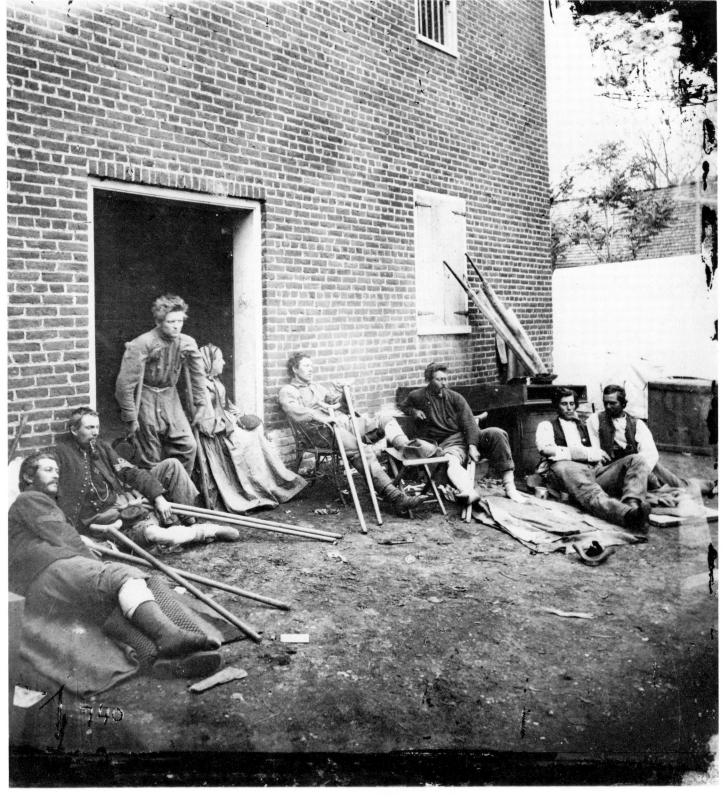

87. **UNION WOUNDED AT FREDERICKSBURG**
Photographed by Brady with a stereoscopic camera following the Battle of May 3rd, 1863. From
an original albumen print

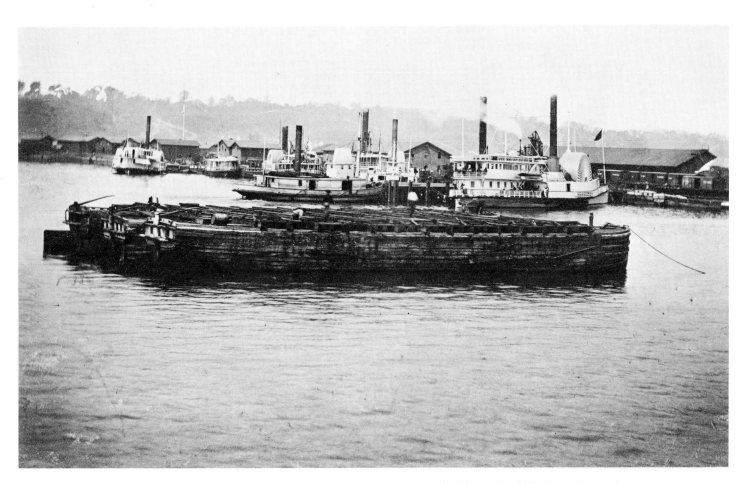

88. *Above:* **THE EVACUATION OF AQUIA CREEK.** Photographed by T. H. O'Sullivan from a barge shortly before the march of the Second Corps, Army of the Potomac, to Gettysburg. *Below:* **PONTOON BRIDGE ACROSS THE RAPPAHANNOCK.** Photographed by T. H. O'Sullivan in March of 1863 during the Union Army's stay in winter quarters

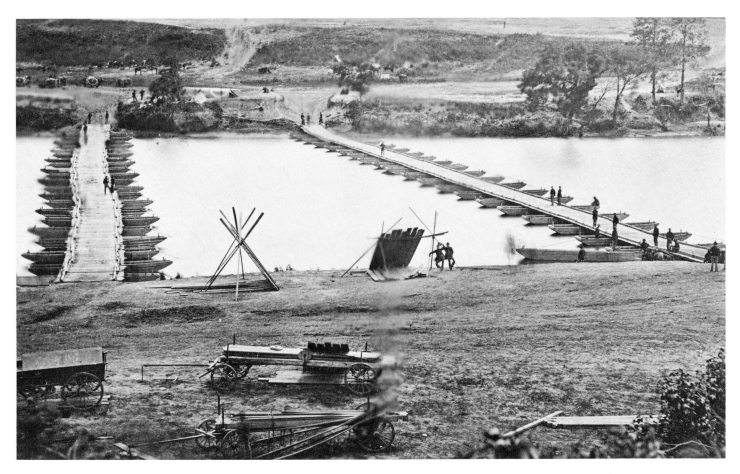

CHAPTER

SEVENTEEN

ON FEBRUARY 9, 1864, President Lincoln, accompanied by his young son Tad and two unidentified ladies, favored Brady with a visit at the gallery. This was shortly before the bills were presented to the Senate and House proposing the revival of the rank of Lieutenant General of the Armies of the United States containing the provision that Ulysses S. Grant be nominated for that post. Lincoln was dressed in a rich black broadcloth suit and polished boots. He wore a white shirt with black bow tie, and the only other prominent feature of his dress was the large gold watch chain that hung through the second buttonhole of his vest. Young Tad was also dressed in a dark suit adorned with almost the same type of heavy watch chain his father wore. It was the first time the boy had visited the gallery.

Young "Tad" Lincoln, probably consumed with curiosity at the great cameras, watched with intense interest the mysterious goings on while his father took his seat.

Brady made eight different portraits. One of these was destined to appear on the five dollar note,—the one Robert Lincoln described as, "the best likeness of my father". Brady that same day made a portrait of "Tad" and his father together. To hold the boy's attention Brady gave him one of his picture albums which he studied with interest while the plate was being exposed.

But not so tranquil was a later sitting, at the White House. It was the day following the review of Ambrose Burnside's Division. Brady sent two of his men from the gallery to make some stereoscopic studies of Lincoln in his office to assist Francis Carpenter, the painter, who had been working on an oil portrait of the President for several months while he lived at the White House.

Brady's men requested a dark closet in which to develop their plates. Carpenter, without any thought of infringing on anyone's rights, took the photographers to an unoccupied room that young "Tad" Lincoln had taken possession of for a playroom. A few days before, the boy, with the aid of a couple of servants, had fitted it up as a miniature theatre, with stage, curtains, orchestra, stalls, parquette, and all. The operators went at once to the room and installed their darkroom equipment without disturbance to the "theatrical" arrangements.

160

Back in the President's office, the sitting was going well when there was a sudden uproar. The darkroom operator came rushing in and said that "Tad" had taken great offense at the occupation of his room without his consent. The boy had locked the operator out, "refusing all admission", and the chemicals were inside and there was no way of getting at them. As the operator was explaining his predicament, the irate boy burst into the office in a fearful temper. Rushing up to Carpenter, he screamed that he had no right to use his room, and furthermore, the photographers could not go in and get their things. He had seen to that, for he had locked the door; and he shouted: "They had no business in my room".

The President had been sitting quietly for a photograph during this tirade. Turning to "Tad", he said very mildly, "Tad, go and unlock the door." But "Tad" openly defiant, ignored his father's request and went off to his mother's room, muttering.

Carpenter followed the boy out into the hall, pleading with him; but no manner of coaxing would pacify him, and he returned to the President, who was still patiently sitting in the chair. "Mr. Carpenter," Lincoln asked, "has not the boy opened that door?" Carpenter shook his head, replying that he could do nothing with him.

Mr. Lincoln's lips came firmly together. Suddenly rising, he strode across the hall with an air of one "bent on punishment" and disappeared into the family apartment. In a few moments he came back with the key to the 'theatre', he unlocked it himself, saying to Carpenter, "There, go ahead, it is all right now". And he walked back to the office and resumed his seat.

As Brady's men prepared the camera, Mr. Lincoln turned to Carpenter and said, apologetically: "Tad is a peculiar child. He was violently excited when I went to him. I said, 'Tad, do you know you are making your father a great deal of trouble?' He burst into tears, and instantly gave me the key".

Lincoln's recommendation that Grant be given the rank of Lieutenant General of the Armies of the United States was finally confirmed by the Senate. And Ulysses S. Grant, the only Union general with a string of resounding victories to his credit, at Nashville, Tennessee, received orders to proceed to Washington.

With his fourteen year old son, Fred, and his good friend and Chief of Staff, John F. Rawlins, Grant was received with cheers at every stop on the way. On the evening of March 8 the group arrived at the Capital.

There had never been any recognizable portraits taken of Grant before. No one in the East, not even in Washington, had ever seen him. On the day he was expected to arrive, two reporters, Mr. Hanscomb and Mr. Crounce, and a group of New York newspaper correspondents rushed into Brady's studio and asked him whether he could describe the general, as they wanted to "waylay" him for an interview at the station. Brady couldn't help them.

Some time before this, Brady had corresponded with General Rawlins on the matter, and Rawlins had sent Brady a cheap photograph showing Grant's face with a beard and with a hat drawn down almost to the tip of his nose. But nothing much of Grant's appear-

ance could be gathered from this. "I couldn't help them," Brady said, "even though I had an inkling of the appearance of the lower part of his face."

The correspondents induced Brady to go to the station with them to meet Grant and help identify him, and when the train rolled in, a man whom Brady afterwards discovered to be General Rawlins appeared on the platform of a car, looked around, and going back into the car reappeared with another, who walked with Grant's "peculiar slouch".

"I knew by the lines of his mouth who it was", Brady said afterwards, "and rushing up on the car platform, I grasped his hand. I introduced myself and asked if he were General Grant. He replied in the affirmative."

After introducing the reporters, Brady asked Grant where he was going to stay while in Washington. "I don't know," Grant replied. "I know nothing about the hotels." Brady suggested Willard's Hotel as the rendezvous of the army. This seemed to meet with Grant's approval. They put the General and his party into a carriage, and taking another, Brady and the reporters preceded them to announce their coming.

At the hotel, when Grant had registered, Brady said to him, "General, the desire to obtain your portrait is so universal I hope you will favor me with a sitting as early as you conveniently can." "Certainly," Grant replied. "I go away at one o'clock tomorrow, and must pay my respects to the President and the Secretary of War, but after that I promise you I will give you a chance."

The following morning the gallery was the scene of feverish activity. Brady waited anxiously with the operators, who prepared to take every view of the General possible. Four cameras were lined up. It was growing late, and the light was losing its brightness. "I had the studio in readiness early," Brady said, "for we realized that with his [Grants] departure from Washington, we might never have another opportunity like it again. We waited long after 1 o'clock and had almost given him up when a carriage drove up and Secretary of War Stanton jumped out followed hurriedly by Grant."

It was four o'clock when Grant and Stanton rushed upstairs to the studio. Grant had lost one train and was obliged to take the next one. They all went to the 'operating room', where the four cameras were stationed. Grant took his place, and as it was growing dark, Brady sent his assistant to the roof to draw back the shades from the glass. The fellow was clumsy and just as he got above the spot where Grant was seated, he stumbled and both feet crashed through the glass, sending a shower of thick splinters about the General. Grant sat motionless. Stanton turned white as a sheet. "It was a miracle that some of the pieces didn't strike him," Brady said. "And if one had, it would have been the end of Grant for that glass was two inches thick! . . . Grant casually glanced up to see the cause of the crash and there was a barely perceptible quiver of the nostril, but that was all! It was the most remarkable display of nerve I had ever witnessed." Stanton grasped Brady nervously by the arm and dragged him into a closet, saying excitedly, "Not a word about this, Brady, not a word! You must never breathe a word of what happened here today. The newspapers will say it was designedly done to injure General Grant! It would be impossible to convince the people that this was not an attempt at assassination!"

162

Brady managed to get several fairly good pictures, and this meeting was the beginning of an acquaintanceship that lasted until Grant's death. When Grant left he said nothing of the accident.

Brady now prepared to take to the field again. On April 30, 1864 Grant planned a hammering policy that was designed to carry everything before it, "that if by attrition and no other way . . ." he would end the matter.

From April of '64 through May of '65 Brady and the war photographers spent most of the time in the field. During Grant's campaigns of '64 the photographers most active in the Eastern theatre, including Brady, were T. H. O'Sullivan, David Knox, and J. Reekie, along with Captain A. J. Russell, engineer-photographer with the Union Army Railroad Construction Corps, attached to Grant's Military Railroad.

While Grant prepared his campaigns during the month of April, Brady and O'Sullivan operated within a thirty-six mile radius on either side of the Orange and Alexandria Railroad, the army's supply line from Washington to Brandy Station. During this time the territory covered by the photographers included Bealton Station, Rappahannock Station, Warrenton Junction, Brandy Station, Culpeper Court House, and Cold Harbor, the last for a short time becoming the base of operations for the photographers in the Petersburg campaign. This territory followed the line of the railroad from Fairfax Court House to Brandy Station and approximated a distance of sixty-five miles. It was this often fought-over territory that Brady, during the next year, would have to cover in travelling to and from Washington.

Sometime during the latter part of April, Brady arrived with his assistant and his darkroom wagon at Brandy Station to prepare for the strenuous work involved in the forthcoming campaign, where since February O'Sullivan had been actively engaged. Here was General Meade's winter headquarters.

The Staff Officers' tents formed a semi-circle in front of Meade's headquarters, and the whole camp was enclosed with a neat brush fence with plank foot-walks connecting the officers' quarters. Beside the headquarters was a stockade for prisoners that required two regiments for police and guard duty, and in addition a squadron of cavalry was maintained for escort duty.

At Brandy Station, camp architecture took on a striking appearance. The camp was in a grove surrounded by evergreens, and in front of each tent was constructed a bower of leafy branches. The soldiers had searched the forest for the brightest foliage and collected bunches of pine, cedar, and holly.

Surrounding the camps were neat hedges, and over each archway entrance was a large Corps Insignia. Many of the camps had sun porches erected to which were fastened coverings of thick evergreens almost completely hiding the interior. These camps had an indescribable charm, and combined with the glitter of military parades and the music of the bands, made memories that were not easily forgotten. Life in headquarters was always pleasant for the photographers during these days of military inactivity. There were always visitors to entertain, and the army bands were on hand, making music at all hours. At

night chess and the old game of whist, not to mention the popular game of poker, helped to pass time that might otherwise have hung heavy. The war photographers were not always idle while in camp. Alert to the beauty and the picture value of the scenes surrounding them, they made many plates, and these plates numbered among the most beautiful photographs taken during the war.

One of the most colorful of regiments was the 114th Pennsylvania Volunteers, attired in the uniforms of the French Colonial Zouaves, with red baggy trousers, blue tunics, and white turbans. They acted as headquarters guard to General Meade. During this time many photographs were made of them. Thus was the remainder of the month of April spent by the photographers at Brandy Station.

Brady and O'Sullivan during the army's stay in winter quarters made many photographs in and around Bealton and Rappahannock Station. Al Waud, the *Harper's Weekly* artist, who was with Brady on the eventful ride to Bull Run in '61, was also present making sketches of camp life and army activity. It is not unreasonable to suppose that he and Brady again met and worked together at that time.

An area in that particular part of Virginia is known as the Wilderness. It is a territory that lies directly South of the Rapidan River and extends North and South for about fifteen miles, running about the same distance from East to West. Almost impassable, its physical aspects were as grim and forbidding as the battle that was to be fought in it: scrub oak, of second growth, tangled underbrush, muddy streams infested with water moccasins, swamps, and briar bushes. Lee had deliberately chosen this territory as a battlefield for two reasons: It would conceal his inferiority in numbers and at the same time prevent Grant from employing his superior artillery with full effect.

Grant's plan was to swing around past the Confederate Army and place himself between Lee and Richmond.

The powerful Army of Northern Virginia, consisting of three corps, was in a strong position South of the Rapidan with its right on the river under the command of General Ewell. General A. P. Hill held the center near Orange Courthouse, and the left was held by Longstreet at Mechanicsburg.

The Union Army, encamped North of the Rapidan from Hazel's Run through Culpeper to Stevensburg, was composed of the corps of Generals, Warren, Sedgewick, and Hancock. This was the main strength, although Burnside's Corps was a day's march away to the North.

At midnight of May third, Grant crossed the Rapidan River at Germanna Ford, and by 8 o'clock on the night of the fourth most of Grant's army was deep in the labyrinth of swamp, thicket, and thorny underbrush.

To meet Grant's move Lee promptly dispatched Ewell's and A. P. Hill's forces along the Orange Turnpike and the Orange Plank Road.

Ewell advanced his troops toward Germanna Ford Road. The two opposing forces met, and thus began the battle of the Wilderness. The battle was sanguinary, with Sedgewick, Warren, and Hancock's corps tenaciously holding in a ragged line. Burnside with his

corps, who had been guarding the Orange and Alexandria Railroad, started on the afternoon of the fourth of May and made a forced march to the field from Brandy Station crossing at Germanna Ford, halting at Wilderness Tavern.

Brady and his companion arrived with the divisions of Potter and Willcox, reaching the field about daylight of May fifth with his darkroom wagon. Brady remained in Potter's headquarters during the battle of May sixth.

To Brady this was not unfamiliar territory, for he had followed the army over many weary miles, through mud and dust, in the broiling sunshine that made working with the wet plate a trying task, and these were last year's battlefields of Fredericksburg, Chancellorsville, Gaines Mill and the Chicahominy. Over this territory as he drove his darkroom wagon the skeletons of men who had died in combat two years before met his eyes.

Because of the clogged conditions of the roads and the swampy terrain, it seems that for the moment there was little photographic activity. The roads were choked with moving troops, artillery and wagons, and it would have been almost impossible to drive to any point on the field, or attempt any pictures because of the feverish military activity.

The battle raged in the tangled thickets and the rattle of musketry and the yells of the combatants could be heard by Brady and the photographers as they waited the outcome. At times both lines could hardly distinguish each other fifty yards apart. At the Lacy House near the Orange Turnpike, Grant, Meade, and Warren anxiously waited at four that afternoon. Then, Lee threw Longstreet's and Hill's men against Hancock's lines. In the extremely heavy firing the underbrush caught fire quickly traveling to the Union breastworks. Suddenly the Confederates charged and broke through the Union line, and panic spread among the stragglers and wounded wandering in the burning, smoking forest. The attack was repulsed and the battle ended in a draw. Grant was stopped in the Wilderness, for the time being at least.

During the lull that followed, at General Potter's headquarters Brady induced that officer and his staff to pose in front of their tent. They agreed, and while Brady posed them his assistant set up the camera. When everything was ready Brady stepped into the picture himself, not with the group of officers facing the camera, but to the left, leaning against a tree, holding a stick in his hand, dressed in a tarnished and dusty dark gray suit and wearing the familiar old straw hat. This is one of the first self portraits that he made while on the battlefields all during the war.

It was on May 7th, after dark, that Grant attempted a shift to the left to by-pass and turn Lee's position,—his objective was Spotsylvania Court House. Lee devined this almost at once, and immediately ordered R. H. Anderson to Spotsylvania. Then began a race for the position, with the two armies marching on parallel lines. Anderson reached the Court House first and was already entrenched on the arrival of the Union forces under Warren.

Between these works and the opposing army the Confederates constructed an abatis of saplings trimmed and sharpened, the points facing the opposing army. Lee's entrenchments took the form of a "V" with the apex pointing against the center of the Union line.

At daylight on May twelfth, Hancock assaulted this salient. The Union soldiers, leaping the breastworks on the unsuspecting Confederates, became embroiled in a hand-to-hand conflict with muskets used as clubs and bayonets. The fire from other parts of the salient was so heavy that it split and leveled the blades of grass. Rain began falling in torrents.

By midnight of the twelfth the battle ended and Lee withdrew. It was early on the thirteenth that Brady drove his darkroom wagon to the works near the 'Angle'. Burial parties were already at work. The rain that continued through the night soon stopped, and the sun coming out lighted up the scene. There was still danger from sharpshooters, but while the photographers went about their duties they were unmolested.

Brady and his assistant mounted the camera, the legs of the tripod sinking into the soft muddy ground. The rain returned intermittently but the sun shone for short periods, allowing Brady to make some pictures. While his assistant prepared the plates, Brady studied the scene. Hundreds of Confederate soldiers, dead and dying and piled over one another, lay in the pits behind the timbered breastworks, some groups lying in heaps three or four deep. The trenches were almost full of muddy water and strewn all about were arms, ammunition, wrecked cannon, and broken branches. What fire had not done to the trees the minie-balls and shells made up for. Some trees had been literally cut down by musket balls. Not far away from where Brady was working, a Union burial party was burying the Confederate dead by simply pushing their own breastworks over upon them. His assistant handed him the prepared plate, and the scene was exposed in all its ghastliness. When Brady and his assistant had completed their work they drove back to headquarters. Then began a rain that continued for three days, putting a stop to any further photographic activity. On May 17 the weather cleared enough for him to continue camera work. He made pictures of the McCool House within the Bloody Angle and the vicinity of the Allsop Farm around where Ewell had fought. Here Brady photographed the burial parties at work in the garden and behind the barns and outbuildings. Behind the barn a detachment of the First Massachusetts Heavy Artillery was digging a burial trench. The camera was again mounted and the scene exposed, the diggers paying little heed to Brady or the strange-looking camera.

After Spotsylvania and the Battle of the Bloody Angle Brady returned to Grant's headquarters. Spotsylvania had been Grant's second repulse—not a good thing for a new general who had just taken command and of whom much was expected. At Massaponax Baptist Church Grant called a council of war. The benches in the church had been taken outside by the soldiers and placed in a semi-circle under the trees. Grant's officers took their places on the benches and were discussing the situation. Brady carried his camera to the upper floor of the building, and from that position made three plates in the space of probably ten minutes.

These, taken in succession were almost equivalent to motion pictures. While the slow plate was being exposed, Grant got up from his seat, and walking over behind Meade,

166

leaned over his shoulder and pointed out a location on a map, while the second plate was being made. Before the third plate had been placed in the camera, Grant went back to his original seat on the bench, and while he was writing out his orders the cap was once again taken from the lens and the last plate exposed.

During these sultry days toward the end of May, O'Sullivan, too, had been busy with his camera at Jericho Ford, photographing pontoon operations near Jericho Mills on the North Anna River.

On June third, Grant attacked Lee at Cold Harbor.

Promptly at four-thirty in the morning the Union forces advanced, leaving the comparative safety of their entrenchments. The summer air was rent with the crash of artillery and musketry that leveled everything before it. As the Union soldiers surged forward against this withering fire, more men fell than at any time under like conditions during the war. In less than ten minutes ten thousand Union soldiers lay dead and wounded on the field. The battle was over almost as quickly as it had begun; then silence reigned, and the armies watched for the next move. None was made. Grant ordered no further assaults.

The dead and wounded lay uncared for beneath the blazing summer sun for three days. The sultry night air was filled with the pitiful cries for water. The groans of the desperately wounded—all Union—who were lying between the lines tormented the soldiers who waited in the trenches. It was against orders and almost certain death to go beyond the earthworks, for the Confederate sharpshooters were ever on the alert. On the evening of the third day after the battle a short truce came in force for the burial of the dead and the care of the wounded, who for the most part now needed none. Grant said of Cold Harbor: "I have always regretted that the last assault at Cold Harbor was ever made."

It was not until June seventh or thereabouts that the photographers were able to appear on the scene of the conflict, and only a few pictures were made of the field, which had by that time been cleared of the dead and wounded. Thus ended Cold Harbor, and the first phase of Grant's campaign of '64.

After Grant's disastrous repulse at Cold Harbor on the third of June, he moved his whole army to the James River, establishing his headquarters at City Point, the terminus of the military railroad. The main object of this move was to take Petersburg, which would in turn force the Confederate Army's evacuation of Richmond. Butler's Army of the James was to advance simultaneously, attacking Richmond from the rear. Thirteen days later, on June sixteenth, Grant assaulted Lee's entrenched forces at Petersburg in a battle that lasted for three days. It ended in a bloody repulse. Then Grant settled down for a siege.

After the three days' battles, Brady advanced his photographic headquarters to the Petersburg front, establishing himself in a small log hut similar to the huts the soldiers had built when in winter quarters. Alongside was a regular army field tent. On the left of the hut, nailed to the wall, was a large, flat, copy-board. Jutting out from the wall below this was a long, narrow table on which was placed a large camera with a brass-barrelled lens.

That summer of '64 was one of the hottest the photographers had to undergo—and the pictures show it. The trees drooped in the still air. The overall glare made camera operations difficult, as they had no filters to cut down glare. And the intense heat made working in the darkroom wagon and field tent akin to working in a steam boiler room.

On June twenty-first Brady and his assistant drove their darkroom wagon out to a sector held by the Fifth Corps where Battery B, First Pennsylvania Light Artillery, was in position near the Avery house. Since the battles that ended five days before, the front had been comparatively quiet, both sides content to wait and watch for the next move. Up until the time Brady appeared on the field there had been little or no exchange of fire, and the artillerists were busy building lunettes and strengthening their entrenchments.

Lieutenant James A. Gardner, who watched Brady make his pictures under fire, in writing of the incident stated: ". . . On the night of (June) the eighteenth we threw the lunettes in front of our guns. The position was occupied by us until possibly the twenty-third or the twenty-fourth of June, when we were taken further to the left. The position shown in the picture is about six hundred yards in front and up to the right of the Avery House, and at or near this point was built a permanent fort or battery, which was used during the entire siege of Petersburg. While occupying this position Mr. Brady took photographs . . ."

It was just before noon. The sun was at its height, and the intense heat of the day parched the ground. The gunners were lolling around, talking, when Brady approached. He sought out Captain James A. Cooper and asked if he could be allowed to take a picture of the battery just in the act of firing. Captain Cooper agreed. Brady and his assistant took the big Anthony camera out of the wagon and mounted it on its tripod, slightly to the right and rear of the battery.

While Brady adjusted the camera his assistant returned to the darkroom wagon to prepare the plate. When Brady was ready, his head under the focusing cloth, Captain Cooper gave the command and the gunners jumped to their posts. Just two miles over the ridge, along the skyline, was Petersburg with its church steeples; and along the ridge lay the Confederate army. All this activity did not escape the notice of the vigilant enemy. To the Confederates it meant one thing—that the battery was about to open fire. Brady was lining up the picture on the ground glass, when shells began bursting all around. The air became filled with flying metal. When the first shell struck and burst, Brady's horse took fright and ran away with the wagon, scattering plates and chemicals all over the parched ground.

Brady's assistant, after extricating himself from the darkroom debris, brought the horses under control while Brady made a hurried examination of the camera. Cooper withheld his fire, and the shelling ceased. Brady, finding that the camera was uninjured, remounted it on its tripod and recalling his assistant, changed the position. Bringing it back a little, he again made the plate with no further molestation from the rebel batteries. After Brady had exposed the plate it was quickly processed and several more plates prepared.

Lieutenant Gardner said:

"... Mr. Brady took picture number one from a point a little to the left, and front of our battery; and the second one was taken a little to the rear, and left, of the battery. Petersburg lay immediately over the ridge in the front ..."

When these plates had been completed, Brady took a position in the midst of the battery. His assistant made another picture while Brady stood near one of the guns with his hands in his pockets.

After their work was completed Brady and his assistant drove back to headquarters where the plates were washed, dried and varnished. Their work went on long after dark.

89. **WHERE BRADY MET GRANT FOR THE FIRST TIME**
The old Baltimore and Ohio railroad station at New York Avenue and "C" Street, N.W. Washington, D. C. From a rare print made in the 1880's

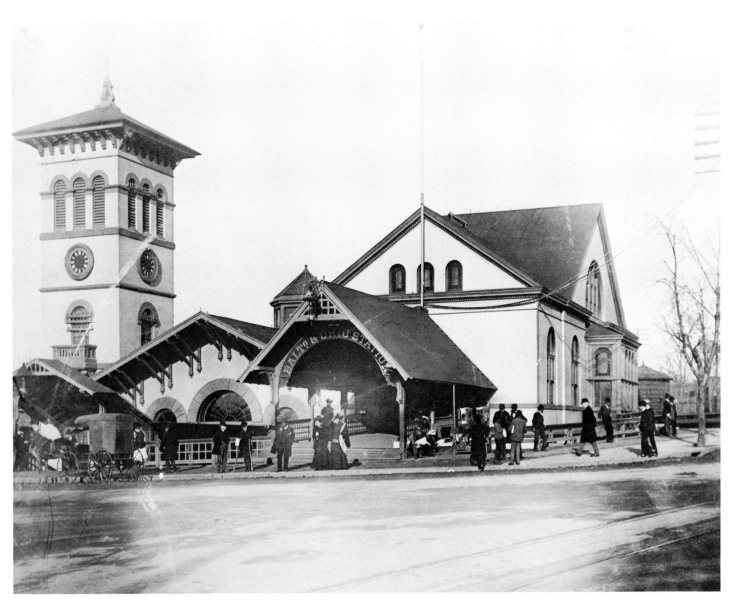

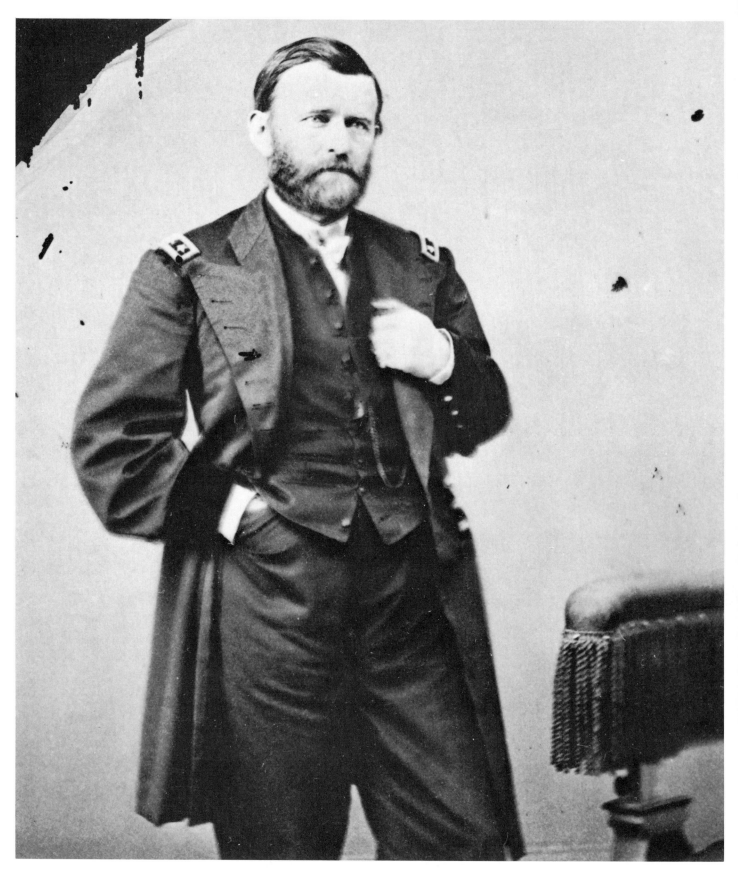

90. **ULYSSES SIMPSON GRANT**
One of the four portraits made in the Washington Gallery by Brady, when the accident of the falling skylight occurred

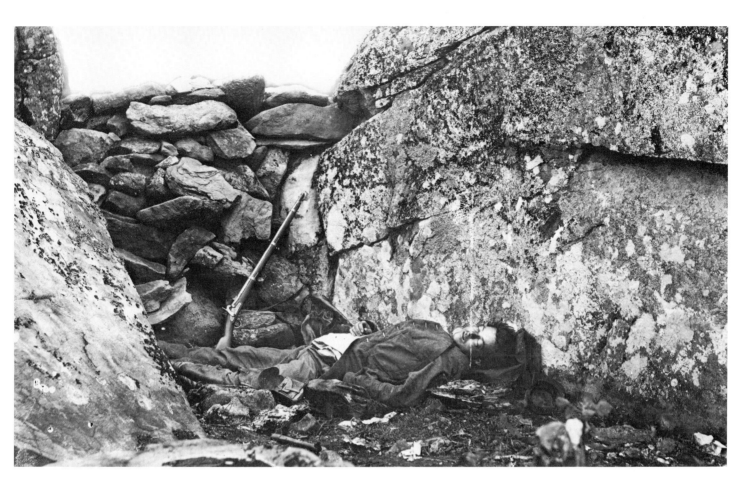

91. *Above:* DEATH OF A REBEL SNIPER: Photographed by Alexander Gardner at Gettysburg on July 5th, 1863. *Below:* UNION DEAD. Photographed by Brady with a Stereoscopic camera shortly after the battle near the Devil's Den

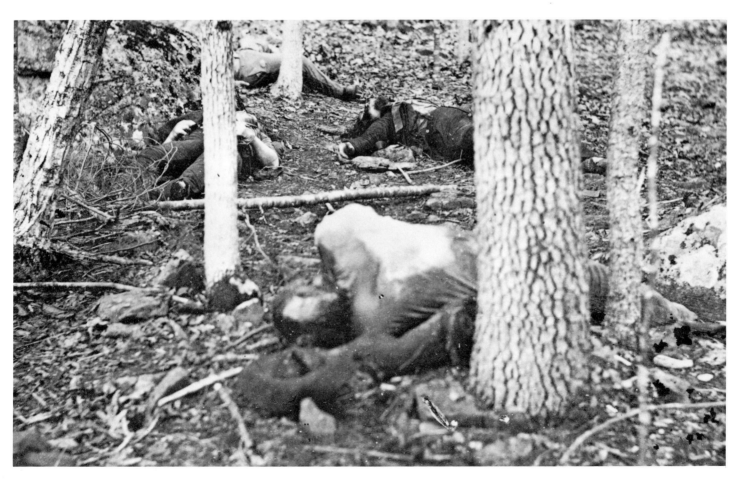

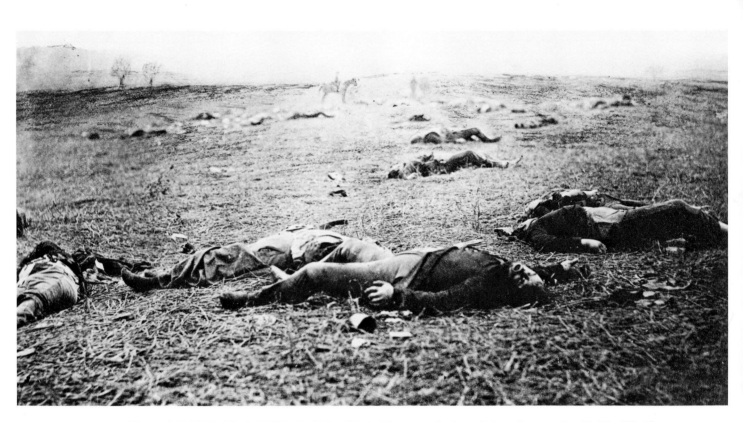

92. *Above:* DEATH ON A MISTY MORNING. Photographed on July 5th, 1863 by T. H. O'Sullivan on the field of Gettysburg. *Below:* MEN OF THE 1ST MINNESOTA. Photographed by Brady shortly after the battle of July 3rd, 1863 near the Peach Orchard

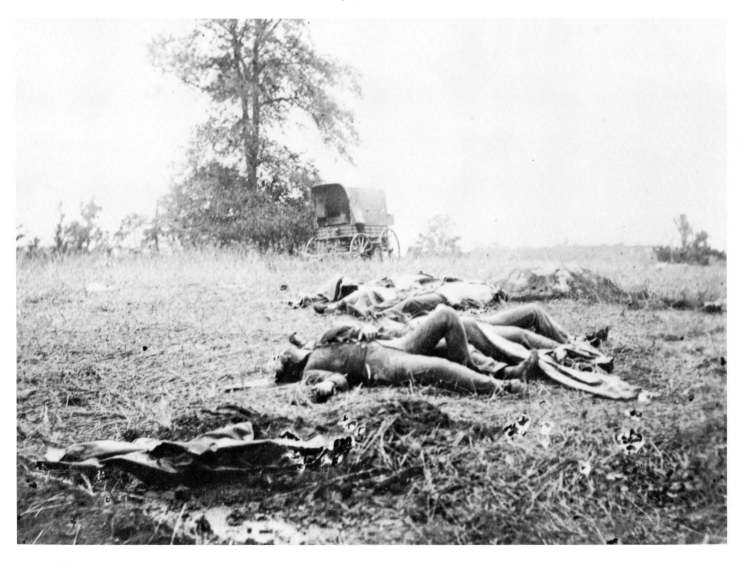

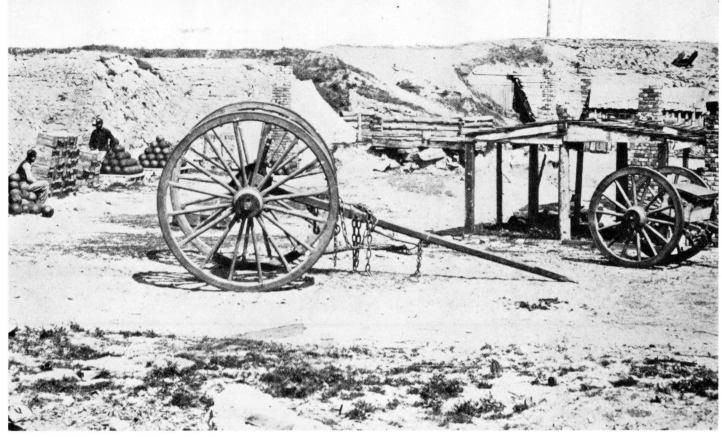

93. *Above:* INTERIOR OF THE SECOND FORT SEDGEWICK. Photographed by Brady during the summer of 1864. *Below:* LOCOMOTIVE AND BLOCKHOUSE OF THE U. S. MILITARY R.R. Photographed by Brady at Port Royal in the Spring of 1863. From a rare albumen print believed never before published

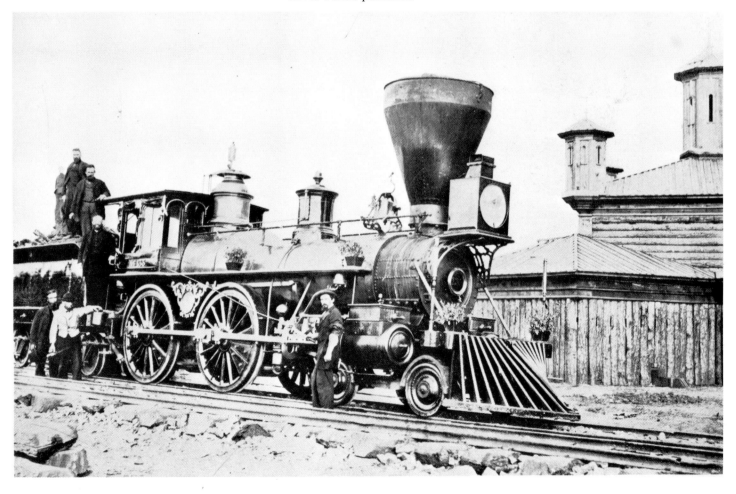

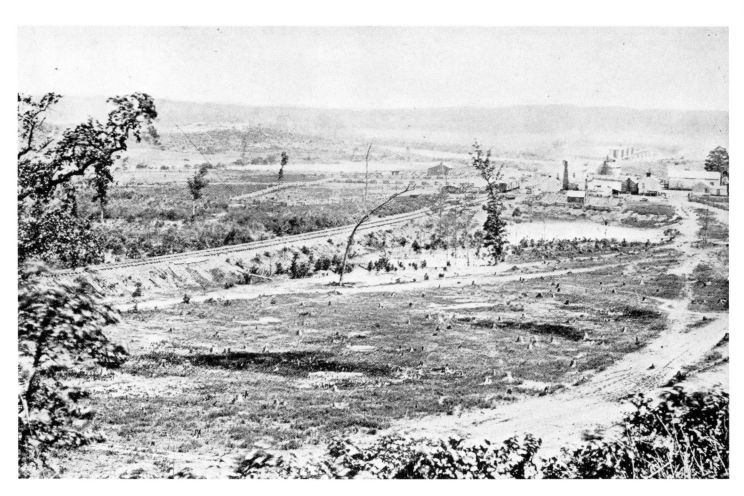

94. *Above:* BATTLEFIELD OF NEW MARKET. Photographed by Brady in the Spring of 1863.
Below: UNION ARMY SUPPLY DEPOT AT WARRENTON, VIRGINIA. Photographed by Brady
sometime in August of 1862. From a rare original albumen print made on thin paper

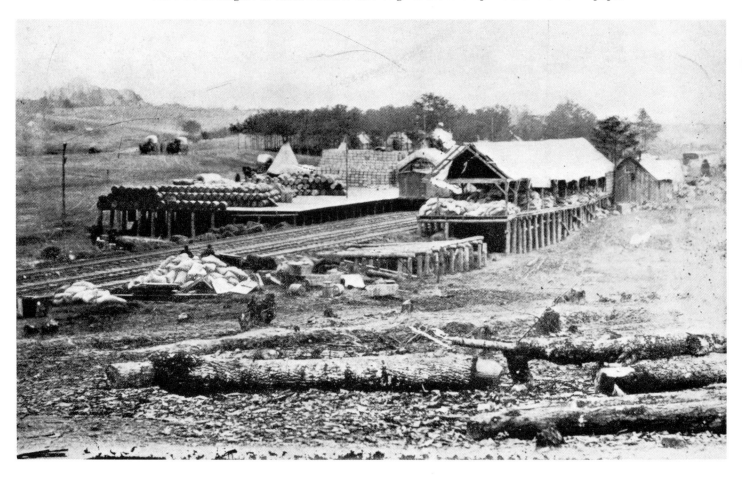

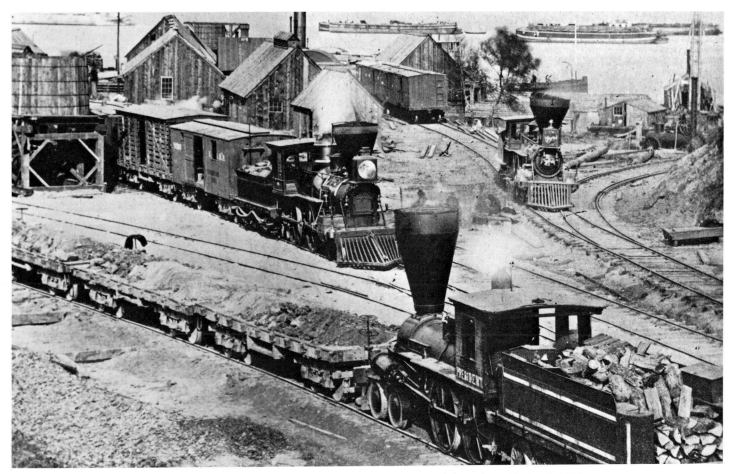

95. *Above:* TERMINUS OF GRANT'S MILITARY RAILROAD AT CITY POINT. *Below:* WHARVES AND TRANSPORTS AT CITY POINT. Photographed by Brady during Grant's drive against Petersburg, Virginia in early 1864

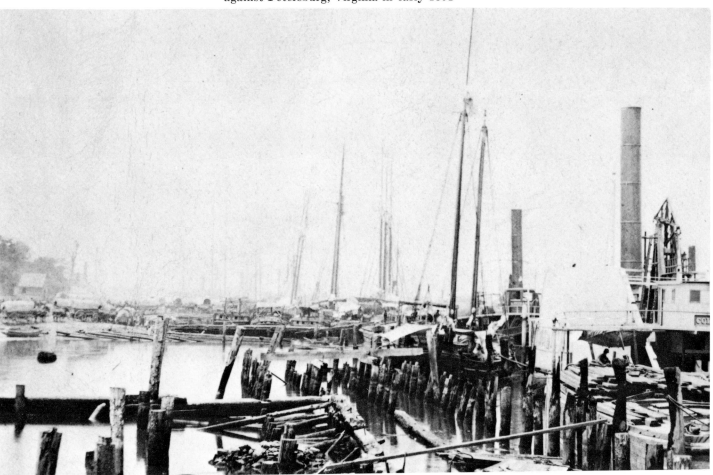

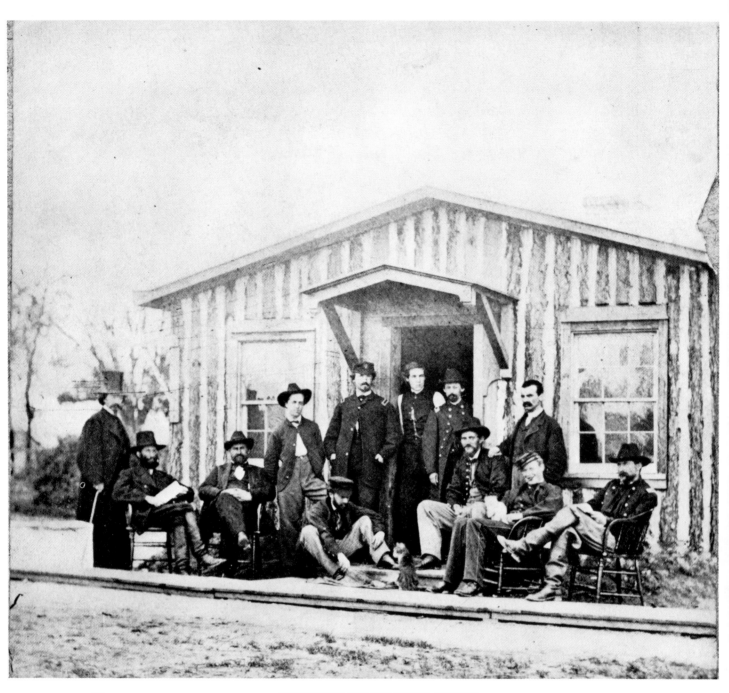

96. OFFICERS OF GRANT'S STAFF
A rare unpublished photograph made at City Point, Virginia in the Spring of 1864 by one of Brady s
photographers. Brady is standing on the extreme left. From an original print in the Brady Album
 Gallery on a large card with five other photographs

97. THE "WHATSIT" AT CITY POINT

Two views of Brady's Traveling Darkroom wagon photographed by him at City Point, Virginia in the Summer of 1864. From original albumen prints in the Brady Album Gallery

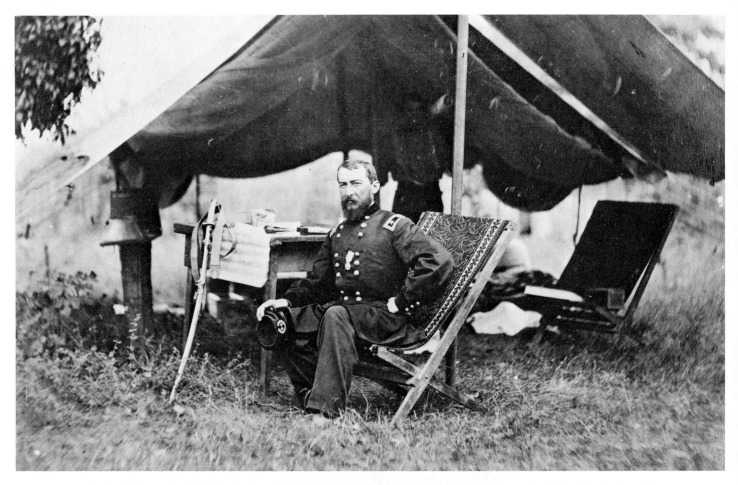

98. *Above:* **MAJOR-GENERAL PHILLIP HENRY SHERIDAN.** Photographed by Brady late in 1864. *Below:* **U. S. GRANT AND STAFF.** Photographed by Brady at City Point in June of 1864

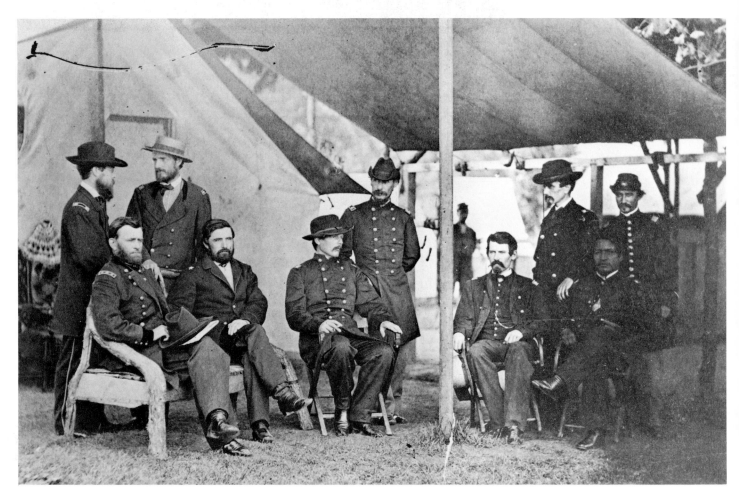

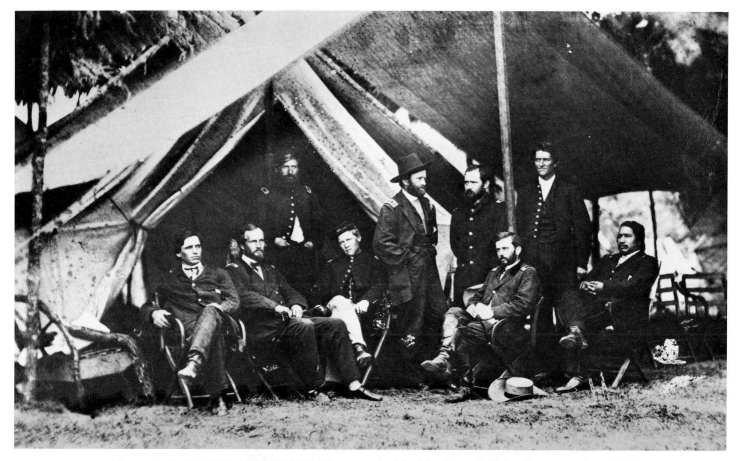

99. *Above:* U. S. GRANT AND STAFF. Photographed by Brady at field headquarters shortly before Lee's surrender. *Below:* MAJOR-GENERAL ROBERT B. POTTER AND STAFF. A photograph made by Brady's assistant just before the battle of the Wilderness. Brady is leaning against a tree on the right. Photographed on or about May 2nd or 3rd 1864

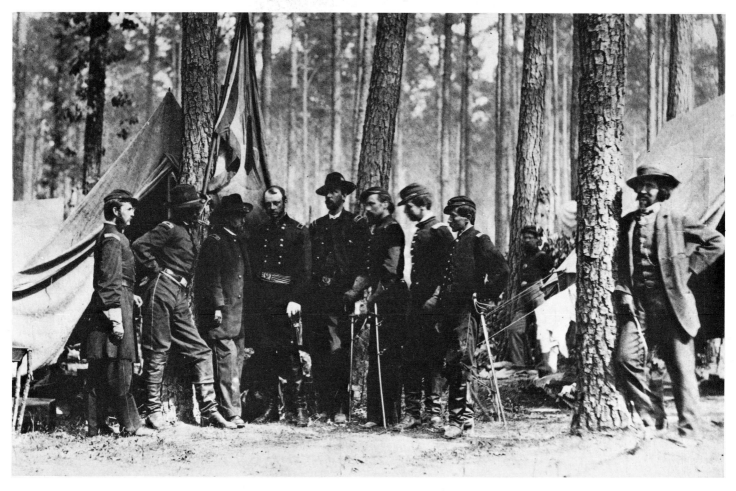

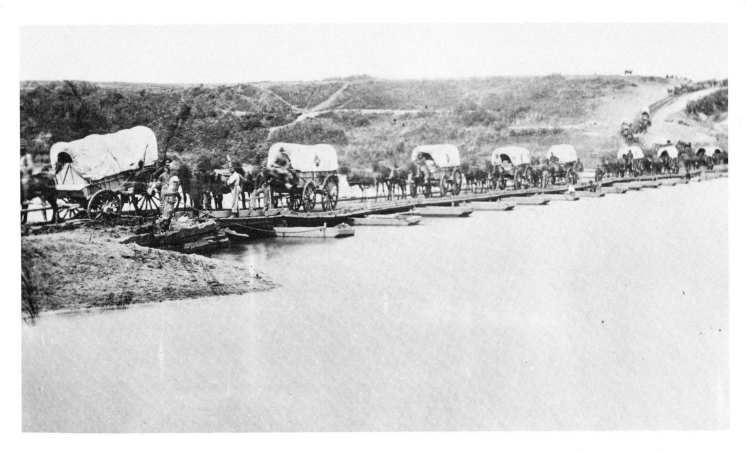

100. *Above:* GRANT'S WAGON TRAINS CROSSING THE JAMES AT GERMANNA FORD.
Below: CONFEDERATE PRISONERS AT BELLE PLAIN. Photographed by Brady during the campaign of the Wilderness

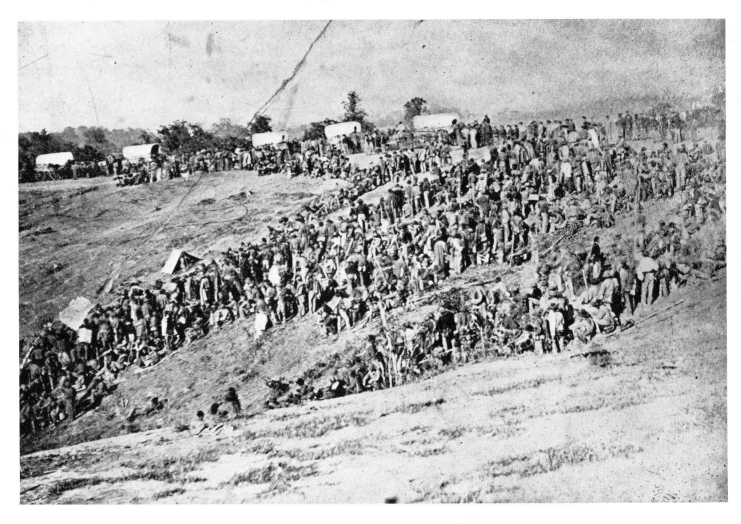

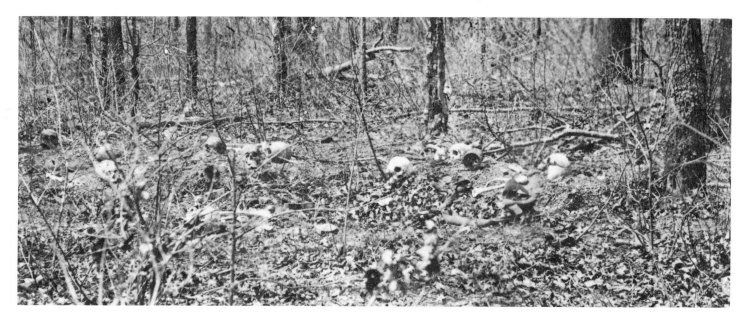

101. *Above:* REMAINS OF THE DEAD OF CHANCELLORSVILLE. Photographed by Brady during Grant's Wilderness campaign. *Below:* BRIDGE OVER THE NORTH ANNA. Photographed by O'Sullivan immediately after Grant's crossing

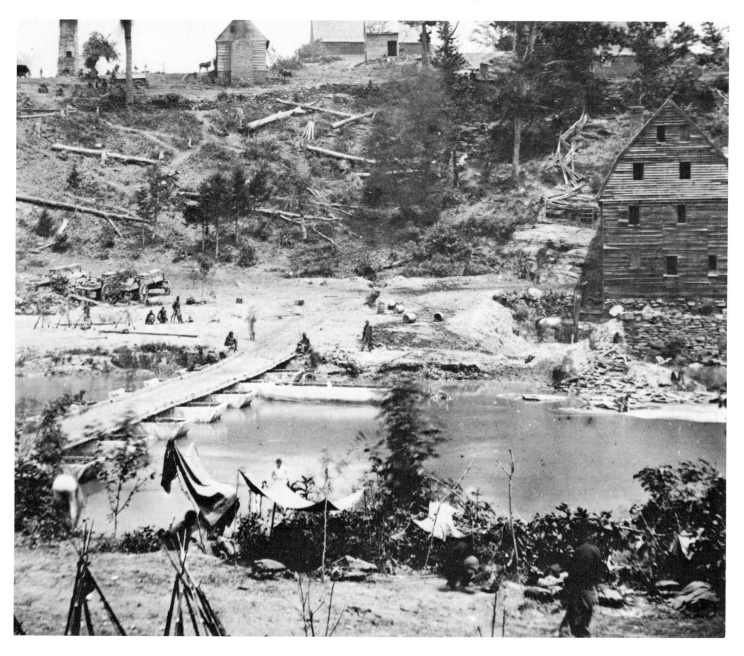

102.

THE PETERSBURG COURTHOUSE

A photograph made by Brady shortly after the Union Army entered in 1865

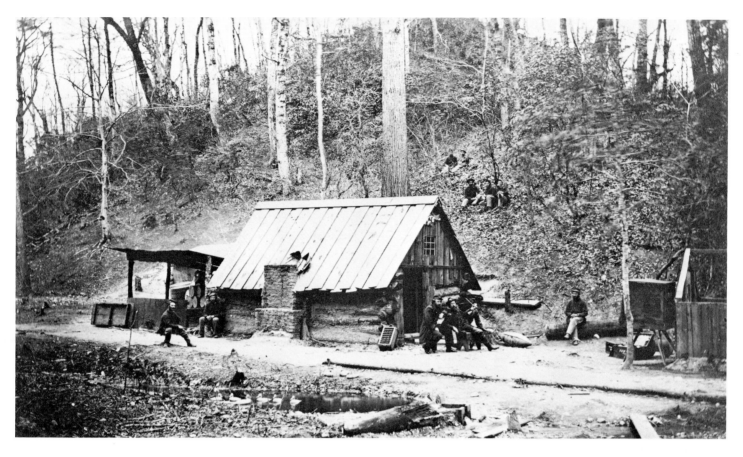

103. *Above:* TORPEDO STATION ON THE JAMES RIVER. Photographed by Brady during the siege of Petersburg. Note the portable photographic outfit in extreme right hand corner. From a rare original albumen print never before published. *Below:* BOMBPROOF IN THE LINE IN FRONT OF PETERSBURG. Photographed by Brady during the siege

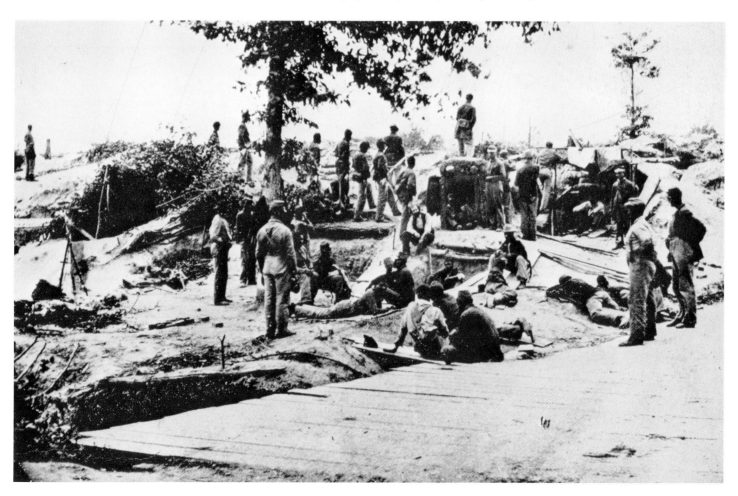

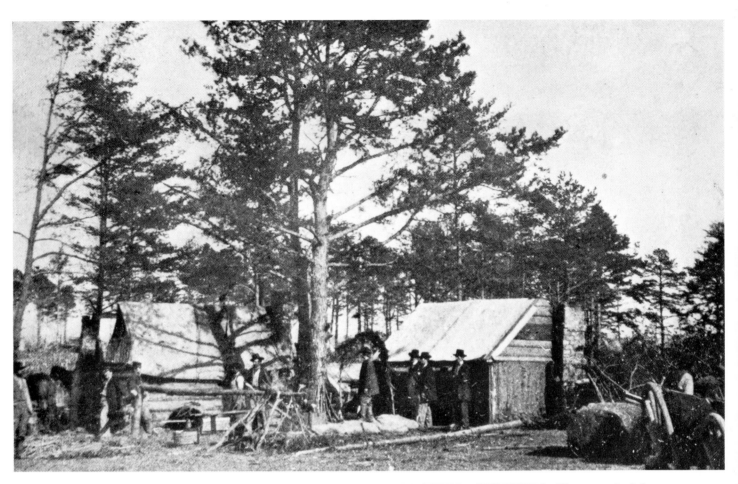

104. *Above:* A VIEW OF BRADY'S PHOTOGRAPHIC FIELD QUARTERS. Photographed by Brady near Petersburg, Virginia in 1864. *Below:* CAMP SCENE BEFORE PETERSBURG. A Brady photograph

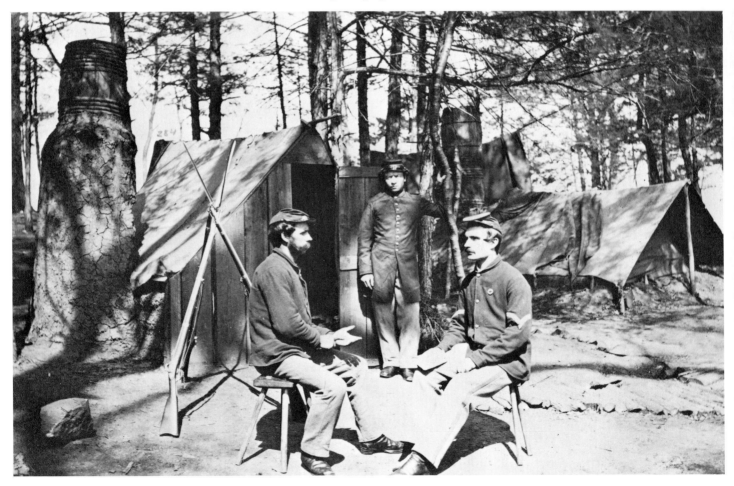

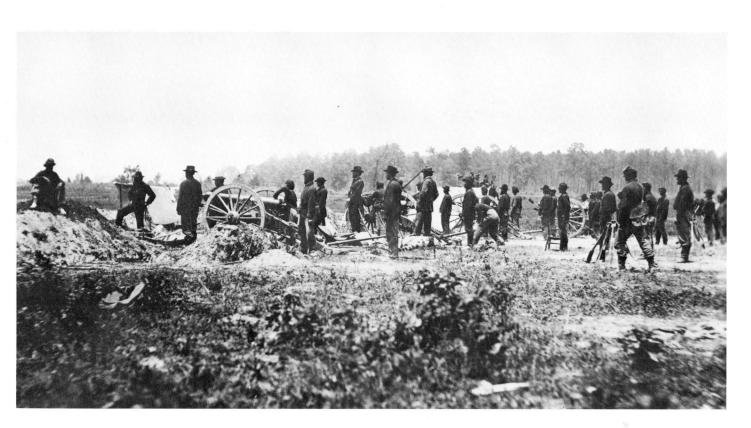

105. *Above:* BRADY WITH THE ARMY BEFORE PETERSBURG. Cooper's Battery under fire taken by a Brady assistant in 1864. Brady is the civilian in the centre standing on a little mound with his hands in his pockets. *Below:* BATTLEFIELD OF THE WILDERNESS. Photographed by Brady in May of 1864, during the campaign against Petersburg

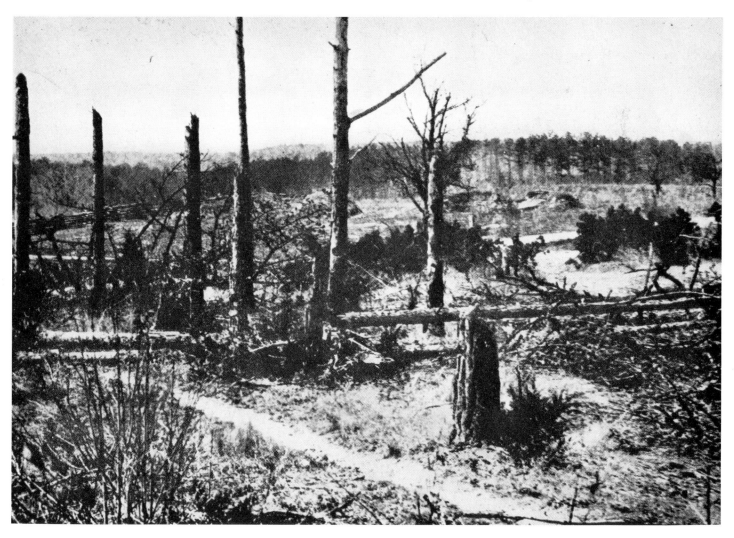

CHAPTER

EIGHTEEN

THE MILITARY PRISONS of the South were notoriously bad. The Confederate Government, blockaded from medicines and food, allowed these prisons to get into such a state that death and disease were rampant. But the most notorious was the "Stockade" at Andersonville in Georgia. The role photographers played in the exposé of the Andersonville Military Prison concerned one Northerner and one Southerner. Definite proof of who the Confederate photographer was does not exist, but in all probability he was either George S. Cook, a former Brady employee, or E. B. Lytle, the Confederate spy-photographer. And although Brady's name is not mentioned in connection with this affair, it is logical to assume that he was the Northern photographer who took the damning pictures.

The Andersonville affair arose under the pressure brought on the South by the closing in of the armies of Grant. The Confederate Military Prison of Andersonville was in Sumter County, Georgia, sixty miles from Macon. Built of spiked timbers with a cat-walk around the outside, it resembled the type of fort used during the Revolutionary and Indian Wars. Into this pen were thrust 41,678 Union prisoners, cooped up in thirteen acres of swampy ground. There was hardly room to lie down at night. The enclosure was crossed by a small sluggish stream about a foot deep and five feet wide. The Confederate Armies, drained of manpower, could not leave adequate guard for the prisoners. And to discourage escape, a "dead line" was drawn around the inside of the enclosures. This was a fence that reached almost to a man's knee. It encircled the stockade about five feet from the inner side of the wall. Any prisoner who as much as placed his foot over this fence was immediately shot.

There were no barracks or huts. The prisoners, exposed to the rigors of torrid heat in summer and the ravages of rain and sleet in winter, built crude tents and used straw for beds. The Confederacy, short of food for her armies, could not properly feed them. Sickness and death resulted.

The prisoners were so desperately eager to get outside the stockade even for a moment that it was considered good fortune to find a man who had died during the night, for whoever found a corpse would be allowed to help carry it outside the stockade to the dead-

house. On the way back he might pick up a chunk of wood to use for cooking.

Under the blazing, hot, Southern summer sun, pestilence stalked at noon-day. To look in any direction was to see dozens of men in the last frightful stages of scurvy, gangrene, and disease.

This Prison was under the command of Captain Henri Wirz, whose disciplinary methods were regarded as contemptible from any viewpoint, and whose favorite saying was, "Py Gott, you don't vatch dem damn Yankees glose enough! Dey are schlippin' round an' peatin' efery dimes".

Jefferson Davis made several proposals for the exchange of prisoners, but his plea met deaf ears in the North. Grant, who had parolled 29,000 Confederates at Vicksburg on their word alone, did a turnabout on Davis' question and was heartily opposed. During the midsummer of 1864 Grant wrote an indirect reply to Davis:

"On the subject of exchange of prisoners, however, I differ from General Hitchcock. It is hard on our men held in Southern prisons not to exchange them, but it is humanity to those left in the ranks to fight our battles. Every man released on parole, or otherwise, becomes an active soldier against us at once either directly or indirectly. If we commence a system of exchange, which liberates all prisoners taken, we will have to fight on until the whole South is exterminated. If we hold those caught, they amount to no more than dead men. At this particular time to release all rebel prisoners North would insure Sherman's defeat, and would compromise our safety here."

As it appeared to Davis, able bodied prisoners need not be exchanged. To relieve the Confederacy of the responsibility of taking care of the sick and wounded prisoners, Davis offered to return without equivalents, 15,000 sick and badly wounded Union prisoners at an arranged meeting place at the mouth of the Savannah River. This offer would stand if transportation were supplied by the North. At first this proposal was flatly refused, and not until seven months had passed was it accepted.

During this time, Brady had been with Grant's army at Cold Harbor and the Wilderness. He was told to take his paraphernalia to Annapolis, Maryland, where he would be further instructed in what he was to photograph. In the meantime pictures by the Confederate photographers of the conditions at Andersonville were sent to the Northern Government to stimulate action on the Davis proposal.

An eye witness to the taking of these photographs was a soldier of the North who described himself as "a former 'star-boarder' of Andersonville". He wrote: "I was a prisoner of war in that place during the summer of 1864 and I well remember seeing a photographer with his camera in one of the sentinel boxes near the south gate during July or August, trying to take a picture of the interior of the prison. I have often wondered in later years what success this photographer had and why the public never had the opportunity of seeing a genuine photograph of Andersonville."

Apparently the pictures had the desired effect, for the transports were sent to the designated place and the prisoners were transferred to Annapolis. After the prisoners were

187

taken care of, a place was selected for Brady to take his photographs. The prisoners were photographed at their worst. Desperately wounded and sick men without an arm and leg were numerous. Others, emaciated from lack of proper diet, indescribable wrecks of humanity, were photographed one by one.

The pictures were sent to Washington. Who received them, or for what purpose they were to be used, was never made public. There is no record of them in Northern journals. But that they were used is indicated by Jefferson Davis who in writing of the incident states:

"On two occasions we were asked to send the very sick and desperately wounded prisoners, and a particular request was made for men who were so seriously sick that it was doubtful whether they would survive a removal a few miles down the James River.

"Accordingly, some of the worst cases, contrary to the judgment of our surgeons, but in compliance with the piteous appeals of the sick, prisoners were sent away and after being delivered they were taken to Annapolis, Maryland, and there photographed as specimen prisoners.

"The photographs were terrible indeed, but the misery they portrayed was surpassed by some of those we received in exchange at Savannah. Why was this delay between summer and November in sending vessels for sick and wounded, for whom no equivalents were asked?

"Were the Federal prisoners left to suffer, and afterward photographed to aid in firing the popular heart of the North?"

It seems that here Davis had struck on something. But how did Davis get the prints of the pictures that Brady had taken? Were spys among the Northern authorities? Pictures could not be published in the papers. Only line cuts could be made from photographs and they were crude at best.

The pictures never appeared publicly until engravings from the Confederate photos were used to illustrate a book on Southern military prisons written by one of the inmates a few years after the war.

The Civil War Johnny was not to come marching home for another nine months,— nor was Brady except for occasional trips to his studio. On those occasions he was engaged in the work of cataloguing the plates and prints that the field men sent in.

Following the battles of June, Grant laid siege to Petersburg. Assaults on the Confederate lines were frequent and sanguinary. Then for a time all was quiet.

Just before dawn on July 30th, the silence was broken by a terrible explosion in the Confederate lines. A huge mine the Pennsylvanians had planted under the Confederate trenches had been set off, blowing a whole regiment and a battery of artillery into the air. An assaulting column of white and negro Union troops was rushed into the breach before the enemy could recover, but instead of going around the edge of the crater, they rushed into it. The Confederates opened fire at once, pouring shells into the crater upon the confused mass of men. This was the Battle of the Crater, another disaster for the Union.

The Confederate lines were quickly restored and the siege went on. Heavy fighting broke out at intervals during the following months but the Confederate lines still held. Night sorties and surprise attacks were frequent and bloody, and sniping was a pastime indulged in by both sides.

Ignoring these dangers, Brady once took his equipment out to the advanced picket lines where, behind sand-filled gabions the sharpshooters were carefully searching the Rebel lines for a target. Brady made the pictures from an extremely low angle with the camera almost on the ground. The darkroom tent was set up behind one of the gabions with bottles of chemicals and glass in boxes lying about on the hard-packed earth. The camera was moved three times, while musket balls sang over head.

During the early fall, rainy weather hampered photographic operations, but on fair days the photographers were kept busy, and the cameras were again familiar sights in the lines and around the camps.

In October heavy seacoast siege mortar, weighing seventeen thousand pounds, and mounted on a flat car, made its appearance on the City Point Railroad. The very capable combat photographer, David Knox, was probably assigned by Brady to make a pictorial record of this land gunboat when it was pushed into position on a spur track. The soldiers named it "The Dictator" and called its accompanying train "The Petersburg Express".

This gigantic weapon was capable of throwing a two hundred pound shell over four thousand yards. These shells, lobbed over the enemy trenches in a high arc, were terrifying to the Confederates, who knew their damaging effect; but they learned to dodge them. "The mortars are thrown to great height," wrote one Confederate, "and fall down in the trenches like a ball thrown over a house . . . We have become very perfect in dodging them and unless they are thrown too thick, I think I can always escape them, at least at night." It was easy to trace their burning fuses as they hurled against the dark sky.

The mortar was likened to the Irishmen's flea by the photographers because of its elusiveness. For as soon as the enemy got its range and started shelling, it was quickly hauled to another position along the track, and like the flea, "When they put their hand on it, it wasn't there." But once Knox was in the vicinity of the Jordan House, where the mortar was in position, with his darkroom wagon and equipment. He had his camera a little to the right and front of the "Dictator". Between the long intervals while the crew prepared and loaded the gun he exposed his plates.

Grant's last Spring campaign was about to open. Rumors were circulating thick and fast at Brady's photographic headquarters. Captain A. J. Russell, the army photographer, was sitting in his tent at headquarters, when Thomas C. Roche entered. Addressing the Captain, he said, "Cap, I am in for repairs and I want to get things ready for the grand move, for the army is sure to move tonight or tomorrow night. The negatives on hand I wish to send North with some letters, prepare my glass and chemicals; in fact, get everything ready for the grand move, for this is a final one, and the Rebellion is broken, or we go home and commence over again." That night the two photographers sat up late, smoking and talking of the events of the past few days. Roche had been with Butler's Army

of the James photographing that luckless officer's operations, when his equipment was damaged by shell fire. He told how while he was working with his camera, the Confederates were bombarding the works, lobbing big shells over from Howlett's Point every few minutes. Roche had already completed several plates and was in the act of winding up the operation by photographing one of the main sectors of Butler's project. He had the camera mounted ready to expose the plate, his head under the focusing cloth, when a shell landed at great velocity and exploded within a few rods of where he was working, throwing a shower of dirt and rocks all over him and the camera.

Shaking the dust from the camera and himself, he quickly moved the camera, *placing it over the crater just made by the shell,* and calmly made his plate. Not until he was finished did he fold up his tripod and return to the safety of the dugout.

Later as they sat and talked of the incident, Captain Russell asked him if he was scared. "Scared?" he answered, "two shots never fell in the same place!"

At nine o'clock on the morning of March 29th, 1865, Grant's last campaign began. Roche's prophecy had proved correct. Since before three o'clock that morning the Federal columns had been in motion. The weather had been favorable for the past few days, and the roads were in fair condition for marching troops. But by April first, when the whole Union Army was in motion, the roads and fields had become beds of quicksand in which horses sank to their bellies.

Lee made a stand at Five Forks where the forces of Sheridan, Merritt, Warren, and Custer attacked Pickett. The thunder of hundreds of guns shook the ground like an earthquake. Soon the troops all along the line were engaged. Finally Generals Wright and Parke carried the enemy's outer fortifications. As soon as word reached Brady of the breakthrough, he and his assistant hitched up the horses and struck out for the trenches that had just been evacuated. Their progress was slow, for the wagon often sank almost to the hubs in the thick mud and teamsters, prisoners, stragglers and walking wounded choked the roads.

Upon reaching the fortifications just evacuated, the photographers carried the dark tent and cameras to the scenes that were now accessible. Most of the trenches were filled with mud and water, and the violence of the shelling was evident all around. The next two or three days were spent in photographing these fortifications, while burial parties searched for bodies overlooked in the hurried advance.

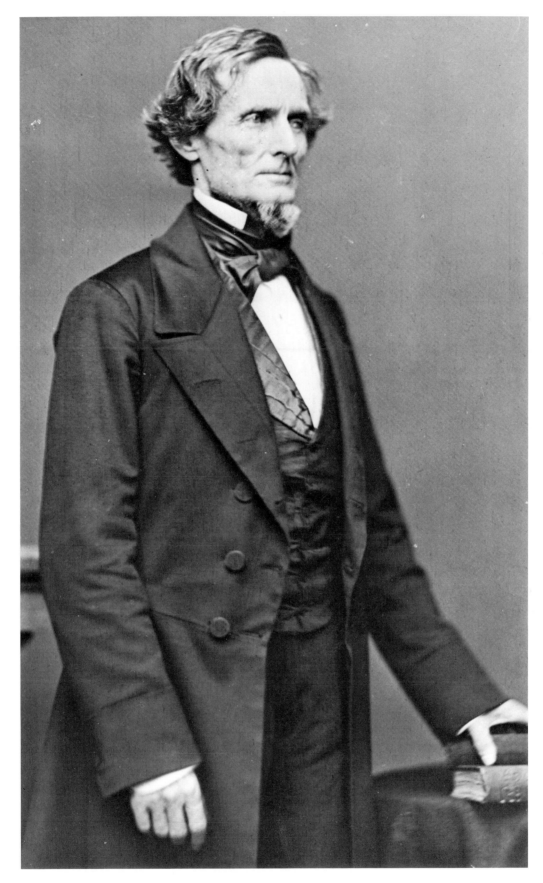

106.
JEFFERSON DAVIS
From an original negative by Brady made presumably in 1859-1860 in the Washington Gallery

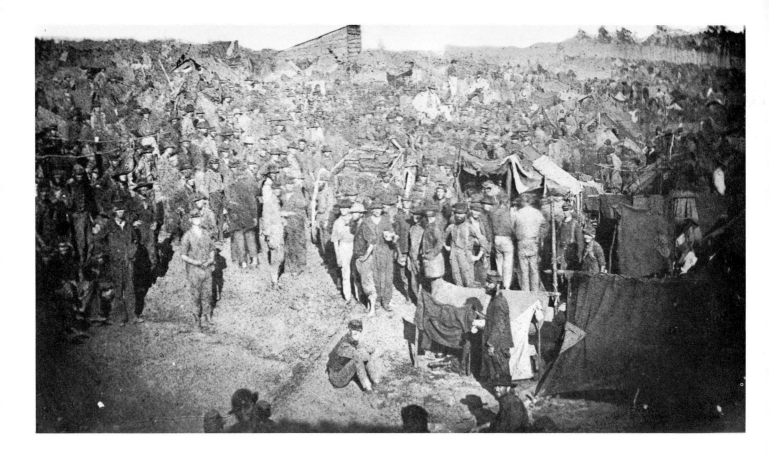

107. TWO VIEWS OF THE CONFEDERATE MILITARY PRISON AT ANDERSONVILLE, GEORGIA. *Above:* Union prisoners awaiting the distribution of rations. *Below:* The living quarters of the prisoners. Both photographs are from original albumen prints made by a Confederate photographer, presumably Cook or Lytle, and reproduced in their exact size. Published for the first time since 1907

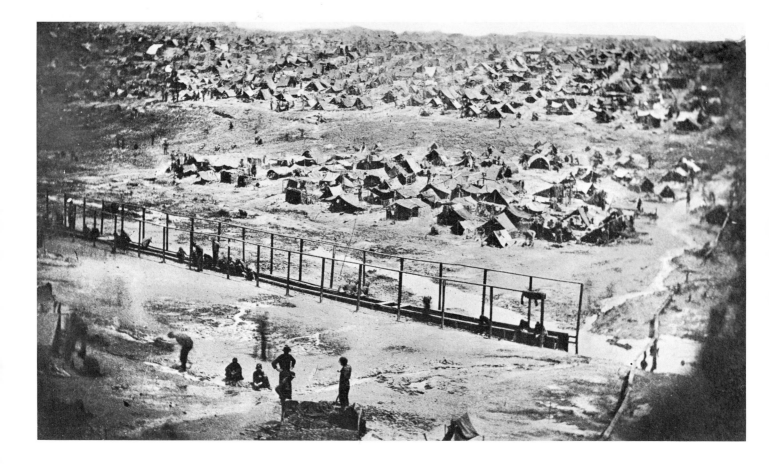

virulent condition, according to the changes o
and occasionally raging in destructive epidemics
to speak with any degree of definiteness as to
since I had ceased to interest myself about the

CORPORAL JOHN W. JANUARY,

Co. B, Fourteenth Illinois Cavalry.

(From a photograph taken after his arrival at Annapolis.)

ter of wood in the daily issues to me, were
importance than the increase or decrease of the

rhages from the bowels, and the effusion into the various tissues
of a deeply-colored fibrinous exudation ; but, as we have con-
clusively shown by *post-mortem* examination, this state is also
attended with consistence of the muscles of the heart, and of
the mucous membrane of the alimentary canal, and of the

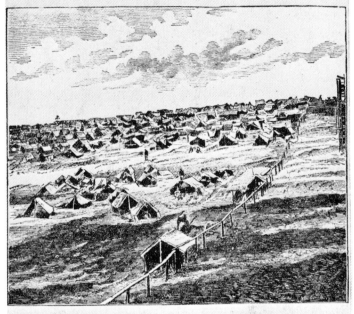

A SECTION FROM THE EAST SIDE OF THE PRISON SHOWING THE DEAD LINE
(From Rebel Photographs in possession of the Author)

solid parts generally. We have, according to the extent of the
deficiency of certain articles of food, every degree of scorbutic

108. *Above Left:* Facsimile of a photograph made at
Annapolis presumably by Brady, which appeared in
a book by John McElroy in 1879. *Above Right:* Fac-
simile of a Confederate photograph appearing in the
same book. *Below Right:* Facsimile of a photograph
of a Union prisoner suffering from gangrene at An-
napolis presumably taken by Brady and reproduced
in the McElroy book on Military prisons

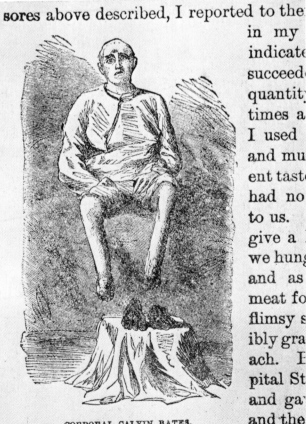

sores above described, I reported to the
in my
indicate
succeed
quantity
times a
I used
and mu
ent tast
had no
to us.
give a
we hung
and as
meat fo
flimsy s
ibly gra
ach.
pital St
and ga
and the
pleasan
A m

CORPORAL CALVIN BATES.

Company E, Twentieth Maine.

[From a photograph taken after his arrival at
Annapolis.]

CHAPTER NINETEEN

N APRIL 8, General Grant sent this note through the lines to Lee:

Hdqtrs., Armies of the
United States.
5 p.m., April 7th, 1865

General R. E. Lee, Commanding C. S. A.

The results of the last week must convince you of the hopelessness of further resistance on the part of the Army of Northern Virginia in this struggle. I feel that it is so, and regard it as my duty to shift from myself the responsibility of any further effusion of blood by asking of you the surrender of that portion of the Confederate States Army known as the Army of Northern Virginia.

U. S. Grant, Lieutenant-General

Lee, realizing the end was near, asked Grant what the terms of surrender would be.

Lee arrived at the McLean House shortly before 1:30 in the afternoon on April 9. He waited about a half hour before Grant, Sheridan and General Ord arrived. They mounted the steps and entered.

Now that the end was at hand no photographer was present. Brady had been in the lines near the Petersburg front, but no rumor of surrender had reached him. It seemed inconceivable that such an historic moment was to go unrecorded. But so it was, and the only record, pictorially, is a painting made from pencil sketches of the event by an eye witness at the time.

After terms of surrender were arranged, Lee bowed to Grant and the other Union officers in the room and slowly walked out to the porch and looked around for his horse, Traveller. An orderly saw him and brought the animal to him. Lee mounted and started back to his own lines. As he slowly rode away, the Union officers followed Grant's example and removed their hats. They stood bareheaded until Lee was out of sight.

On April 10, Lee bade farewell to his faithful troops. At the end of a touching address and shaken with grief, he quietly left his headquarters in the field. Accompanied by Colonel Venable, Colonel Walter Taylor, his aide, Colonel Marshall, and Colonel Cook, Lee took the Old Stage Road to Buckingham and Cumberland Courthouse.

At Cumberland Courthouse, he went at once to the bivouac of General Longstreet a few miles outside the town. There, Lee pitched his tent. Townspeople came out with provisions and some invited him into their homes. The next day he stopped at the home of Charles Carter Lee, in Powhatan County, Virginia, where he was joined by the following morning by his son, Rooney, and his nephew, John Lee. The party continued down the River Road toward Richmond.

Brady had been in the vicinity of Warren's VI Corps headquarters on the Petersburg lines in Virginia, busily photographing the Confederate field fortifications that had withstood Grant's siege for nine months. When he received word of the surrender, he and his assistant immediately got their equipment together and drove to Appomattox and the McLean House, recent scene of the Peace negotiations. But nothing was left to photograph but empty rooms.

The Union officers had taken or bought everything for souvenirs of the event. One of the most important items was the table that Lee and Grant used for a desk. General Ord bought the table from the McLeans and years later sold it when he was desperate for funds. The ink stand, pen, lamp, pictures, the chairs on which the principles sat—in fact, everything was gone.

Brady set up his outfit and made several pictures of the empty rooms. He also took an exterior shot of the McLean house itself.

Arriving at the Capital of the dying Republic, General Lee rode through streets filled with debris, past fire-charred buildings, and on toward his home at 707 Franklin Street. The news of his arrival had spread before his coming and crowds gathered, lined the streets, and silently watched the little procession. Many openly wept. A few Federal soldiers recognized and cheered Lee as he passed.

Brady was hurrying to Richmond over the same roads Lee had taken. On April 14, while he was enroute, President Lincoln was shot and killed by John Wilkes Booth, whom Brady had known and had photographed several times when theatrical troupes had visited Washington and New York. But Brady did not learn of the assassination until he reached Richmond.

Brady drove up to the Lee residence, walked up on the porch and rang the bell. It was doubtless Custis Lee, the son of the defeated general, who answered the door. He and his cousin had been receiving callers to allow the General to get a much needed rest.

Brady introduced himself and stated the purpose of his visit. He received a courteous refusal, perhaps because of Lee's dislike for being photographed.

"It was supposed," said Brady to George Townsend in an interview, "that after his defeat it would be preposterous to ask him to sit, but I thought that to be the time for the historical picture".

"Of course", he continued, "I had known him since the Mexican War, when he was on General Scott's staff and my request was not as from an intruder."

Shortly afterward Brady met General Robert Ould, whom he had known in Washington. Brady told of his wish to photograph Lee and also of his first unsuccessful attempt at

winning the General's consent. General Ould promised to assist in arranging for a sitting. The following day Brady was allowed exactly one hour to photograph the General. He felt that time would allow for about five pictures.

The picture-taking was done on the back porch. When Brady had his camera in position and the plates ready for coating, one of the chairs was brought from the house. Shortly after, the General appeared, dressed in the uniform he had worn at the surrender.

Brady first took a portrait of Lee seated, a profile picture. Then another with Custis Lee and Colonel Walter Taylor on either side of him. Then, Brady took a photograph of Lee standing alone in the doorway. This was a stern picture.

Brady said, "There was little conversation during the sitting, but the General changed his position as often as I wished him to."

Early in 1850 when a young Colonel of Engineers, Lee had a Daguerreotype made by one of the early practitioners. His second sitting was made for Vannerson, a Richmond photographer, in 1862. This last was the result of pleadings of a group of Richmond ladies who had made him a set of shirts. There was another photograph of him which was made in the field by an itinerant photographer. Brady was the fourth to take a picture of the General, and by far the most successful.

Throughout the war the illustrated papers had printed an engraved impression of a painting of Lee. It represented him as he looked when a professor at West Point, smooth shaven with jet black hair and a black mustache. This engraved impression had been freely circulated through the South as well as the North and until Brady made the photographs, "the country had but little knowledge of his personal appearance."

109. FREEDMEN ON THE CANAL BANK AT RICHMOND.
A group of negroes photographed after the evacuation of the Confederate forces in April 1865

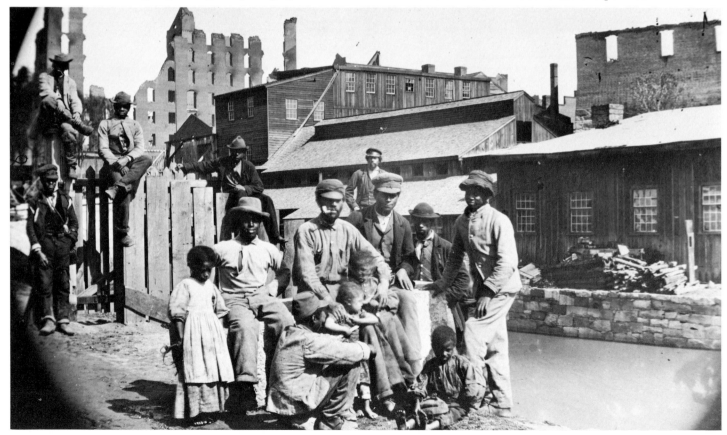

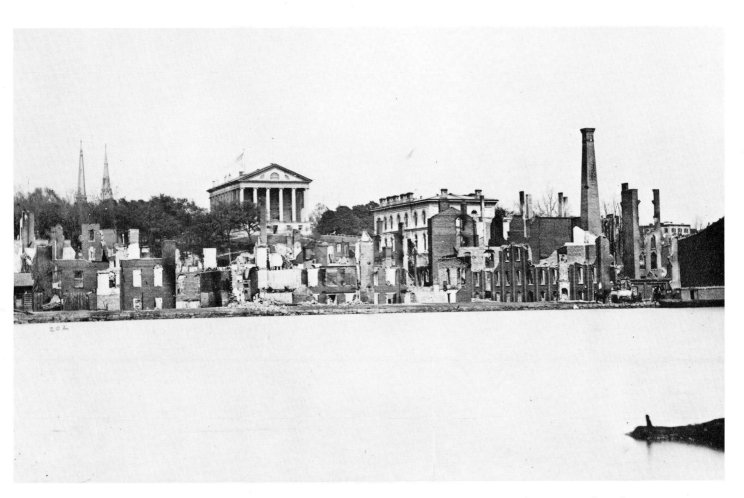

110. *Above and Below:* RICHMOND IN 1865. From rare original albumen prints mounted on heavy cardboard, believed unpublished

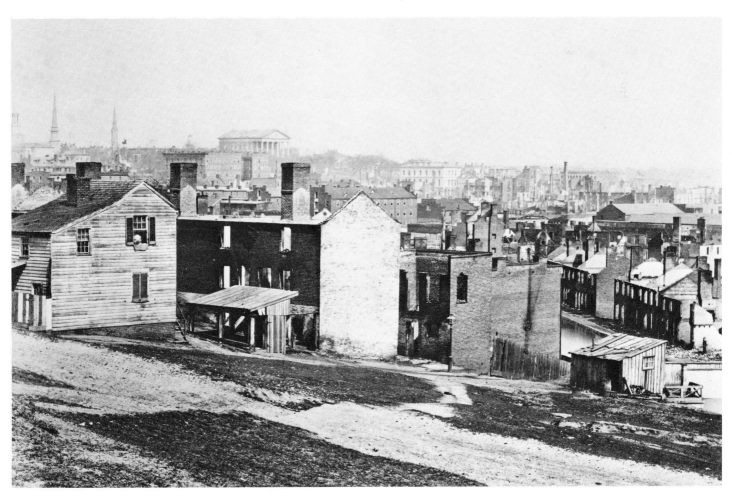

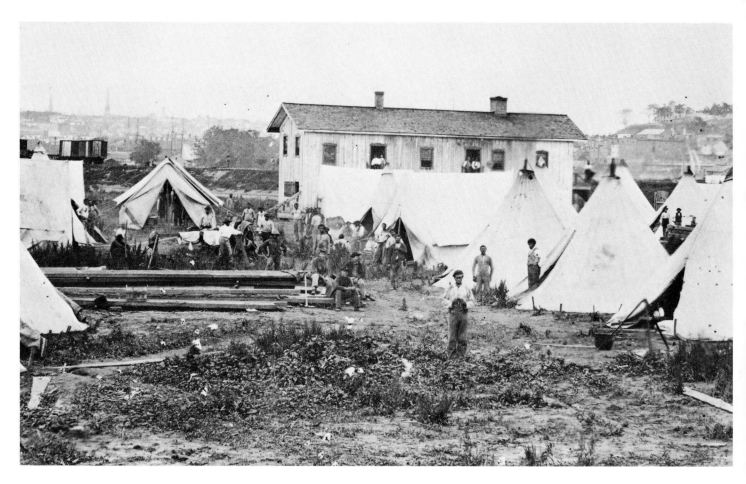

111. *Above:* A rare photograph of a Freedman's Camp on the outskirts of Richmond. The city can be seen in the distance. Believed unpublished. *Below:* CANAL AND RUINS OF THE CRENSHAW AND GALLEGO MILLS. From rare original Brady prints made sometime in 1865

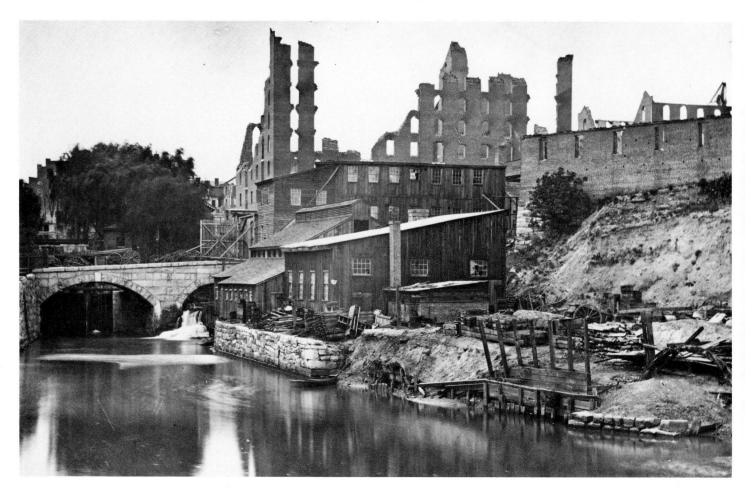

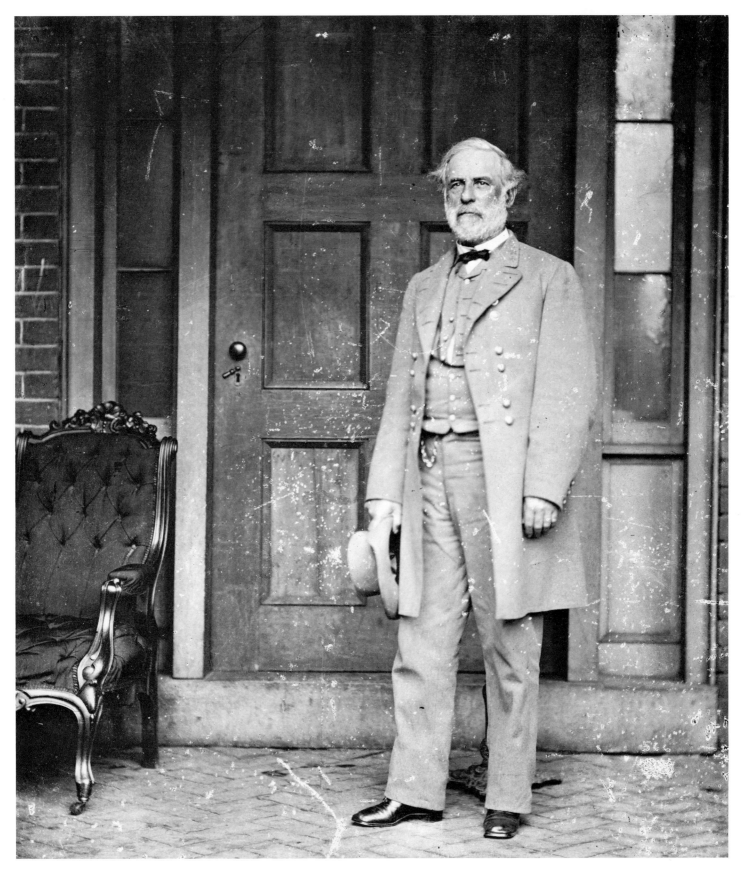

112.

ROBERT E. LEE
From an original negative made by Brady in the rear of the General's house in Richmond in April of 1865

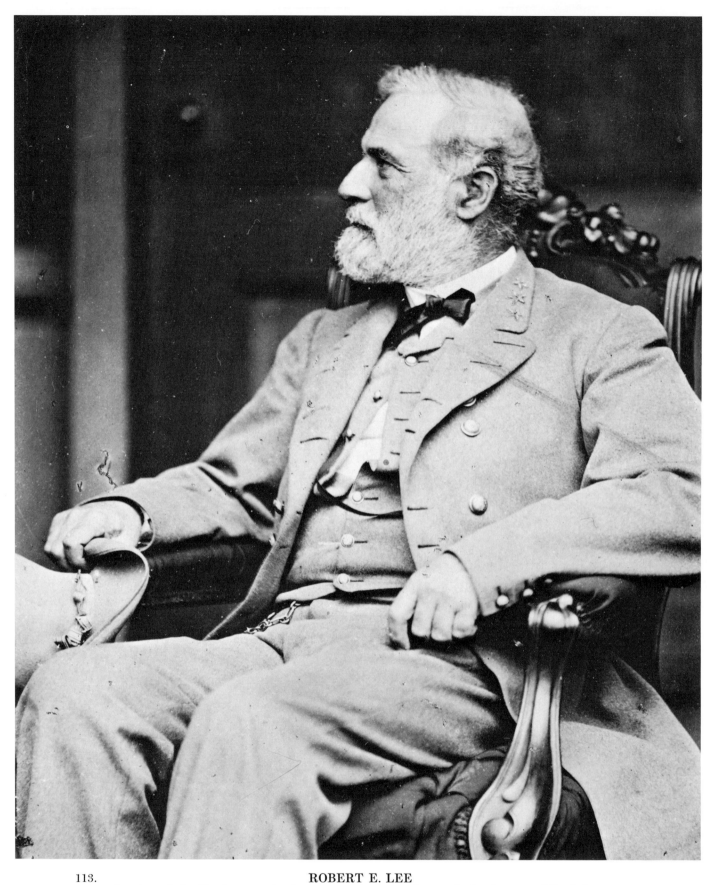

113.
ROBERT E. LEE
Another of the Brady portraits from an original negative made in the rear of Lee's home

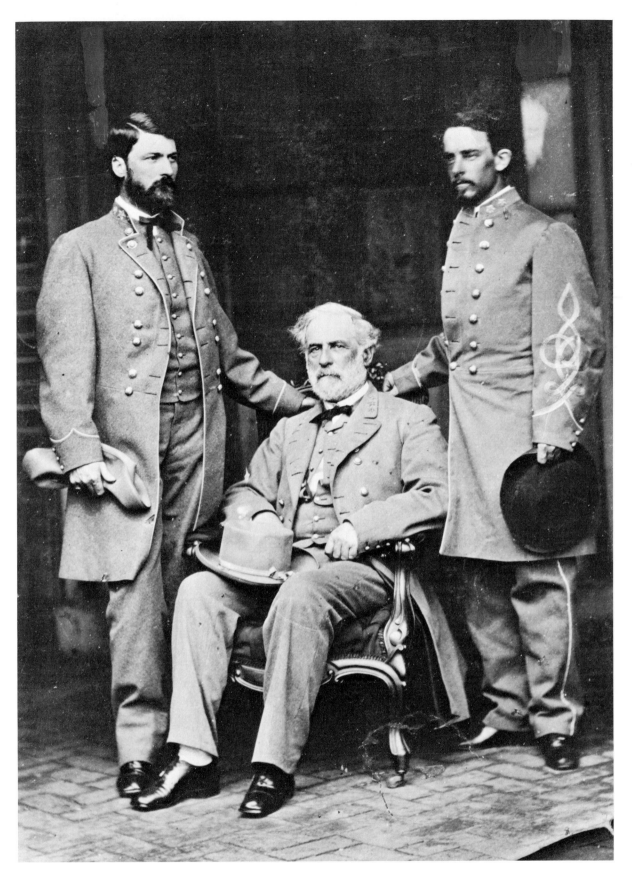

114.
ROBERT E. LEE
Standing, are General Custis Lee on the left, and Colonel Walter Taylor. From an original Brady negative

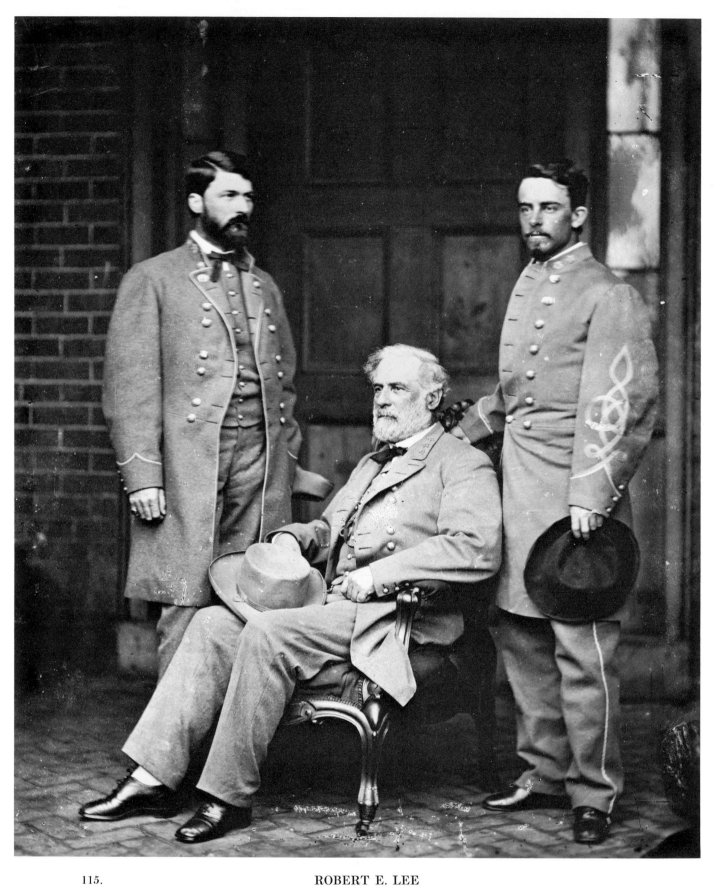

115.

ROBERT E. LEE
The fourth of the six plates made by Brady on the back porch of the Lee home

CHAPTER

TWENTY

WASHINGTON was teeming with men in blue. The Army of the Potomac was encamped on the Virginia side of the river, and Sherman's Army was momentarily expected from its long march up from the Carolinas. At Brady's, as in the days of '61, a land office business was deluging the studio. Soldiers, government people, officers, statesmen and sightseers were all having their pictures taken.

The Northern Army had reached the total of over a million men, and these legions had never been seen all together. They had fought for four long years over the farm lands of the South, and before they were to vanish, they were to be reviewed for all to see.

May 23, 1865 was the first day of the Grand Review. Through the busy streets of Washington Brady drove his wagon to the main grandstand and there set up one of his cameras. The other camera he had carried down to the corner of Pennsylvania Avenue, near the Treasury Building, to get a view of the marching men with the Capitol in the background. Working with his assistants was Brady's nephew, Levin C. Handy, whom Brady had started in the business sometime earlier that year, and who was destined to carry on in later years and achieve as commanding a reputation as his esteemed uncle's.

Spring is kind to Washington, and in the bright May sun the crowds gathered on both sides of the avenue. Suddenly the parade started. The bands blared over the noise of the multitudes a noisy counterpoint to "When Johnny Comes Marching Home," "Tramp, Tramp, Tramp," and "When This Cruel War is Over".

In the main grandstand were President Johnson, General Grant and other dignitaries of the Government, all acknowledging the plaudits of the crowds that cheered them again and again.

The Review opened with Sheridan's Cavalry. Sheridan rode in the lead, followed by the long-haired Custer, who rode in front of the 10,000 horsemen who had devastated the Shenandoah Valley. Then came the infantry in new uniforms, white gloves, with rifles at "right shoulder", marching in perfect step. Column on column of marching veterans, flying banners which had been blackened and shot torn in battle, passed the grandstand, followed by artillery, caissons, forage wagons, and endless lines of men in blue.

As the columns approached the field of Brady's camera, they halted long enough for him to take an exposure. Another pause allowed him to take an exposure of the grandstand. This was done without mishap, something of a miracle in view of the fact that he was surrounded by onlookers who were more interested in the mysteries of photography than in the parade. His co-worker at the Treasury corner made an attempt at an instantaneous shot which turned out a little blurred.

The following day, May 24, was Sherman's day. Behind him marched the "Bummers", so called by the Southerners. In contrast to the marching men of the day before, Sherman's men wore the mud spattered and ragged uniforms they had worn on the "great march". It was a spectacle. Columns of ragged veterans, forage wagons loaded with pots and pans, pack mules loaded with turkeys, chickens and geese. Cows, sheep, goats, and racoons, the mascots of regiments, followed the artillery and cavalry as the procession paraded down Pennsylvania Avenue. The crowds that lined the streets cheered and wept as the columns marched on to the corner of the Treasury Building, where they wheeled and marched out of sight. Brady packed up his equipment and drove back to his studio, a little regretfully perhaps. He had followed these comrades to many battles and now they were gone forever. The war was over.

It was not long afterward that he decided to enlarge his studio business and improve his work. There were innovations to be discovered, new clients to get, and it was not unreasonable to suppose that now there would be an increasing demand for the pictures taken during the conflict. There was never a doubt in Brady's mind that the Government would be interested in his collection of pictures for the official records. He had placed a value of $100,000 on the plates, and he immediately went to work mounting and cataloguing them to be ready when the Government would call for them. At this time Brady's assistants came in from the field. Of these men whom he had trained, Stanley Morrow and T. H. O'Sullivan were interested in joining various expeditions that were going to explore the Great West. But Brady had too big an interest at stake to chance leaving his business. He preferred to await the outcome of his offer to the Government.

In the meantime the tribunal to try the conspirators in Lincoln's assassination got under way. Grim work was still to be done before the last taints of the rebellion were to be washed into oblivion. In the old Washington Penitentiary, hidden from all eyes, the alleged perpetrators of the crime were tried by a military tribunal presided over by General David Hunter. Of all the accused four were to be hanged.

They were, Mrs. Mary Suratt, who owned the boarding house where the assassins held their meetings; George Atzerodt, a carriage maker and Confederate spy, who was assigned to kill Vice President Johnson but who lost his nerve at the last moment; David Herold, a feeble-minded clerk who accompanied Booth on his flight and later ran out when the two were cornered in Garrett's barn; and Lewis Powell, alias Paine, who broke into Secretary Seward's room and slashed his throat as he lay ill in bed.

The hanging was to take place in the yard of the Washington Penitentiary. Brady

got permission to photograph the execution from the office of General Frederick Hartranft, the officer in charge of the prison. On the morning of the execution Brady set up his cameras on a platform facing the gibbet. The light was just right from his position and he used two cameras to secure plates before and after the trap was sprung.

The prisoners were escorted into the yard to the scaffold where four chairs were placed for them. The hot sun beat down on the wooden platform and an umbrella was held over Mrs. Suratt while the warrants were being read. The officers in charge stood around uneasy in the knowledge that they were about to hang a woman. Plenty of time was taken in adjusting the straps and nooses to wait for a last minute reprieve for Mrs. Suratt. But none came.

Brady's two large cameras directed at the scaffold were focused and ready, and while the death warrant was read he made an exposure of the group on the platform. In the silence that followed, all saw the jailor signal to General Hancock that no White House messenger had arrived with a reprieve, and Brady made ready for the recording of the final scene as the prisoners were assisted on the trapdoor. Mrs. Suratt started to whimper. The simple-minded Powell stood firm. Herold trembled. Atzerodt, shaking with fear, gibbered something unintelligible. All others left the scaffold by the steep wooden steps, and at a given signal the soldiers underneath knocked out the props under the trapdoor. The silence was shattered by a loud clatter as the trapdoor dropped the four bodies. At that moment the shutter was lifted on the camera and the scene burned on the wet plate as the bodies swung back and forth, blurring the plate with the motion. Then the shutter dropped back with a click, shutting out the light.

When the yard was cleared of soldiers Brady made one more plate while the unfortunates hung limp, the ropes now still and the platform empty. Then hurriedly developing his plates he and his assistant packed the equipment and drove out of the prison yard and back to the gallery.

The event was something everyone wanted to forget as soon as possible. Mrs. Suratt was found innocent. Several who had presided at the trial committed suicide. The prison was torn down to its very foundation as if to erase the affair forever.

But there were other reminders of the assassination not so easily erased, although an attempt was made to that end. For a complete pictorial record of the tragedy, Brady gained access to Ford's Theatre where he set up his camera to make a negative of the stage, and the box in which Lincoln met his death. Brady made the plate, using a large camera for the purpose.

Shortly after, Secretary of War Stanton learned of the existence of this plate, and for reasons known only to himself, ordered it destroyed. The order was carried out, but not before a print from the original negative came into possession of Joseph Sessford, ticket agent of Ford's Theatre.

This fact was not known to Stanton. In an interview with an unknown newspaper reporter, Mr. Sessford claimed he had the print, "a large photograph of the stage and boxes, just as it was at the time of the assassination". This print he kept along with several other

mementoes of the grim occasion which included the "little tin postoffice that hung in the office, in which Booth kept his mail." The print came back into Brady's possession and other prints were made. Thus, as far as Brady was concerned, did the incident end.

It was but six weeks after Lincoln's death that Andrew Johnson as President, in trying to carry out Lincoln's policy—that of amnesty toward the seceding states—made a speech which was taken to mean that he would treat with the utmost severity the leading secessionists. This was immediately cheered and accepted by the radical Republican element in Congress. But instead of taking the course his speech indicated he took exactly the opposite. Being under the influence of Secretary Seward, he brushed aside all restrictions regarding trade with the southern states, proclaiming a general amnesty except in a few cases.

In August, Johnson removed Stanton, replacing him with Grant, and shortly after his appointment as Secretary of War, he walked into Brady's studio for a portrait sitting. He was still in uniform. Walking up to Brady he asked, "Well, how do you want me to sit, sir?" Brady said, "Just as you like. Get as much comfort out of it as you can." With that Grant walked over to a straight chair, and opening his coat, slumped down and crossed his legs. Brady photographed him just as he sat.

The conflict between the President and Congress reached a climax when the Senate resolved that the President had no power to remove the Secretary of War, and making the removal of Stanton the primary article, the House voted impeachment. The men who were to preside at the impeachment hearing were no strangers to Brady, and an appointment was made with his studio for a picture of the Impeachment Managers. Brady himself attended to the posing of the group. First, on the left, he seated General Ben Butler. Next was Thad Stevens, described as "the dead ash of a great fire". Next to Stevens, Brady placed the "well-to-do-looking" Williams. And then Bingham, who was known for his nervous temperament. Behind these three Brady placed the three younger of the prosecutors: Logan, Boutwell, and Wilson. Then Brady, the focusing cloth over his head, adjusted the lens and lined up his picture on the ground glass. Taking the cap off the cannon-like Harrison lens, he made the exposure. As soon as the picture appeared in Brady's Gallery the press got hold of it. The reaction of one newspaperman was:

"Brady has made an Imperial Photograph of the Impeachment Managers, Bingham, Boutwell, Williams, Wilson, Logan, Butler and last but not least Thad Stevens. Regarded as a photographic achievement, its finish and the accuracy of the likenesses are admirable, and the production will have its due historical value. But, to speak plainly, we fancy the sensation it will generally inspire will be one not of chagrin—for we are becoming hardened to such things—but of disgust. Of the seven men to whom has been entrusted the conduct of one of the momentous events in the life of the nation, there are but two whose appearance conveys assurance that they are gentlemen; one has the aspect of a fireman arrayed for a ball, a typical Bowery swell; the remainder suggest farmers in their Sunday clothes, the boots of the entire party having evidently received on the eve of their posting, the

preternatural polish of a street boot-black; while, without even the exception of the two faces whose refinement distinguishes them, General Butler's is the only one of the countenances upon which one ignorant of their ownership would be compelled to cast a second glance. We do not mean that in at least five faces out of the seven there is anything particularly sinister, but that they are essentially commonplace and mediocre, of the type one would expect to encounter in a country tavern or meeting house rather than in a high legislative assemblage."

All the men were lawyers, including Ben Butler, one of the so-called "political generals" who had had no notable military triumphs, and had failed Grant in the field when Grant needed him; but, strangely enough, he was to come to Brady's rescue when he needed help most,—at the time when Congress was to take a vote on the purchase of the Brady negatives. About this time Brady began to feel pinched for funds. The war venture had cost him a hundred thousand dollars and his largest creditor, Anthony and Company, who had supplied him with chemicals and equipment during the war, was pressing him for the payment of bills long overdue. Apparently Anthony and Company hoped to acquire the several thousand negatives that Brady still owned, to use them in their then popular Stereoscopic Views.

Gardner had closed his studio and was engaged in photographing the opening of the West, like O'Sullivan, Stanley Morrow, and others who had worked under Brady in the war. Brady, aggravated by financial difficulties and haunted by the indifference of the public, grew melancholy. He felt his life work had gone for nought.

To add to his troubles, his eyesight began to fail. He had always worn glasses. They were part of his make-up, but his vision was now such that he was compelled to wear heavy blue lenses. Others whom he had trained were now coming to the fore. Why then was he falling behind? Was debt to bring to nothing a lifetime of hard work and enterprise? Was it to stifle all further success?

Early in 1866 Brady prepared his collection of War Views, sorting and captioning them for the prospective sale to the Government. He had made public his intentions and the newspapers wrote articles favorable to the proposed sale.

Late in 1866, just before his untimely death, Admiral Farragut wrote of these War Views of Brady's, "I have always admired their spirit and truth, and the intention of transferring them permanently, this collection to become the property of the nation, is one that must meet the approval of every lover of art and history." But all this favorable comment availed nothing. The general inclination was to forget the war as quickly as possible. What became of the pictures of the conflict was of no interest at the moment.

It was not long, however, before agents from London and Paris came to New York to buy up all the mementoes of the war. They would be of interest and historical value in Europe, and the French government wanted to conclude a bargain for Brady's collection. But selling it to a foreign government was repugnant to Brady and he declined the offer.

When this news reached the press they made a great noise. This aroused the New York Historical Society to buy, but they were prevented for lack of funds. Again, the

newspapers, always friendly to Brady and appreciative of his efforts, prodded the Chamber of Commerce of New York City to purchase and place the collection on exhibition in their contemplated new building. The newspapers also clamored for the Park Commissioner to purchase and exhibit in the old Arsenal in Central Park, protesting that "under no circumstances should the collection be allowed to go to a foreign government". On January 29, 1866 the Council of the National Academy of Design, at a meeting of that body, adopted this resolution: "That we esteem the extensive and valuable collection of photographs by Mr. Brady, of scenes and incidents, and portraits connected with the late rebellion and other material of historic interest, as one of great value; as reliable authority for Art and Illustration of our history, and strongly recommend the proposal to secure it in a safe and permanent place, in the keeping of the New York Historical Society".

The resolution was signed by its President, D. Huntington and as soon as it was made public Grant wrote to Brady: "I am glad to learn that you have determined to place on exhibition, in the Galleries of the New York Historical Society, your Collection of Photographic Views of the Battlefields etc., taken on the spot while the occurrences represented were taking place. I knew when many of these representations (pictures) were being taken, and I have in my possession most of them, and I can say that the scenes are not only spirited and correct but well chosen. The Collection will be valuable to the student and artist of the present generation; but how much more valuable it will be to future generations."

While this proposal was being bandied about, Brady on Friday, March 30, 1866 opened his new National Historical Museum and Portrait Gallery on Tenth Street in Washington for a private showing to the members of the press and the leading art connoisseurs of the city. This exhibition, aside from giving stimulus to his portrait business, was doubtless to display the collection to gain public support in acceptance of the collection. The showing was well received and got encouraging mention in all the leading papers. It was considered a success from a publicity standpoint. The Government, preoccupied with other matters was still reluctant. Consequently a fund toward the purchase was to be raised and applied to the collection which consisted of about 8,000 negatives. Shortly after this the New York Herald stated: "It would be extraordinary if Congress does not authorize the purchase of Mr. Brady's collection of historical works and locate them in some public place in the Capital where all the world can study the progress of the Civil War in pages copied from life itself. We suppose the whole large collection would not cost the government more than eighty or a hundred thousand dollars—a trifling sum—compared with their value as great historical works of art."

The amount the Herald suggested was the value Brady had placed on the collection himself, the estimated cost of making the pictures. But it was too much for the New York Historical Society to raise for the venture. However, the exhibition was a great success, and altogether the verdict of the public and the press "was as flattering to its proprietor as it was satisfactory to his friends".

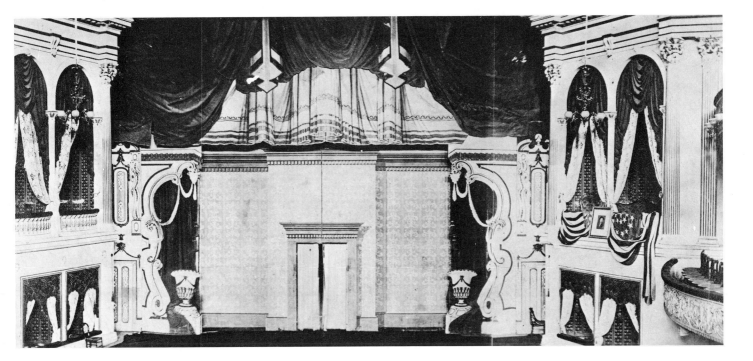

116. *Above:* INTERIOR OF FORD'S THEATRE SHOWING THE BOX IN WHICH PRESIDENT LINCOLN MET HIS DEATH. Copy of a print made from a negative by Brady that Secretary Stanton ordered destroyed. *Below:* LINCOLN'S FUNERAL PROCESSION. Photographed by Brady from a rooftop overlooking Pennsylvania Avenue

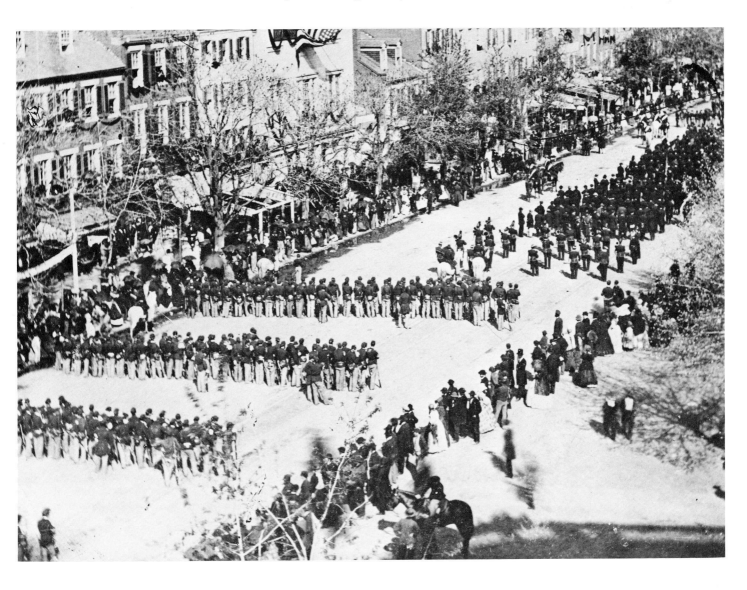

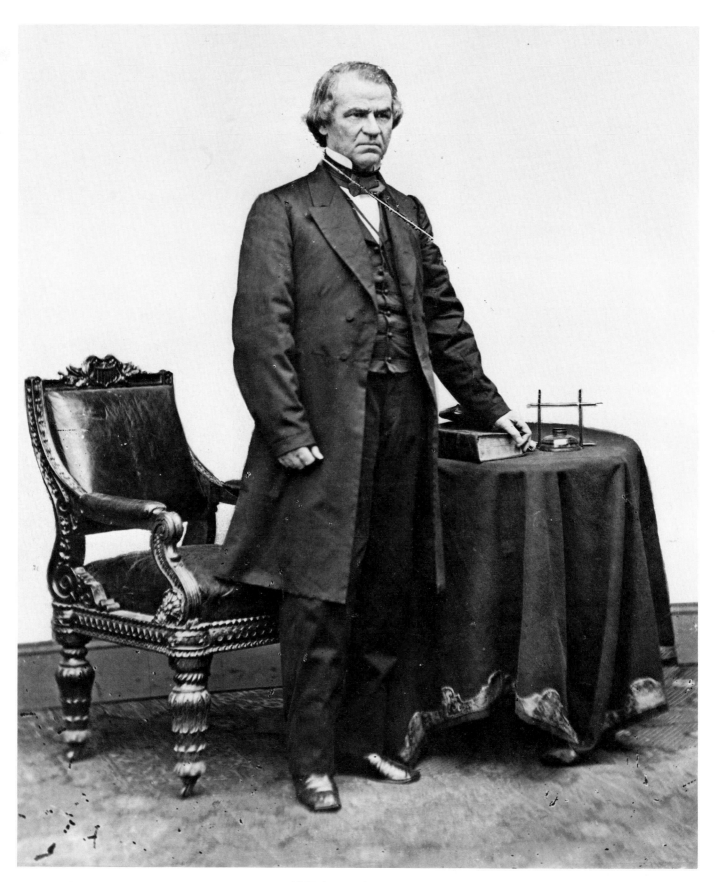

117. **ANDREW JOHNSON**
Taken in the Washington Gallery by Brady shortly before his inauguration as president. The famous
Brady chair is on the left

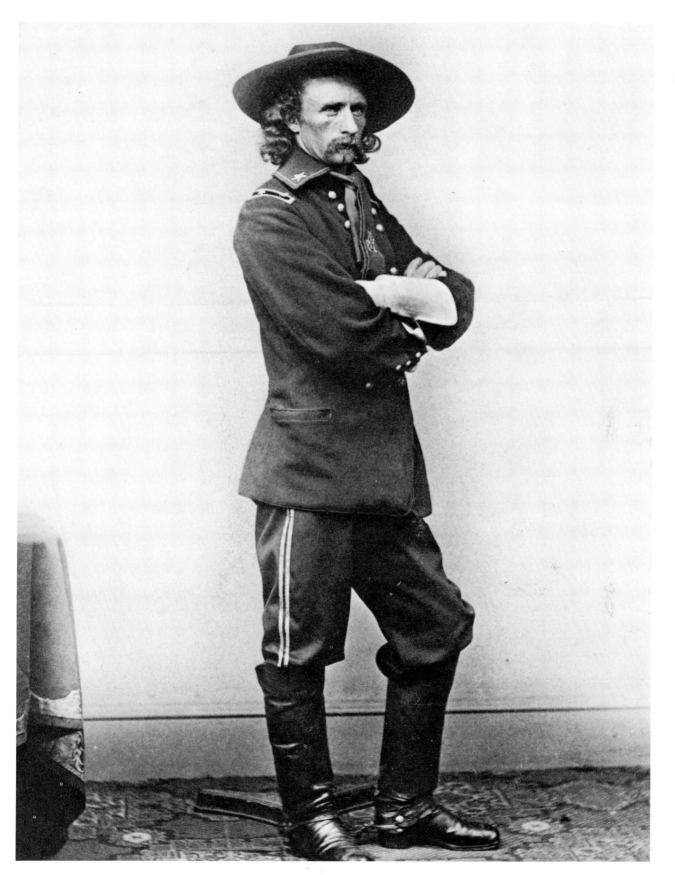

118. **GEORGE ARMSTRONG CUSTER**
A rare photograph of the Union Cavalry general taken in the Washington Gallery by Brady toward the
close of the war. Believed hitherto unpublished.

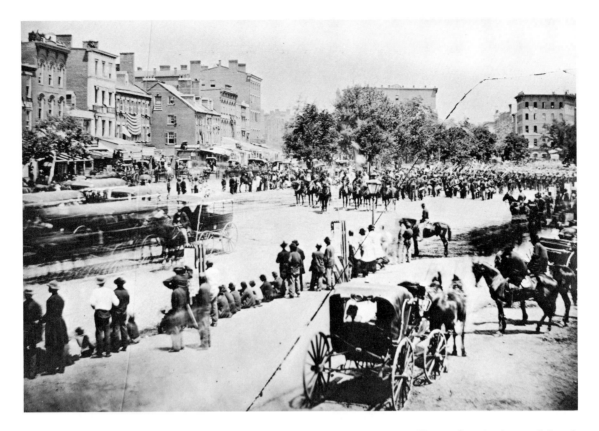

119. *Above:* THE GRAND REVIEW. Parade of the Union Troops on Pennsylvania Ave. celebrating
the victory. A rare print from a negative made by Brady in 1865. *Below:* GRANDSTAND IN FRONT
OF THE EXECUTIVE MANSION. President Andrew Johnson and Cabinet officials watching the
Grand Review of the Union Army

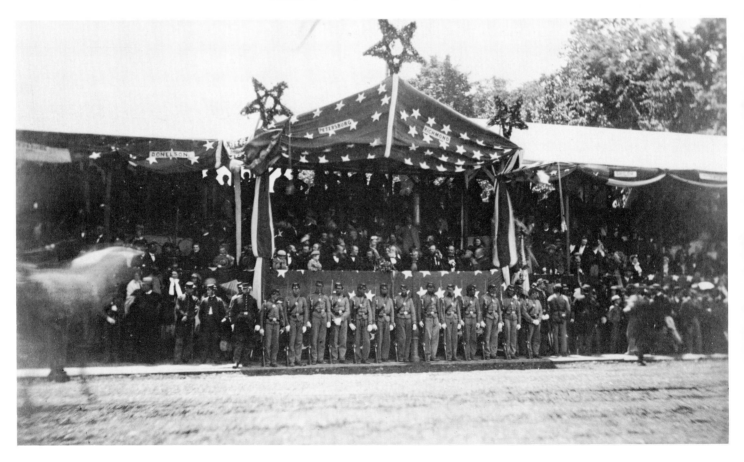

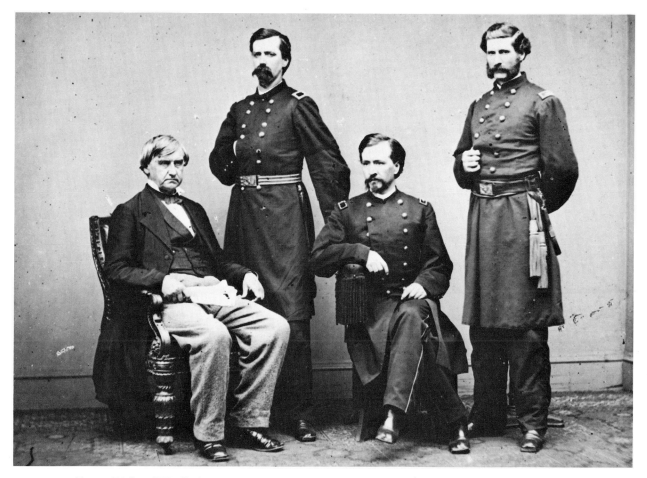

120. *Above Right:* JUDGES OF THE LINCOLN CONSPIRATORS. Left to right; Judge-Advocate Joseph Holt, General Robert S. Foster, Brig. Gen. Henry L. Burnett, Assistant Judge-Advocate and Colonel C. H. Tompkins. *Below:* AT THE HANGING. The warrant is being read and the nooses are adjusted. The first of the three pictures at the hanging

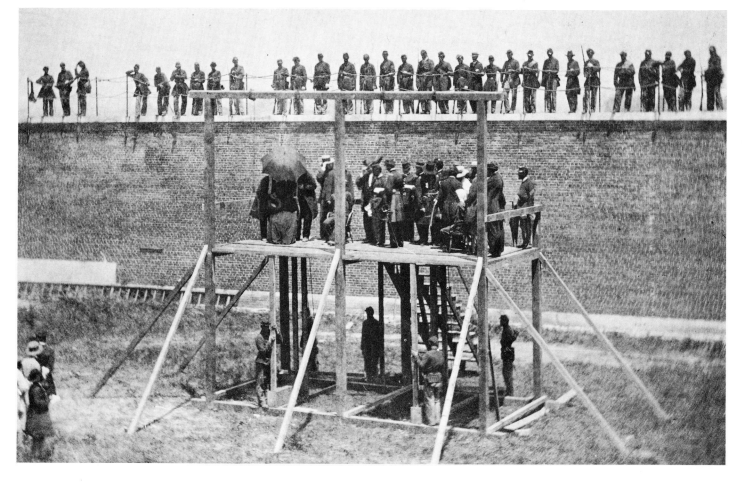

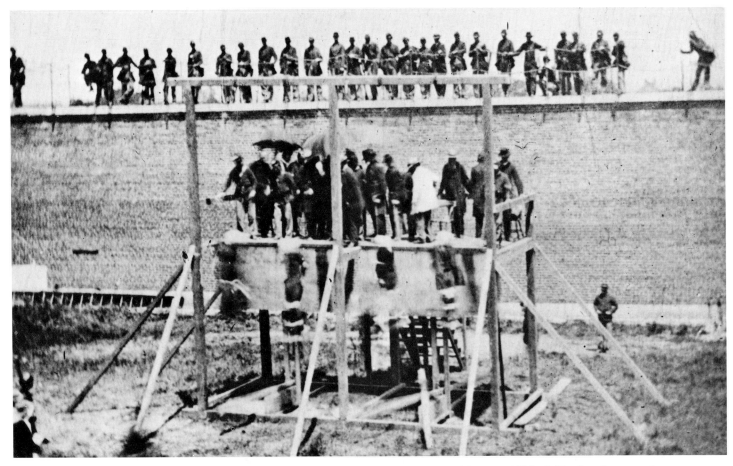

121. *Above:* **THE TRAP HAS BEEN SPRUNG.** A rare presumably unpublished Brady photograph showing the bodies as they swing in death. *Below:* The warrant has been carried out

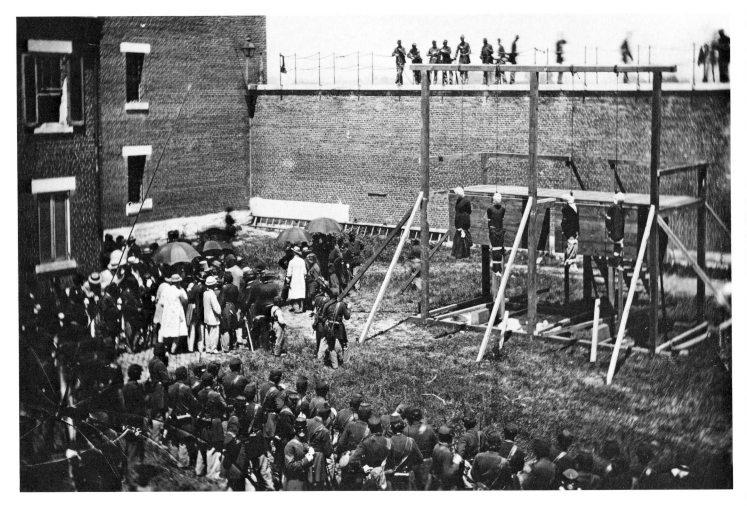

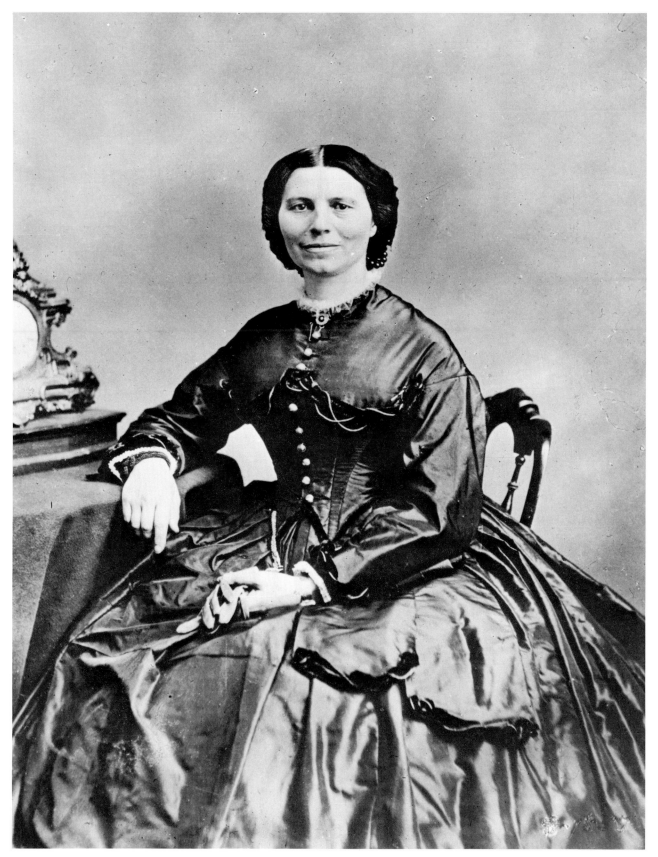

122.
CLARA BARTON
Photographed in the Washington Gallery by Brady in 1866, shortly before the *National Fair*

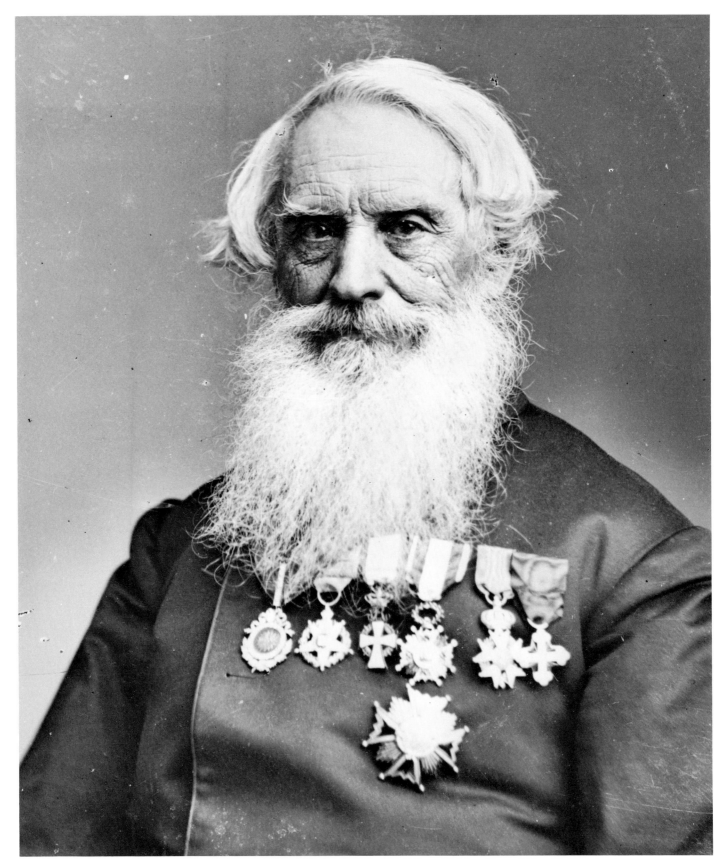

123. **SAMUEL FINLEY BREESE MORSE**
Photographed by Brady in the Washington Gallery in 1866. A rare print, published as a line cut engraving in Harper's Weekly of that year

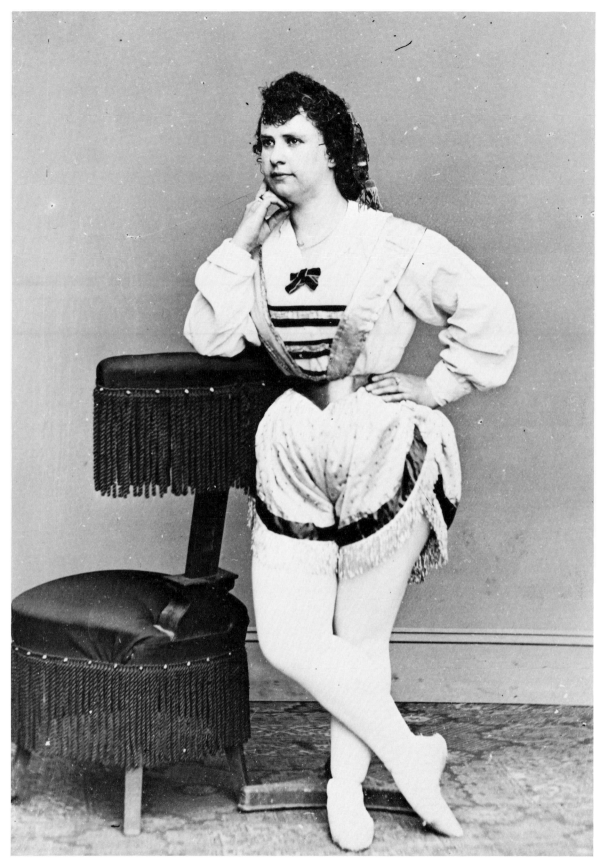

124. **LAURA LE CLAIRE**
A rare unpublished photograph of the celebrated dancer of the Civil War period. From an original
negative by Brady made in the Washington Gallery in 1866

CHAPTER
TWENTY-ONE

IN WASHINGTON, Brady's studio work continued as usual. But his war picture collection had to be put aside for the time. It was not until March of 1869 that Brady tried to interest the Government in the purchase. The *New York Herald* said: "Mr. Brady, the well-known photographer, is again endeavoring to secure passage of a bill to authorize the purchase of the War Gallery." Another newspaper suggested: "Surely this is a purchase the Government ought make." But despite this prodding by the press Congress remained uninterested. Three more years were to pass before any action was taken by Congress. Having to abandon all efforts toward congressional action, Brady placed the collection in storage and gave his entire attention to rebuilding his studio business.

It was in the Spring of 1869 that General Lee came to his gallery to sit for three portraits. He was then President of Washington University. The General had been visiting friends in Baltimore, accompanied by Mr. and Mrs. Tagart. Following that visit, the General and his friends left for Washington. Soon after their arrival in Washington, Lee went to the White House to see President Grant. He was received by Robert M. Douglas, President Grant's secretary, the son of Stephen A. Douglas. Lee's interview with Grant is known to have lasted for about fifteen minutes. It was a brief, pleasant and sociable call —though rumor had it otherwise. News of Lee's visit quickly spread among the men of the press, and it is likely that Brady heard of Lee's visit through them.

A day or so later, the General visited Brady's studio. The resulting pictures clearly showed his advanced age and the ravages of care and sorrow. After bidding Brady farewell, Lee left Washington for the last time, going directly to Alexandria, Virginia, where he had lived as a boy. When he was walking through the familiar streets, an old Mulatto woman hurried after the General calling, "Marse Robert, Marse Robert." He stopped and waited, and as she came up to him she said, "I am Eugenia, one of the Arlington slaves." Lee greeted her warmly and shook her hands, saying, "I wonder if you would not like to have my picture, Eugenia?" "Deed I would, Marse Robert," she answered. A little later she received it by post. One of Brady's portraits.

Brady was in dire financial straits by 1869. In fact, he was forced to sell some of his New York property. This consisted of four lots on the Northwest corner of 5th Avenue

and 105th Street, now included in Central Park. Brady sold the lots for $34,000 and paid a one percent commission on the sale. But his debts were well over $100,000. He again made an unsuccessful attempt to interest Congress in purchasing his collection.

Finally, on March 3, 1871, the Joint Committee on the Library recommended to the House of Representatives, 41st Congress, that the collection be purchased. Congress replied in a long report, pointing out that "there are many considerations which are of controlling influence in the conclusion to which your committee have arrived, that such a collection as the one in question—one so comprehensive and national in character, and so impressive with personal associations,—in fact all its portraits have been taken from actual life—should be purchased." This report showed that Congress was still awed by the fact that the pictures *were* taken from life. The Committee further recommended, "They should not be permitted to remain subject to the viscissitudes of mere personal ownership, but for the sake of preservation and safety they should become the property of the Government." But despite the Committee's recommendations, Congress adroitly sidestepped the issue by simply ignoring it. In the meantime, the storage bill was mounting on the 2,000 negatives. It had now reached a total of $2,840—a staggering figure.

Competition was now taking a lot of the photographic business from Brady, and this loss of trade, coupled with the enormous investment he had placed in the war venture, left him without the necessary funds to meet the storage bill. The collection was placed at public auction. Secretary of War William Belknap was advised of the auction. He took action and placed a bid for the Government for the total amount. The Government's bid was accepted through Belknap, and the Government came into possession of the negatives —but without title—the storage bill being paid with money accumulated by the Provost Marshall's office which had been turned over to the Adjutant-General at the close of the War.

An amusing incident came out of this unfortunate circumstance. Olive Logan, a correspondent of the *Graphic,* had had some portraits made by Brady. Waiting a long time to receive the prints, she called on Brady to inquire about them, accompanied by a friend named Fanny. Her visit occurred shortly after delivery of the "War Views" had been made to the War Department. Miss Logan at once noticed Brady's discomfiture when she asked him about her plates. She said, "He cast down his glance behind his blue glasses— rather vexed, I thought,—while nothing in the world could have prevented the revelation he made. My portraits were at the War Department with his 'Views'! Brady said they got there by mistake, but that truly awful Fanny who was with me says she believes that Belknap wanted them for the Post Traders."

This remark of Miss Logan's friend grew out of ugly rumor concerning the Secretary of War's alleged corruption and his shady activities with the Post Traders of the West. These rumors grew and finally impeachment charges were brought against him. But Belknap resigned, and the charges were dropped. Shortly afterward he committed suicide.

The panic of 1873 began with the failure of the renowned Jay Cooke and Company. The Stock Exchange in New York was immediately suspended. Runs started on even

the largest and most solid banks. Government clerks left their posts. A court was adjourned in the midst of a murder trial. Prices fell without regard to actual values. There had been many panics before, but none so devastating. Of Brady's holdings only the Washington gallery survived the disaster, and business there was almost at a standstill.

Then, on April 15, 1875, interest was revived in his collection of War pictures. General James A. Garfield, whom Brady had known during the war, and who now was a member of Congress, knew the value of the collection. He was also aware of Brady's impoverishment. Garfield insisted that something be done for Brady. General Ben Butler, then Congressman from Massachusetts, also felt that an injustice had been done. On his motion a paragraph was inserted in the Sundry Appropriations Bill whereby the sum of $25,000 was to be paid to Brady, and the Secretary of War was to acquire title to the Brady negatives, already in the Government's possession. In reply to the opposition, Garfield pointed out that, "the commercial value of the negatives was placed at $150,000, and this amount, "was little enough for a man who devoted his life and who risked all he had in the world and through misfortune lost the results of his labors."

125. Facsimile of a receipted bill for commissions on the sale in 1869 of Brady's Central Park lots in New York City

Garfield's eloquent appeal finally convinced Congress, which came to Brady's relief with a payment of $25,000. But the payment came too late to save his credit. During the years of waiting, he had been continually pressed by his creditors, especially Anthony & Company, the photographic supply firm in New York. Brady had three complete sets of the negatives of the "War Views". Being unable to satisfy the demand for payment, one was stored in New York. Anthony & Company received a judgment against him and immediately attached the plates, and this set legally became the Company's property.

The $25,000 awarded by the Government gave Brady some relief, and somewhat

stimulated his business. A newspaper notice that appeared in the *National Republican* said, "Mr. Brady has refitted his Gallery at 625 Pennsylvania Avenue, and has thoroughly reestablished himself in the photographic business in all the various departments of retouching, coloring, copying, ideal, genre, and alto-relievo."

Brady's energy and his devotion to his work seemed to overcome any misgivings. Dom Pedro, Duke of Braganza of Portugal, paid a visit to Washington during June of 1876. He inquired for the National Portrait Gallery. He wanted to study the portraits of the most illustrious men of our country. Particularly, he said, he wanted to examine the pictures of Webster, Clay and Calhoun. "He was told to our shame," says one reporter, "that we had no such Gallery here, but at the private studio of that prominent artist of America, Mr. Brady, he would find what we considered the finest portraits extant of the time." Dom Pedro immediately drove to the Brady Gallery where he studied the portraits. He then gave Brady several sittings.

The new year of 1877 was a fortunate one for Brady. It started with a humorous incident in the studio. Early in January a group portrait of five former generals of the Confederate Cavalry, Fitz Lee, Thomas L. Rosser, Beverly Robertson, William Paine, and Pierce Young, disappeared from Brady's gallery. This received some notice in the press, one newspaper saying, "the obliteration of the faces of the ancient Doges of Venice from the panels of the Venetian Gallery was not more strange or marvelous . . ." The year before, these five gentlemen, all old war friends, had met in the St. Marc Hotel. While talking over old times, they discovered that each had been a full general of Confederate cavalry. This called for a celebration, and the proposal was made that they go to Brady's gallery to be photographed together. This they did.

Before the strange disappearance of the portrait, a party of ladies and gentlemen met at Willard's Hotel. General Beverly Robertson was one of the group. By some chance a proof of the year-old picture came into their hands, and was passed around the table for everyone to see. "Who is the handsomest?" was the question among the ladies. "Why, General Beverly Robertson," exclaimed several in unison. Beverly Robertson, visibly embarrassed, left the party shortly afterward. Calling a hack, he drove directly to Brady's and purchased two dozen of the sets and ordered a dozen more. All this surprised and amused Brady. He said that, "Beverly was flushed and excited."

Robertson was evidently under the impression that he was buying all the pictures which concerned him, but Brady had one photograph left, which he carefully laid aside, "until Beverly's excitement would be over." Brady exhibited the picture, and three days later it mysteriously disappeared. Beverly, on the day of its disappearance, was seen mailing a large bundle. No doubt it was the missing photograph.

On February 4, 1877 Brady gave a reception in his gallery. The guests included many senators and members of Congress, representatives of the press, and gentlemen well known in Washington. The evening was spent in examining the collection of portraits which formed Brady's exhibition. One correspondent attending the reception wrote, "There are some very fine portraits there, produced by a remarkable process. The masterpieces ex-

hibited represent a combination of art, mechanical skill, photography, india ink and crayon." The correspondent also noted that over the door was a portrait of Samuel Tilden that had been taken twenty years before. He wrote, "Mr. Tilden looked older and crustier than he does now. A dry, pinched-up expression about his face suggested parchment, calf-bound books, and musty documents."

This reception gave public notice of Brady's reestablishment of his business and made a bid for new clients. All the press representatives gave glowing accounts of it.

"One can get very sentimental and do a deal of philosophizing in Brady's as we look upon face after face of prominent men," commented one newsman. "He had pictures of all the intellectual idiots of the present day, which will be valuable some years from now as a souvenir of the days of ungrammatical wisdom." This correspondent also noted, "There is also a fine colored picture of Madame Catacazy, whose beautiful hair and figure are still remembered."

On the afternoon of September 27th, 1877, the East Room of the White House presented an odd spectacle when Brady, accompanied by his nephew, arrived with camera equipment to make pictures of Sioux Chiefs, the slayers of Custer. At the suggestion of General Crook they had made the visit to present a claim that the treaty of 1868 giving the Indians the right to select land on which to farm and live had not been fulfilled. The main object of the visit was to see that the treaty provisions be enforced.

Spotted Tail and Red Cloud, accompanied by twenty-two chiefs, were photographed together with President Rutherford B. Hayes, Secretaries Evarts and Schurz, General Crook, Mrs. Hayes and Mrs. Crook.

It took some time to arrange the picture. The lack of light presented a problem, and so did the length of the exposure, for the Indians were continually moving around the room. After several trials Brady made a satisfactory plate.

No. 1,130—VOL. XLV.]

SIOUX CHIEFS IN THE WHITE HOUSE.

CUSTER'S SLAYERS IN CONFERENCE WITH THE PRESIDENT.

THE East Room of the White House presented a very odd appearance on the afternoons of September 27th-28th, when the famous Sioux warriors Spotted Tail and Red Cloud, accompanied by twenty-two chiefs, made an official call upon the Great Father, the President. There were present, among others, Secretary Evarts, Secretary Schurz, Commissioner Smith, General Crook, Lieutenant Clark, who commanded the Indian scouts at the Red Cloud and Spotted Tail Agencies; Doctor Irvin, the agent at the Red Cloud Reservation; Mr. Hayt, recently appointed Commissioner of Indian Affairs, and who succeeds Mr. Smith; William Walsh, of Philadelphia, formerly of the Board of Indian Commissioners; Bishop Whipple, Assistant-Secretary McCormick, and several ladies, including Mrs. Hayes and Mrs. Crook, wife of General Crook.

These chiefs made their visit at the suggestion of General Crook and others in authority on the Plains, to ask that the treaty provisions of 1868 and 1899 be enforced. That treaty gave the Indians the right to select good agricultural lands, and pledged that the Government would aid them in selecting them. This, they claim, has not yet been done. The treaty has not been fulfilled.

(Continued on page 87.)

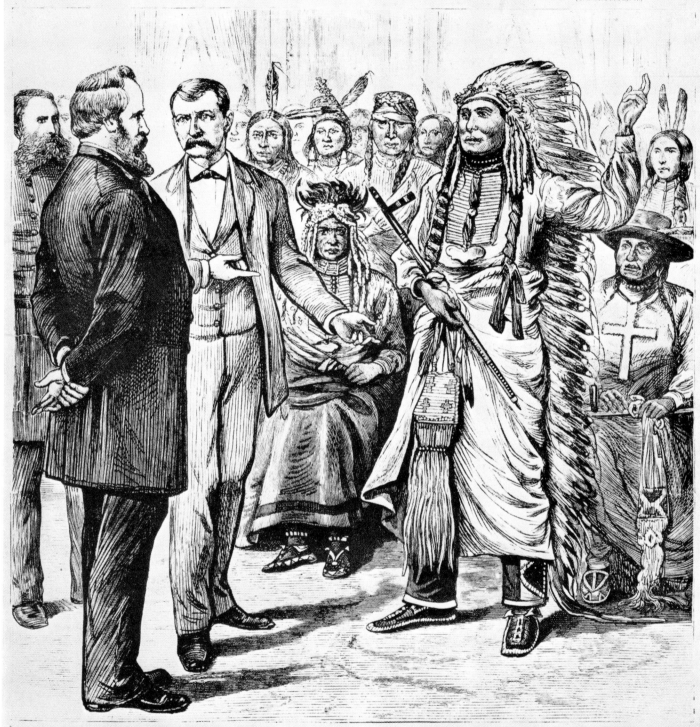

DISTRICT OF COLUMBIA.—OUR INDIAN ALLIES—INTERVIEW OF A DELEGATION OF INDIAN CHIEFS WITH PRESIDENT HAYES, IN THE EAST ROOM OF THE WHITE HOUSE, SEPTEMBER 27TH.—PHOTOGRAPHED BY BRADY, WASHINGTON.

126. Facsimile of a page from *Harper's Weekly* showing an engraving from Brady's photograph of the Sioux Chiefs Delegation in the East Room of the White House in 1877

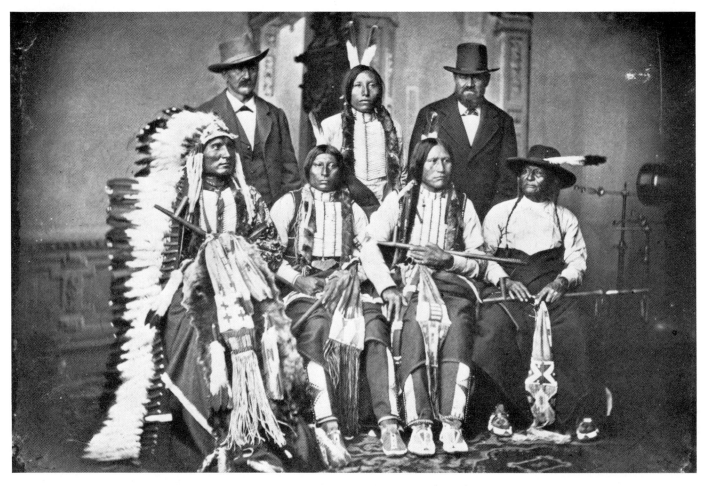

127. **CHIEFS OF THE SIOUX INDIAN NATION** photographed by Brady in the Washington Gallery following their visit to the White House. *Above:* Spotted Tail. *Below:* Red Cloud. From an original negative by Brady made in 1877. Never before published

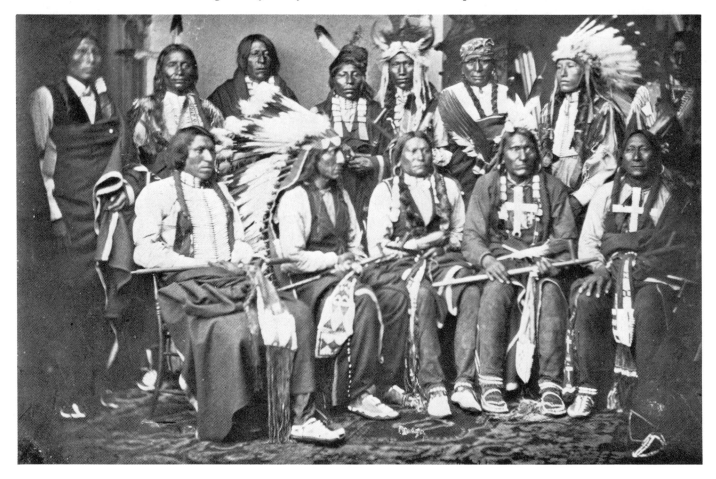

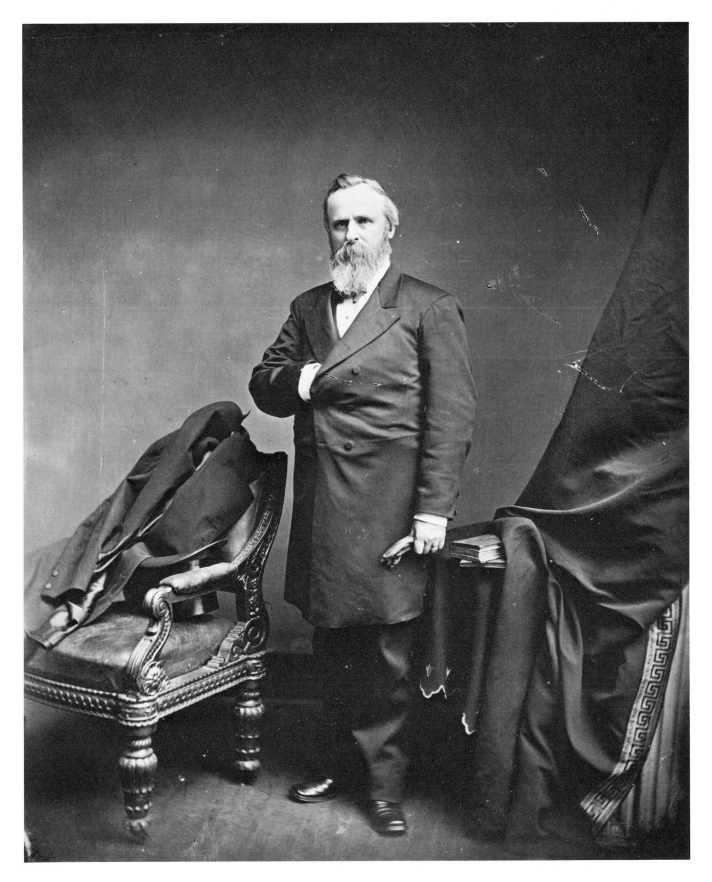

128.
RUTHERFORD B. HAYES
From an original negative made by Brady in the Washington Gallery shortly before Hayes' Inauguration
as President of the United States

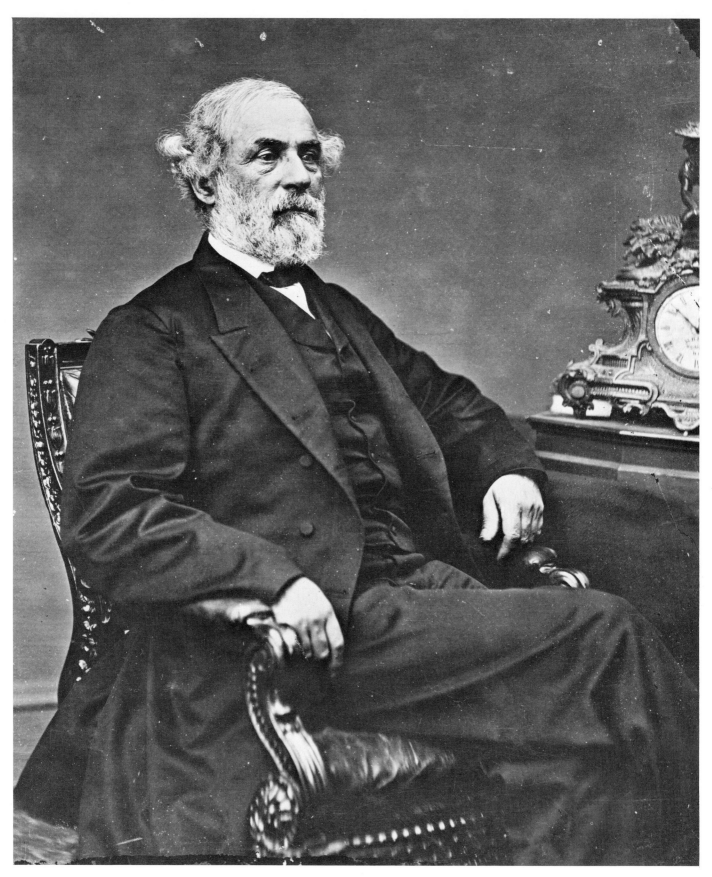

129.
ROBERT E. LEE
Portrait made by Brady in the Washington Gallery when Lee came to visit Grant at the White House.
From a rare original negative by Brady. This and the two following portraits believed never before
published

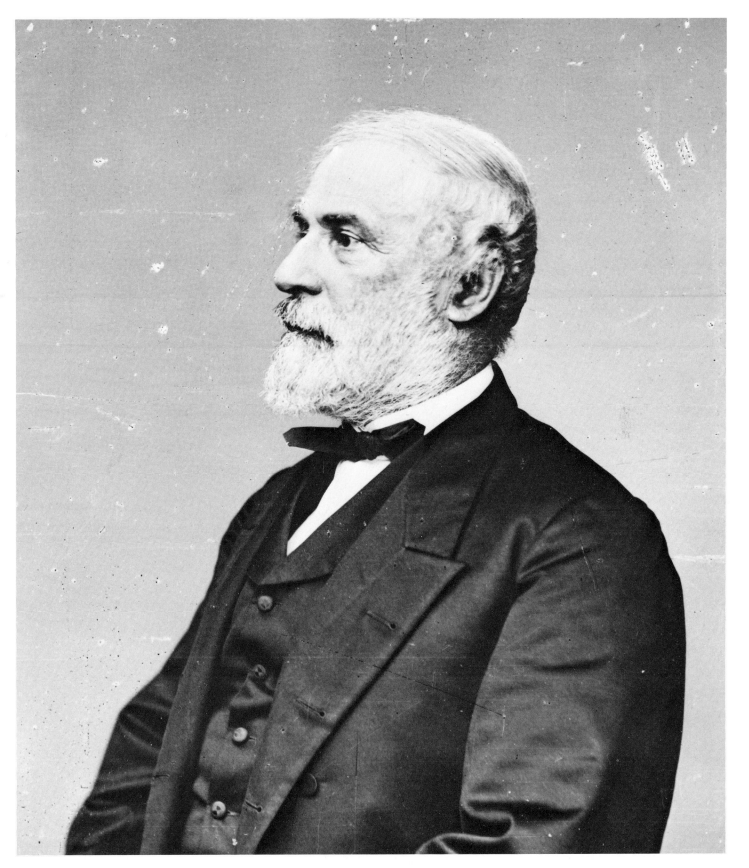

130. ROBERT E. LEE

The second of a series of three portraits made by Brady in the Washington Gallery at the time of Lee's
visit to Washington to see Grant

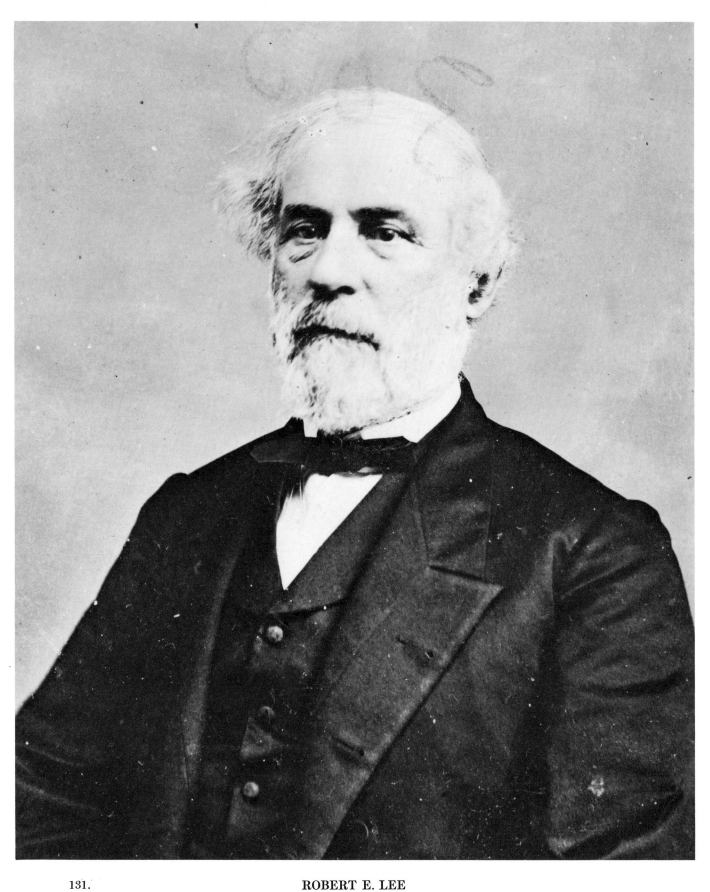

131.
ROBERT E. LEE
The third portrait taken by Brady in the Washington Gallery

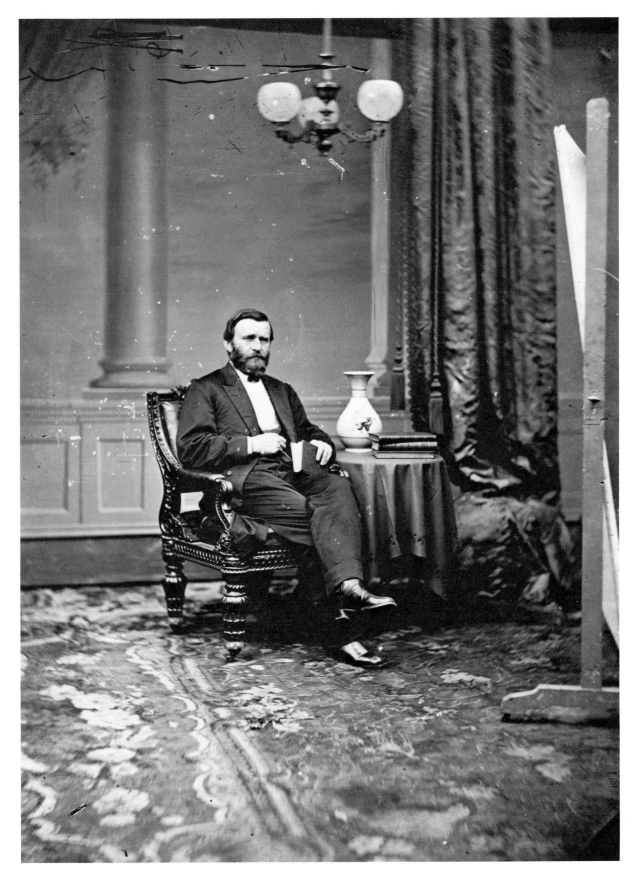

132.
PRESIDENT ULYSSES SIMPSON GRANT
A rare print from a negative made by Brady in the Washington Gallery about the time of General Lee's
visit. Believed unpublished except for a line-cut in *Harper's Weekly*

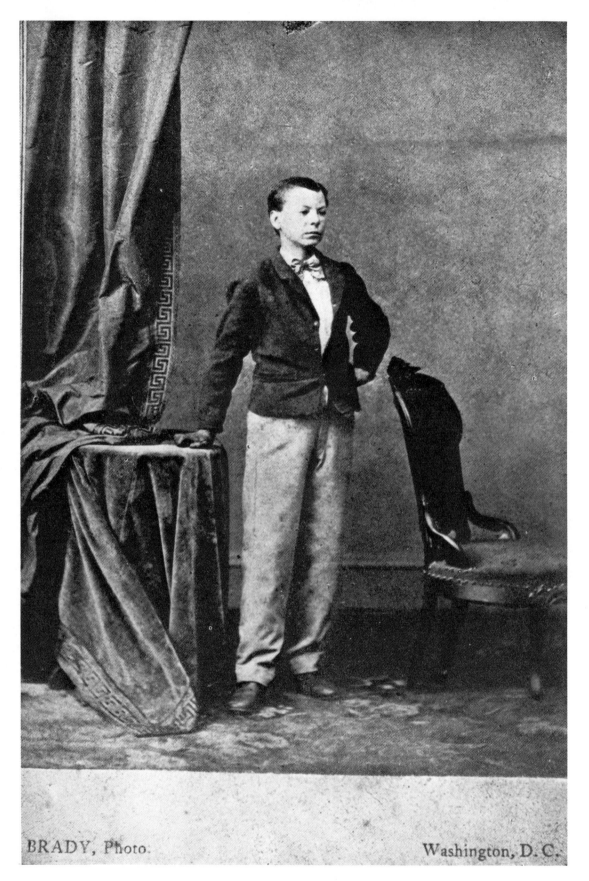

BRADY, Photo. Washington, D. C.

133. LEVIN HANDY, MATHEW B. BRADY'S NEPHEW
From an original negative made by Brady when Handy came to work as an apprentice in the Gallery
in 1866. Never before published

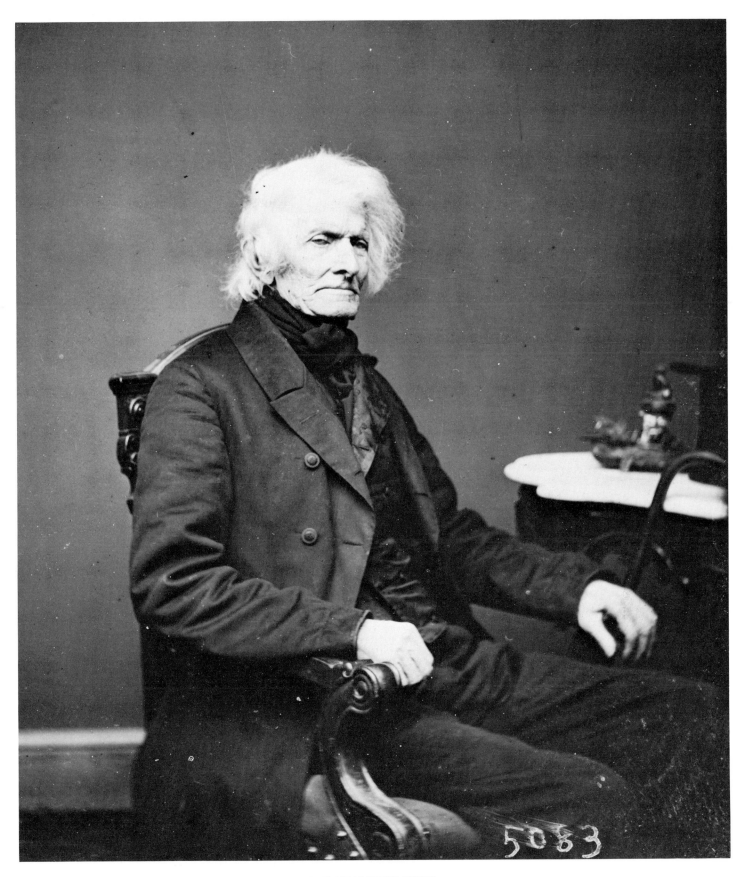

134.
WILLIAM WILKINS
Secretary of War under President Tyler. Photographed by Brady in the Washington Gallery in 1860
and never before published

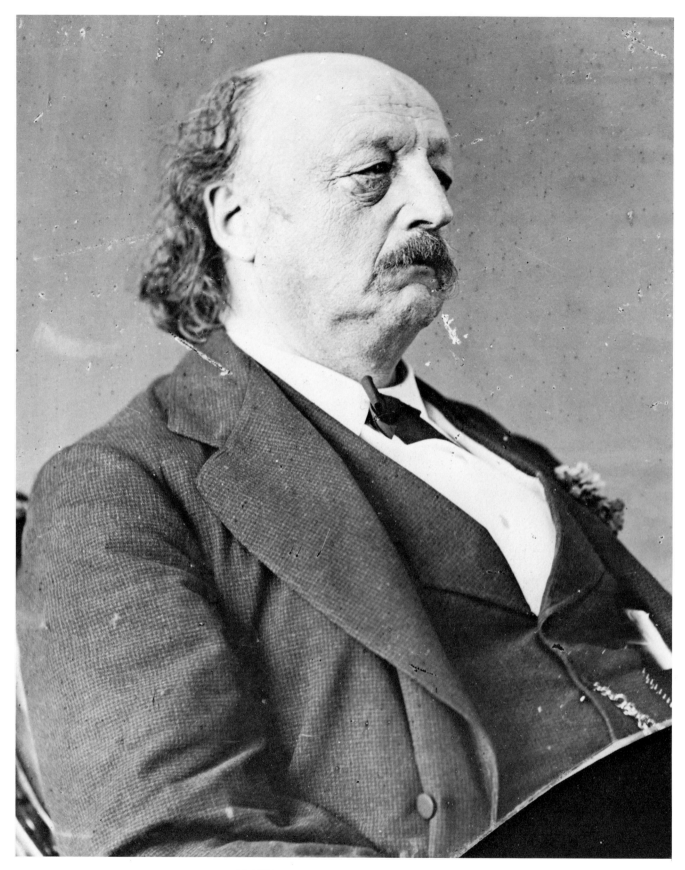

135. **BENJAMIN FRANKLIN BUTLER**
As Congressman from Massachusetts Butler advocated the passage of the bill for the Government pur-
chase of Brady's War View negatives for $25,000. Never before published

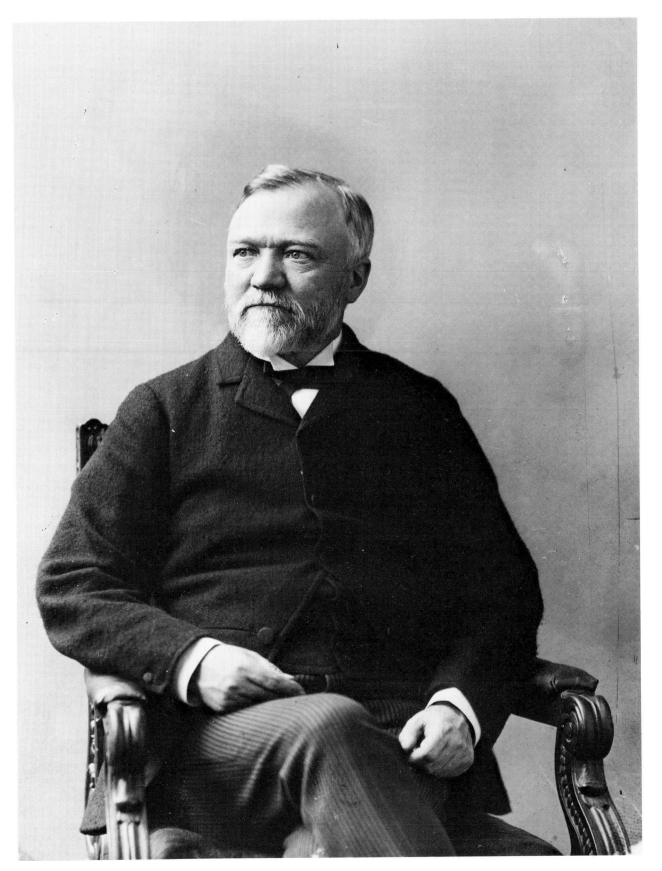

136. **ANDREW CARNEGIE**
**A rare unpublished print from an original negative made by Brady in the Washington Gallery in the
seventies**

CHAPTER

TWENTY-TWO

ONE OF THE most important of Brady's assignments at this time was the photographing of the Florida Electoral Commission. It was a high point in the politics of the nation in that it decided the political future of Rutherford B. Hayes. Hayes was nominated by the Republican Party for the office of President of the United States, with William A. Wheeler, as his running mate, nominated for Vice-President. The nominees of the Democratic Party were Samuel J. Tilden and Thomas A. Hendricks. The contest was severe and close, and bitter disputes arose as to the electoral votes of the several states. After a period of great tension, all the contested questions were decided in favor of Hayes by the Electoral Commission. When the smoke had cleared away Hayes had come through with a majority of one electoral vote and was duly elected to the Presidency.

There was bitter controversy over this newly arisen political deadlock, and it occupied the press of the nation. Some of the newspapers were bitter, others humiliating, and some were humorous;—but their limit at the fount of material supply had been reached—that is, until Brady's photographs of the Electoral Commission appeared. What the actors in the third dimension lacked in physical beauty was magnified in the second;—and the press again went to work.

The Evening Express stated: "Brady, of the Washington National Gallery, has issued upon three cards, at a price of one dollar for the three, portraits of the Fourteen Electoral Commissioners, of the nine Democratic Counsel, and of the five Republican Counsel. The likenesses of course, are good, and the work done in the best Brady style. The faces of Bayard, Thurman, and Field, and of the Democratic Counsel are among the best in the Gallery of Portraits. Bradley looks like a sneak, and Miller like a professional bull-dozer." Another newspaper *The National Republican* noted: "Of this important event in our history no better memory and knowledge can be had than in these photographs. Possessed of them one can have a rogues' gallery that history will hold up to the contempt of humanity through all times; the heads of a few patriots throw rogues in stronger relief, and the collection of the brightest heads in the legal profession." The paper further stated that it was their intent to take up each face on Brady's photograph of the Com-

mission and make a study of it, but they regretfully admitted their time and space did not permit that indulgence. But they further strongly advised their readers to go to Brady's Gallery and procure one of those interesting Cartes.

Shortly thereafter, a special correspondent of the *Telegraph* asked Brady why of all people he included William Chandler in the picture of the Commission with the Republican Counsel. Brady confidentially told the newspapermen that he put Chandler in the picture to 'fill up space.' But it can be assumed the true reason was because Brady believed "Bill" had much to do with carrying Florida for the Republicans.

The special correspondent of the *Telegraph* later wrote, "It was probably alright to give 'Bill' Chandler that place in history for that was an historical event which in future years will be appreciated in its true light." Thus was the pot calling the kettle black.

As did all Presidents after inauguration, on April 8, President Hayes went to Brady's for his portrait. It was a beautiful day, and there was a strong sun pouring through the skylight. Brady secured twenty-five negatives of Hayes, each in a different style and setting.

The Press once again announced, "Secretaries Evarts and Schurz have gone to New York, and Secretary Thompson has gone to Indiana, so there was no formal meeting of the Cabinet today. President Hayes, improved the occasion, to visit the studio of Brady, the veteran photographer, and to use his own words Hayes said, 'What is worth doing should be done well'. . ."

President Hayes remained in Brady's studio for over two hours after posing for his pictures. He examined the pictures of past celebrities and the pictures of the war, and glowingly complimented Brady on his work. Coming from the President, this tribute to Brady was a generous one.

On April 26, ex-President Grant visited Washington with Mrs. Grant. That afternoon a reception was given to the ex-President and Mrs. Grant at the residence of the Reverend Doctor Newman. It was fully attended by members of the congregation of the Metropolitan Church. Earlier Grant had visited with his old friend Brady, and many were the reminiscences of the times they spent in the fields of war together. After Brady made some photographs of the General, the visit ended. That was the last time Brady saw Grant.

That year, although for the most part a good one, had its darker moments. Gone was the good fellowship that was so prevalent among his competitors in the years before the war. Now entered the unethical, ruthless type of personality with an eye to making easy money. Gone were Alexander Gardner, O'Sullivan, Knox, Woodbury and the others, making new careers in the West, having taken Greely's advice. Now Brady was alone trying to rebuild what following an ideal had torn down.

On July 20, 1877, the Aquatic Representatives of Great Britain, the Dublin and Cambridge University Crews, visited the United States. Their first visit was made to the office of the Attorney General, Robert Taft. He received the guests in the absence of the President and welcomed them in behalf of the Government.

After a few moments of pleasant conversation with Attorney General Taft, the party drove to Brady's Gallery. During the past thirty years few Englishmen of distinction visited New York or Washington without availing themselves of the opportunity to sit for a Brady portrait. The Prince of Wales and his friends, the Alabama Claims Commission, and the British Ministers, were among the best group pictures Brady had taken.

Following their countrymen's example, the Dublin and Cambridge crews visited Brady's Gallery. They were accompanied by their hosts, the Analostan Boat Club members. After the portraits were taken the Analostan boys drove the Englishmen in their carriages to the boathouse on the Potomac. Brady followed with his wagon. At the boathouse he took pictures of the club members and spectators.

Later that afternoon just before the boat race, Brady photographed the visiting Britishers again. This time they were in their rowing uniforms and seated in their shells. Brady photographed these pictures as stereoscopic views. They were later to be used as souvenirs. But those taken in the Gallery were Imperials, or large portrait groups. Later the whole party, including Brady, made its way to the patent office. There, they saw an exhibit of all types of inventions of the period.

The first personal involvement with the law came at the time of the Inventors Congress. Brady made a written contract with the Executive Committee to take pictures of the Congress delegates. On the appointed morning Brady sent his operators in a wagon to the designated meeting place which was the steps of the patent office. A competitor of Brady's by the name of George Prince also arrived and began setting up his camera next to Brady's.

Prince then ordered his Negro assistant to stand in front of Brady's camera when Brady was about to take the picture. Brady retaliated by standing in front of Prince's camera just as Prince was about to make his exposure.

Prince grabbed Brady by the arms and shook him, almost knocking him down. Taylor, Brady's assistant, coming to Brady's aid caught him before he fell. A great crowd of spectators gathered while the wrangle developed into an uproar. Secretary Noble, incensed at the whole affair, sent a messenger for the police, while others of the group stood on the steps nearly a half hour in the broiling sun. Finally a patrol wagon arrived filled with policemen and peace was restored after a time.

Not long after the case went to court and on cross examination Brady said that he had received orders for a number of the pictures. He also pointed out that he was there under the authority of the Committee and had personally arranged the groups.

Brady hotly denied that he had ever set his camera in taking pictures where Mr. Prince had been engaged. He asserted he could not say whether or not there was any exposure on his plate before James Mann, Prince's Negro assistant, stood in front of the camera. Mr. Taylor, Brady's assistant gave similar testimony. He stated that a vote was taken among the delegates as to whose pictures should be ordered. By a large majority Brady was chosen.

It would appear from this part of Taylor's testimony that Prince had deliberately 'horned in' so to speak. There's no doubt he knew all the while that Brady had a previous agreement with the Committee. But the group standing on the steps of the patent office in the hot sun apparently became angry. Tempers probably reached the high collar mark. Individually, members of the group didn't care who made the pictures. That probably was the reason they later took the vote. Taylor also testified that the first exposure before the trouble began, was gotten only after a member of the committee pushed aside the Negro. One of Brady's pictures was produced. With the exception of a slight blur in one corner. the Judge thought the picture was excellent.

Levin Handy, Brady's nephew who had been connected with him for twelve years, also testified. Handy stated that he was near by when he overheard Prince order the Negro to stand in front of Brady's camera. Prince, he said, told Mann to hit anybody who tried to make him move. Handy heard Prince say to Mann, "I've got the stuff and will pay your fine."

Prince, testifying in his own behalf, admitted that he pushed Brady aside. The Judge then asked Prince if he expected to find the group on the steps when he drove up Seventh Street.

Prince: Yes Sir.

Judge Miller: How did you know that they would be there?

Prince: I saw it in the papers.

Judge Miller: For what purpose were they to be there?

Prince: To be photographed.

Judge Miller: By whom?

Prince: Mr. Brady.

Judge Miller: Exactly. And Mr. Brady had the right to take it, and he alone, under his agreement with the Committee. Mr. Brady had the right to use all reasonable force to prevent you from taking photographs.

After hearing Prince's counsel, Judge Miller continued his scathing remarks. He said, "Mr. Brady had a right to drive a horse in front of Mr. Prince's instrument, and beside its being an assault it was a very reprehensible spectacle. There were Cabinet Officers and many distinguished men assembled in front of the building. It was disgraceful that they could not be photographed without this scramble." Prince was subsequently fined twenty-five dollars and the case against the Negro dismissed.

To a younger man starting a career this 'reprehensible spectacle' would mean just one of the many disconcerting obstacles to be overcome. But to a man who had spent his life achieving a universal reputation in his profession, it was, to say the least, an embarrassing situation. The entire incident was humiliating even though it brought nothing but contempt for Prince and applause for Brady;—but it came at the wrong time.

Although Brady continued his post-war photographic work, and retained his reputation he was losing his preeminence as the leading photographer. Competition was be-

coming an extremely serious problem, and younger men with newer methods began crowding the field. Brady's business was functioning, but just getting barely by. He still lived at the National Hotel where he had lived for so many eventful years. Among the few remaining celebrities living at the National Hotel was Alexander H. Stevens, former Vice-President of the Confederacy. He was old and crippled and was spending his last years in the hotel quietly and alone. Many of the former well-known guests were gone now. They had all been Brady's friends; and in the fabulous years past, his suite had been the haven innumerable times, for these guests, at lavish entertainments he and Mrs. Brady had given. But all that was past. Mrs. Brady was in bed, stricken with a heart ailment. During her illness many of their old friends visited her and helped make as pleasant as possible her bedridden hours, days, and weeks. Of all the troubles which now confronted him, his wife's illness was the most serious. He was devoted to her and whenever his work permitted he was at her bedside. His own health was causing him some concern. His eyesight, that had recently been troublesome, was now failing him rapidly and becoming a serious handicap. His nephew, Levin, had taken over most of the work and the main chores of maintaining the Gallery.

The New York Studio had been closed for lack of funds. However, Brady continued to make trips to Manhattan to visit old friends and attend reunions of the Seventh Regiment of which he still was a member.

Rheumatism began to bother Brady. This was probably the result of four years of forays with the army when he had so many times slept on wet ground in dreary bivouacs. This tended to slacken his pace, and little by little his photographic work and his duties at the Gallery were absorbed by his nephew, Levin.

On his occasional trips to New York he visited his old friend, Colonel E. M. Knox, the well-known hatter whose establishment stood opposite Brady's old Fulton Street studio. During these friendly visits Brady sat for hours and talked in retrospect. Sometimes a little bitterly perhaps, when he was plagued by thoughts of the final results of his years of effort. "The old man liked to think back to the past," said Mr. Knox.

The New York Advertiser, in a column entitled 'People We Meet', stated: "Brady, the famous Washington photographer was in the city yesterday . . . Mr. Brady loves to visit New York to renew his acquaintance with his old friends."

On one of these visits to New York Brady paid a call to his old friend Sarony, a New York photographer. Sarony persuaded Brady to sit for a portrait.

Almost all of Brady's old friends and the celebrities he had known, were dead now. He, too, was getting on; he was 68 years of age. That this fact was not lost on him he revealed in a letter to his nephew, "I have been very much shocked," he wrote, "by several recent deaths, among them my friend Colonel Cone."

One of his many friends, a newspaperman, wrote, "Mr. Brady is getting along in years, as his huge grey mustache and imperial demonstrated when he called on me yesterday with his friend John J. Farrell. "His eyes have looked through cameras so long that they are weakened and he is obliged to protect them with blue glass goggles . . . he is still

the sociable companion who could always fill his salon with the brightest men and women of their day because of his intellectual merit."

Although Brady was well along in years he still retained his interest in his work. He was as enthusiastic as in former years. On occasions when celebrities were expected at the studio, he was always on hand to meet them and direct the picture taking operations.

In the late Fall of 1877 the Ponca Indians came to Washington on a visit, accompanied by their agent and interpreter, Major Oliver O. Howard.

Major Howard took them en masse to Brady's Gallery. It proved a source of wonder to the Indians. The tribesmen were greatly interested in the pictures adorning the walls. Brady, taking pride in them, pointed out the various personalities. The Indians particularly liked looking at pictures of people they had seen in person or of whom they had heard. When photos of General Grant, Carl Schurz, the Secretary of Indian Affairs, or of the President were shown, the room was filled with grunts of admiration and surprise. After the tribesmen studied the pictures, Major Howard suggested to Brady that a photograph of the group be taken. Brady agreed and started to place them in front of the camera. As soon as the Indians realized what was happening, they flatly refused. They were afraid of the large instrument. Brady and Major Howard explained with many words and gestures that Brady was not aiming a gun at them. They finally yielded, but only after the inside workings of the camera had been fully explained to them. The Chiefs and Braves sat for several group pictures. But they stubbornly refused to sit for any individual portraits. Individually, each one apparently was still wary of the camera.

The following day Director-General Goshorn of the Philadelphia Centennial Commission and a party visited Brady's studio. They presented him with a handsomely engraved Certificate of Award and a large bronze Centennial Medal.

These awards, the Board of Experts decreed that Brady was entitled to for the display of the best photographs, crayons, portraits, and photographic views at the Centennial. Brady later displayed the medals at the Gallery.

During that same year Brady made another attempt to retrieve his fortunes. He rented two complete floors in the Pennsylvania Railroad Building for a photographic museum. The pictures were to be newly mounted and presented in a different style.

A newspaperman came to see Brady at his Museum gallery. Brady told him, "In 1873 my New York property was forced from me by the panic of that year. The Government later bought my plates and the first fruits of my labors. But the relief was not sufficient and I have to return to business. I have a great deal of property here.

"Mark Twain was here the other day. He looked over everything visible, but of course not at the unframed copies of my works, and he said, 'Brady, if I were not so tied up in my enterprises, I would join you upon this material, in which there is a fortune'." This was true, Mark Twain being fully committed to the publishing of Grant's memoirs.

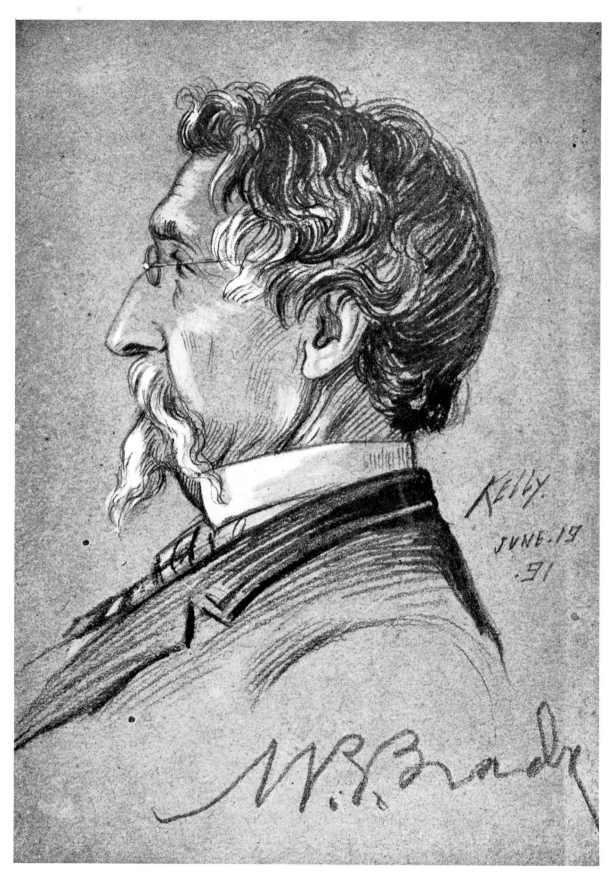

137. **MATHEW B. BRADY**
Reproduction of a rare drawing in charcoal and white chalk by Kelly believed to be from the original
sketch made in 1891 for Fassett's painting of the Electoral Commission.

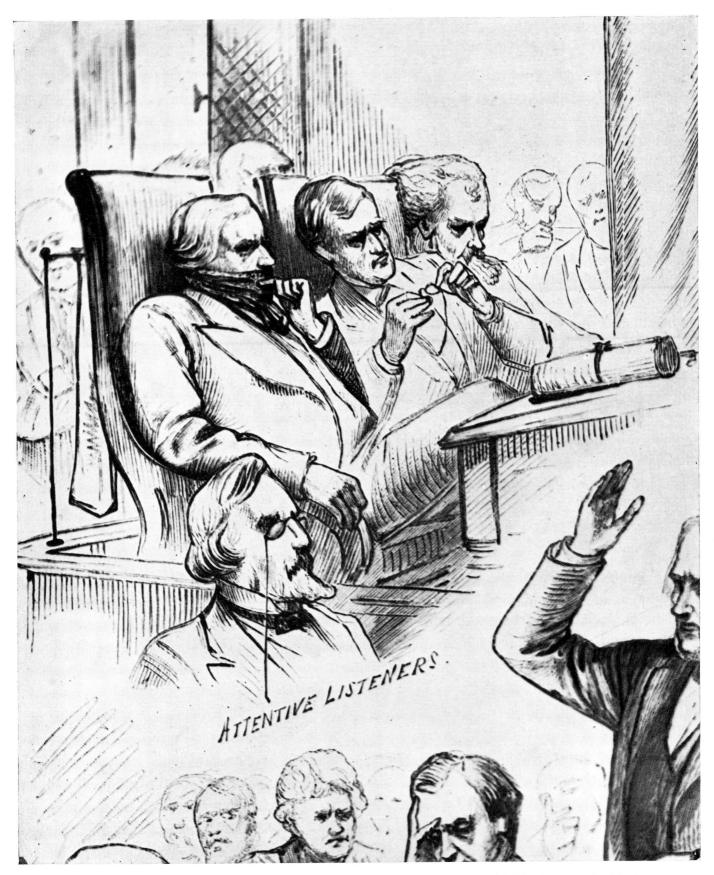

ATTENTIVE LISTENERS.

138. BRADY AT THE ELECTORAL COMMISSION. Brady is shown with his pince-nez, beside the railing. From a sketch by a *Harper's Weekly* artist

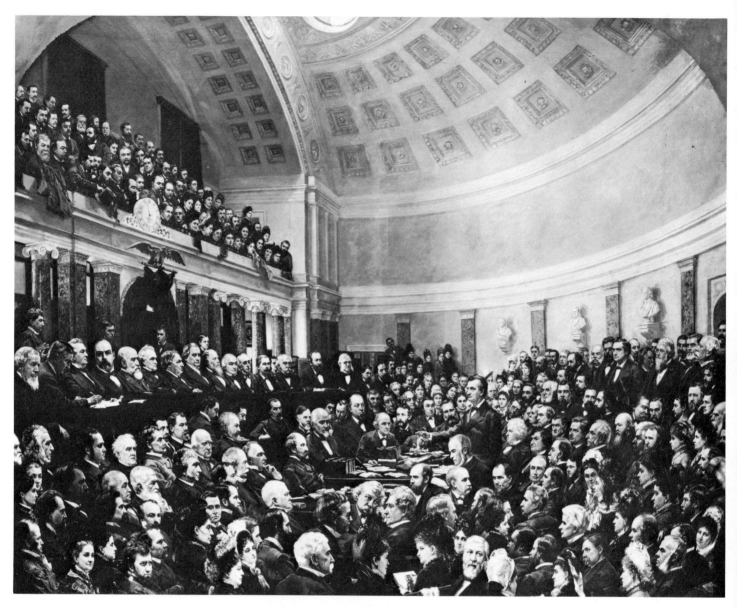

139. **THE FLORIDA ELECTORAL COMMISSION**
Facsimile of a painting by Fassett which now hangs in the Capitol in the Upper Corridor of the Senate
Wing. The profile of Brady can be seen under the middle statue of the right rear wall

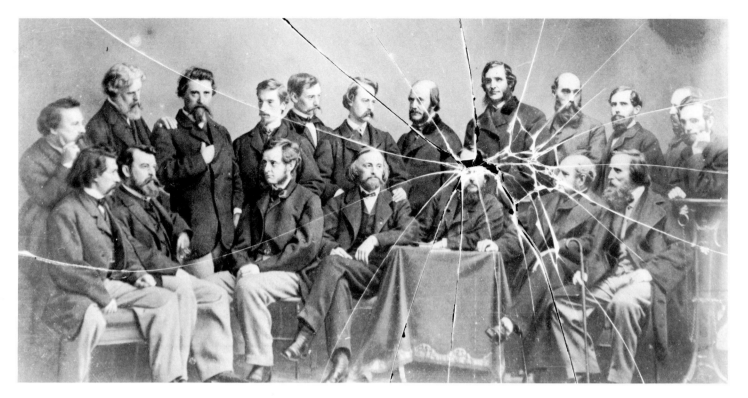

140. *Above:* **BRADY ARTIST GROUP.** From a rare unpublished photograph of some noted artists. Seated on the extreme left is Brady. Standing fourth and fifth from the right is C. L. Elliott, and S. F. B. Morse. Seated on the extreme right is Henry Kirk Brown. *Below:* **M. B. BRADY AND FRIENDS IN THE GALLERY.** Copy of a rare print from a negative made in the Washington Gallery in 1860. Seated on the extreme left is Admiral David Dixon Porter. Next to him is John A. J. Creswell, Postmaster General of Grant's Administration. Brady is seated on the right

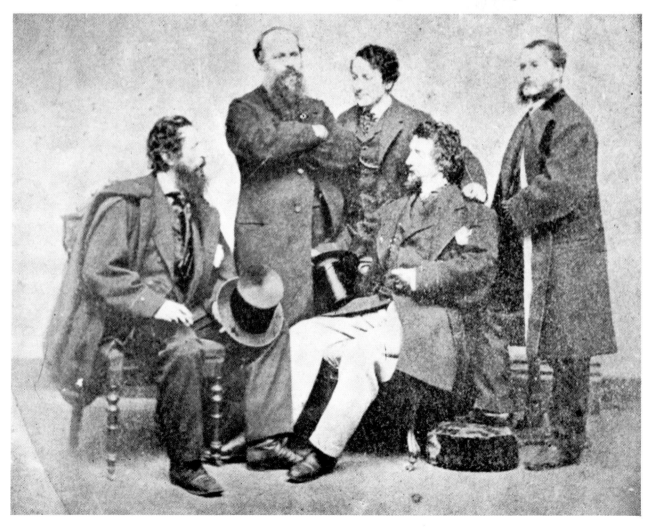

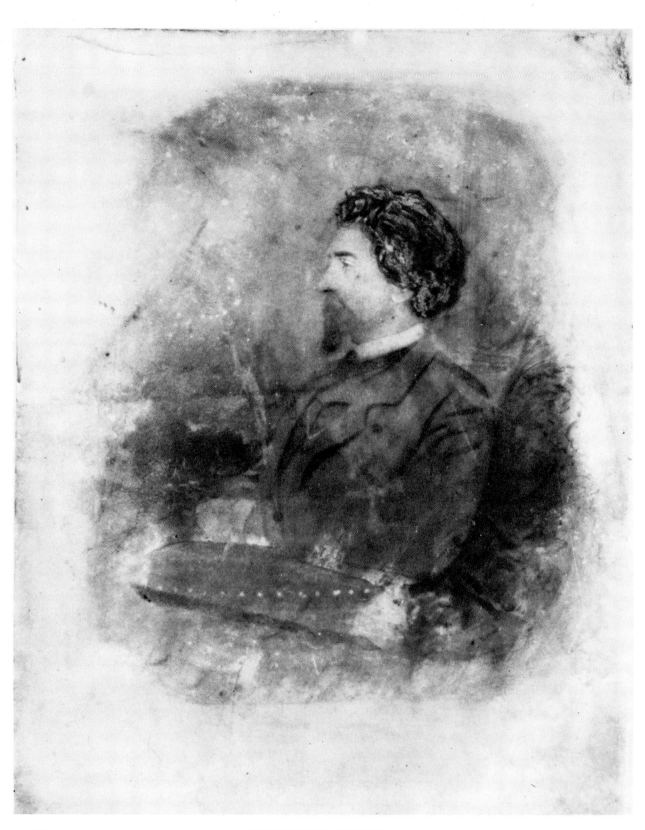

141. MATHEW B. BRADY

Photograph of a rare retouching palette showing a water color sketch of Brady by Danby who was in the
Brady Gallery, sitting for his own portrait. The palette is of opal glass. Never published before

CHAPTER

TWENTY-THREE

A S LATE AS 1882 the Government, upon inspection of the negatives in the War Department, disclosed the fact that the Brady plates which Belknap had acquired were rapidly deteriorating. Prompt measures were demanded, and Edward Bierstadt, was called in for advice. He had for years been experimenting with photo-engraving and reproduction processes, and was considered the one best qualified to give an opinion.

Bierstadt made his examination of the negatives and reported, "The breakableness of the glass and the fugitive character of the photographic chemicals will in a short time obliterate all traces of the scenes these (plates) represent. Unless they are reproduced in some permanent form they will soon be lost."

The Government immediately sent him fifty-two of the plates to use for experiments in restoration. Bierstadt made reproductions of six by a photo-mechanical process—possibly his own for he had been experimenting for several years with a method of this kind. Upon examining Bierstadt's results, the Government decided that the cost was prohibitive and flatly turned down the proposition on the ground that the process would not allow any general circulation. Actually the cost of reproduction amounted to $75.00 per 1,000 plates. But despite this low rate, the plates were to lie untouched for another long period.

Shortly afterward the Honorable John C. Taylor, a veteran of the Civil War, and at this time, Secretary of the Connecticut Prison Association, heard about the Brady plates that Anthony & Company had gained through foreclosure. Taylor, also a Post Commander of the G. A. R., thought that the soldiers of the recent conflict should be allowed to look upon the scenes in which they had participated, and immediately started a search for them. At Anthony & Company he was informed that the plates had been misplaced and could not be found.

Although greatly disappointed, Taylor was not to be swerved from his purpose, and, after a long search of the city, he found them. As he said at the time: "I have found 2,000 negatives in New York stored in an old garret. Anthony, the creditor had drawn prints from some of them . . . I also made a deal with him to allow me to use them exclusively. General Albert Ordway of the Loyal Legion, became acquainted with con-

ditions, and with Colonel Rand of Boston, jointly purchased the negatives from Anthony & Company who had clear title through court procedure." He later said: "I met these gentlemen and contracted to continue my exclusive use of the prints. I finally purchased them from General Ordway and Colonel Rand with the intention of bringing them before the eyes of the old soldiers, so they might see that the lens had forever perpetuated their struggle for the Union." Mr. Taylor continued, "The Government collection remained neglected through lax supervision and disregard of orders which caused 300 of these negatives to be broken or lost . . . I loaned my 2,000 negatives to the Navy Department to assist them in securing prints for their records and shipped them to Washington where they were placed in a fireproof warehouse at 920 E. Street N. W. I did all that was possible to facilitate this important work."

It was undoubtedly Taylor's lofty motives and untiring effort which brought about the recovery and restoration of these valuable sets of plates, and he deserves praise;— but by the same token it is deplorable that lack of foresight and indifference in official circles should cause the results of a talented man's work suddenly to come under the control of others. But this was not quite all.

It will be recalled that sometime before Brady had a young man working for him as a 'contact'. This man also worked for the Government, and Brady had previously arranged with him that, for every Government official he could induce to come to the Gallery he would give him a photograph of that person for his efforts. Brady lived up to his bargain, and with the pictures the young man had made quite a valuable album. In later years this album was put up for sale. It was offered to Cyrus W. Field, the millionaire, by the man who had made the album. Field flatly turned down the offer. "At my age such things are no longer desirable", he said. "My wife begs me not to buy anything more with which to fill our house. My room is literally piled over the floor with books, prints, photographs, and a hundred such things, which I have not been able to arrange or in some instances to see! Every addition is a trouble . . . "—and he half impatiently, half smilingly bowed his caller out.

The final whereabouts of the album is unknown. With its owner, it has apparently slipped into oblivion. This was the fate of another set of Brady's pictures.

These were indeed the most unhappy years of Brady's life. His fortunes sank lower and lower, and there seemed to be no relief from his worries. On May 20, 1887, the greatest blow befell him, for Mrs. Brady died. She had been hopelessly ill with a serious heart ailment and confined to her bed for five long years, and her death was not unexpected as her health had taken a turn for the worse and little hope had been held out for her recovery. Her death was a great loss for they had been devoted to each other, and she, always interested in his work, had been a steady source of encouragement. During her illness he had insisted they live at the National Hotel even though finances were low, for to him moving from a place which had been home for so many years would have been unthinkable, and a tacit admission of defeat.

Undoubtedly he now endured great loneliness. The settlements of his business affairs and of his enterprises one by one had gone beyond his control. His most fervent hope was that he would have a new beginning. But in these later years of sadness a mental conflict was always going on within him. The struggle, effort, and money he had put forth in one enterprise he had regarded as a patriotic duty,—that all this should now go unrecognized and unrewarded was a torment. His mind and great imagination could not comprehend the reasons for the gradual and persistent run of bad luck that seemed to haunt him. For several weeks after Mrs. Brady's death, Brady did nothing. His nephew took over his duties and carried on the operation of the gallery. Later, he tried to work whenever his health permitted. Rheumatism was slowing him down considerably. The long days and nights in dreary, wet bivouacs were now exacting their toll on his once strong body. His eyesight too was failing to a point where he had to resort to a jeweler's glass even to read a newspaper.

The strain on him had been great. All his life he had avoided strong drink, but now at his great age he was imbibing. Yet, he was always the polished gentleman, and his clothes, always immaculate, made his appearance belie the fact that he was in desperate financial straits.

During the remainder of that year Brady did not concern himself much with the operation of the gallery although he did make an occasional portrait. For the most part he rested. Sometimes he revisited familiar scenes and old friends and talked long of the past and what might have been.

He was a familiar figure in Washington and always the newspapers would write some friendly piece on his activities. But a reporter noted with some concern the manner in which he rushed around the city at his age: "Brady, although a Seventh Regiment veteran has the active step of a youth, and the way he hurries about town, is a caution to professional pedestrians."

In November of 1887 Clara Barton, the intrepid Civil War nurse and founder of the American Red Cross Society, received an invitation to come to the Washington studio for a portrait. When the time for the engagement approached she evidently couldn't face the ordeal. To Brady's nephew she wrote: "As the time approaches for the proposed sitting, I find I cannot overcome my dislike to having it done, and must ask to be kindly released from the engagement.

"Thanking you most warmly for your friendly courtesy, and Mr. Brady as well, I beg to remain,"

Very cordially,

I am, Clara Barton

During the summer of 1888 Brady started important work on an album of the Fiftieth Congress. It was an extensive work containing over four hundred pictures, each accompanied by a biographical sketch. Included in the volume were the photographs of President Cleveland and his cabinet, the Chief Justice, and the judges of the Su-

preme Court. Brady completed the work in October of that year. The album included all the members who took part in the famous tariff debate during that session of Congress. Of this herculean effort of Brady's the *New York Tribune* stated: "It is in itself a fine work of art, and being the only thing of its kind in existence, is sure to prove a popular book". *The New York Sun,* astonished at such zeal and energy at his age, took yet another view. "Within his line", said *The Sun,* "as a historical photographer he is without equal. It is a rare privilege to hear him detail what he has seen and known during his unrivaled career, and yet he appears like a young man". He was still the man of the trim, wiry, square shouldered figure, with the white mustache and goatee, and notwithstanding his sixty-eight years, he was still the enthusiast. Just what success this new album of the Fiftieth Congress enjoyed is unrecorded, yet it can be presumed that it was fair. The Government probably bought the prints separately, for the whereabouts of the volume, intact as it was originally projected, is unknown.

Brady, as time settled on him, became desultory and uncertain; but he did engage in a great deal of transitory and fugitive work during the next few years. Most of this consisted in taking pictures of large groups and organizations visiting Washington, and in this he was assisted by his nephew. Unquestionably, his failing eyesight was a handicap that was hard to overcome. But despite this he continued to work with his camera every time opportunity afforded.

In October of 1889, Brady made the last sitting of General Albert Pike, of whom he had made a Daguerreotype in 1844 at the Fulton Street Gallery. This sitting was noteworthy because General Pike was the last of his clients who had witnessed the opening of his first gallery, and recalled many memories of the past.

The press of Washington and New York always laudatory and loyal followed his activities more closely now. The winter of 1889 was devoid of much activity for Brady, but during the Christmas holidays, on December 31, he received an assignment to make sittings of the officers of the American Historical Association, whose central figure was the venerable George Bancroft.

The little gallery was crowded with celebrities. *The Washington Post* remarked, ". . . a more distinguished group is seldom seen in an artist's studio." After the gallery sittings were made, the members of the Association, perhaps a hundred, were assembled in front of the National Museum. The weather was cold, but the day was clear with good light. Brady, accompanied by his nephew, drove over to the chosen location in their wagon, perhaps the same one that had seen service on many a battlefield, and there made plates.

These pictures made on the steps of the Museum were apparently quite successful, for with its usual enthusiasm, *The Washington Post* congratulated him upon the success of what they called, "the greatest historical achievement of his later professional life".

In April of 1891 the Pan-American Congress convened in Washington. Brady was given the assignment by the State Department to make portraits of all the members. Albums then would be made and presented to the foreign representatives as souvenirs of the occasion. It was quite the largest photographic order he had received in several

years from the Government, and its make-up required several days of hurried work. It was subsequently finished on time and delivered.

On February 25, 1892, he was asked to photograph Mrs. Benjamin Harrison, the President's wife, who was Vice President of the First Continental Congress of the Daughters of the American Revolution, an organization chartered two years before. The sitting had been arranged by a Mrs. Doremus. Mrs. Harrison was to be in the center of the group and the leading figure. Illness had prevented her once from keeping the appointment. Three days later she was able to leave her home, but not at the scheduled time. It had rained heavily earlier that morning and only at noon did the sun come out. Then Mrs. Harrison drove to Brady's Gallery where the rest of her party had been waiting.

The portraits were taken. Later, she walked about the Gallery and showed great interest in the pictures. She asked Brady if he would show her a picture of her husband, the President. Brady gave her one. It showed him as a general at the close of the war in 1865. Looking at it she exclaimed, "Surely, Mr. Brady, he must give you another sitting."

Brady's habit of a lifetime was to walk fast and even his great age had not slowed him down. While he was crossing 14th Street and New York Avenue in downtown Washington, he was struck and run over by a runaway horsecar. The driver finally brought his horses under control but not before the animals hoofs had done their work. Brady, unconscious and bleeding was rushed to the hospital where he lay delirious with severe internal injuries and lacerations on both his legs.

For several months he was confined to his bed in the hospital. At last, when he recovered sufficiently to be able to leave, he hobbled out with the aid of crutches. For some time he was unable to get around without them. The accident put an end to his photographic activities forever, and he was obliged to live at the home of his nephew and niece. For a short time he remained in their home where their tenderness and care restored him sufficiently to walk around and look up his old friends.

Despite the efforts of Brady and his nephew to rebuild their business it persistently declined. It was in July of 1895 that they were finally compelled to sell the last of the galleries, the property going to William Staley, one of the leading photographers on "F" Street.

Staley did not operate the gallery long. One day he was found lying at the head of the stairs, dead from a heart attack. The gallery, upon Staley's death, came into the hands of Will H. Towles, a capable photographer who carried it on successfully until 1913, when he sold out entirely, closing the gallery forever.

Brady and his nephew retained ownership of their one remaining valuable collection of plates. But the collection could not be sold, pictures of their type being no longer in demand. Brady by now was practically destitute. His fortune had dwindled to nothing. He had continually hoped the Government would buy the remaining plates of his own collection. But from this quarter came no response.

Because he was a member of the Seventh Regiment in New York they insisted that he accept their financial aid. He rented a room at 126 East 10th Street in the lower part of the city. It was near the scene of his old haunts and only a short distance from the location of his old studio. His chief occupation was renewing friendships and acquaintances of former days, and revisiting familiar scenes.

142. **GROVER CLEVELAND'S INAUGURAL PARADE**
Probably one of the last photographs made by Brady in 1893. His National Portrait Gallery can be seen in the center left of the photograph, just above the grandstand draped with a double flag

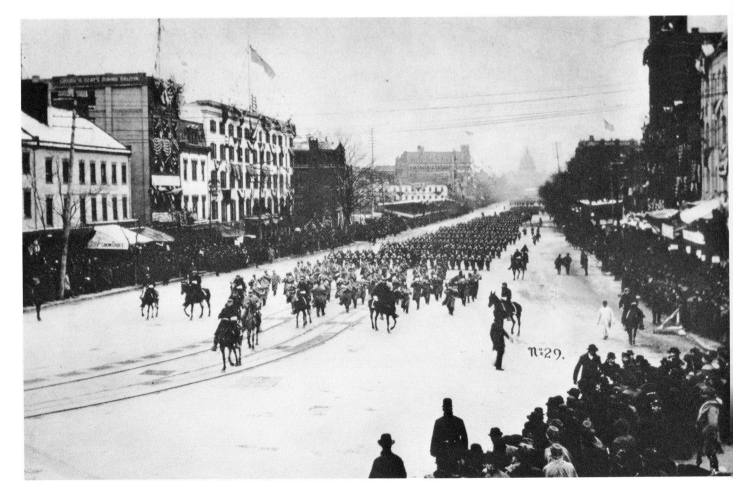

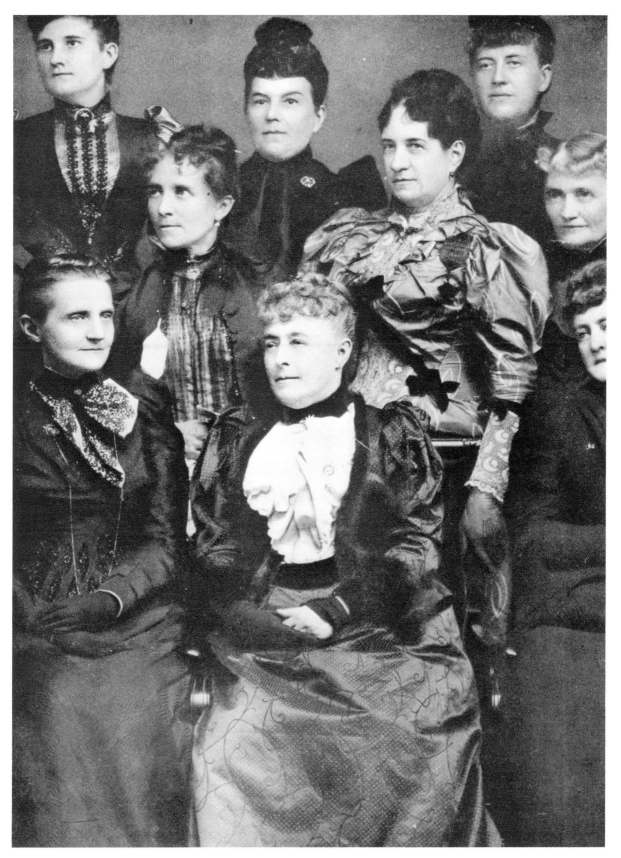

143. MRS. BENJAMIN HARRISON
This photograph was taken by Brady on the occasion of the First Continental Congress of the Daughters
of the American Revolution. Never before published

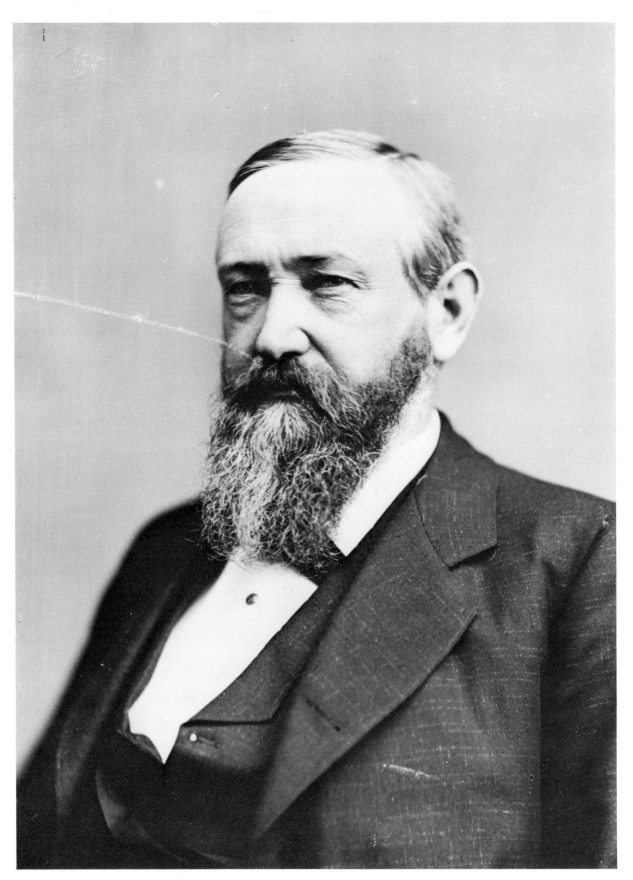

144.

BENJAMIN HARRISON
From an original negative made by Brady in the Washington Gallery in the late seventies

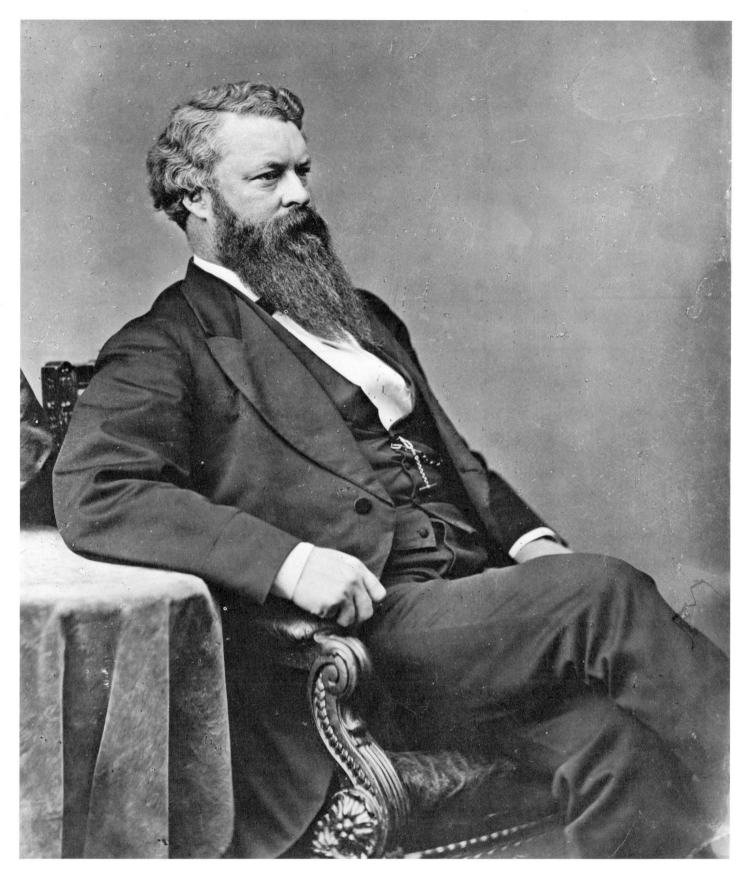

145. WILLIAM BELKNAP
A rare print from an original negative made by Brady in the Washington Gallery in 1872 when Belknap
served as Secretary of War in Grant's Cabinet

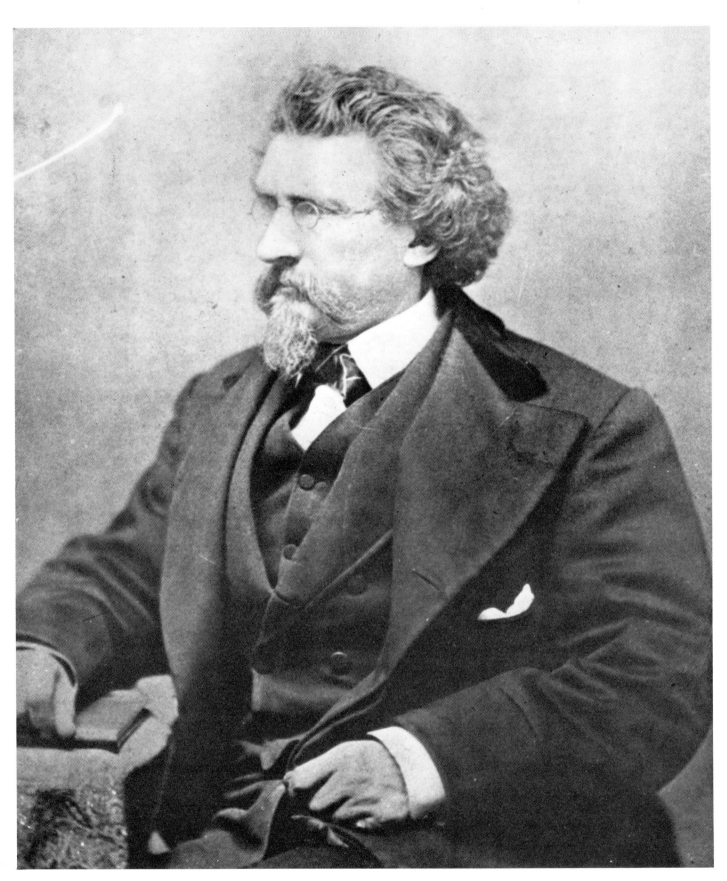

146. **MATHEW B. BRADY**
Copy of a rare print from a negative by Sarony of New York made in the late 1880's when Brady came
to the city for a visit. Never before published

CHAPTER

TWENTY-FOUR

ON APRIL 8, 1895, Wilson MacDonald, editor of "The Monument", a New York art magazine, penned the following letter to Brady's nephew in Washington: "Mathew Brady is here with me, and directs me to write to you and request you make out a list of the War Views, all that you can send, that refer to the Seventh Regiment." MacDonald further requested that slides be made from the negatives, suitable for stereopticon projection. Brady was to receive a Grand Testimonial Benefit that coming Fall from his life-long comrades of the Seventh Regiment. At the Benefit, Brady planned to give a lecture with the aid of a stereopticon projector with which he would 'screen' his photographic record of the War. MacDonald wrote: "He will of course, pay you as soon as the Benefit is over. From the number of prominent citizens interested, it is seen that it will be a splendid success." His nephew finally sent the list of pictures that Brady requested through MacDonald.

On April 30, Brady himself wrote to point out to his nephew: "Success of the exhibition depends upon promptness with which the material is furnished and in the character of the work . . . Of late, amateur clubs have been getting up some very fine work and you can see the necessity of furnishing for our purpose the very finest and first class work."

Brady had great hopes of this benefit. He had been given considerable encouragement by his friends, and he continued to exert his efforts to the utmost to make it a success.

When a month passed and Brady had not received any word from his nephew, he became anxious. On June 14 he again wrote, "I am somewhat worried over the fact that I have not received communication from you for the past two weeks. In relation to the camera (projector), I have had a man who is thoroughly posted in that business, search through New York and Brooklyn without finding one." He must have been disappointed, for in order to present his slides at the proposed Benefit, Brady needed a stereopticon projector. He wrote further, "I advertised in the *World* and two other papers without success. I see no other way than to have one made to order, the cost of which will be seventy-five dollars."

That he was in desperate financial straits is evident by the fact that he was forced

to sell a cherished portrait of himself which had been painted by his friend, C. L. Elliott. Brady had it placed on sale at Wilmot's Store on Thirteenth Street, and this was probably done to allow him to raise money for the purchase of the stereopticon projector and in addition to ease somewhat his personal financial difficulties. He added: "I am at present engaged in trying to make something out of a portrait of myself by Elliott", I shall get something out of it, but at this time of the year it is necessarily slow work".

During that summer Brady was invited to attend an Annual Encampment—a sort of get together of old comrades who had been in the war—at Peekskill, New York, given by the veterans of the Seventh Regiment. At this time his health must have been steadily declining. "It is to my interest to attend", he wrote, "and will do so although it will be a great strain upon me."

He again wrote his nephew, "Before you go away for the summer I hope you will see General Ordway in relation to the affair of next Fall and get all the prints you can on the subject." He later wrote, "I hope that if the affair is a success here, it can be made a success at various other places."

William Slocum, a cordial friend of Brady's, helped take care of the details for the coming show. Slocum, writing of the possibilities of the exhibition to Brady's nephew said: "As you are aware, Mr. Brady has very fully discussed with me the proposition which is being entertained here by very many of his old and particular friends to get up an exhibition on a very large scale, which shall consist of lectures and reminiscences of the late war, accompanied with views produced from photographs taken on the ground.

"From the general discussion with outside parties on the subject, the general impression seems to be, and in which opinion I am in accord, that a very entertaining as well as instructive and unique exhibition can, in this manner, be arranged for production in the principal cities of the United States.

"It seems also to be the general impression that the old plant in Washington can produce more than sufficient material in the shape of pictures, of historical scenes and famous men of the war period.

"That such a production carefully and chronologically arranged would be a financial success, there seems to be no doubt in the minds of the parties interested in the scheme.

"The proposition is, if his strength will permit, to have Mr. Brady go out [on tour] with the exhibition for us . . ."

Slocum later wrote: "There are men throughout the Union who would walk miles for the pleasure of greeting him and the pleasure of shaking his hand."

It seems apparent that Brady's salesmanship came to the front again, for what had started out as a testimonial dinner for his benefit, now began to grow toward an affair in which several prominent people were willing to be financially interested. Everything, it seemed, depended upon the success of the original Benefit show.

As the summer drew to a close, to further impress the necessity of promptness in the delivery of the slides, Slocum wrote to Brady's nephew: "It is now the middle of Septem-

ber and time is passing rapidly. As Mr. Brady is now past his seventy-third year any effort to be made to utilize in his behalf and for his benefit, his past history and the name he has made, should be made without delay."

It will be remembered that Honorable John C. Taylor had access to one set of the 'War Views'. Taylor intended to exhibit the plates to veterans at key cities in the country. This was the same idea that Brady and his backers now entertained, an idea in all probability that grew out of discussions concerning the coming Benefit.

Probably recalling Taylor's plan and wanting to know of his proposed route for his tour, Brady endeavored to have his nephew correspond with Taylor. This he did; he had already started work on the preparation of the slides, and when Levin Handy wrote his uncle for further suggestions, he mentioned that he had written to Taylor. Taylor displayed coolness to the request by not acknowledging Handy's letter, which would indicate that he did not welcome competition.

In another letter, somewhat urgent in its tone, Brady wrote: "I am glad you appreciate the necessity for pressing activity . . . Don't delay anything on Taylor's account. Immediate action is of too much importance to wait for anybody."

However, General Ordway responded heartily and Brady again wrote his nephew, "General Ordway was kind enough to say he would gladly advise you on the subjects to be presented. He is a man of excellent judgment and would be a valuable aid to you. Please call on him." He concluded, "I am better but am still very feeble and I must depend largely on you in this matter."

Nothing more was done that Fall except for the making of the slides. On November 20, or thereabouts, Brady was suddenly taken very ill,—in fact, so ill that he was unable to leave his bed except for a few moments at a time. His devoted friend William Riley took over the details and arrangements for the exhibition.

Finally, as a result of the untiring efforts of Riley, the time for the exhibition was set,—the evening of January 30, 1896. General Horace Porter, formerly of Grant's staff, was to preside and make the opening address. The program, after the fashion of the time, was to include the reading of a patriotic poem and a quartet was to sing "suitable songs". The main feature was to be Brady's stereoptican lecture.

In order to get Carnegie Hall for the exhibition Riley had to secure the names of twenty-five prominent people as patrons. This he easily did. He also secured the services of a man by the name of Murray to act as operator of the projector. But the projector was never found and subsequently forgotten, for Brady's sudden physical collapse changed the outlook. His close friends were dismayed. William Riley took him from his room on 10th Street to the Presbyterian Hospital.

In a letter to Brady's nephew on December 16, William Riley wrote, "I took Mr. Brady to the Presbyterian Hospital this morning and saw him comfortably quartered. This was done because he will have the most skillful attention and the very best of care.

"He is very weak, but I am in hopes that he will, under such care that he will receive, gain strength. The matter of the exhibition is moving along all right. You had better send

your letters to Brady to my care, as I shall make a point to see him every day."

For two weeks Brady remained in the hospital and his condition seemed to improve slightly. He spent the Christmas holidays in bed. Except for occasional visits from a few faithful friends who came to wish him a Merry Christmas and to express their hopes for his rapid recovery, he was alone the greater part of the time. Yet, through these days of loneliness, with only the sounds from the street to keep him company, he was not depressed. Neither then nor thereafter did he give up hope that he would soon be well again and that the contemplated enterprise would be the retriever of everything lost.

In a letter of assurance William Slocum again wrote to Brady's nephew: "... Colonel Appleton of the 'Seventh', and Major Severn of the Old Guards have assured him (Brady) of their hearty and earnest cooperation in making the testimonial an entire success. Colonel Appleton was exceptionally emphatic of this fact ...", and Slocum continued a little anxiously; "... I wish you could be here with him as he is evidently suffering great pain from his injuries, but he is showing his usual pluck and perserverance."

With the coming of New Year Brady's health grew steadily worse. On Thursday, January 16, 1896, he died.

His devoted friend William Riley was the only person with him during his last moments, and in a letter to Brady's nephew he wrote, "Brady was conscious but for two or three days he was unable to speak on account of the swelling in his throat. I don't think he realized he was dying."

And later he wrote again to Brady's nephew, "Of you and your wife he always spoke in the kindest terms and especially of the tender care he received at the hands of your wife during his long painful illness . . .

"I enclose you an ad from which you will see they are already banking on Brady photos. I called them this morning as I came down and found that the work was written by Rossiter Johnson, and the whole thing is a cheap affair. The illustrations are badly printed some of them being indistinct—but they are genuine copies." Nothing ever came of this scheme and the project was apparently abandoned.

Brady's body was sent to Washington for burial in the Congressional Cemetery. A final letter to Brady's nephew, summed up the extremity of Brady's impoverishment. Riley wrote: "I have made a thorough examination of Mr. Brady's effects, and find no papers or other property that it would pay to send you. His wardrobe was only scant, and his coats in number, two . . . an overcoat and frock coat which I gave away. The balance consists of some underwear, a few shirts and socks, etc., not of sufficient [value] to send, and so I thought I would send them to the needy."

Ironic, indeed . . . but to continue, "There is an old worthless Waltham watch and also a ring. (This a gift from the Prince of Wales.) The latter you will, I suppose want, and if you would want, I will send to you.

"The satchel is old and broken and one you would not want. The papers consist mainly of old and unimportant letters which I have put in the wastepaper basket. There are no other papers of the slightest value."

Thus ended the final phase of the career of a man who devoted his life to an ideal, that of perpetuating the history of the land he loved, through the medium he knew best —his camera.

And one thing is certain: as long as the medium of photography survives, so will the credit line, "Photograph by Brady," be remembered.

147. Facsimile of a bill for insurance premium on Brady's photographic outfit. The finished pictures call for a higher premium than the negatives, the reverse would be true today

M. W. BEVERIDGE, *Pres't.* FRANCIS B. MOHUN, *Sec'y.* HARRY C. BIRGE, *Ass't Sec'y.*

Washington, D.C., May 31st 1894

M. B. Brady, Esq.

To The Riggs Fire Insurance Co., Dr.,

NO. 1331 F STREET N. W.

For Premiums on the following Policies of Insurance:

DATE.	NAME.	No.	AMOUNT.
1894 May 14	Photographic outfit &c. 1107. F str. n.w.	4523	3 75
	Finished pictures &c. &c. " " "	4524	15 00
	Negatives &c. &c. in No. 494. Md. ave. s.w.	4525	7 50
			26 25
	Rec'd Payment		

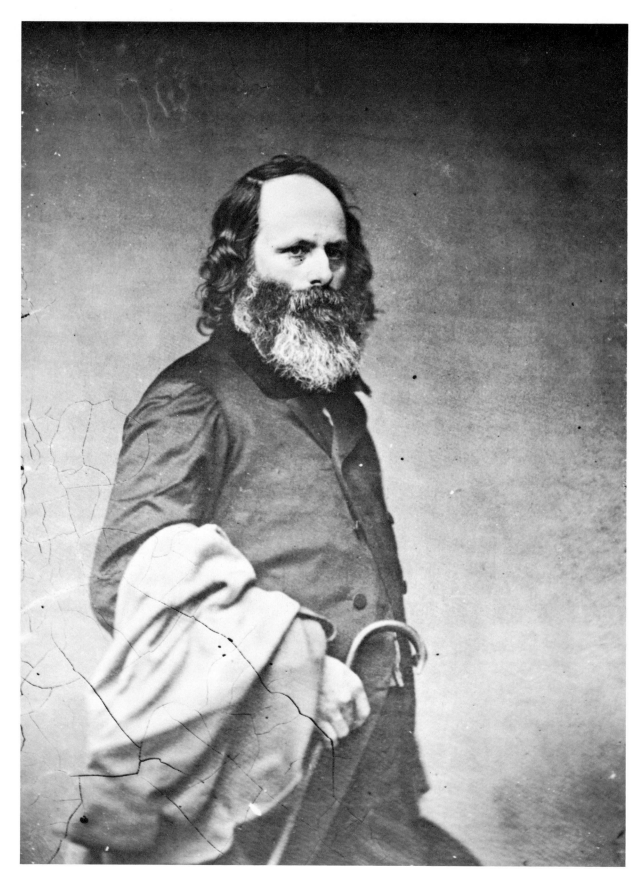

148.
CHARLES L. ELLIOTT
The artist who painted the only portrait of Mathew Brady. From an original negative made by **Brady** in the Washington Gallery in 1868 and never before published.

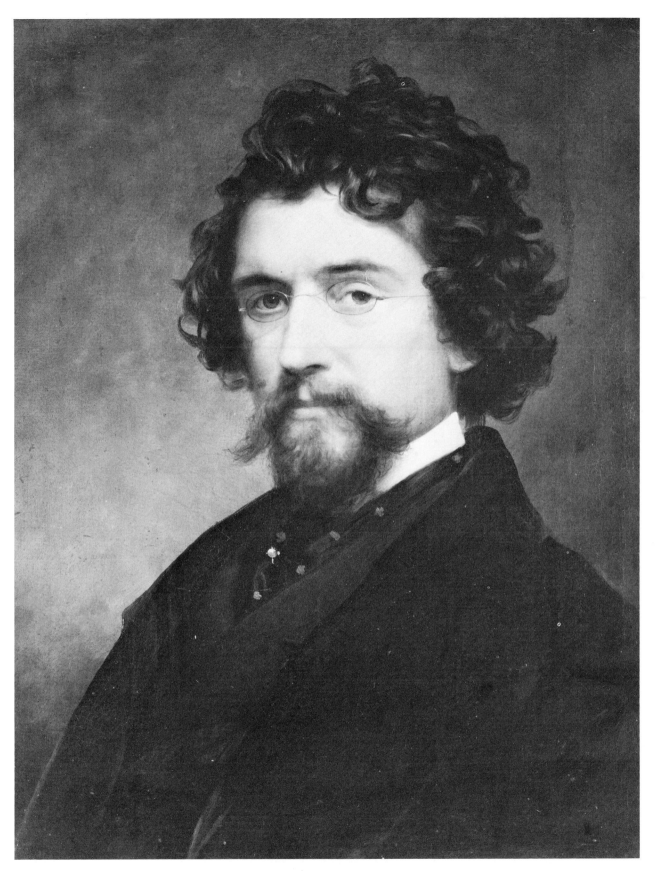

149.
MATHEW B. BRADY
From the famous painting by Charles Loring Elliott
Courtesy of the Metropolitan Museum of Art of New York

On the Battlefield of Stone River

This is a monument erected by the veterans of Hogans Brigade in memory of their comrades who fell here in the battle of Stone River.

The inscription on this Side reads; "The veterans of Shiloh have left a deathless heritage of fame on the field of Stone river.

Then follows the names of those who were killed, with dates &c.

This view will be prized by the comrades of that army

No 46

Atlanta Ga just after its Capture

This is a view near the Rail Road Depot in atlanta Ga just after the city was captured by Genl Sherman

Uncle Sam's baggage trains and the Boys in Blue are a strange Sight to the inhabitants of Atlanta

Raising the Old Flag over Fort Sumter

april 14-1865 (4 years from the day the Rebels had compelled Major Anderson to haul down the Stars and Stripes from the flag-staff at Fort Sumter) Major Genl Anderson raised the same flag over the ruins of the fort, now again in possession of the United States.

The ceremony was of most intense interest, Charleston Harbor was filled with Uncle Sam's vessels covered with holiday flags -

Great crowds thronged Fort Sumter Henry Ward Beecher delivered the Oration at a given signal, amid booming cannon, and with the Bands playing the Star Spangled banner, Maj. Genl Robt Anderson ran up the glorious old flag.

And ran it up to stay; a perpetual menace to treason from with-in, or foreign enemies from with-out.

Long shall it wave -

BRADY'S LECTURE BOOK

Mathew B. Brady's Lantern Slide Lecture, "consisting of lectures and reminiscences of the late war accompanied by views from photographs taken on the ground", that was to be delivered at Carnegie Hall in New York, is a pageant of all the work and experiences shared by him and his operators.

The text and the pictures are herein reproduced exactly as he would have presented them to his audience. The text has not been edited, but is presented verbatim, misspelling and all, for its original flavor. The pictures speak for themselves.

The Author.

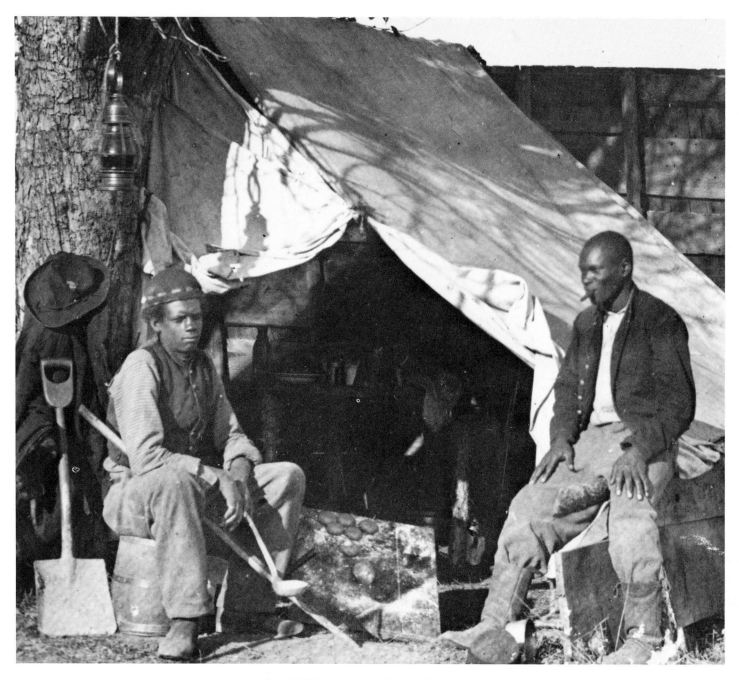

No. 1 JOHN HENRY & REUBEN AT LIESURE

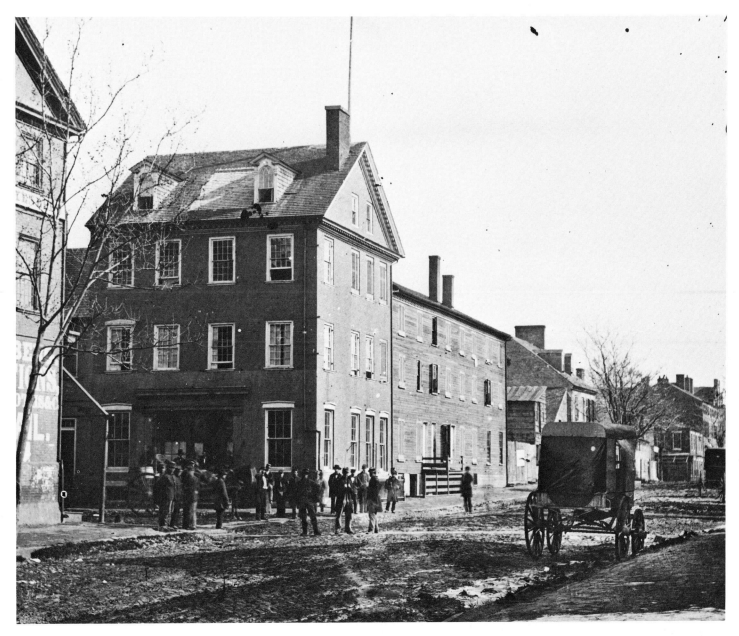

No. 2 **MARSHALL HOUSE, ALEXANDRIA VA.**

Scenes of the assissination of Col. E. E. Ellsworth commander the New York Zouaves. He was shot and instantly Killed by Jackson the landlord for pulling down a rebel flag from the flagstaff on the roof. Col. Ellsworth was immediately avenged by Sergeant Ronell of his Zouaves who shot and bayonetted Jackson almost at the same moment that Jackson shot Ellsworth. Their dead bodied fell within three feet of Each other. This occurred on May 24th, 1861.

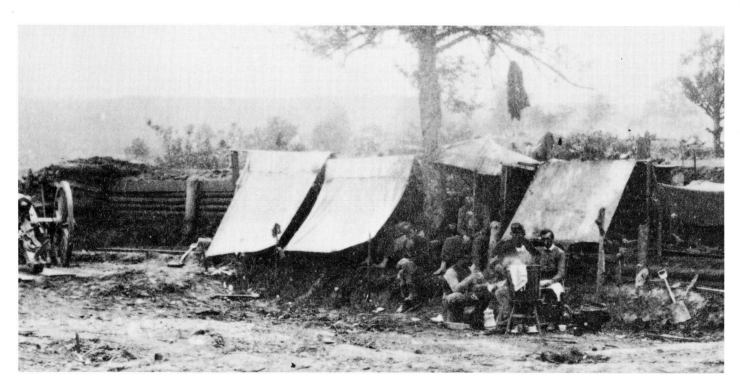

No. 3 A CONFEDERATE REDOUBT

This is an exterior view of a rebel redoubt on the South bank of the North Anna River. The Guns of this redoubt comanded the Chesterfield bridge. The second corps crossed the river and captured this redoubt May 23, 1864. The artillery at the embrasure, the shelter tents, the group of soldiers are all as natural as life.

No. 4 Battery fording a tributary of the Rappahanock at the battle of Cedar Mountain.

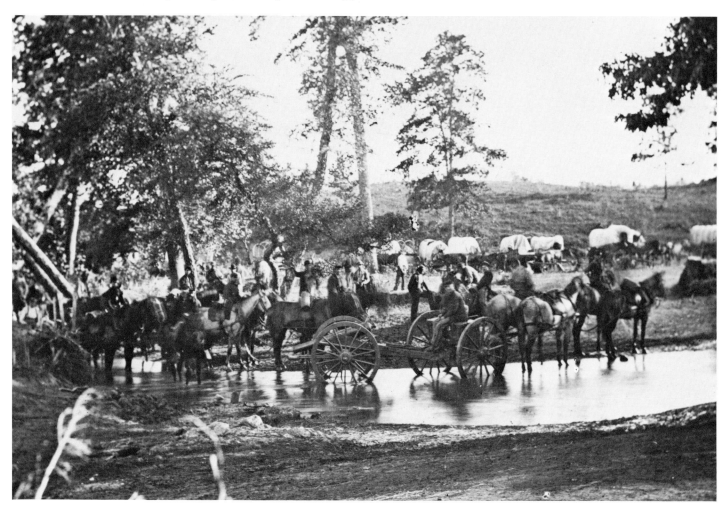

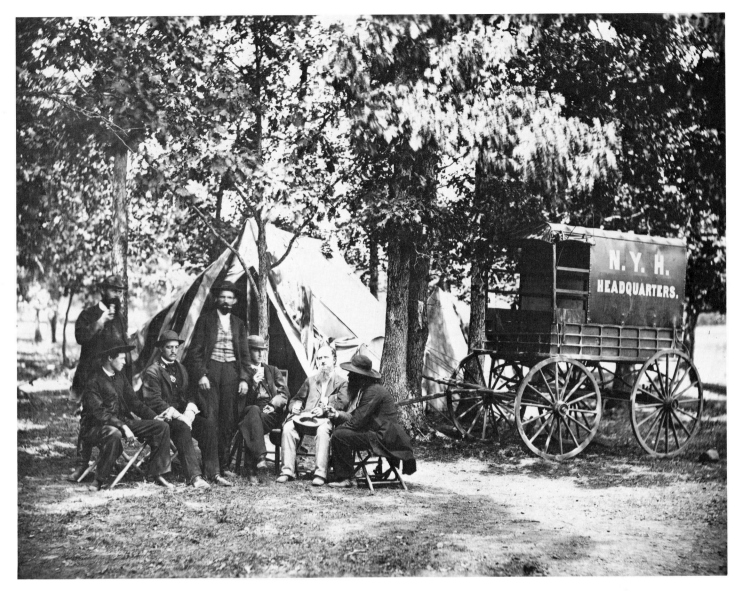

No. 5 HEADQUARTERS N. Y. HERALD IN THE FIELD
This picture was made at Culpeper Court House about four miles beyond Brandy Station on the
Orange and Alexandria R.R.. the place where General Grant first Established his Headquarters in
Virginia after his appointment as Lieutenant-Genl. The army of the Potomac was emcamped around
this place and Brandy Station during the winter 1863-4.

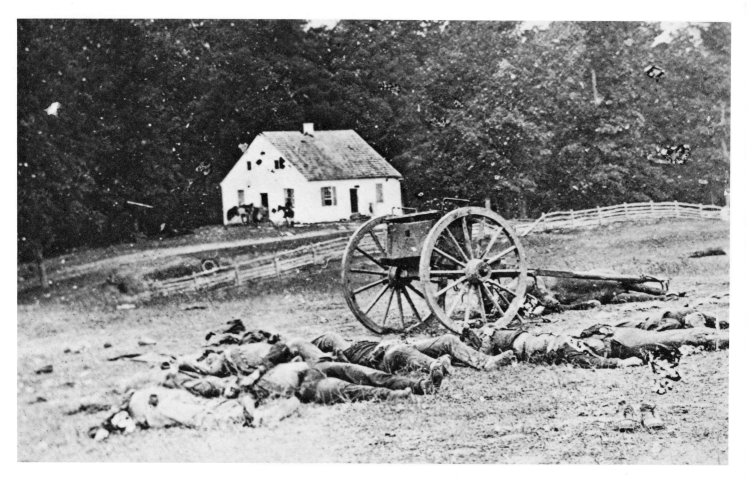

No. 6 **DUNKER CHURCH, ANTIETAM SEPT. 1862**
The rebels posted a battery of light artillery in front of a little one and a half story building used by
the Dunkers as a church. This view shows where one gun of the battery Stood The dead are artillery-
men and horses, and the Shell holes through the little church Shows how terrible a fire was rained
on this spot by the Union batteries.

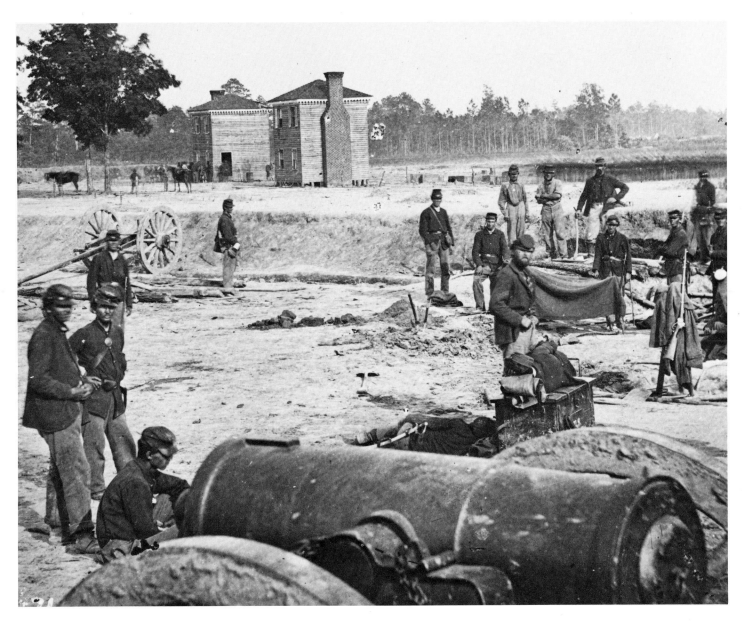

No. 7 FAIR OAKS VA.

Here is where the Battle raged hottest in June 1862 In the rear of the battery of howitzers which is
scene in the foreground, can be seen the left of Sickles brigade in line of battle. Near the Twin Houses
seen still further in the rear, the bodies of over four hundred Union Soldiers where buriied after the
battle. This battlefiled, being only eight miles from Richmond, is more generally visited by tourists
than any other, the frame building still remains.

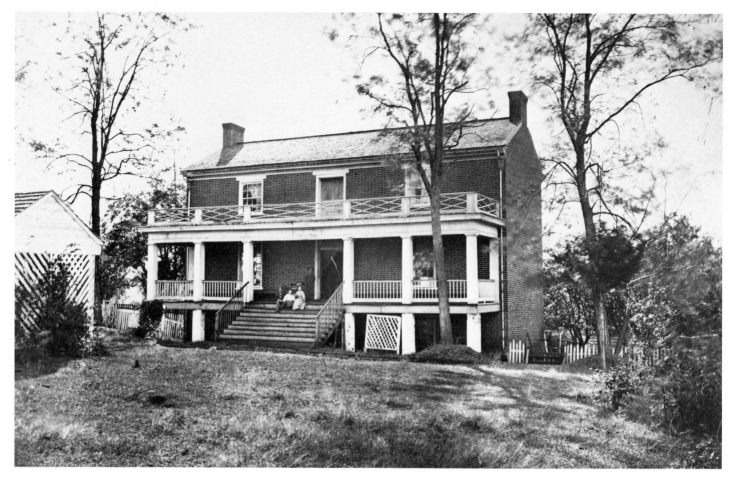

No. 8 McLEAN HOUSE WHERE GENERAL LEE SURRENDERED

This is the Scene of Geneneral Lee's surrender to Gen'l Grant April 9, 1865. It was within this house owned by a Mr, McLean and situated near Appomattox Courthouse that the Surrender was signed. This great historical event took place in the front room on the right of the door as you enter the house.

No. 9 DUTCH GAP CANAL

The famous canal dug by Gen'l Butler across the throat of Dutch Gap is almost the only memorial of the war that remains unchanged.

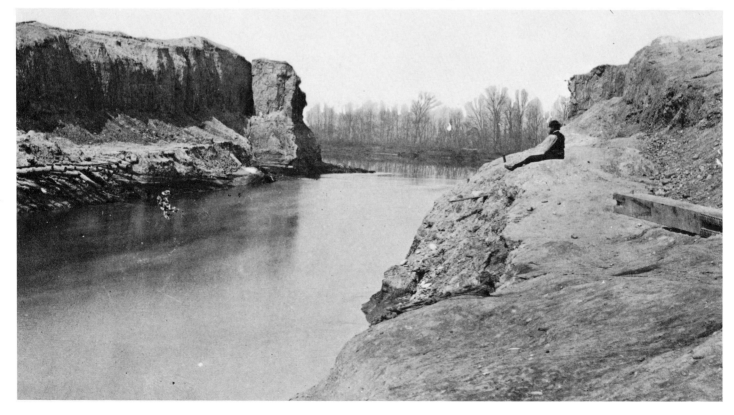

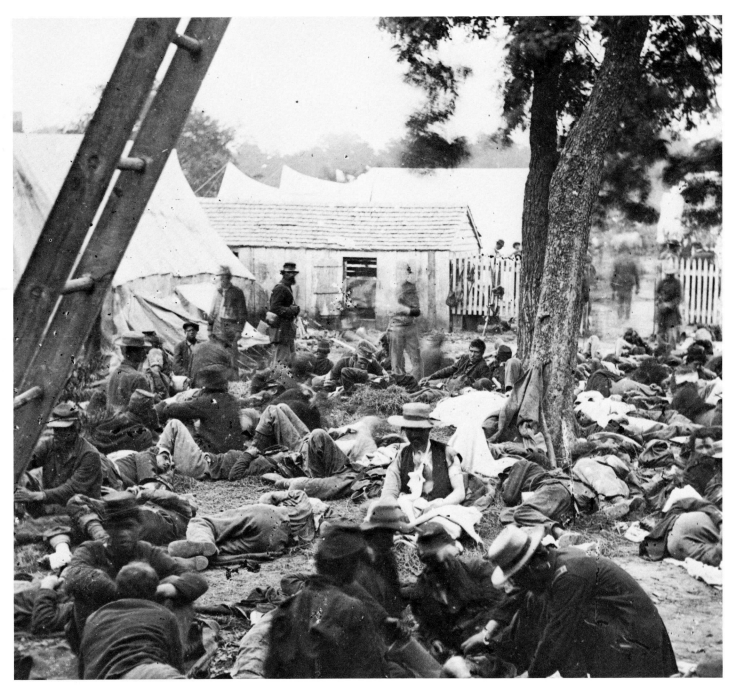

No. 10 A FIELD HOSPITAL SCENE
During a battle field hospitals are established as near as possible to the line of battle. This view gives a glimpse of the field hospital at Savage Station, Va during the battle of June 27, 1862. The wounded are brought in by the hundred and laid on the ground. The surgeons are busy dressing their wounds.

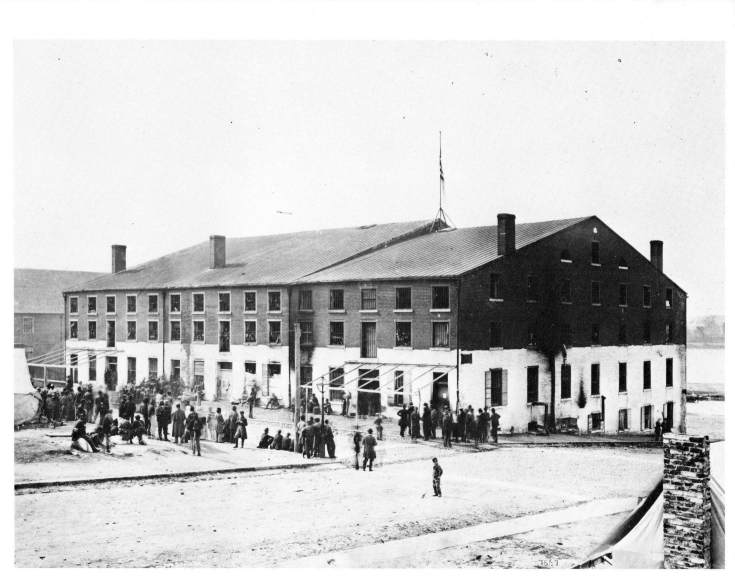

No. 11 LIBBY PRISON, RICHMOND, VA.

This is a view of the infamous Libby Prison, where so many of the Union Soldiers suffered and Starved
during the war. It would take volumns to tell the story of Libby Prison, it was an old tobacco ware-
house which the confed rates turned into a prison for Union Soldiers. There is not a Grand Army
through all our land but what has among its members some comrade who Knows from experience just
what a (Hell Hole) this place was. If the spot where it stood could be wiped off the face of the
Earth it would be well.

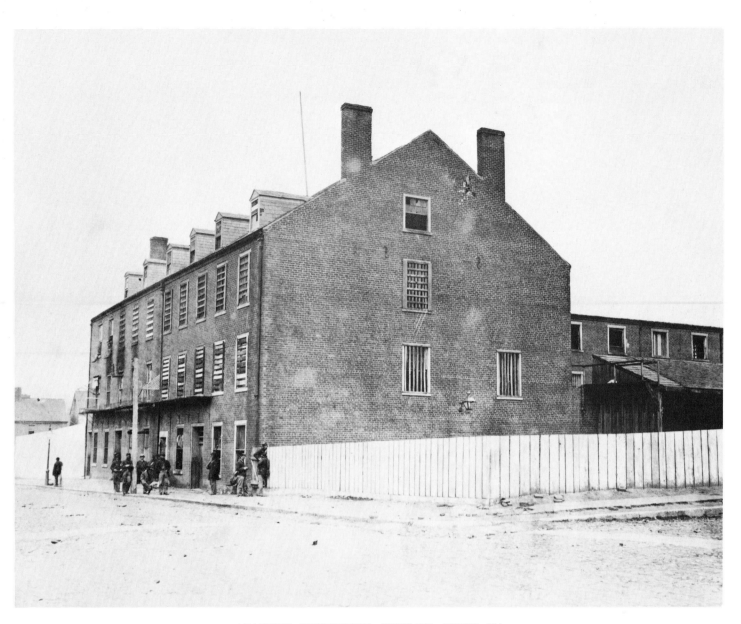

No. 12 (CASTLE THUNDER) PRISON. RICH. VA.
This is a building which was used by the Confederates as a prison to confine Union Soldiers. Its history
is almost as damnable as that of Libby Prison. The horrors of both Castle Thunder and Libby Prison
will be vividly remembered as long as any Soldiers who was therein confined shall live.

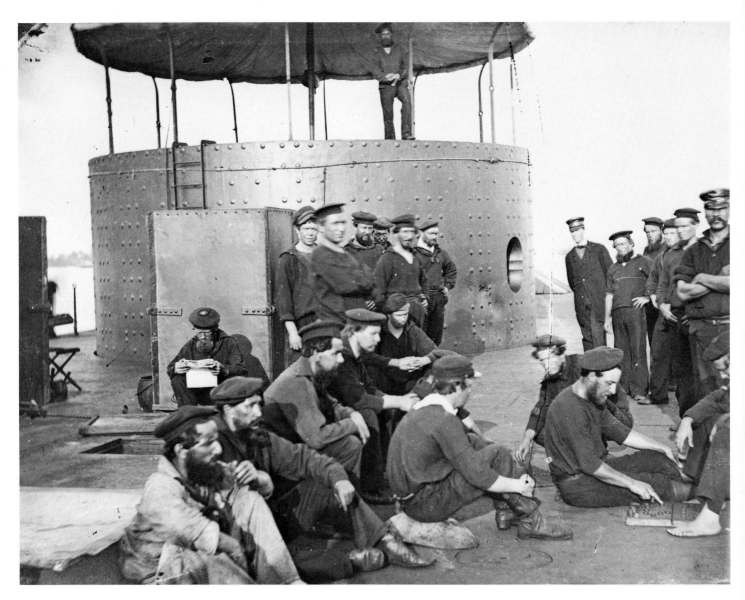

No. 13 CREW OF THE ORIGINAL (MONITOR) ON HER DECK

This view shows the crew of the original (Monitor) on the deck of that world famous little (cheese box on a raft) as the rebels contemptuously called her until she showed them how Easily She could lick their famous Merrimac. The honest Jacktars here seen can always congratulate themselves that they took part in the famous fight which revolutionized the navies of all the world.

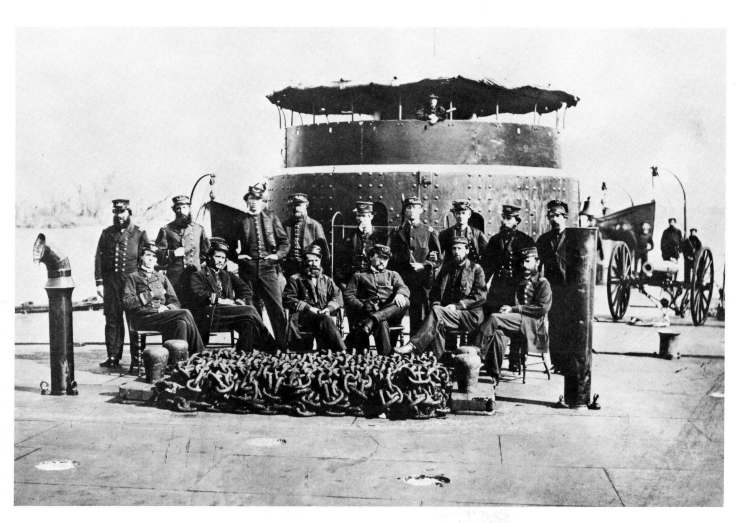

No. 14 OFFICERS OF THE ORIGINAL MONITOR ON HER DECK

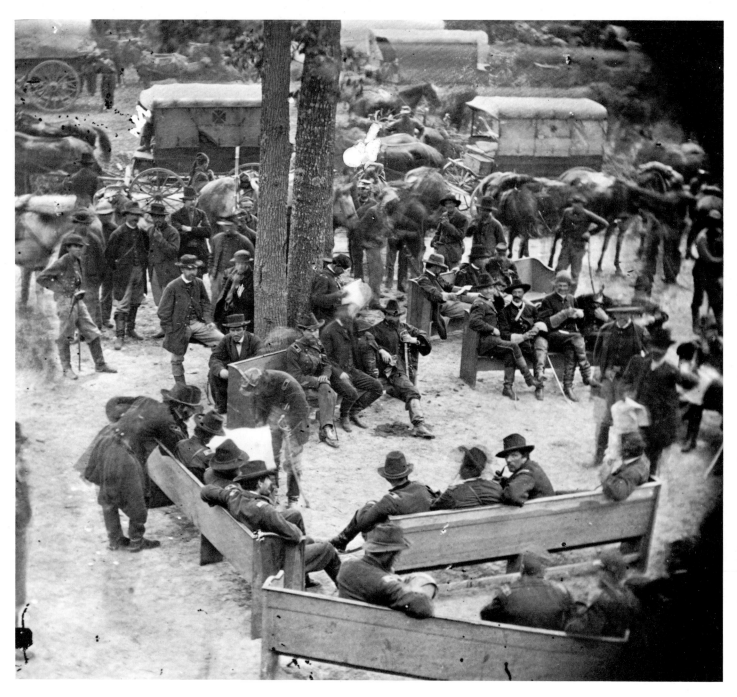

No. 15 GENERAL GRANT'S COUNCIL OF WAR

This (view) shows a council of War in the field near Massaponax Church Va,. May 21, 1864. The pews or benches have been brought out under the trees and the Officers are gathered to discuss the Situation. It has been a disastrous day for the Union Troops; the losses have been heavy, and nothing apparently gained. General Grant is bending over the bench looking over General Meade's Shoulder at a map which is held in Meade's lap. The Staff Officers are grouped around under the trees. The orderlies are seen in the background the ambulances and baggage wagons can also be seen in the background.

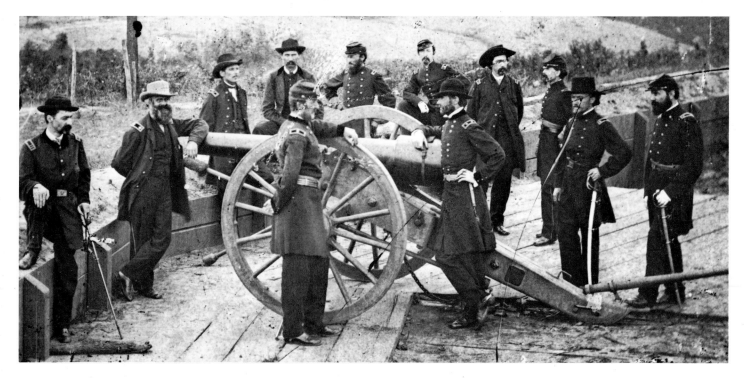

No. 16 GENERAL SHERMAN AND STAFF
This photograph of General Sherman and His Staff, was taken on July 18th, 1864 on the lines before
Atlanta Ga.

No. 17 REBEL WINTER QUARTERS AT CENTREVILLE VA. 1862
During the winter of 1861-62 the rebel army of Northern Virginia were in winter quarters at Centreville,
Va. and this is a view of their quarters, which by the way were much better than either army were
accustomed to have during the later winters of the war.

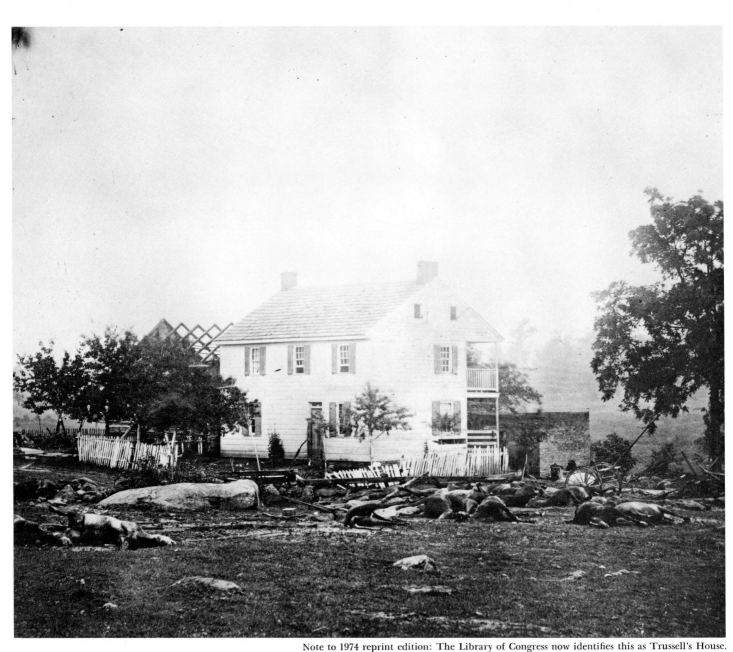

Note to 1974 reprint edition: The Library of Congress now identifies this as Trussell's House.

No. 18 **GEN'L MEADE'S HEADQUARTERS AT GETTYS'BG**

This·little house was the headquarters of the Union Army during that terrible battle. On the three'd day this house was in direct range of the fearful artillery fire rained by the rebels on the Union lines just previous to Pickett's great charge. The horses Gen'l Meade's were hitched to the fence and trees near the house. Sixteen of these horses were killed during the artillery fire. Dead bodies of horses are seen in the road and field near the house and under the trees. This house at the time was occupied by Mrs. Leister rather a warm residence at that time.

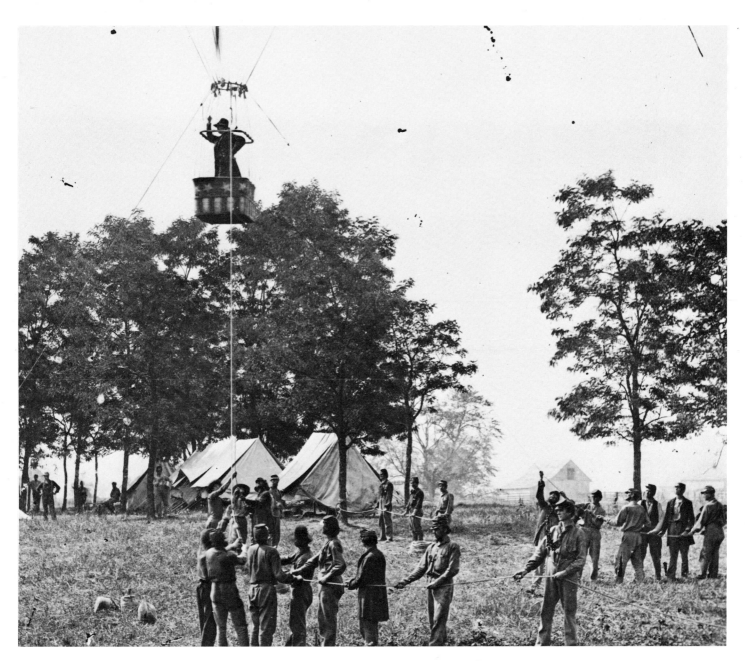

No. 19 PROFESSOR LOWE IN HIS BALLOON

During the Peninsula Campaign in 1862, the army was a valuable aid in the Signal Services. This view showes Professor Lowe up in his Balloon watching the battle of Fair Oaks. He can easily discerne the movements of enemy troops and give warning to our Generals how to head them off. The men at the ropes permit the Balloon to rise to whatever elevation he disires and then anchor it to a tree.

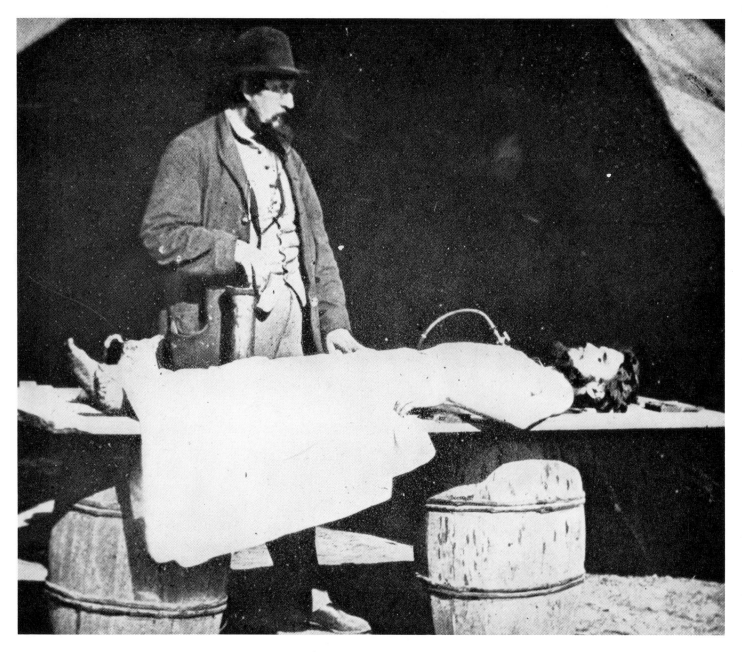

No. 20 **EMBALMING SURGEON AT WORK**
This view Shows Dr. Burr, the embalming Surgeon engaged in the process of embalming a dead soldier. The veins are pumped full Some liquid which possesses the power to arrest and prevent decay. Thus it was made possible to send to friends in the North the bodies of Soldiers, which, but for the Science of embalming, could not have been permitted a grave in their native Soil.

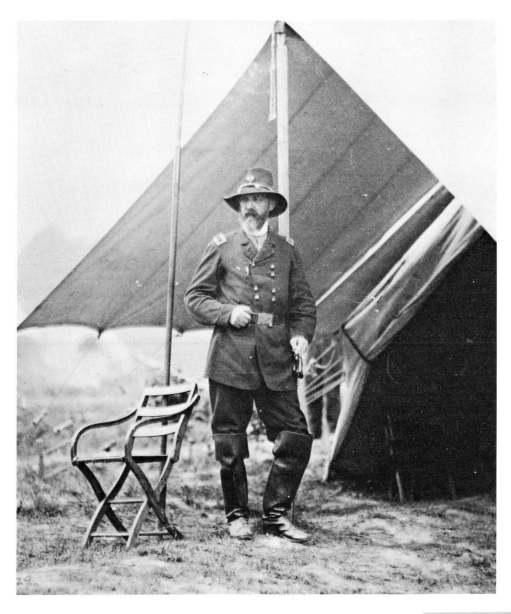

No. 21 GENERAL GEO. G.
MEADE, the hero of Gettysburg

No. 22 GENERAL DIX, Author of the famous
letter "if any man dare pull down the American
flag Shoot him on the Spot".

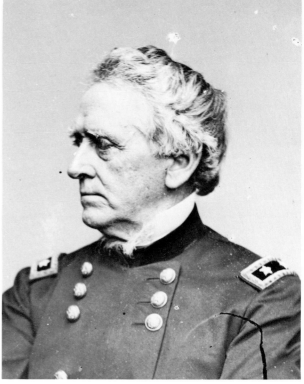

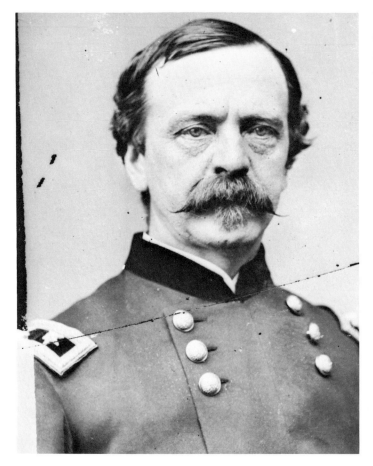

No. 23 GENERAL DANIEL SICKLES

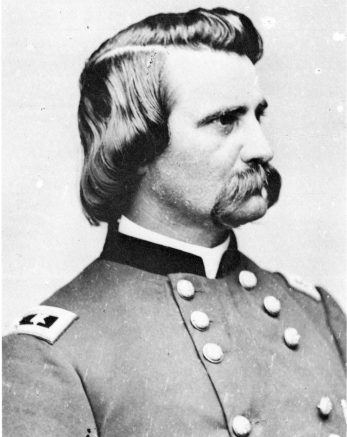

No. 24 GENERAL JOHN A. LOGAN

No. 25 GENERAL NELSON A. MILES

No. 26 GENERAL PHIL KEARNEY

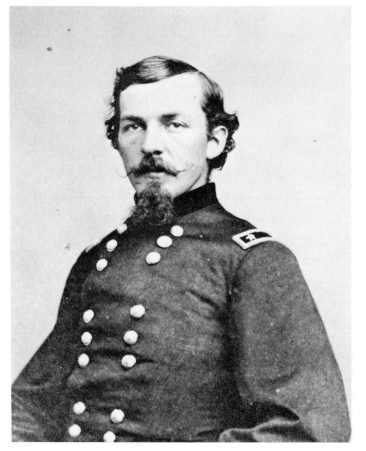

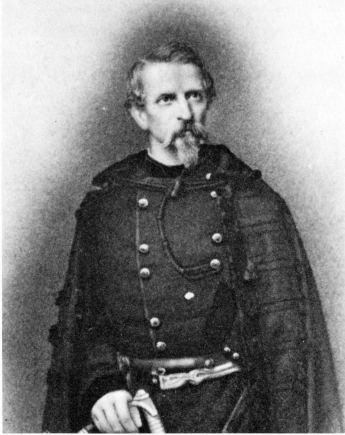

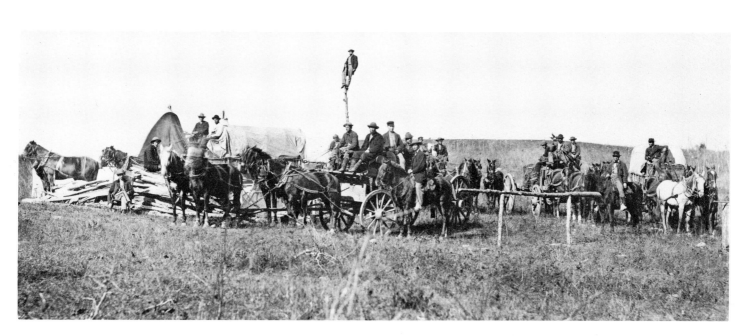

No. 27 FIELD TELEGRAPH STATION

It was often necessary to establish the telegraph between points in our lines very hurriedly. This View shows one of the Characteristic Field Telegraph Stations. An old piece of canvassed stretched over some rails forms the telegraphers office, and a (Hardtack) Box his telegraph table; but from such a rude station messages were often sent which involved the lines of hundreds of thousands of soldiers.

No. 28 NEAR VIEW OF (SIBLEY TENT)

Early in the war the soldiers were much more comfortably sheltered than they were as the war progressed. This view shows a (Sibley Tent) Mess; these (Sibley) were nice large tents, and would comfortably hold from ten to fifteen men. When the army moved up the Peninsula (from Camp Winfield Scott) before Yorktown) Early in the spring of 1862, we bade farewell to our comfortable large tents, and thereafter each soldier carried his house on his back. From the Spring of 1862 till the end of the war we lived in dog tents or shelter (?) tents as the government (Mis) called them.

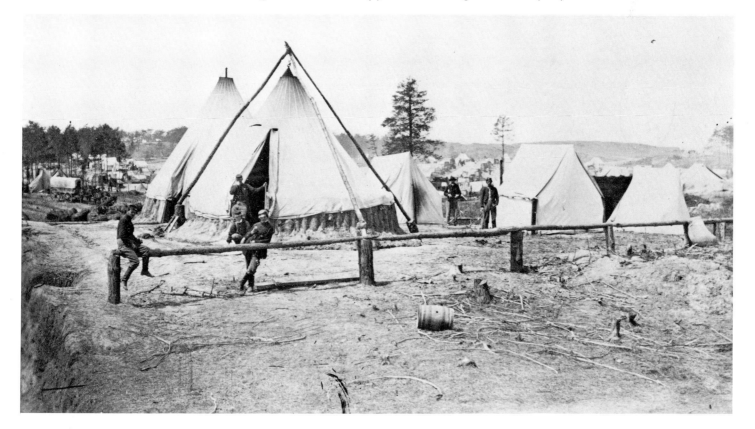

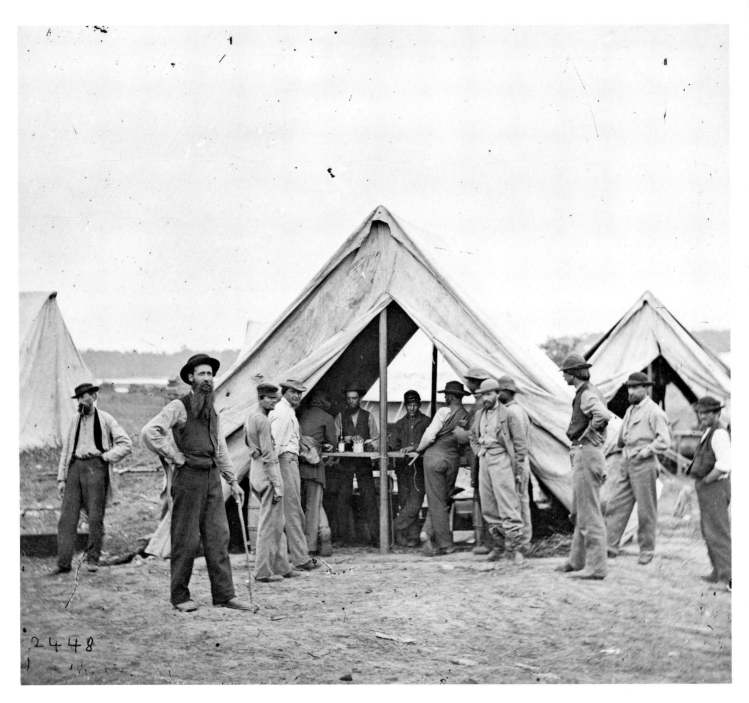

No. 29 A SUTLER'S TENT

The Sutler or army Storekeeper was the fellow who got the most of the soldier's pay. Sardines, canned peaches, ginger cakes, condensed milk, plugged tobacco, etc,. etc,. at extremely high prices, found ready sale on pay day and for the few days th reafter the money lasted, but with condensed milk at a dollar per can, and other things in proportion, thirteen dollars a month did not prove sufficient to keep a fellow in cash more than one or two days per month. This is the tent Johnson the Sutler of the Second Division, Ninth Corp.

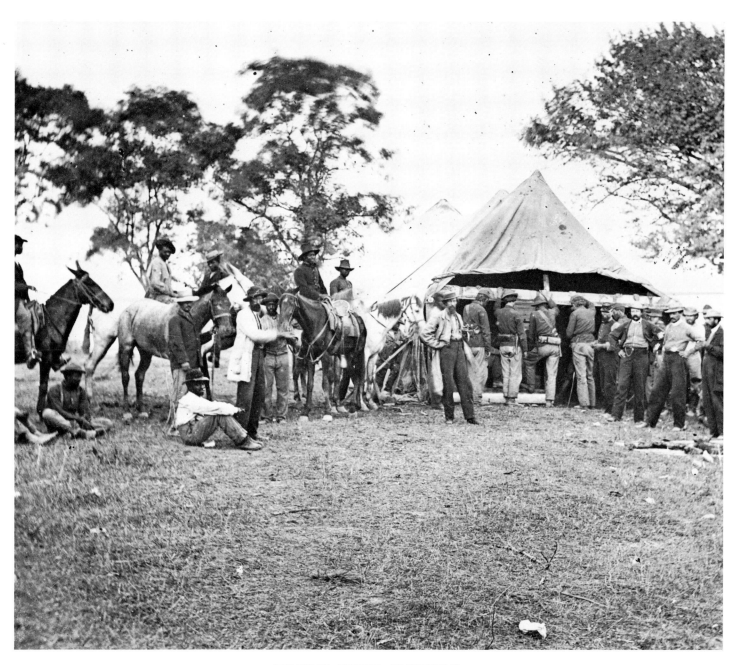

No. 30 FILLING THEIR CANTEENS

Comrades all remember how eagarly they made a rush for the old well when on a long and dusty
march they came to a plantation with its cool "Spring House" or its deep dark well. This view
shows the familiar scene of filling the canteens; The well has been covered with canvas and a guard placed
over it to prevent any waste of water, for a well, however deep and copious soon becomes dry when
the army commence to draw water.

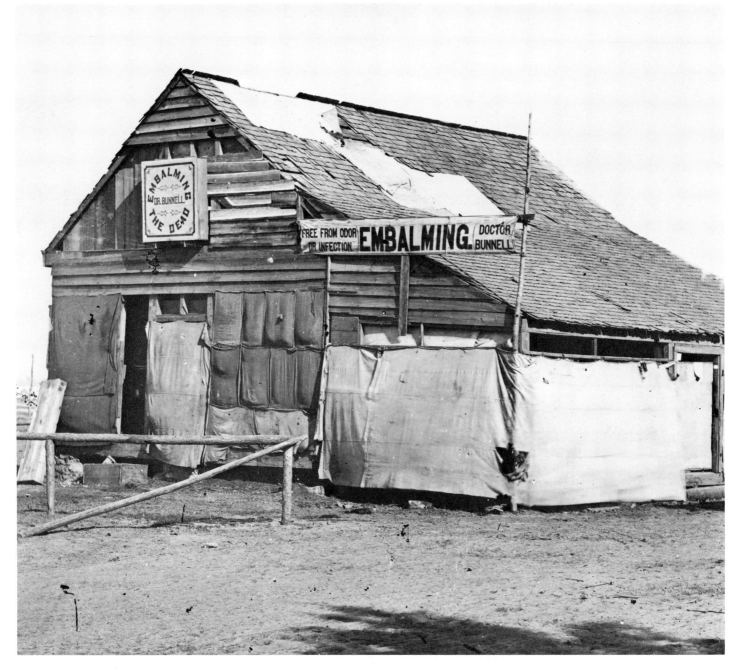

No. 31 EMBALMING BUILDING NEAR FREDRICKSBURG VA.

This old barn near Fredricksburg Va. was used as an embalming building. Here the bodies of the dead soldiers that were to be sent North to their friends were embalmed, more than a hundred bodies were sometimes brought here in one day. During the first battle of Fredricksburg, in December, 1862 several hundred were here at one time to be embalmed. Dr. Bunnell was in charge of this house.

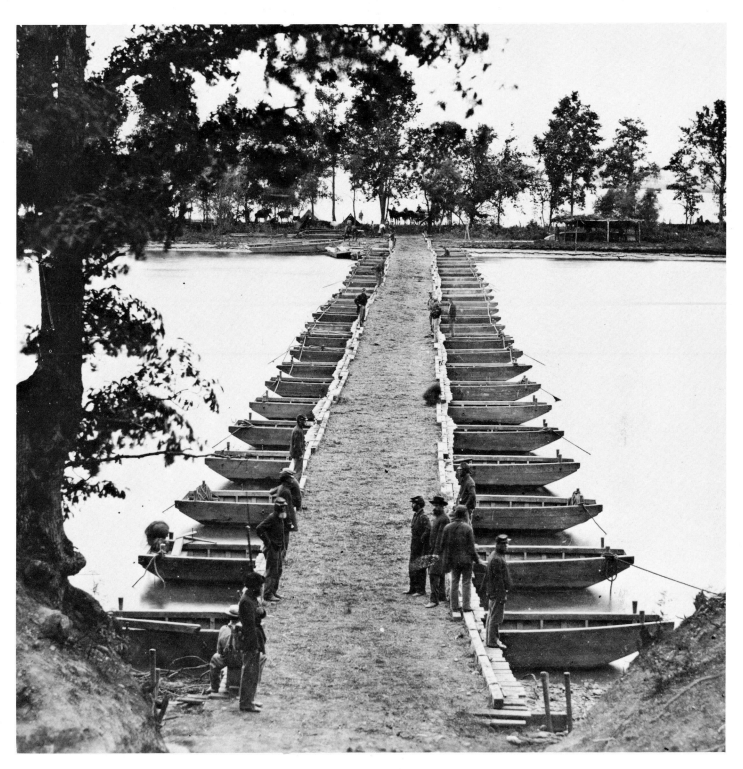

No. 32 A PONTOON BRIDGE ON THE JAMES RIVER

The Boats and timbers forming this bridge were carried on wheels. When the Army needs a bridge, the boats are quickly launched and anchored paralell with the current, the timbers are Soon laid; the bridge is thus formed, Strong enough to permit to cross with the cannon and trains. The boats are then taken up, replaced on the wheels and carried with the army.

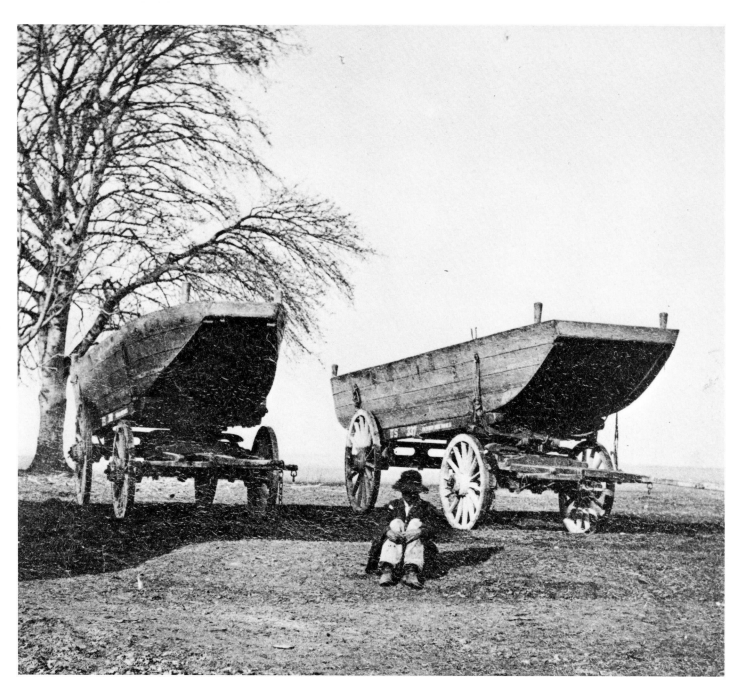

No. 33 **A PONTOON BOAT ON WHEELS**

This view shows two of the boats (of which the army bridge is made) on wheels ready for the march. Each pontoon wagon is drawn by six mules. These pontoons were always getting stuck in the mud, and the soldiers struggling along under their own burdens, were obliged to haul on the drag ropes, and raise the blockade. Probably no Soldier will see this view without being reminded of the time when he helped to pull these pontoons out of the mud, and comforted himself by—swearing at the mules.

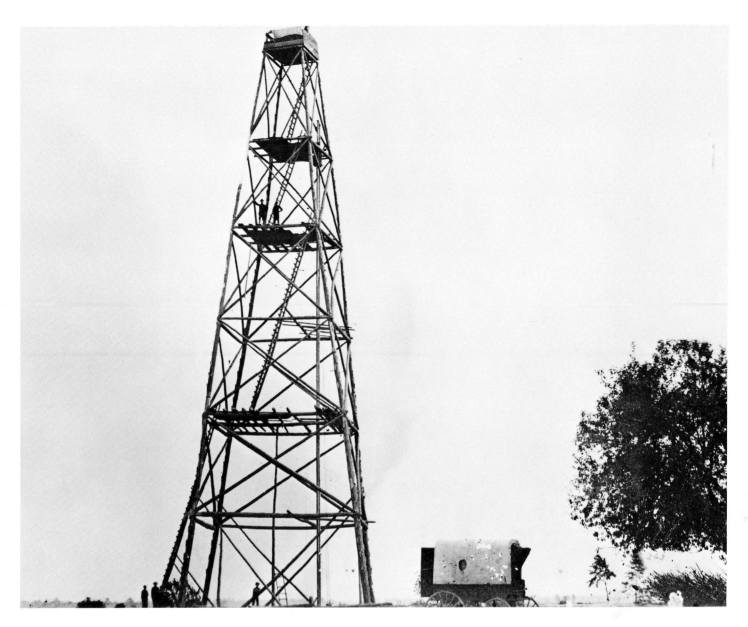

No. 34 SIGNAL ON THE LINE BEFORE PETERSBURG VA 1864

On our permanent lines tall towers were erected on high and commanding positions. From the top of these towers our Signal Corps could transmit messages by means of waving of flags by day, and torches by night.

These were in plain sight of the enemy, but were utterly unintelligible to them, as the messages were all in cipher; the very men who were waving the flags did not know the tenor of the messages they transmitted; they of course knew how to wave their flags so as to make certain given figures, but they did not know what these figures meant.

Only the officers of the Signal Corp had the "Key" to the cipher. The members of theb Signal Corp were brave and cool as any soldiers who were doing the fighting, for when the lines of battle were shifting, the Signal Corp was pushed away out at the front where they could better observe the movements of the enemy, and transmit intekligence to the generals; they had to post themselves in treetops or on housetops in most exposed positions, and were constantly made the target for Sharp-shooters.

When our troops were sorely pressed, sometime a message from the little flags was like an inspiration, telling of re-in-forcements coming to our help.

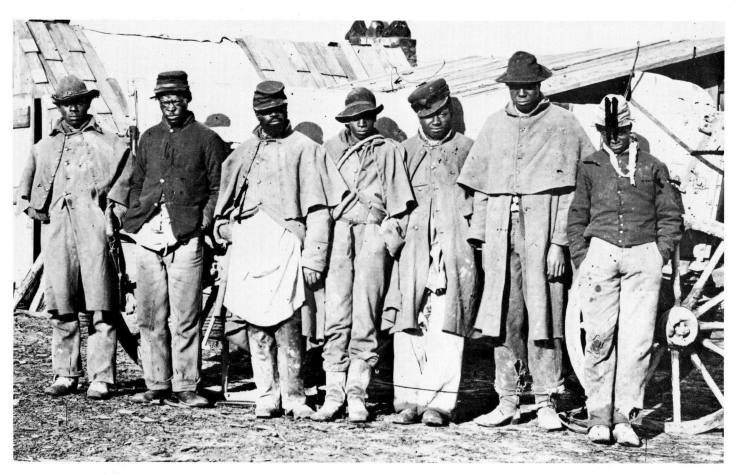

No. 35 A GROUP OF 'CONTRABANDS'

The negroes who ran away from Slavery and came into the Union lines, were employed by the Government as teamsters, laborers, and & c,. They were happy good natured fellows and made lots of fun for the Soldiers. This is a characteristic group of the 'contrabands' as they were called. Standing in front of there rought—built Shanty to have their pictures taken, one of the common characteristic scenes in the Union army during the war was a group of 'contrabands' happy and contented thankful if permitted to remain under the protection of 'Massa Linkum's sojers'.

No. 36 'It is the 'Bean' that we mean So white and clean.' "As the boys" look at this view we think they will sniff the old familliar aroma of Bean Soup.

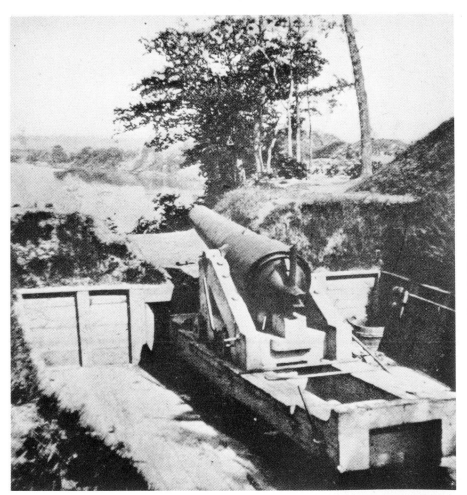

No. 37 ONE REASON WE DID NOT GO TO RICH-MOND.

They were many reasons that we did not go to Richmond as Soon as we expected to. This is one of the reasons: There were lots of such reasons as this all along up the James river. This is one of the many guns which the Rebels had in Fort Darling, which commanded the river approaches for a long distance. The Rebels used to shout across to our pickets that before we could get to Richmond we had a 'Longstreet' to travel and a big 'Hill' to Climb, and a 'Stone-wall' to get over, (But we got there just the same)".

No. 38 COL. ELMER ELLSWORTH

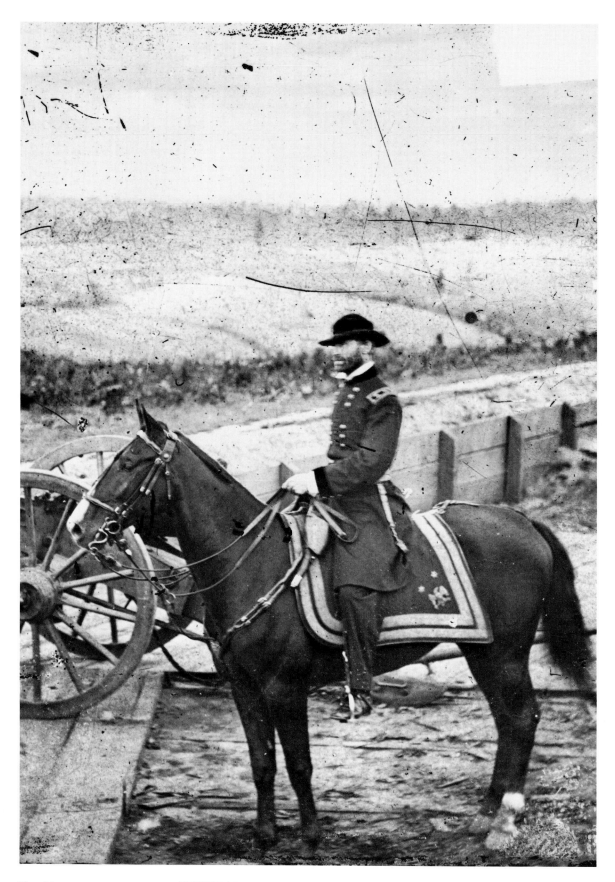

No. 39 **GENERAL W. T. SHERMAN ON HORSE**
General Sherman was familliarly known as 'Old Tecumseh'. His full name being William Tecumseh
Sherman. This photograph was taken of him in the Union Lines before Atlanta July 19, 1864. His
'boys' will be glad to see as he looked during the war.

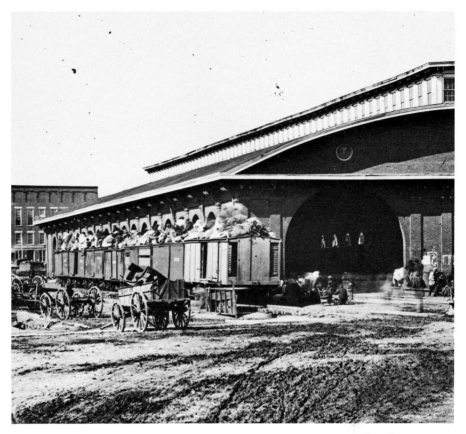

No. 40 PREPARING FOR THE 'MARCH TO THE SEA'
This is the last train of cars that went out of Atlanta just before Shermans men destroyed the railroad. This train is loaded even on the roof of the cars, with families fleeing from the city.

No. 41 FORT SUMPTER AFTER THE BOMBARDMENT
This is a view of a portion of the Exterior of the celebrated Fort Sumter in Charleston Harbor S.C. The heavy batteries on Morris Island aided by a fleet of Monitors gave this fort a terrible bombardment, It was, at the commencement of this bombardment a handsome symetrical fort. This photo was made after the bombardment and shows what a fearful pounding the fort has received; in fact it is Scarcely more than a mass of ruins. Shot, shell, and dismounted cannon are scattered about like leaves of the forest.

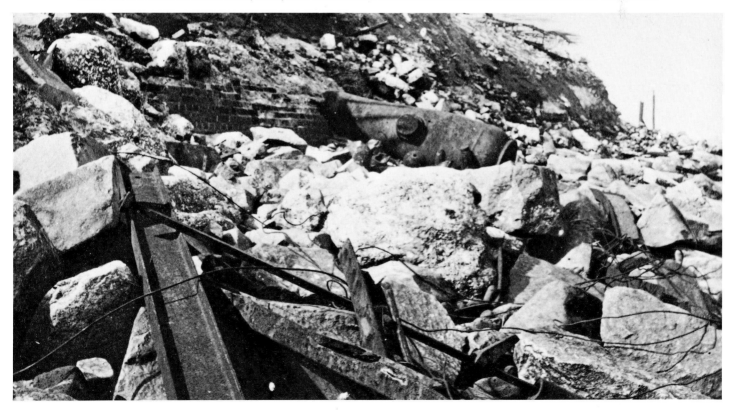

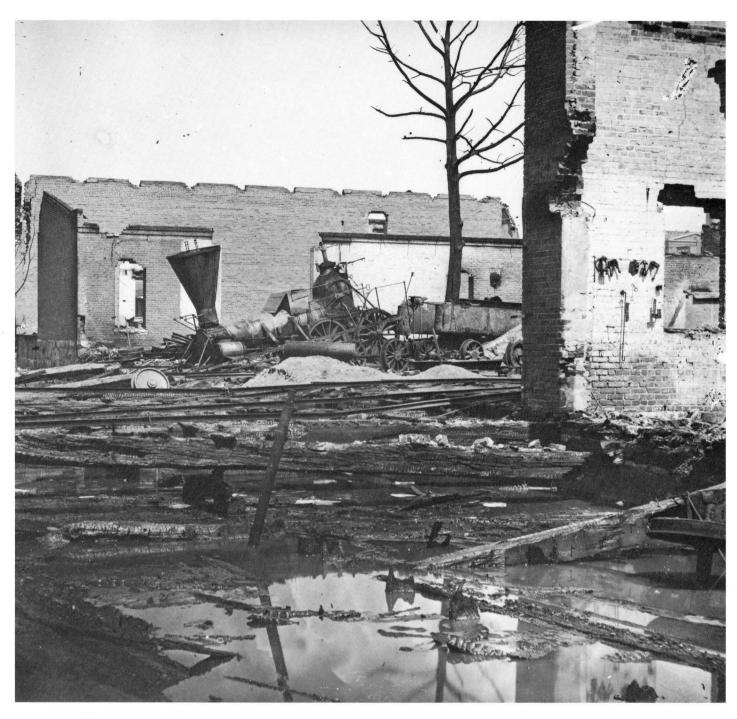

No. 42 A CRIPPLED LOCOMOTIVE

When the Rebels army were forced to evacuate their capitol at Richmond they set fire to the city, exploded the powder in their magazines and did their worst to entirely destroy the city. The Union troops came in as conquerers and immediately set to work with a will to extinguish the fires and save as much of the city as possible, but before the fires could be quenched, over seven hundred buildings were in ruins. This is a view of the Richmond and Petersburg R.R. Depot. The riuned building abd the ruined locomotive shows what destruction war brings.

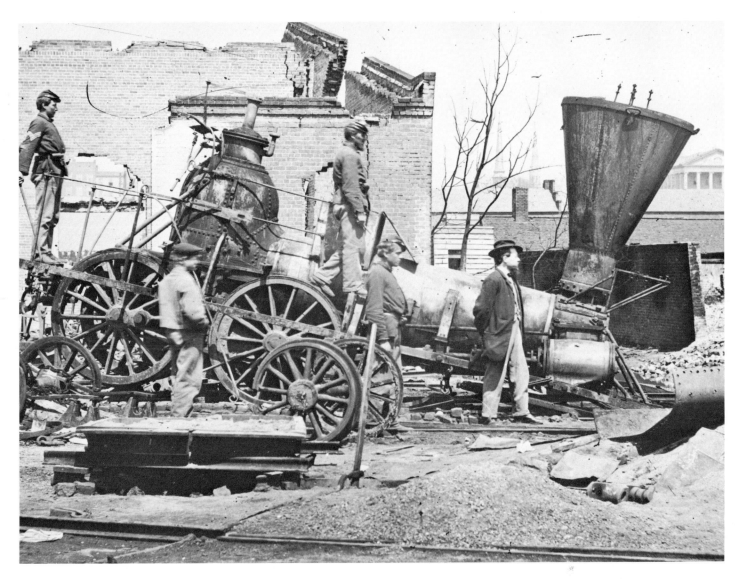

No. 43 RUINS IN RICHMOND VA.

Description similar to view (42) This photograph will perpetuate the rebel capitol as it appeared
immediately upon its capture, and succeeding the great fire, this view was secured during the first week
of April 1865. Since that time the city has been almost entirely rebuilt, and, of course, its aspect corres-
pondingly changed.

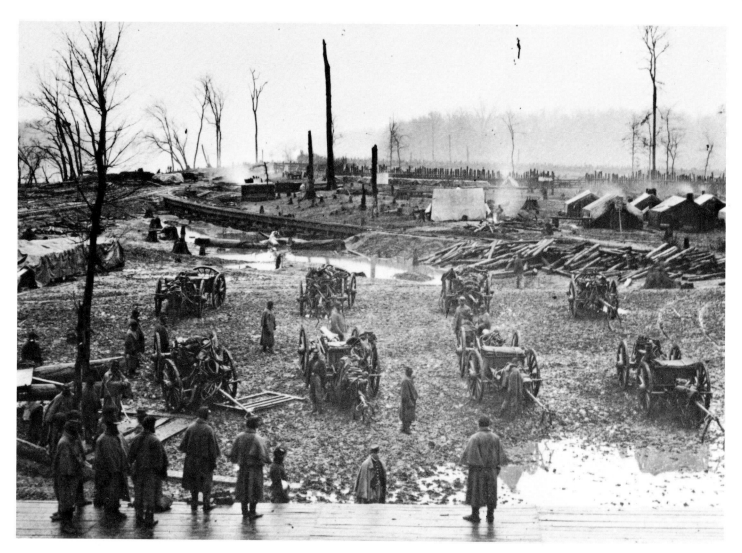

No. 44 FEDERAL CAMP AT JOHNSONVILLE, TENN.
This view was taken at Johnsonville, Tenn. the day before its evacuation in December 1864. In the foreground is the depot platform and just back of that is the first Tennessee Colored Battery. In the background is the camp, the troops drawn up in line.

No. 45 ON THE BATTLEFIELD OF STONE RIVER

This is a monument erected by the veterans of Hogan's Bridgade in memory of their comrades who fell here in the battle of Stone River. The inscription on this side reads; "The veterans of Shiloh have left a deathless heritage of Fame on the Field of Stone River. Then follows the names of those who were Killed with dates etc,. This view will be prized by the comrades of that army.

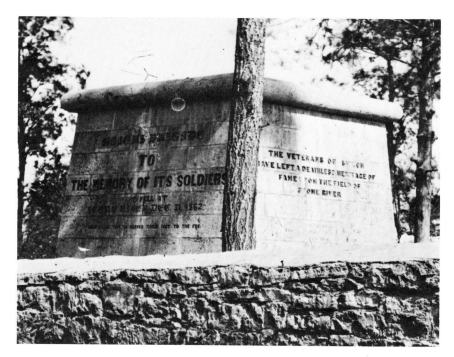

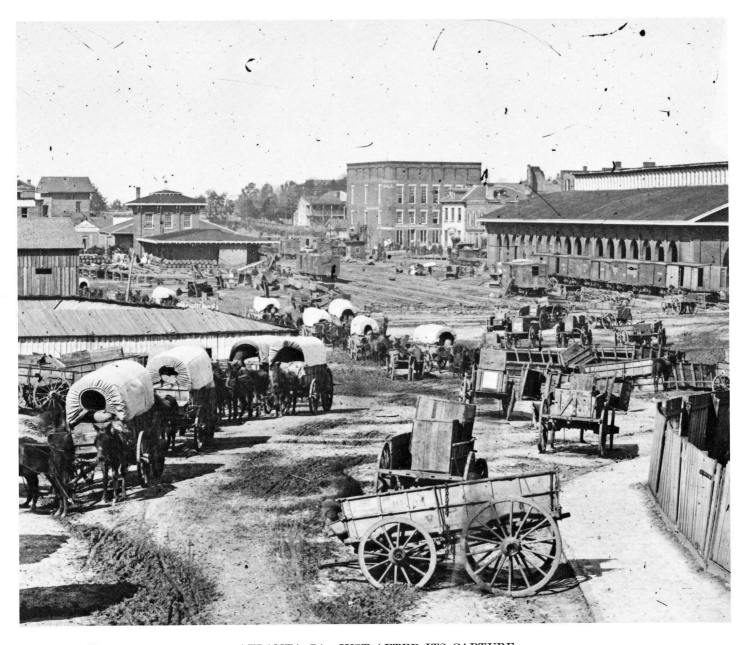

No. 46 ATLANTA GA.. JUST AFTER ITS CAPTURE

This is a view near the Rail Road Depot in Atlanta Ga. just after the city was captured by Gen'l. Sherman. Uncle Sam's baggage trains Boys in Blue are a Strange sight to the inhabitants of Atlanta.

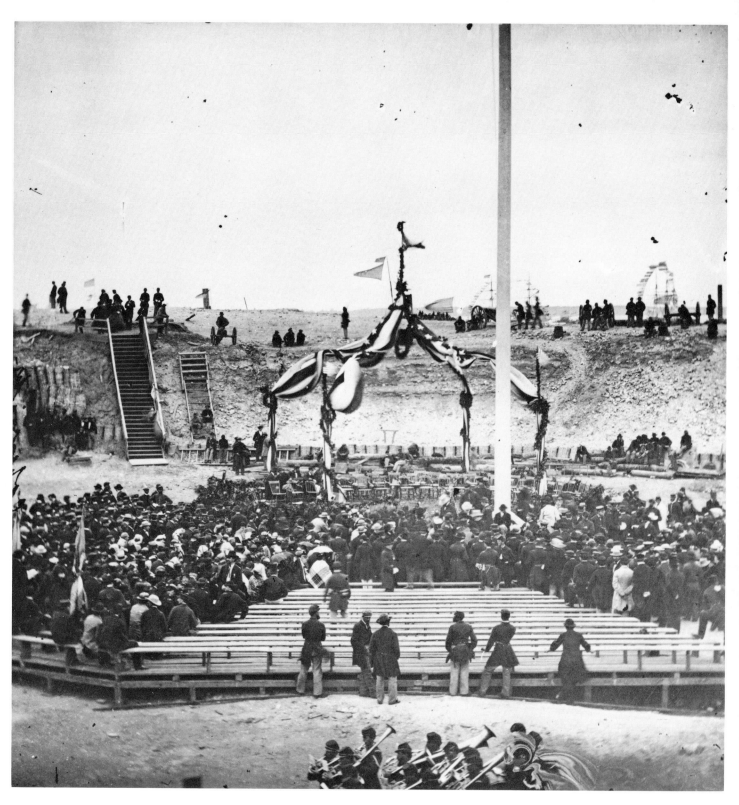

No. 47 RAISING THE OLD FLAG OVER FORT SUMTER

April 14th, 1865. (four years from the day the rebels had compelled Major Anderson to haul down the Stars and Stripes from the flagstaff at Fort Sumter). Major-General Anderson raised the same flag over the ruins of the fort, now again in possession fo the United States. The ceremony was of most interest. Charleston Harbor was filled with Uncle Sam's vessels covered with holiday flags—. Great crowds thronged Fort Sumter, Henry Ward Beecher delivered the oration at a given signal, amid booming cannon, and with the bands playing the Star Spangled Banner, Maj.Gen'l Robt. Anderson ran up the glorious old flag—and ran it up to stay; a perpetual menace to treason from within, or foreign enemys from without. Long Shall It Wave——.

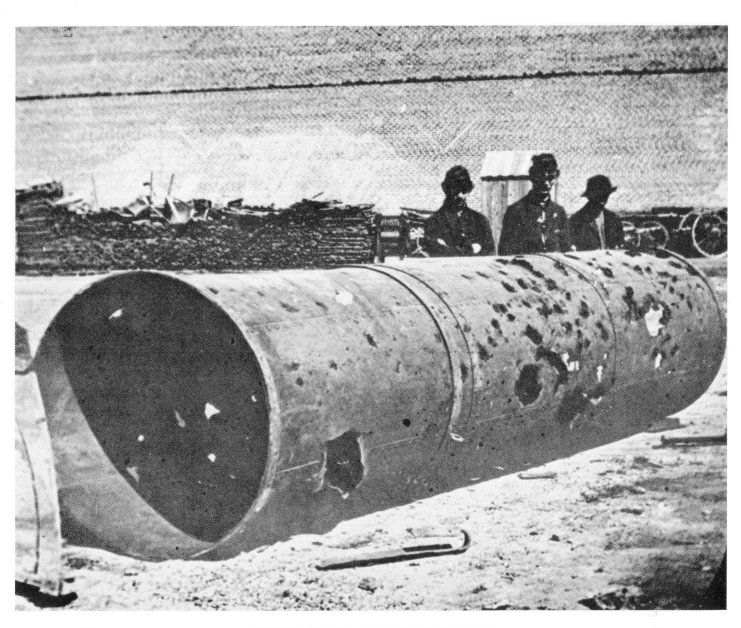

No. 48 **SMOKE STACK OF THE REBEL RAM**
April 1865.

On the wharf at Richmond Va. showing a effect of shot from battery on James river. and shows
how our battery peppered the ram when it made its famous raid down the river and attempted tp run
by our batteries. When Richmond was taken this smoke stack was found at the "(rocketts)", the Rebels
had taken it out and were repairing Ram when they got orders to Evacuate the city. The Ram was
blown up by them when they left.

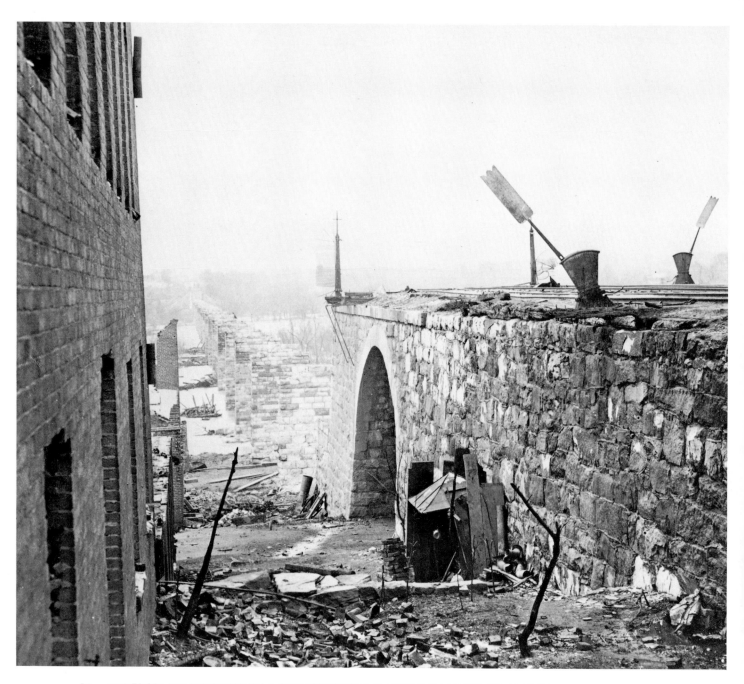

No. 49 RUINS OF RICHMOND & PETERSBURG RAILROAD BRIDGE AT RICHMOND VA.
april 1865. (see descript'n 42-3)

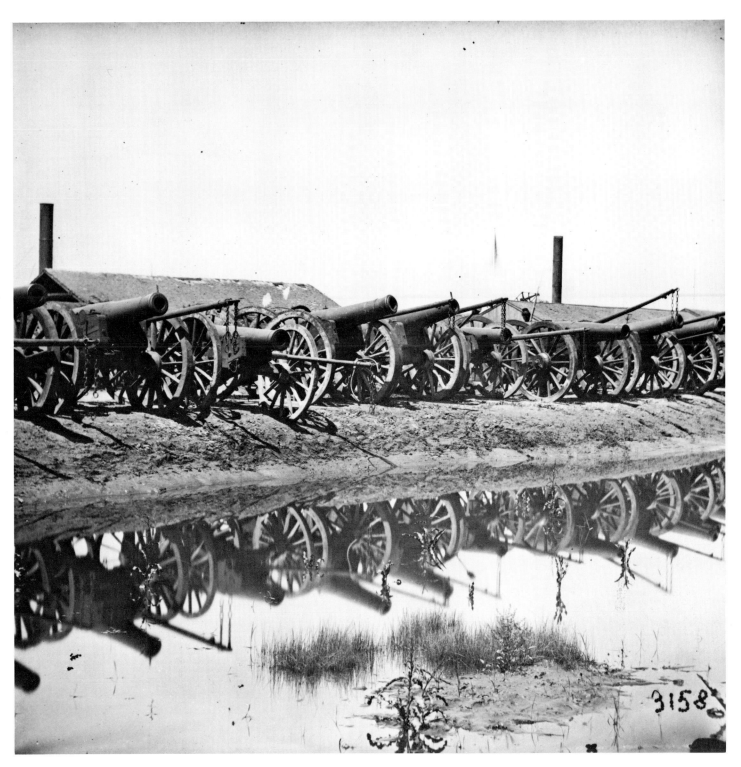

No. 50 PARK OF CAPTURED ARTILLERY ON WHARF AT RICHMOND VA. AWAITING
SHIPMENT

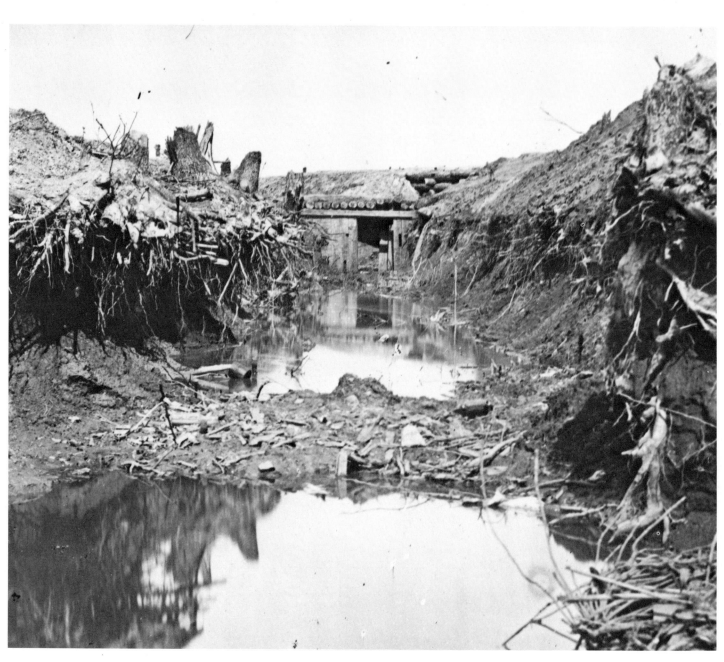

No. 51 **FORT SEDGEWICK– ('OR 'HELL')**
Front of Petersburg Va. Ditch on West Side of Fort. April 1865.

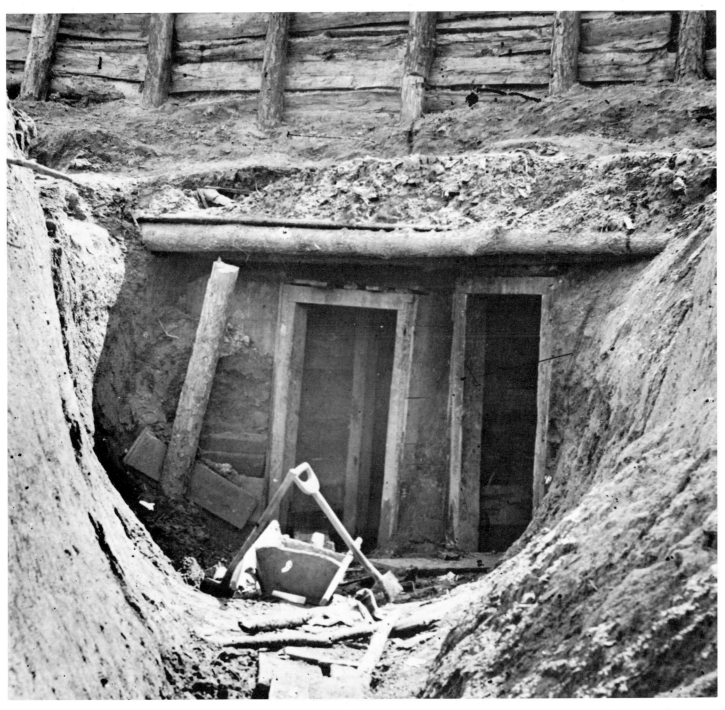

No. 52 ENTRANCE TO MAHONE MINE
This mine was intended to undermine Fort Sedgewick—was run about 600 yards.—ap'l 1865.

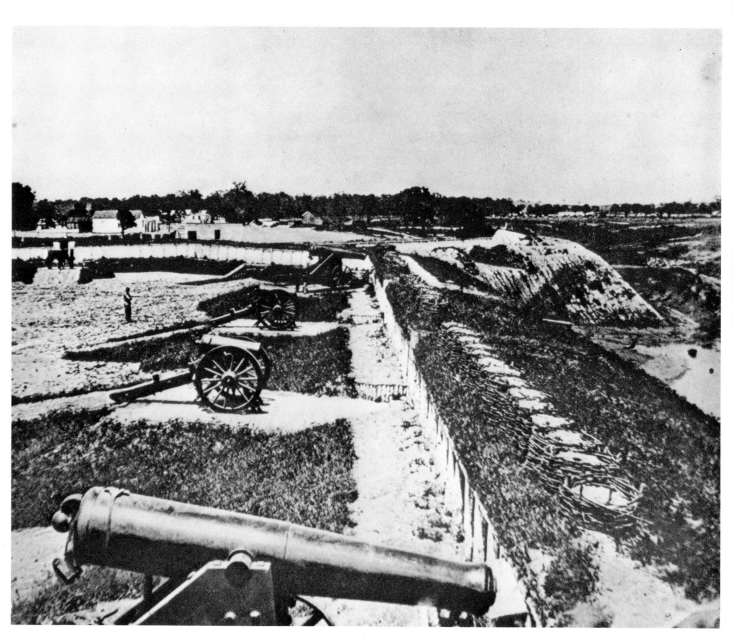

No. 53 **FORT MAHONE OR (FORT DAMNATION)**

This large gun is in Fort Mahone and it is said that this is the spot on which General Lee stood and viewed the battle It was situated on a hill that overlooked all the Union Forts. It is stated that during the fight on Sunday April 12, 1865 that Gen'l Lee stood on the Little Knoll in the foreground and actually Shed tears when he saw his troops being driven back by Union Soldiers.

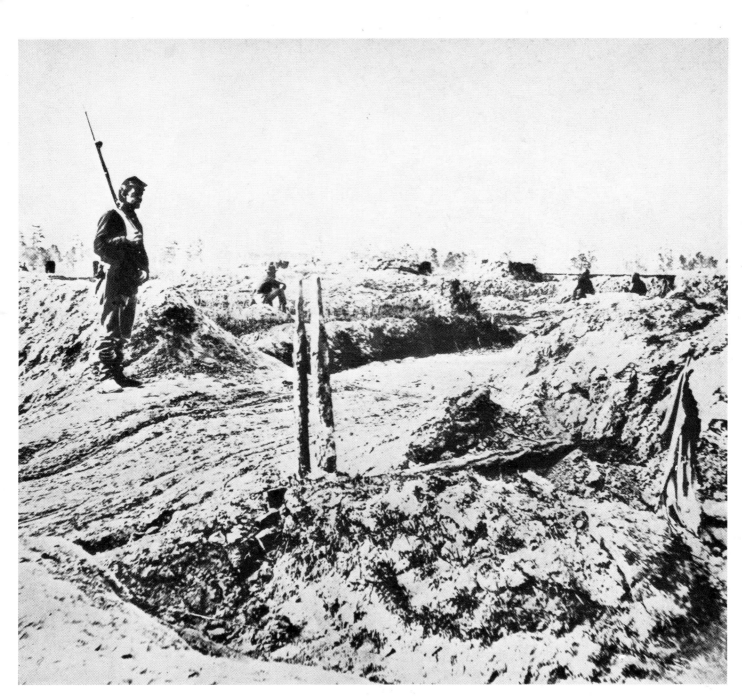

No. 54 RIFLE PITS ON THE FEDERAL PICKET LINE FRONT OF PETERSBURG 1865

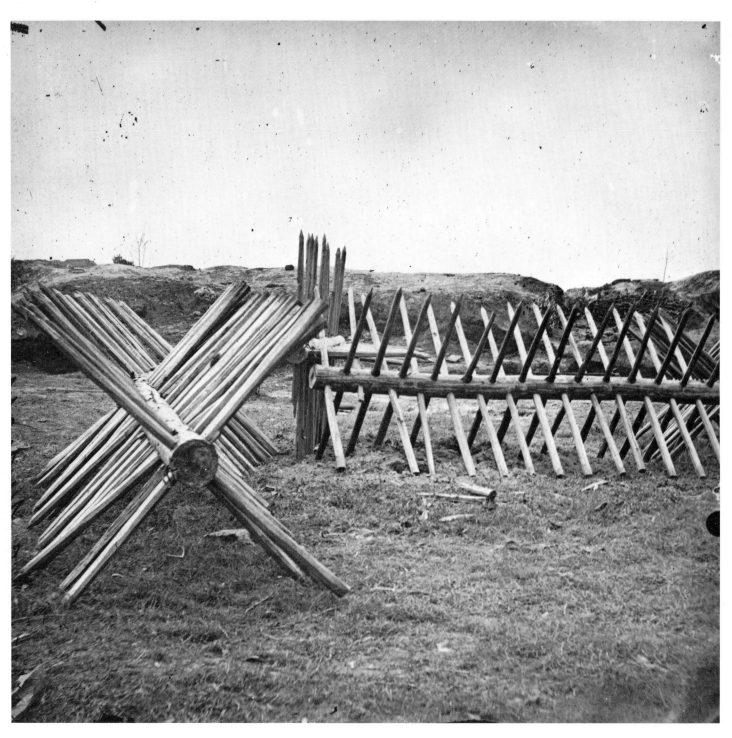

No. 55 CHEVE-DE-FRESE FRONT OF CONFEDERATE FORT AT PETERSBURG—MAHONE—

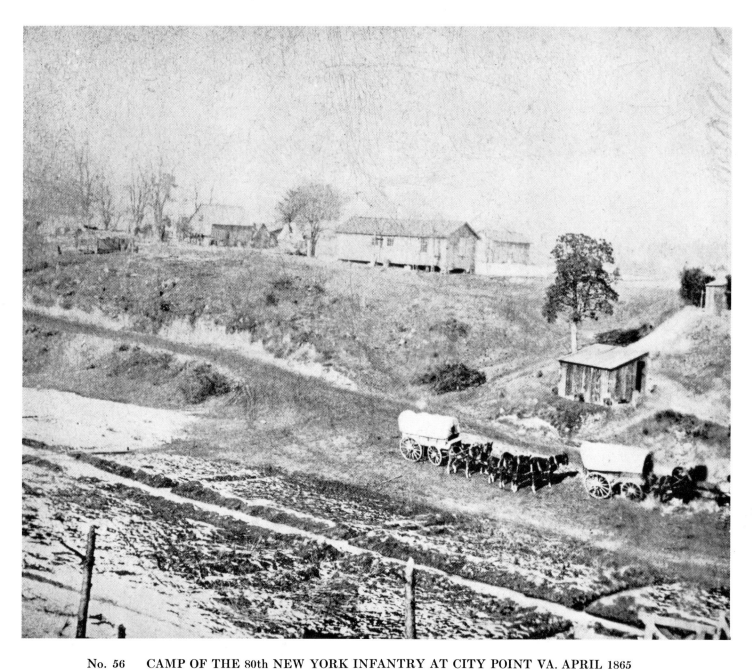

No. 56 CAMP OF THE 80th NEW YORK INFANTRY AT CITY POINT VA. APRIL 1865

City Point an elevated Plateau of Ground at the confluence of the appomattox & James rivers. It was from June 4 1864 until the Surrender of Lee, the base of Army operations against Richmund General Grant having his Head-quarters here. Nothing but a Virginia plantation before the advent of the Union Armies, during the 10 months of military occupancy, it was a populous city. Connected with the front by the famous military rail road built upon the surface of the ground, Studded with Government buildings of every description, and its extensive water front crowded with vessels city point was the most prolific in views of all army bases of the war.

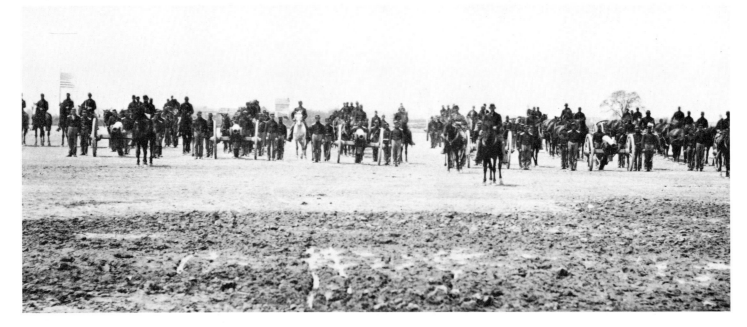

No. 57 SEVENTEENTH NEW YORK BATTERY AT WASHINGTON D.C. JUNE 1863

The federal Capitol was theoretically and practilly (practically) and entrenched camp during the entire war, and these Scenes in and around the city are therefore placed among the WAr Views

No. 58 COMPANY K OF THE 93rd INFANTRY NEW YORK AT BEALTON VA. AUGUST 1863

The company views of the old 93rd New York are so clear that any survivor of that well known regiment can pick out his comrades almost as well as if they were in line before them. This view was taken at Bealton Va. in august 1863. At the request N.Y. Tribune we published these company views for the benefit of N.Y. comrades. who will keenly appreciate this photographic muster of the old regiment, Years after most of the veterans of the old 93d are dead; those of the Regiment who still Survive will take great pleasure in "Looking backwards" more than a quarter of a century into the faces of their comrades of war.

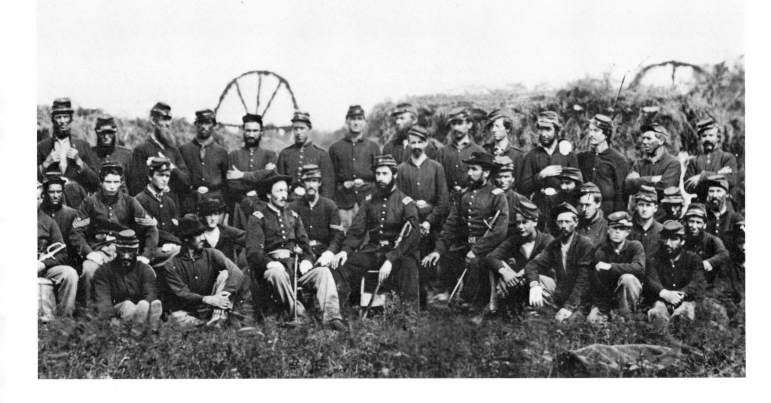

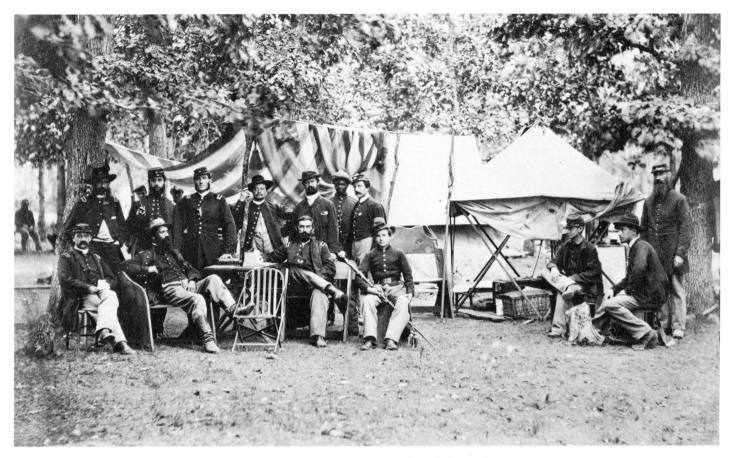

No. 59 REGIMENTAL STAFF 93d N.Y. AT BEALTON VA. AUGUST 1863

No. 60 OFFICERS OF 63 N.Y. INFTY8 AT WASHINGTON D.C. 1863

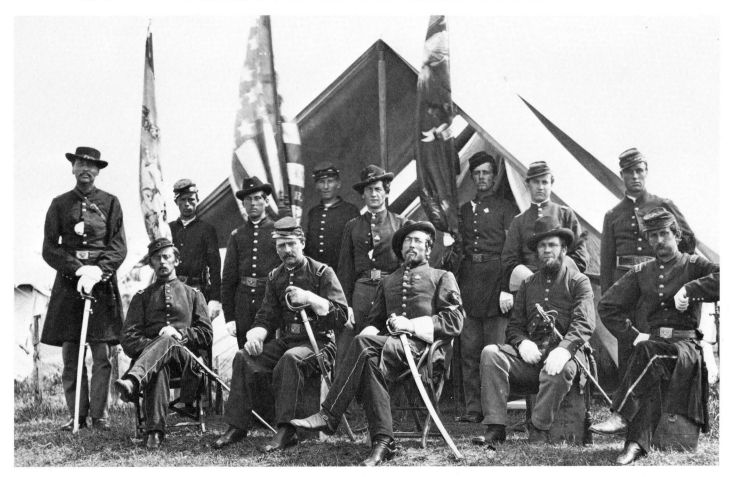

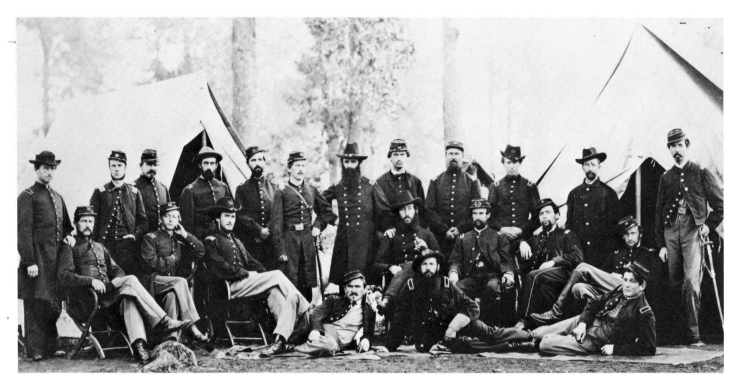

No. 61 **OFFICERS OF 80th N.Y. (N.Y.S.M 20th)
AT CULPEPER VA. SEPTEMBER 1863** (Culpeper See no 5)

No. 62 **MULE TEAM CROSSING A BROOK**

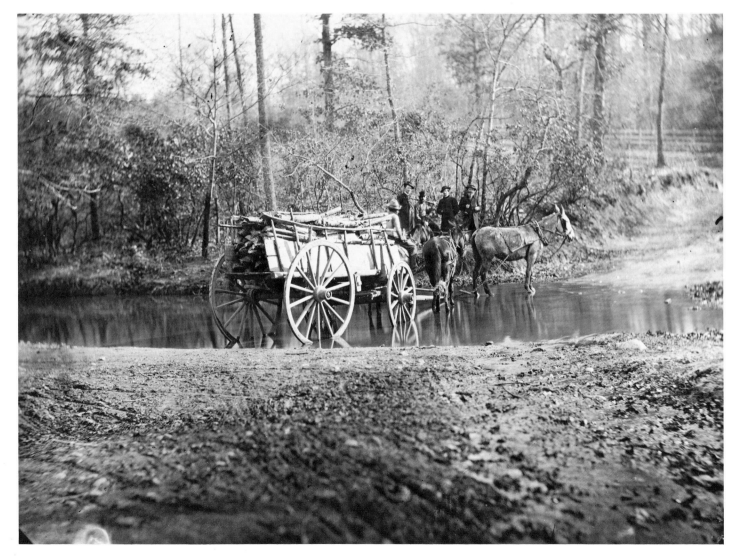

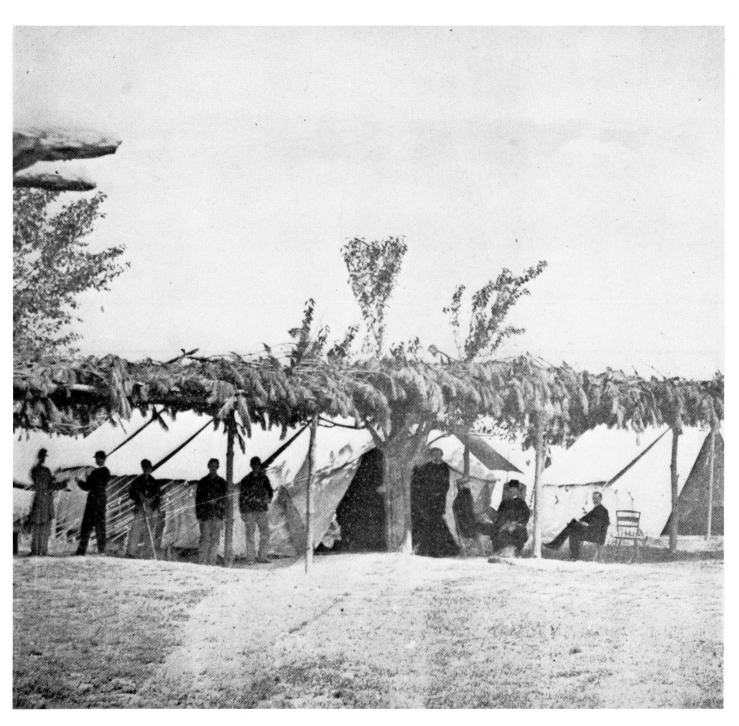

No. 63 GENERAL HOSPITAL CITY POINT (see no 19)

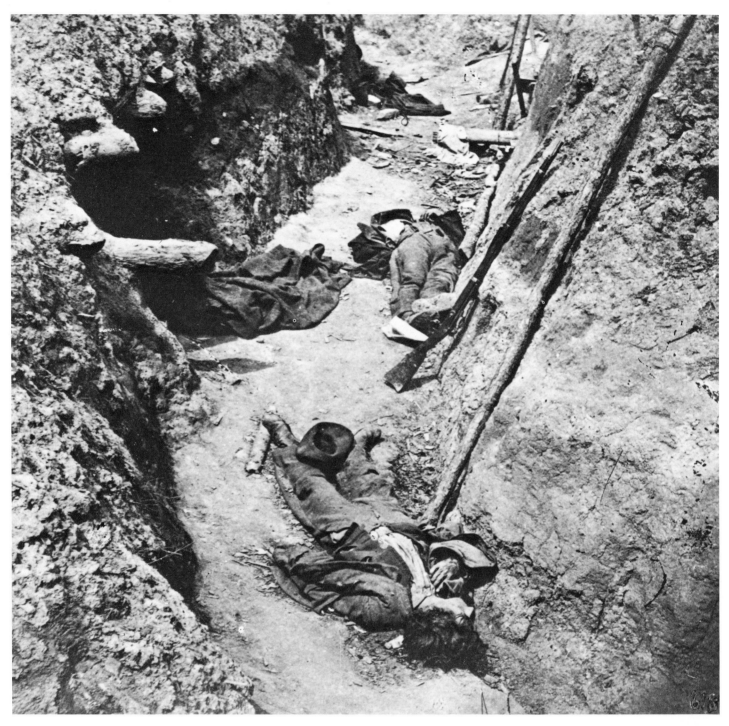

No. 64 CONFEDERATE DEAD IN FORT MAHONE APRIL 3d
1865

This Photograph was taken April 2nd 1865, in the Rebel trenches at Petersburg just after their capture by the Union Troops. The trenches all along the line were found to contain many dead Confederates and this is but one of many that was made M. Brady showing the dead just as they fell by looking at a number of these views you can an idea of how a long stretch of the trenches looked that day. Of course the Camera should take but a small section within the scope of each view.

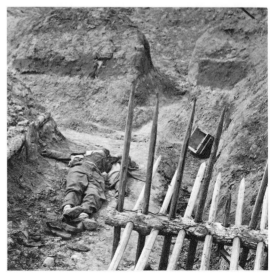

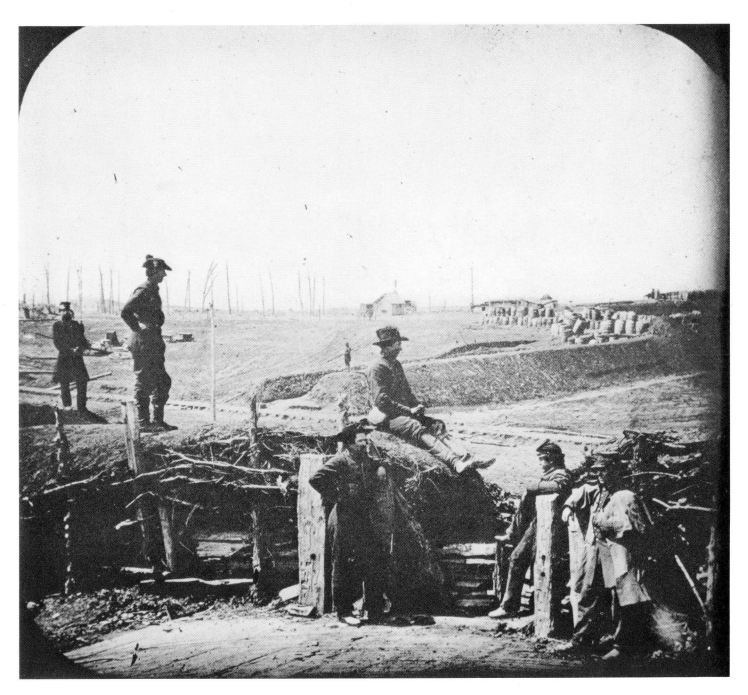

No. 65 CONFEDERATE FORTIFICATIONS AT MANASSAS, VA (OR BULL RUN)

Every part of this memorable field has been photographed, and all points of interest, either upon the
ground actually fought over as well as in the vicinity,

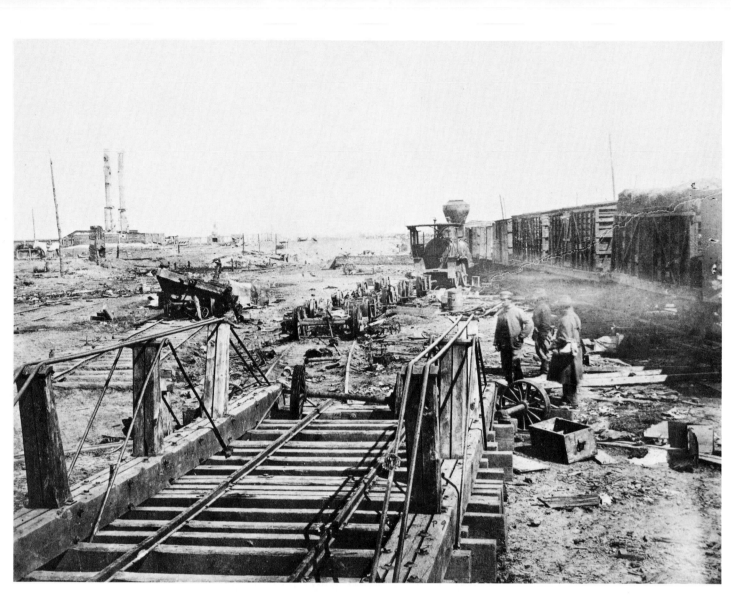

No. 66 (SEE No. 65)

No. 67 ENTRANCE TO NATIONAL CEMETERY AT GETTYSBURG

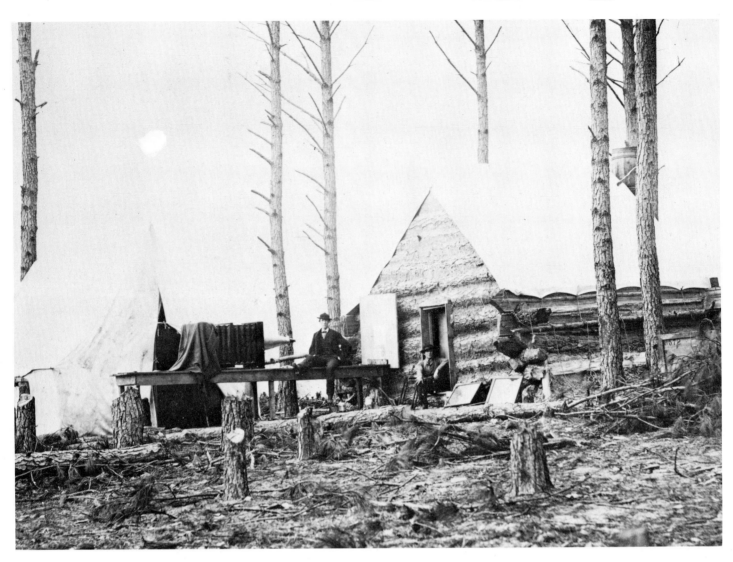

No. 68 BRADYS PHOTOGRAPHIC HEADQUARTERS FRONT OF PETERSBURG MARCH 1865

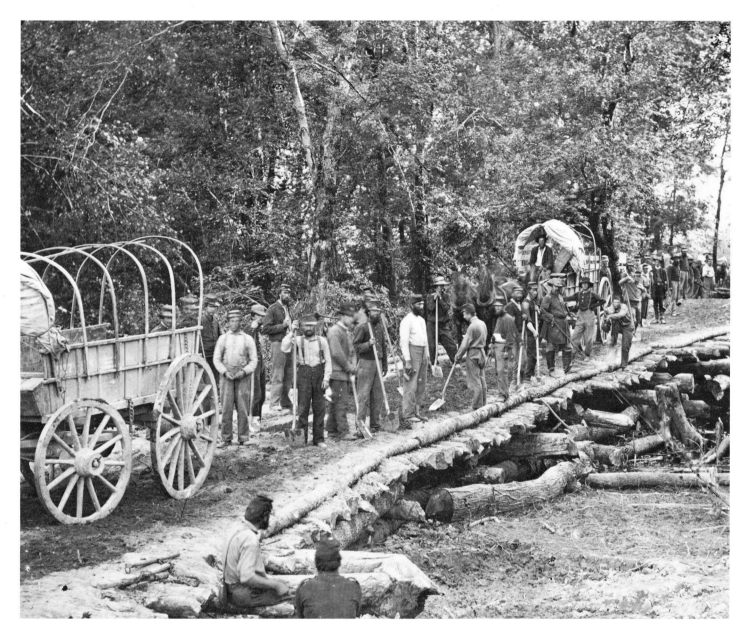

No. 69 GRAPEVINE BRIDGE ACROSS THE CHICAHOMINY RIVER JUNE 1862

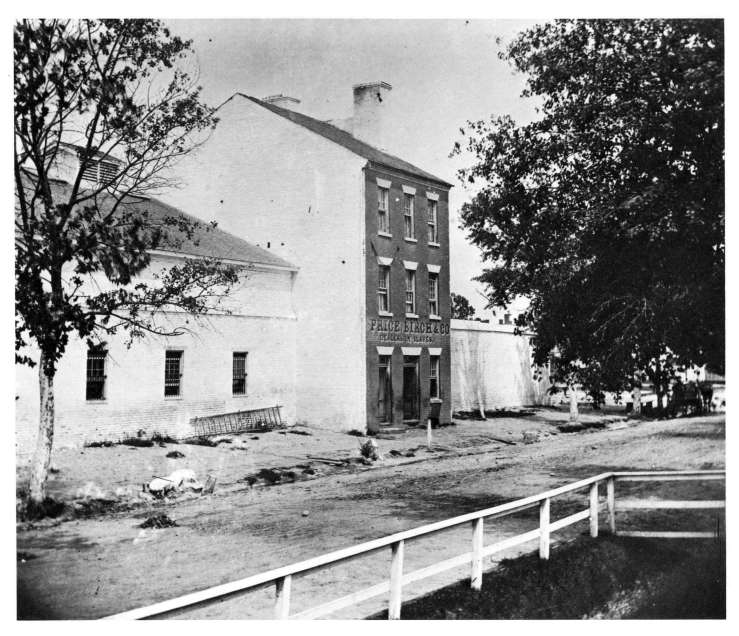

No. 70 SLAVE PEN, ALEXANDRIA VA.

A relic of the past an exterior view of the famous, or rather Infamous Slave pen. People of this generation can hardly make it seem possible that Such an (institution) was ever tolerated under the Stars and Stripes in this "land of the free". Read the inscription on the sign over the door 'Price Birch & Company dealers in Slaves.

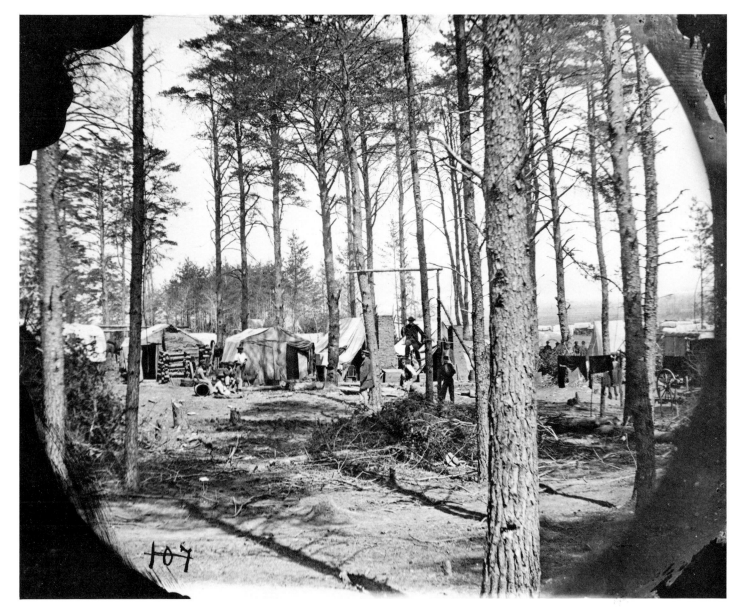

No. 71 CAMP OF THE MILITARY TELEGRAPH CONSTRUCTION CORPS 1864

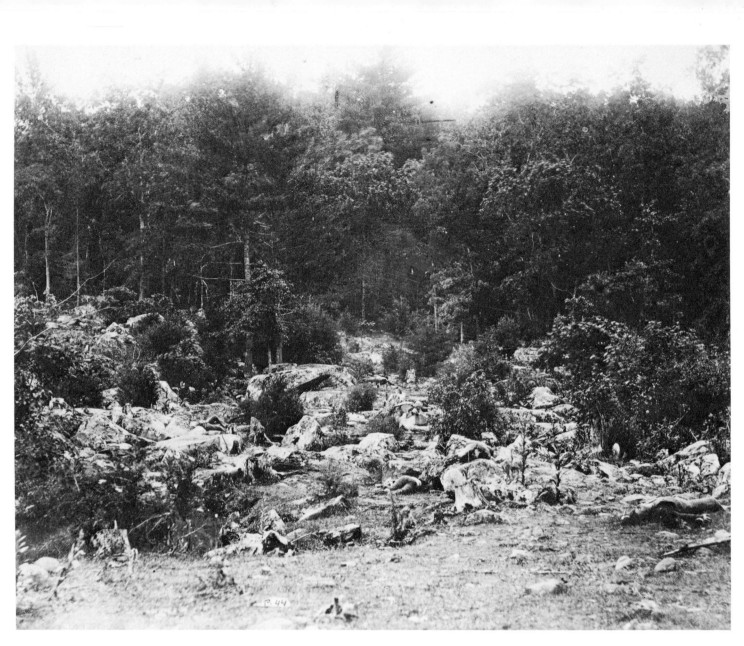

No. 72 SLAUGHTER PEN AT GETTYSBURG

The woods at the foot of Round top, which was the 'right' of the Union line, were named by the Soldiers the 'Slaughter Pen'. The enemy made a desperate attempt to gain a foothold on Round Top for it was virtually the 'Key' to the field. The woods on the Slope were strewn with dead. This view gives a glimpse among the trees, showing the 'Harvest of Death'.

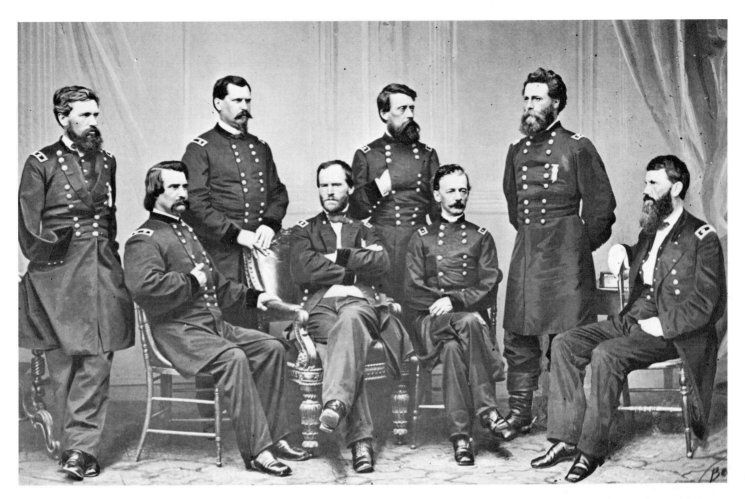

No. 73 SHERMAN AND GENERALS. (MADE IN GALLERY)

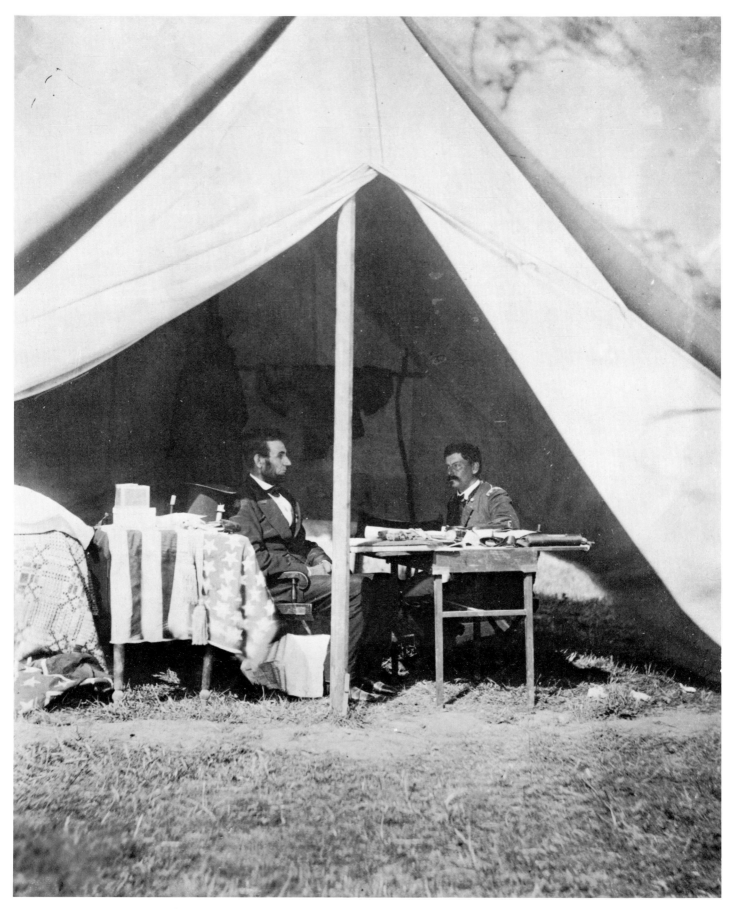

No. 74 PRESIDENT LINCOLN GEN'L McCLELLAN'S TENT AT ANTIETAM OCTOBER 4th
1862
After the Battle of Antietam Sept 17, 1862 President Lincoln visited the army of the Potomac, and this
view shows the President & 'Little Mac' in McClellan's tent at Headquarters. Oct 4th 1862.

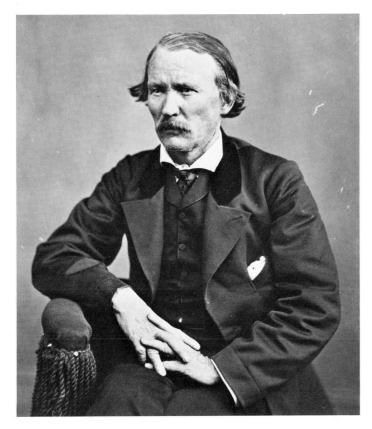

No. 75 GENERAL KIT CARSON

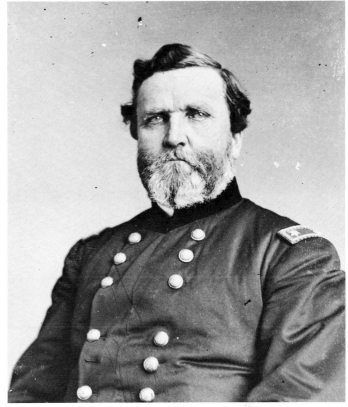

No. 76 GENERAL GEORGE H. THOMAS. (THE ROCK OF CHICAMAUGA)

No. 77 GENERAL GEORGE A. CUSTER TAKEN 1864

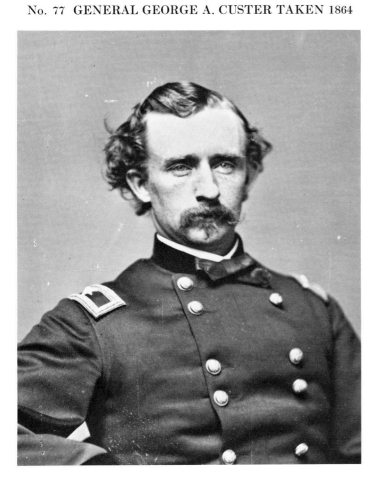

No. 78 HON. EDWIN M. STANTON

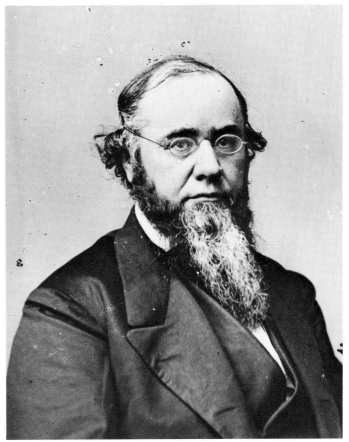

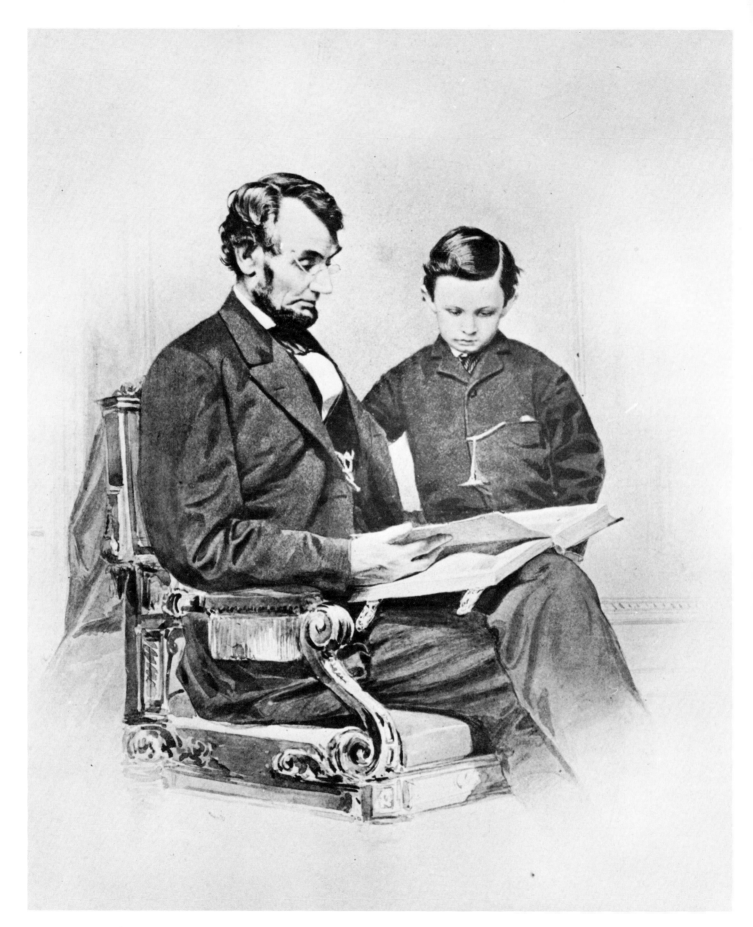

No. 79 LINCOLN AND TADT (TAD)

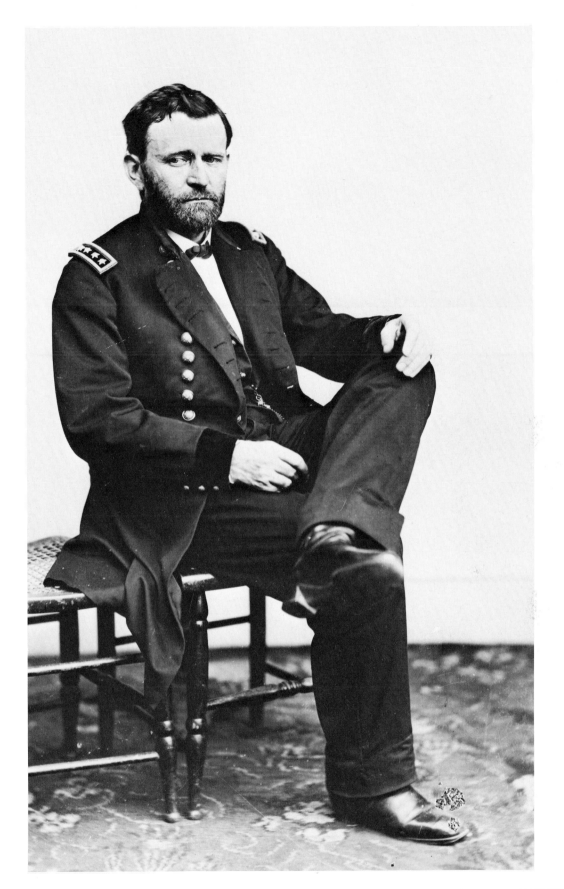

No. 80 GEN'L GRANT—IN GALLERY—MAY (SEE BRADY ABOUT SKYLIGHT BREAKING)

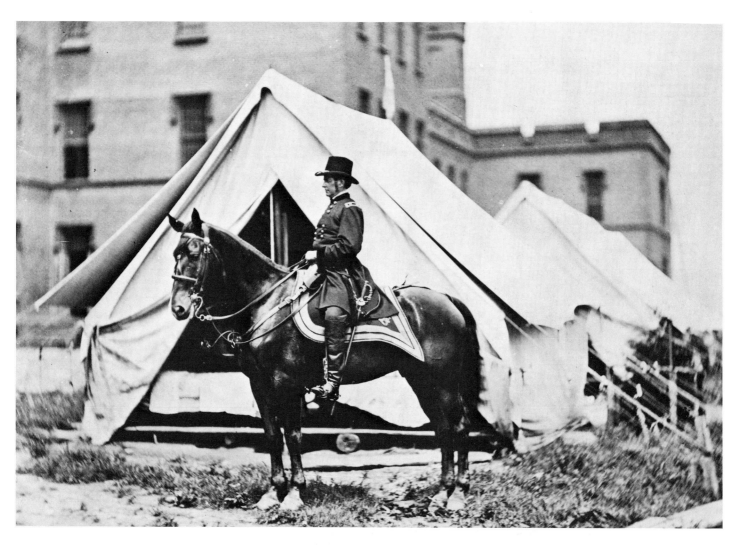

No. 81 GEN'L HOOKER ON HORSE

Fighting Joe Hooker as he was called was appointed in command of the Army of the Potomac January 25—1863 succeeding Burnside. He was himself succeeded by Gen'l Meade June 27th 1863. This was taken just before he started with the army of the Potomac after Gen'l Lee up in Pannsylvania, Gen'l Hooker was born in Holly Mass Nov 3, 1814 died in Garden City N.Y. Oct 31—1879.

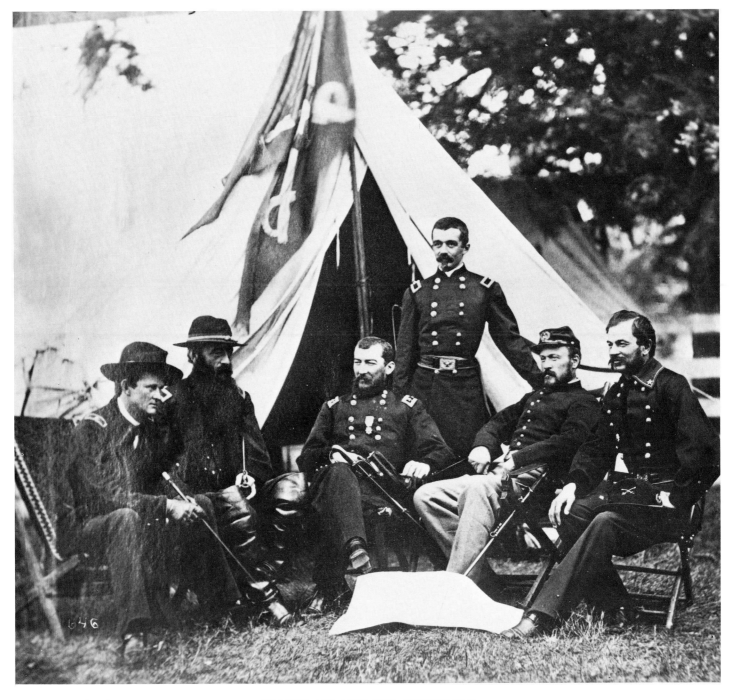

No. 82 **SHERIDAN AND HIS GENERALS**

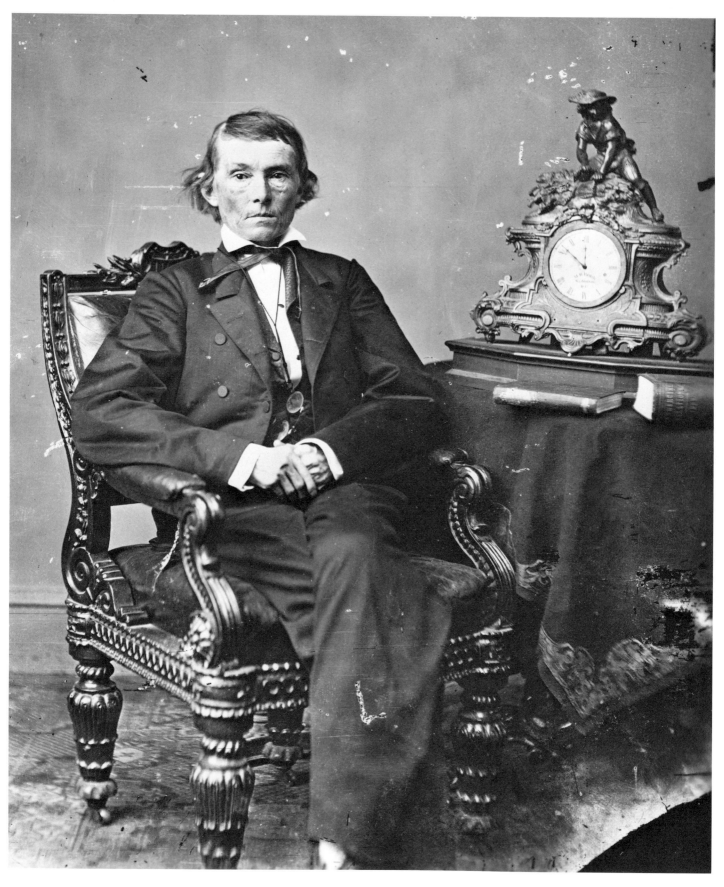

No. 83 HON ALEXANDER H. STEVENS

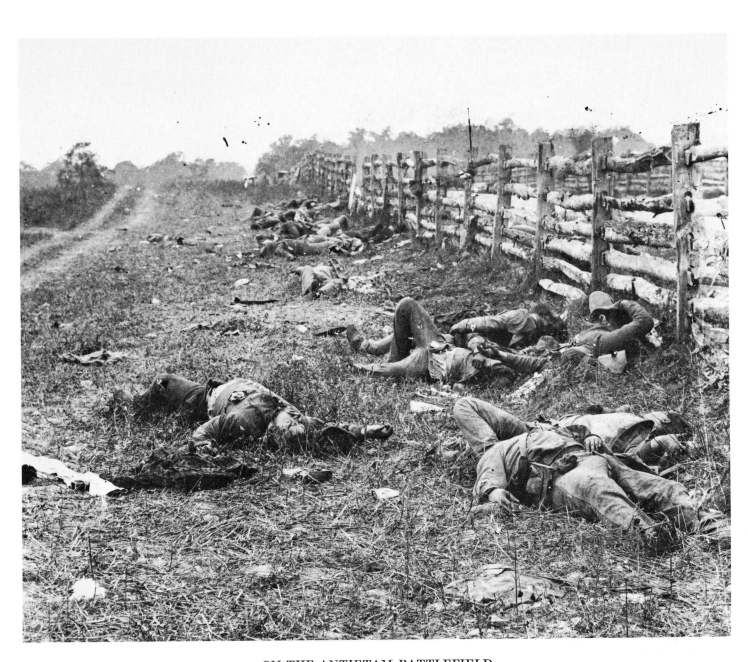

No. 84 ON THE ANTIETAM BATTLEFIELD

This is a view on the west side of the Hagerstown road, The bodies of the dead which are strewn thickly beside the fence just as they fell shows that the fighting was severe at this point on the bloody day September 17— 1862.

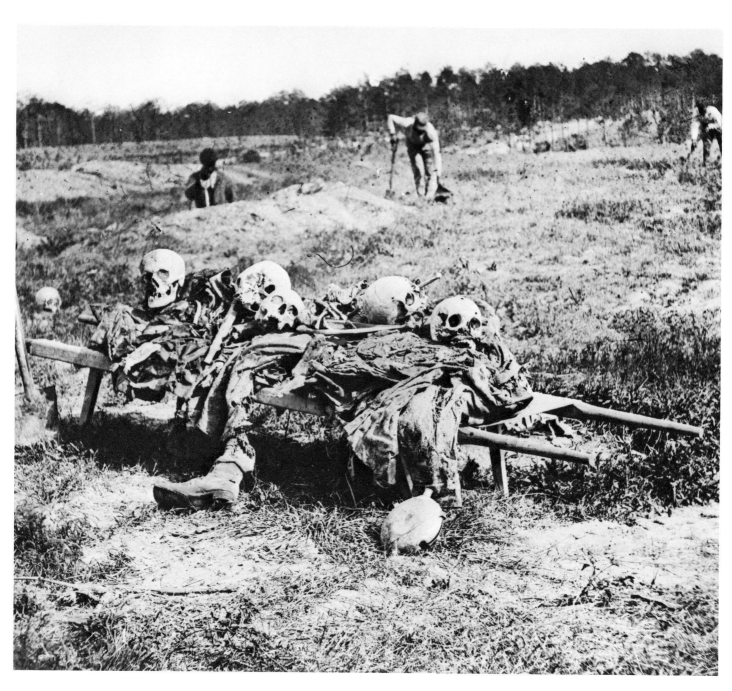

No. 85 COLLECTING REMAINS OF THE DEAD AT COLD HARBOR

This is a ghastly view showing the process of collecting the remains of Union soldiers who were hastily buried at the time of the battle. This is a scene on the battlefield months after the battle, when the Government ordered the remains gathered for permanent burial. The grinning Skulls the Boots Still hanging on the fleshless bones the old canteens on the skeletons all testify to the hasty burial after the battle. Looking on this scene you can easily understand why in all National Cemeteries, There are so great a number of graves marked 'UNKNOWN! These are the unknown heroes of the war who died that our nation might live.

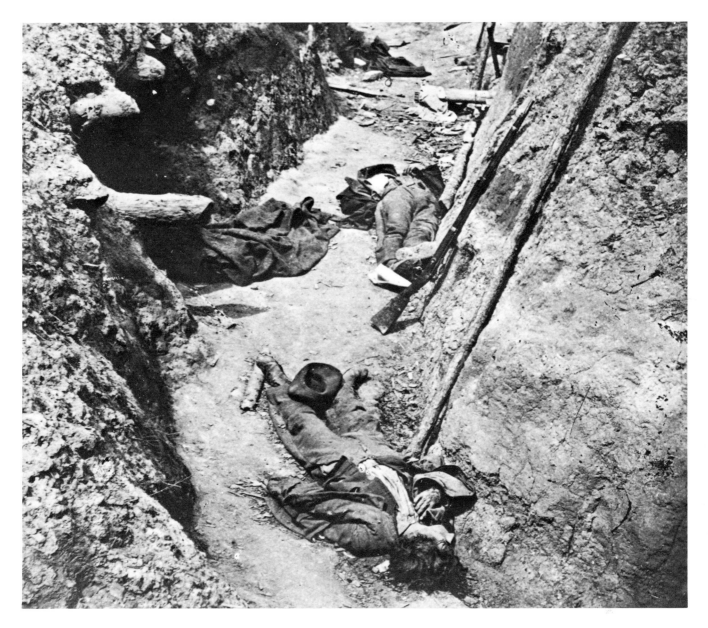

No. 86 DEAD IN THE HOLE

Confederate soldiers killed in the trenches at Fort Mahone called by the soldiers (Fort Damnation)
This view shows the construction of their Bombproof and covered Passages. which branch off in every
direction This picture is a good view of the covered ways inside the rebel Fort Mahone, the Union
Soldiers had to charge up and down these obstructions in the foreground (centre) is a dead Confederate
soldier sticking out through the debrise (debris) and farther on lies another Confederate Soldier.

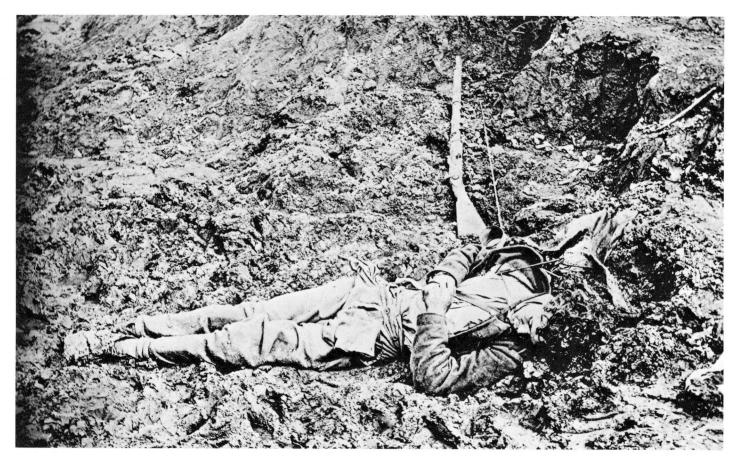

No. 87 DEAD CONFEDERATE SOLDIERS IN THE TRENCHES AT PETERSBURG

This photograph was taken Ap'l 2, 1865 in the rebel trenches at Petersburg just after their capture by the Union troops (see NO 64) You will notice that no (2) two have fallen in (the) same position.

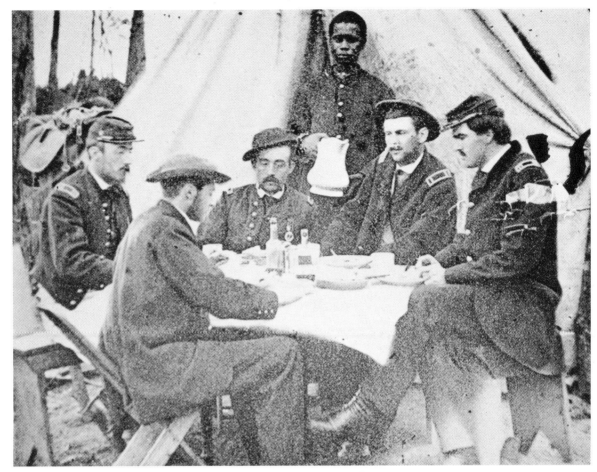

No. 88 A DINNER PARTY APRIL 1864

No. 89 A GROUP OF NON COMMISSIONED OFFICERS OF MASS CAVALRY
Photograph taken at Petersburg during Fall of 1864.

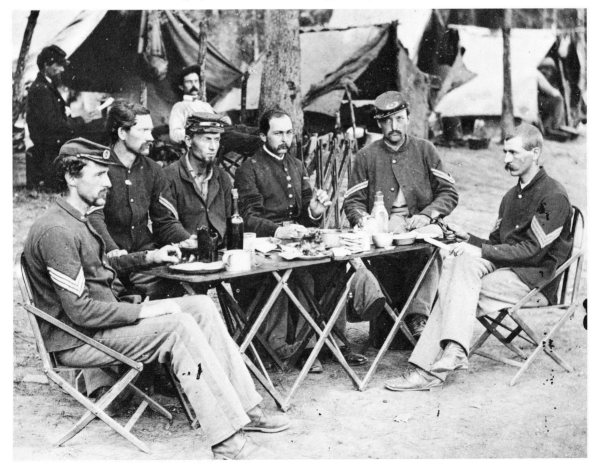

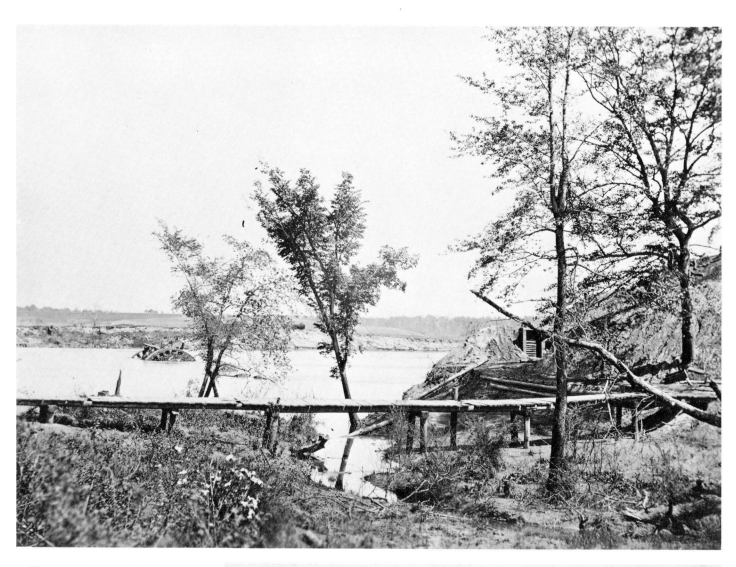

No. 90 FORT DARLING
JAMES RIVER

Drewry Bluff — (see obstruction
in river).

No. 91 Ruins of Bridge on Rich-
mond and York R.R. burned by
the Confederates May 17—1862.

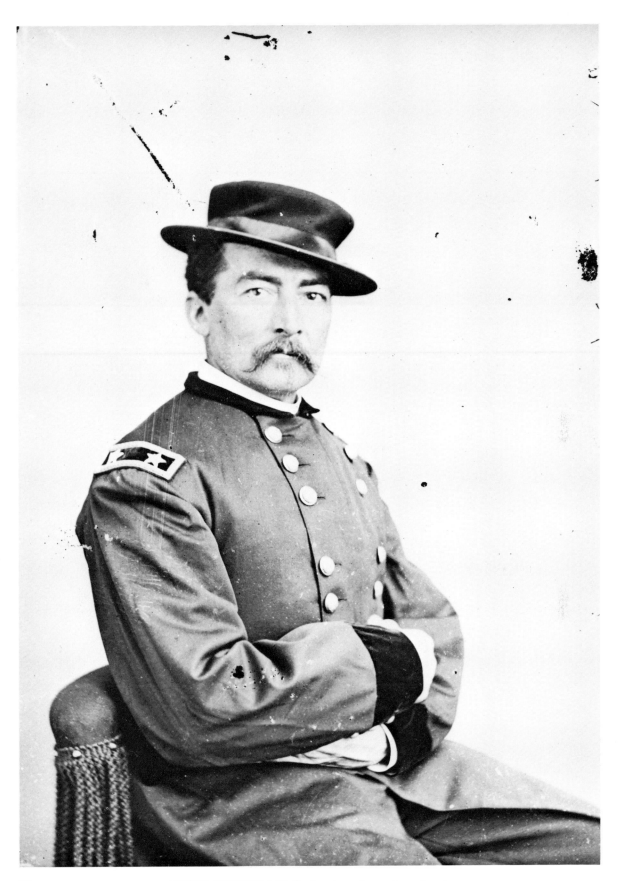

No. 92 GEN'L SHERIDAN (hat on) (page torn here)
 (See Brady about Hat)

FOOTNOTE: CONCERNING SHERIDAN'S HAT:
The hat that Sheridan is wearing in the photograph was given to Brady as a souvenir of the occasion.
Many years after it lay in the cellar of the Gallery. Some workmen doing some repairing took the hat
when they left;—simply as a hat, not knowing any historical value was attached to it.

 The Author.

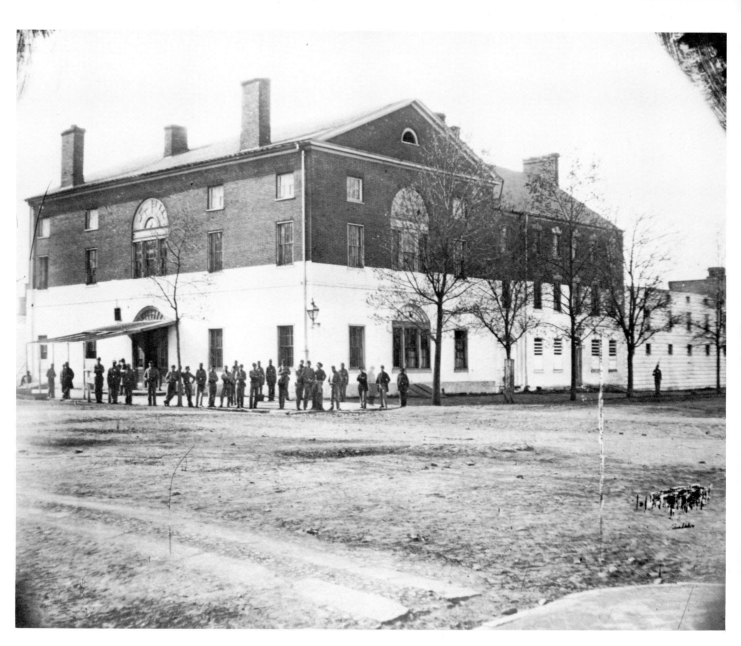

No. 93 OLD CAPITOL PRISON WASHINGTON D.C.
Wirtz the keeper of Andersonville Prison was hung here—Judge Field of Supreme Court lives in the
house NOW.

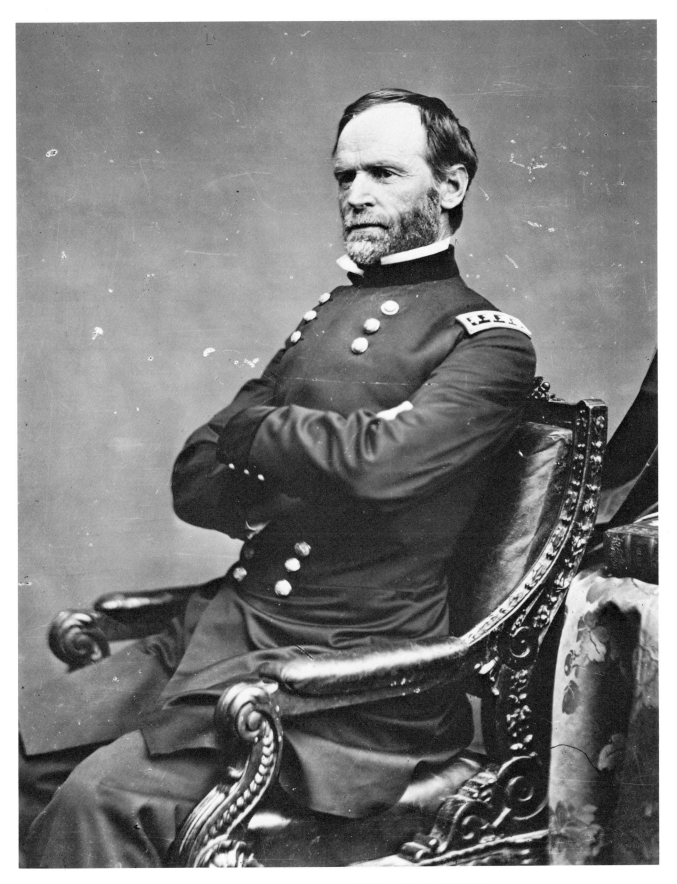

No. 94 GENERAL W. T. SHERMAN TAKEN (IN GALLERY) 1869

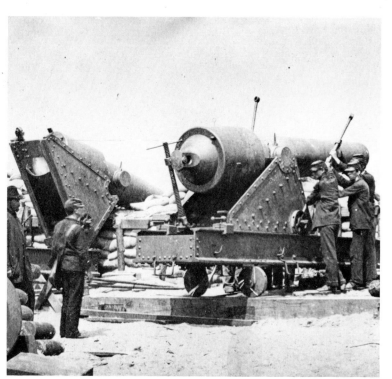

No. 95 BIG GUN—PARROT—MORRIS
 ISLAND

No. 96 (*Below*)

GATHERED FOR BURIAL AT ANTIETAM
After the Battle of Sept 17 1862.

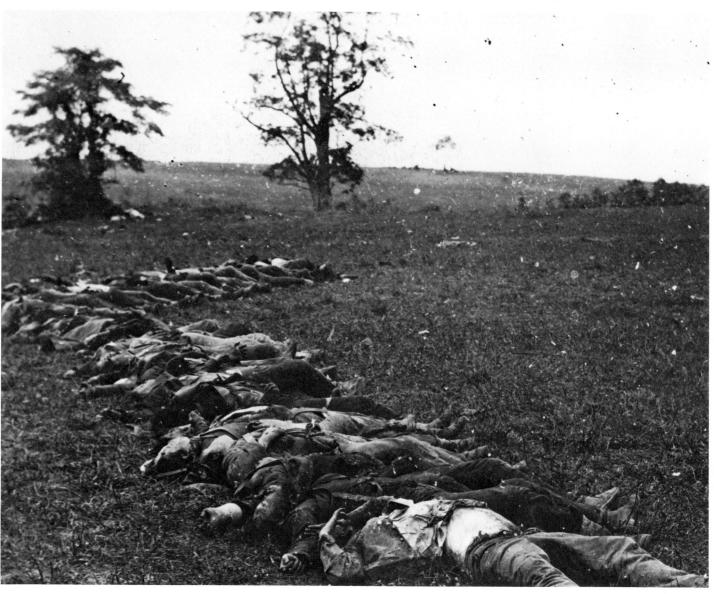

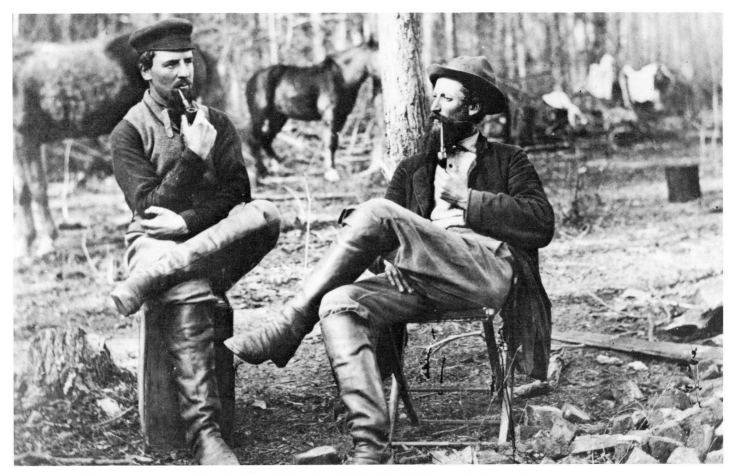

No. 97 DISCUSSING THE PROBABILITIES OF AN ADVANCE

No. 98 HUNDRED POUNDER GUN ON REBEL STEAMER
This view Shows the Hundred Pounder Rifle Gun on the Rebel Blockade runner "Teazer" (Teaser)
captured by the United States Gunboat 'Maritanza' July 4, 1862.

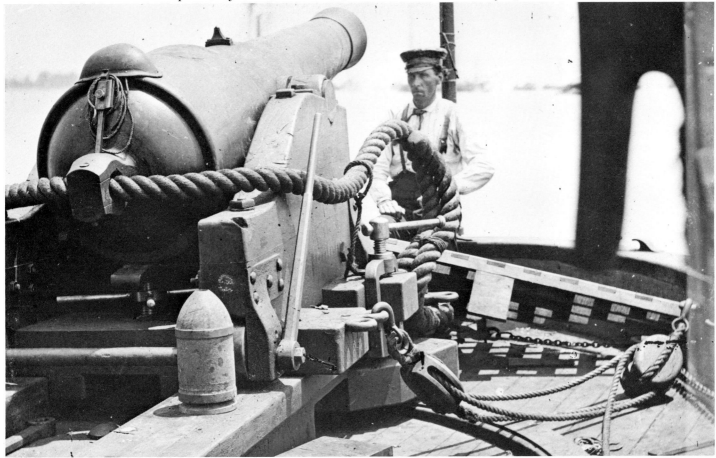

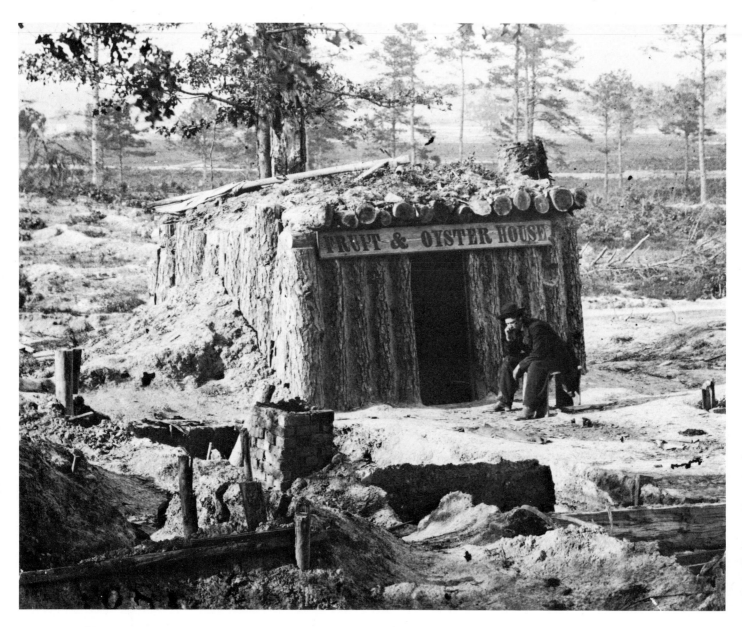

No. 99 **BOMB PROOF RESTAURANT ON THE PETERSBURG LINE**

Who but a 'Yank' would think of starting a "Store" or restaurant on the line of Battle where shot and shell are constantly falling? This is a Bomb proof restaurant on the line at Petersburg. The sign over the door "Fruit and Oyster House" looks as though it might have (been) captured by the proprietors from some regular eating house.

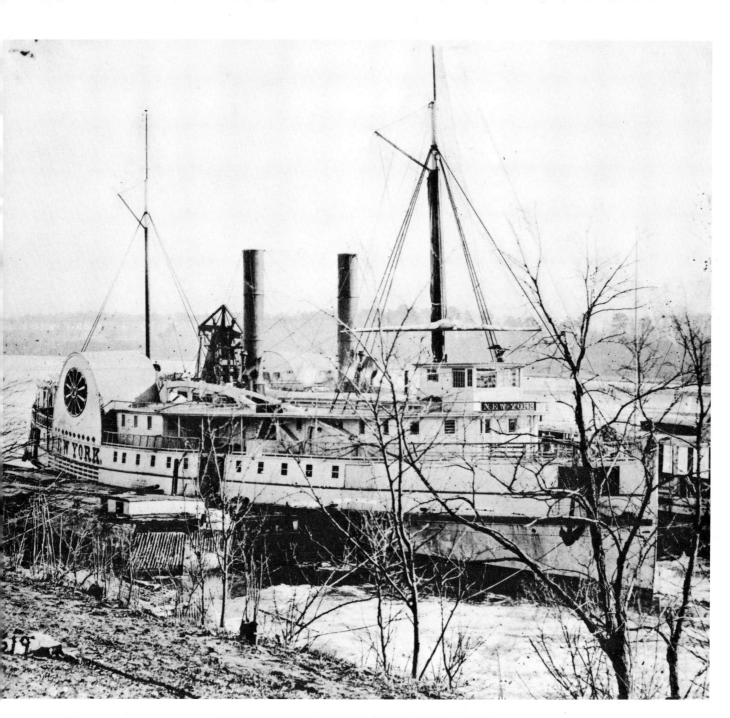

No. 100 WAITING FOR EXCHANGED PRISONERS

This is the Federal flag of truce Steamer 'New York' waiting at Aiken's Landing on the James River for the Rebel flag of troce boat from Richmond with a load of Union prisoners for exchange—and what an exchange it was—The Union Soldiers just from rebel prison pens; starved and often too weak to walk, many of the poor victims had to be brought off in stretchers, some even were dead before they reached the place of Exchange—what did the rebels get in exchange? Man for man, they recieved fat, healthy, well fed, and well clothed Rebel Soldiers. The starving Union soldiers we got from them went directly to the Hospital or Graves. The Rebel Soldiers they got from us went directly into the army, the strongest and best men they had. This is the Secrte (secret) of the Horrible treatment our soldiers received in Andersonville and the other prison pens. it was to weaken us and Strengthen themselves that prompted them to starve our soldiers.

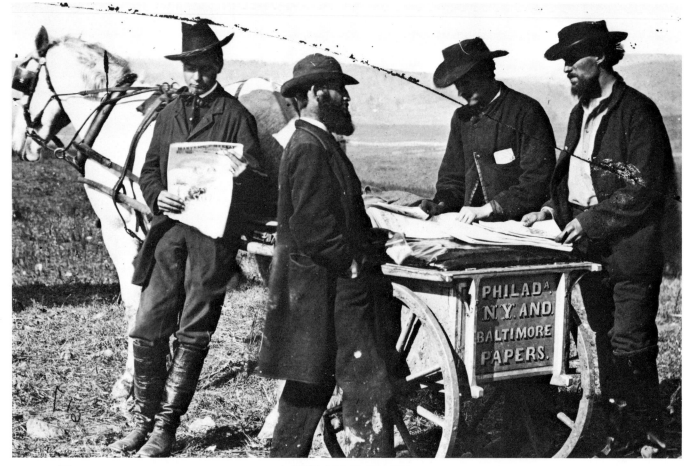

No. 101 A WELCOME VISITOR
Newspapers.

No. 102 GENERAL McCLELLAN AT UPTON HILL

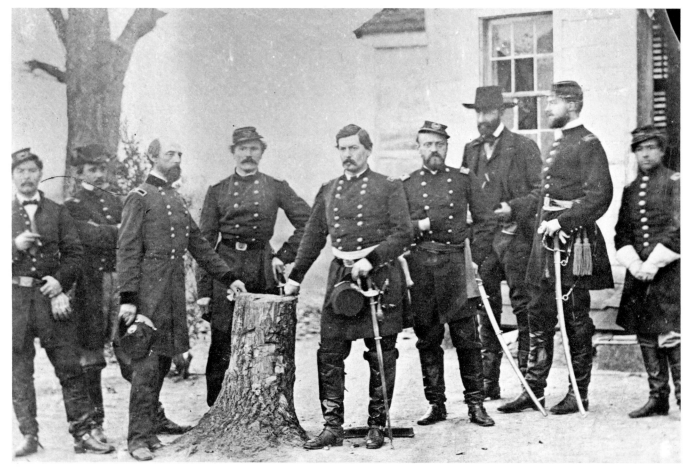

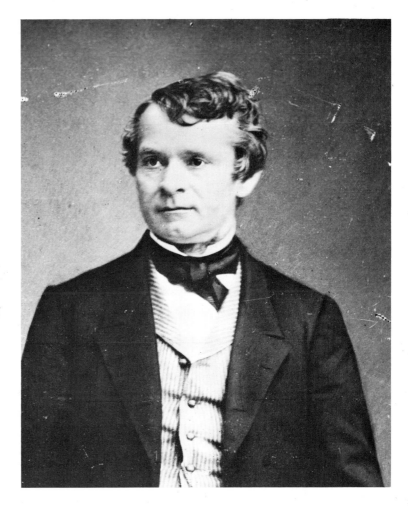

No. 103 GOV. CURTIN

No. 104 COOKING IN CAMP

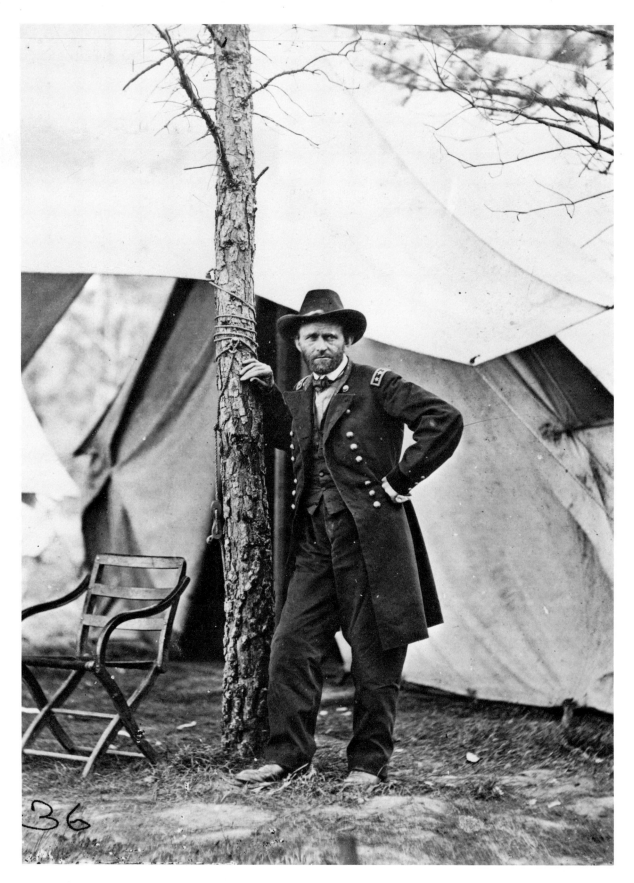

No. 105 **GRANT BY TREE CITY POINT**

(See no 56)

Lt. General U. S. Grant at City Point, Virginia. Brady stated that this was the last photograph he made of Grant while in the field. The picture was made just before the great battles of Spotsylvania and Cold Harbor.

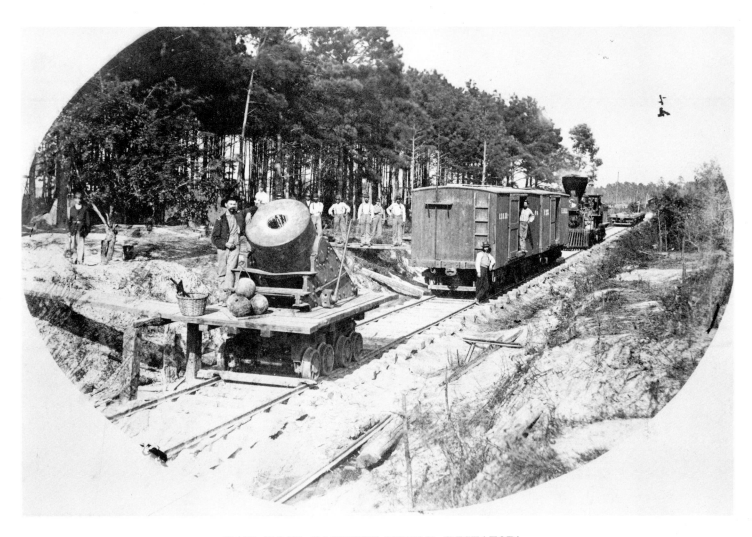

No. 106 RAIL ROAD BATTERY MOTAR 'DICTATOR'

This large Seacoast mortar is mounted on a special Flat-Car made very strong for this purpose. This Mortar car is on Gen'l Grant's Military Railroad at Petersburg The car is redily moved along the line and the mortar is fired whenever required; it is thus made very effective and annoying to the enemy, for it is something like the Irishmen's Flea when they put their hand on it 'it ain't there', in other words, when they turn the fire of their batteries on the 'Dictator' Our boys hitch on to the car and run it along out of the line of fire and commence pegging away again. By the time the 'Johnnies' find out the Dictator is and get the range to smash it, 'It ain't there' the boys run it along to a new 'Stand for Business'

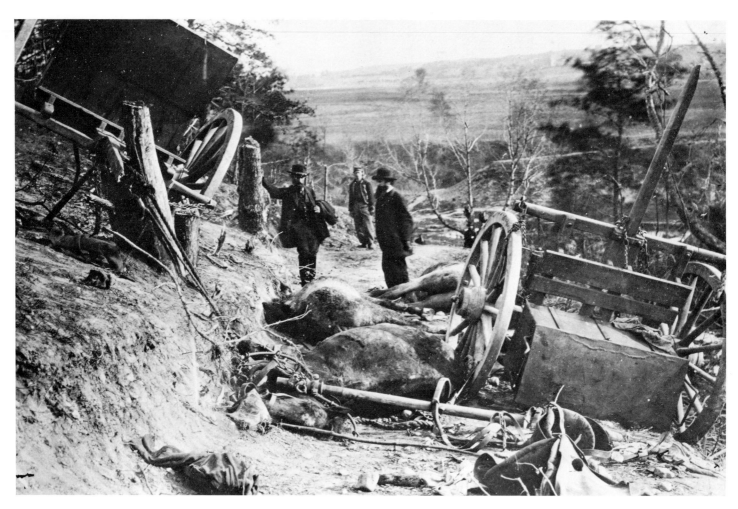

No. 107 EFFECT OF EXPLODED SHELL

No. 108 GUNBOAT ON TRANSPORT (NO NAME)
 No collection of war views would be complete without these boats made at Kingston.

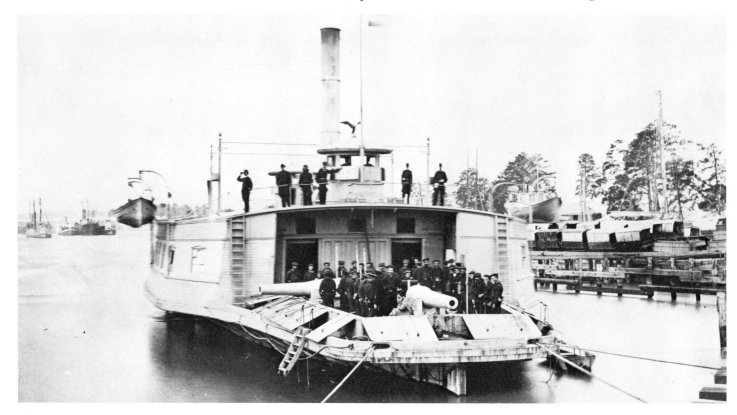

No. 109 HOW SHERMAN'S BOYS FIXED THE RAIL ROAD

On the March to the Sea Sherman's Army burned the bridges and destroyed the rail road as they went. This view gives a scene of the Destruction of the W.A. R.R. The rails are first torn up, then, the wooden ties are pried out and piled in heaps and burned; the iron rails are laid across the burning ties and soon get hot enough in the middle so that the weight of the ends bend the rails, of course when they get cold they are Simply good as "old Iron" This picture is a familliar scene and no doubt Suggests to your minds the words of the old and famillira song So we made a thoroughfare for freedom and her train, Sixty Miles in latitude; 300 to the main Treason fled before us for resistance was in vain While we were Marching through Georgia.

No. 110 CAMP SCENE KITCHEN

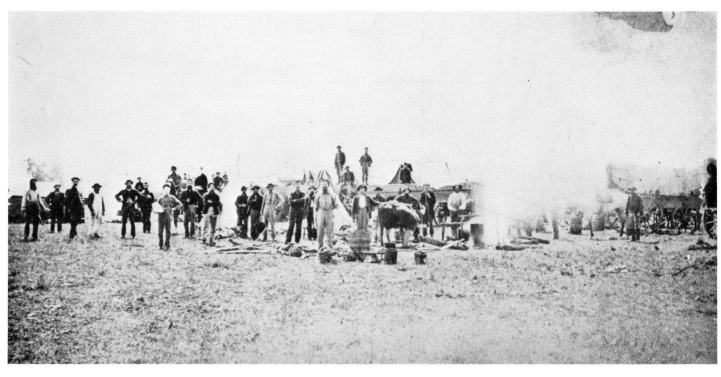

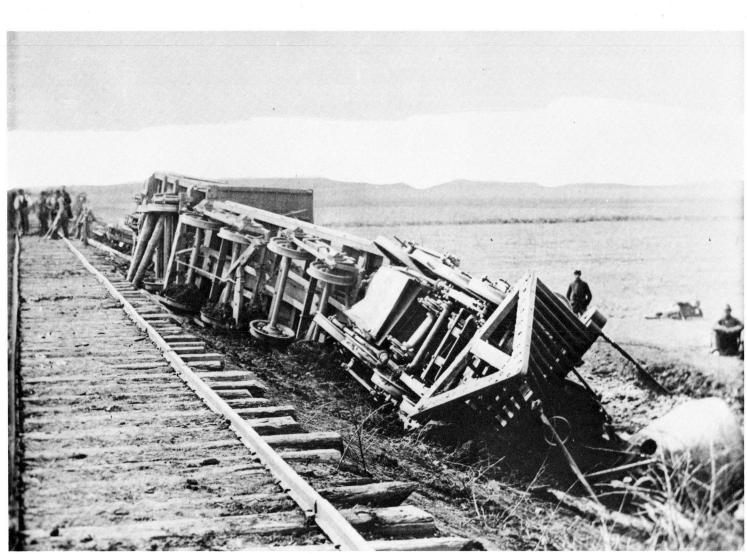

Note to 1974 reprint edition: The Library of Congress now identifies this as Derailed Train, Manassas, Virginia.

No. 111 DESTRUCTION OF HOOD'S ORDINANCE TRAIN
On the Macon and Western Central Railroad. On the abandonment of Atlanta, Gen'l Hood blew up
his magazines and destroyed his stores

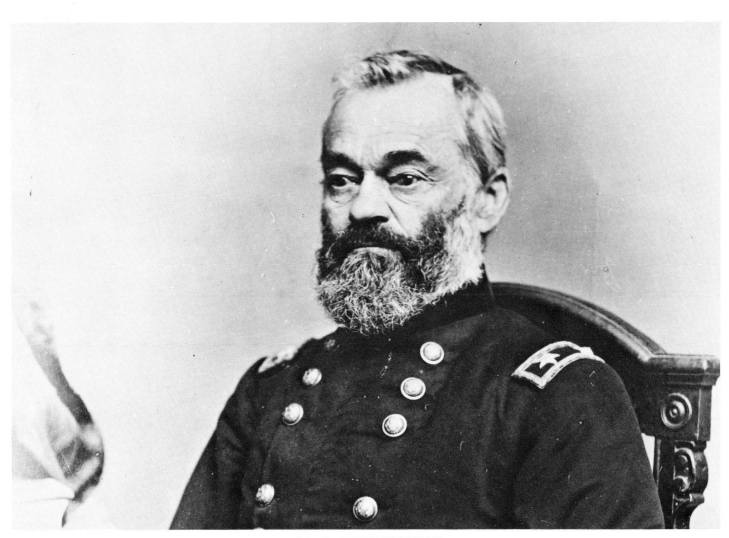

No. 112 GEN'L HEINTZELMAN

No. 113 SEVENTH NEW YORK BATTERY—JUNE 1863

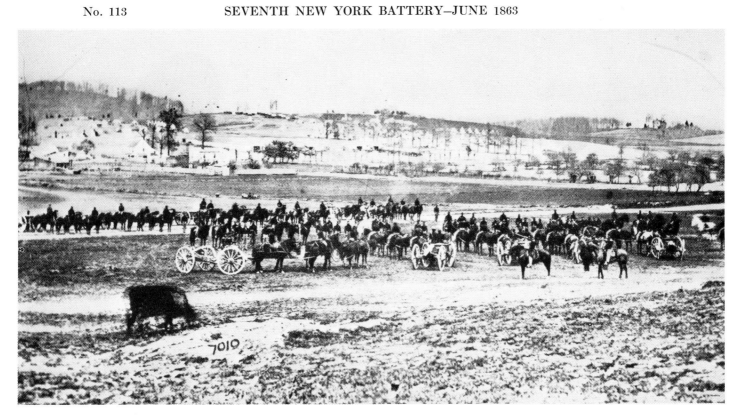

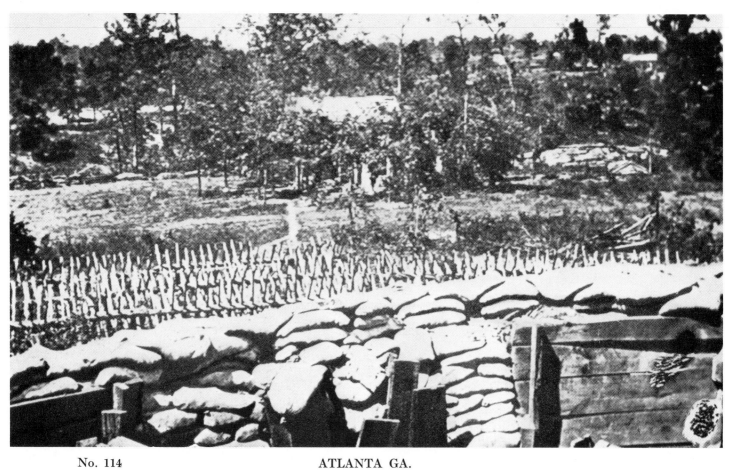

No. 114 **ATLANTA GA.**
View of the Confederate fort, line from the first fort east of W.A. R.R.

No. 115 **GROUP MILITARY TELEGRAPH**
Construction Corp. (See no 27)

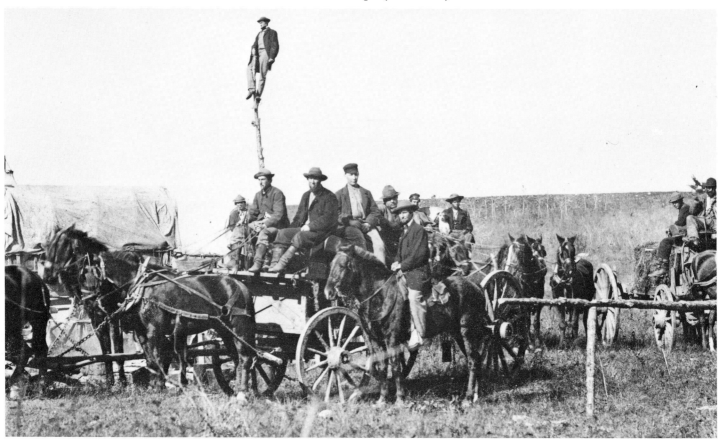

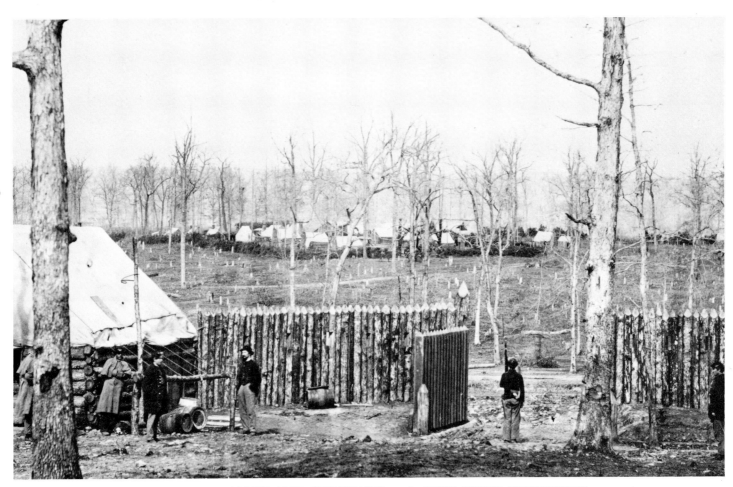

No. 116 SUTLER'S RANCH AND STOCKADE 50th NEW YORK ENGINEERS
This view was taken at Rappahannock Station Va. in early part of the year (March 1864)

No. 117 CAMP OF THE SIXTH NEW YORK ARTILLERY AT BRANDY STATION VA.
April 1864

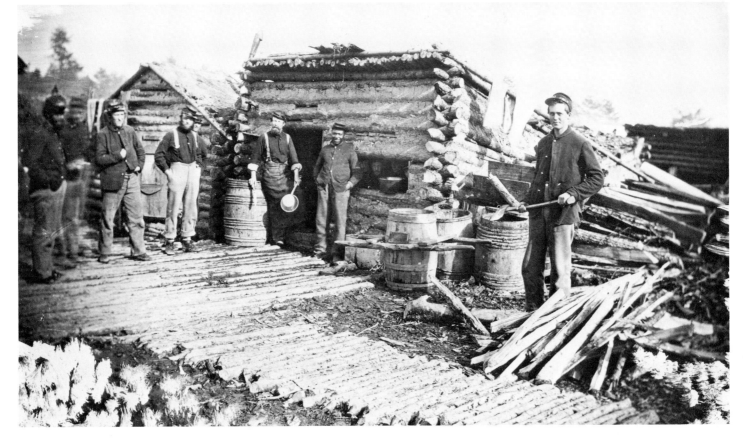

No. 118 GEN'L WINFIELD
SCOTT HANCOCK
(made in Gallery)

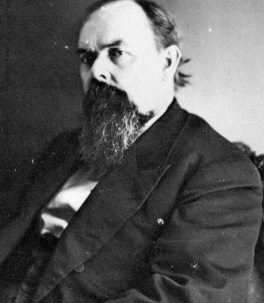

No. 119 GENERAL
GEORGE B. McCLELLAN
(in Gallery)

No. 120 GOV. O. P.
MORTON OF INDIANNA

No. 121 GOV. ANDREWS

No. 122 GOV. SAMUEL J.
TILDEN, N. Y.

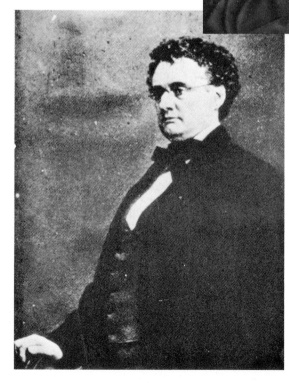

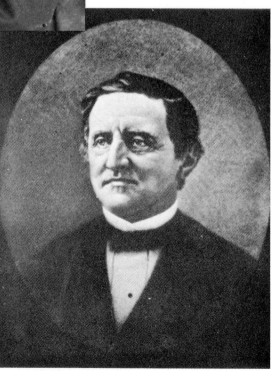

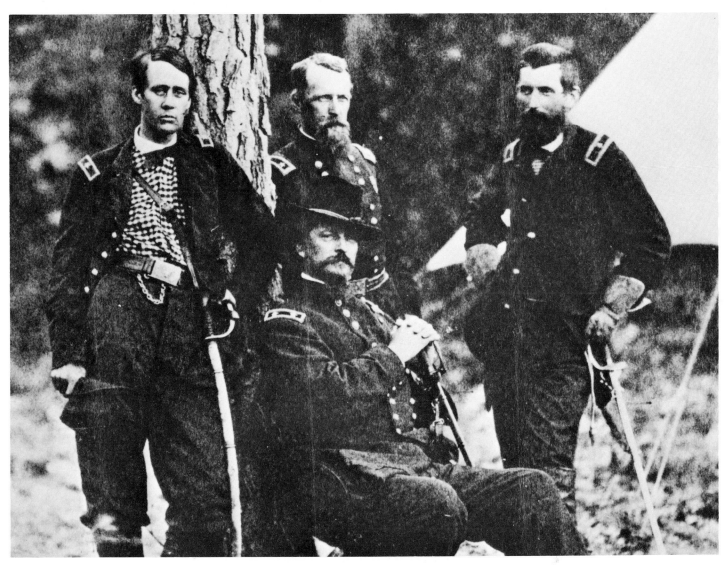

No. 123 **GROUP IN THE VALLEY**
Key: Generals Hancock, Birney, Barlow, and Gibbon (s)

No. 124 **GENERAL SLOCUM AND STAFF**
(Made in Gallery)

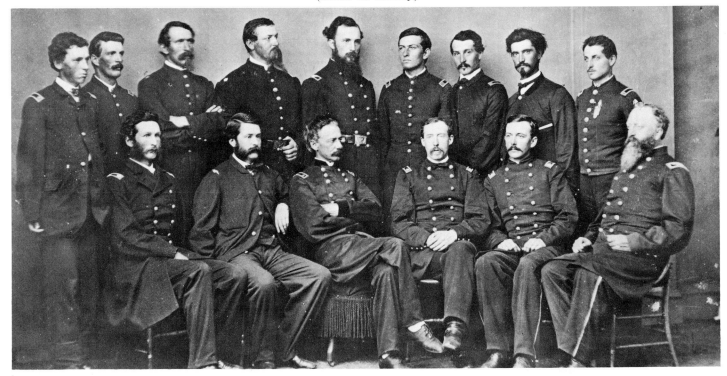

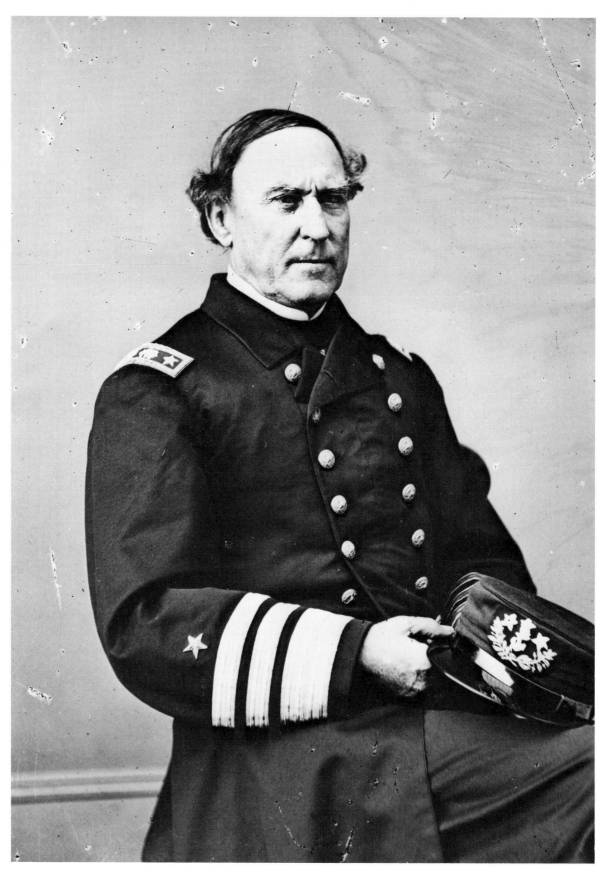

No. 125 ADMIRAL FARRAGUT

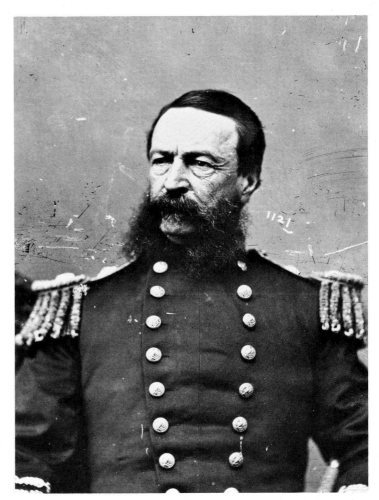

No. 126 ADMIRAL PORTER

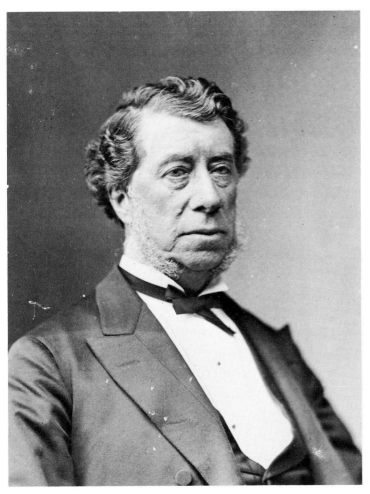

No. 127 GOV. HAMILTON FISH. N. Y.

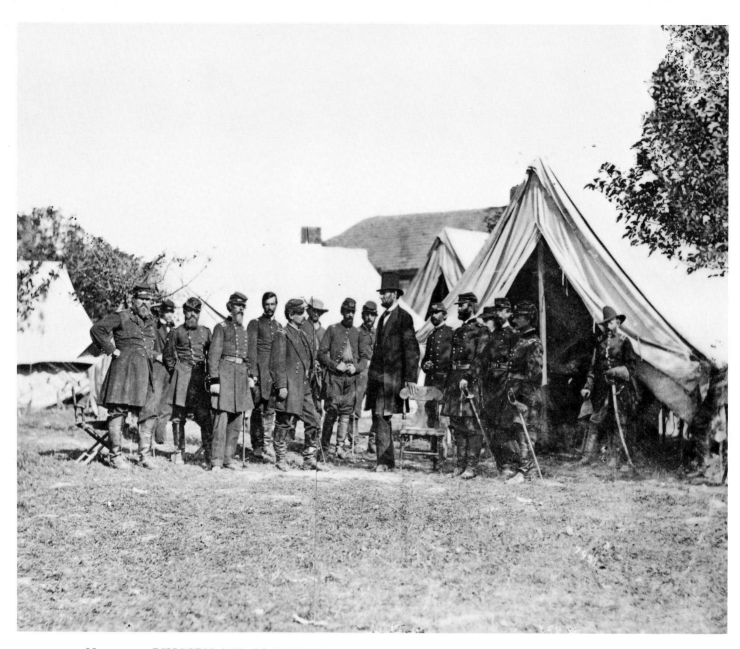

No. 128 LINCOLN AND McCLELLAN ON THE BATTLEFIELD OF ANTIETAM
President Lincoln Gen'l McClellan and a large group of Officers at Headquarters army of the Potomac
Antietam Md. Oct 4th 1862. (see no 74)

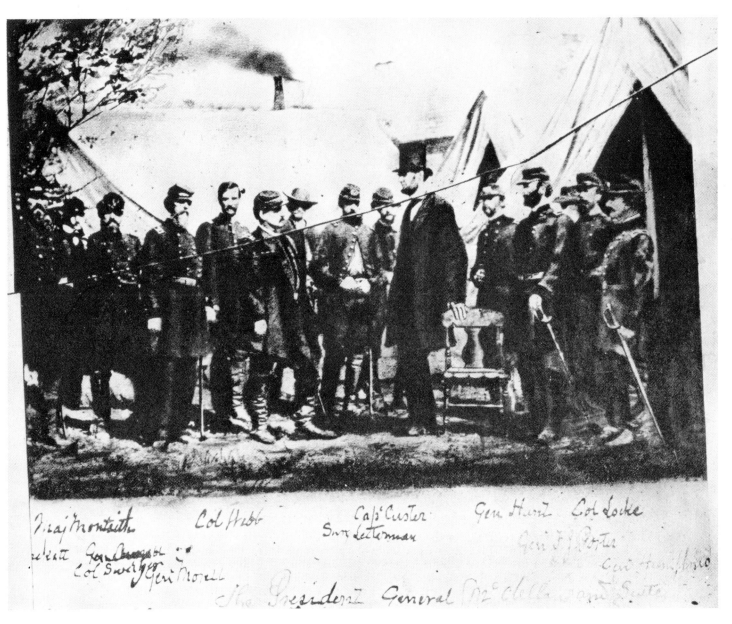

PRESIDENT LINCOLN AND HIS FIELD COMMANDERS AT SHARPSBURG, MARYLAND

A rare unpublished print from a broken negative made by Brady after the battle of Sharpsburg. Found only a few years ago, this print shows the 'KEY' in Brady's own handwriting identifying the officers in the group heretofore unknown. Taken at the same time as plate number 128, it clearly shows the camera has been moved to a closer position.

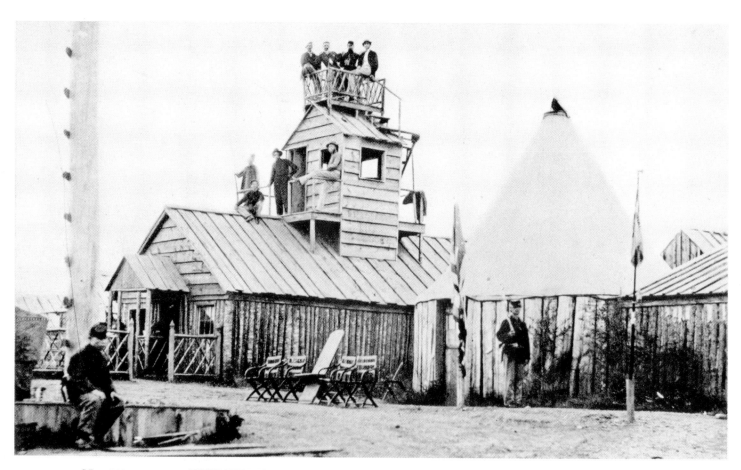

No. 129 THIRTEENTH NEW YORK CAVALRY ON INSPECTION
Prospect Hill Va. Near Washington D. C. July 1865.

No. 130 SECOND CORPS MAIL WAGON

The sight of this wagon coming into the camps of the old Second Corps always gladden the hearts of the boys. It came loaded with letters from home—how welcome these were—non but the weary and heartsick soldiers can never Know. Some letters had to be returned with a line or two written across the envelope, like this "Killed Yesterday" or "Died in Hospital last week" or "Missing" The boys were always anxious for news from home. What the folks thought of their battles, their problems, etc,. By 1864 the P.O. was quite an institution handling thousands of letters each week most successfully conducted under army postmaster Wm. B. Hazlett; of Army of the Potomac. Each regiment had a postmaster-.

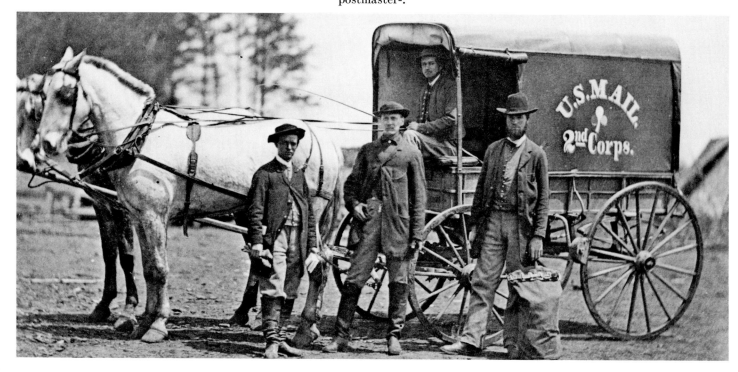

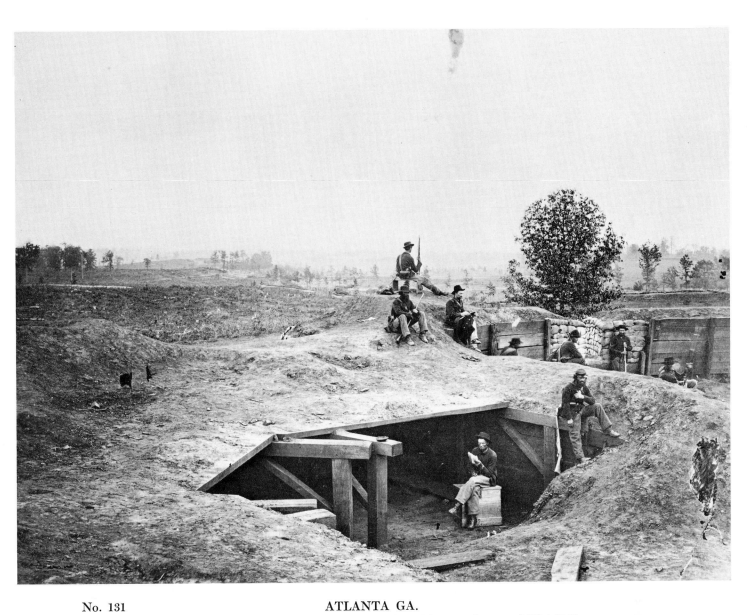

No. 131 ATLANTA GA.
View from casemated Confederate For (D) looking north toward W.A.R.R.

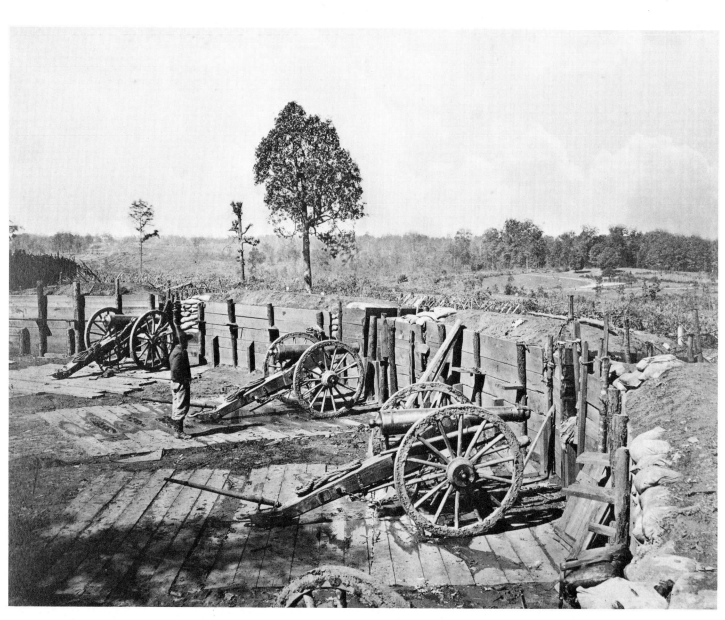

No. 132 ATLANTA GA.
View from Confederate Fort East of Peachtree Street looking Northwest.

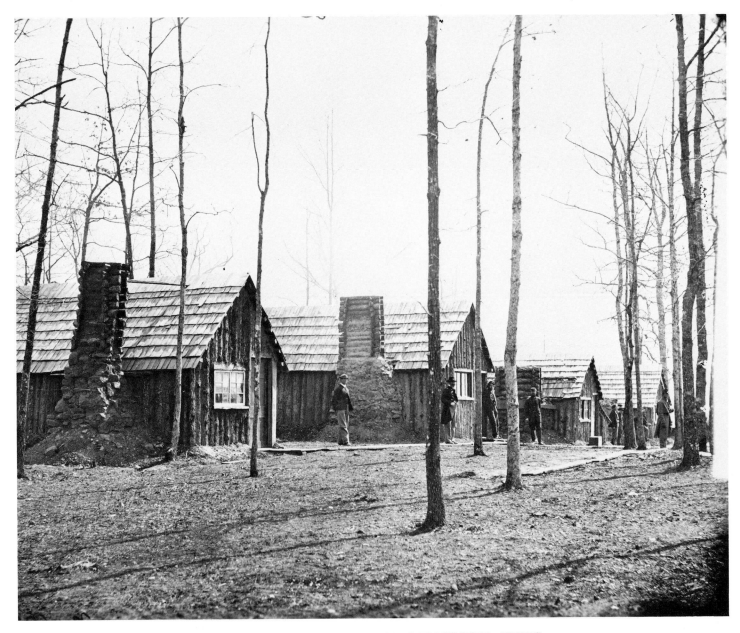

No. 133 **CAMP OF THE 50th NEW YORK ENGINEER CORPS—
QUARTERS OF FIELD AND STAFF RAPPAHANNOCK STATION VA.**

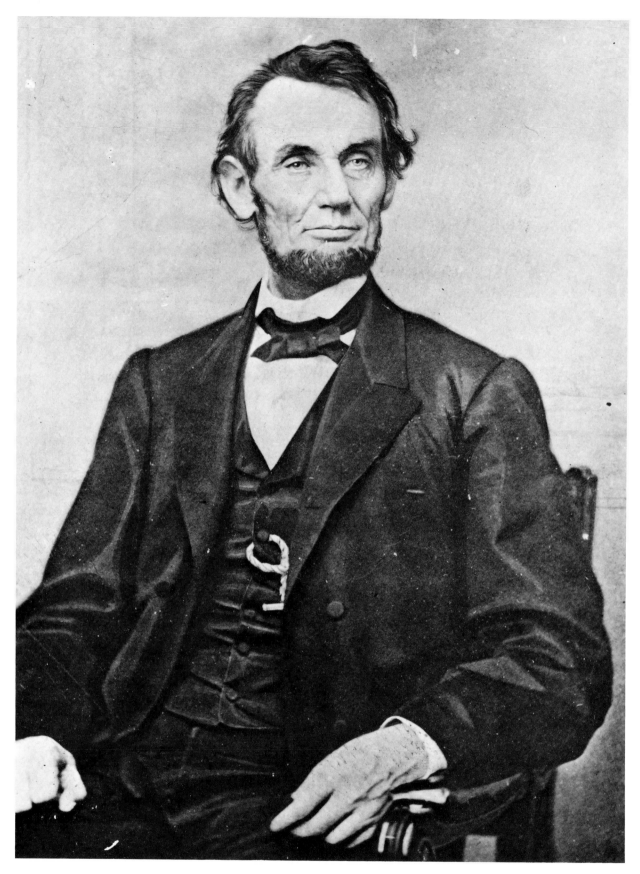

No. 134

PRES. LINCOLN
(in Gallery)
(See Brady about Chair)

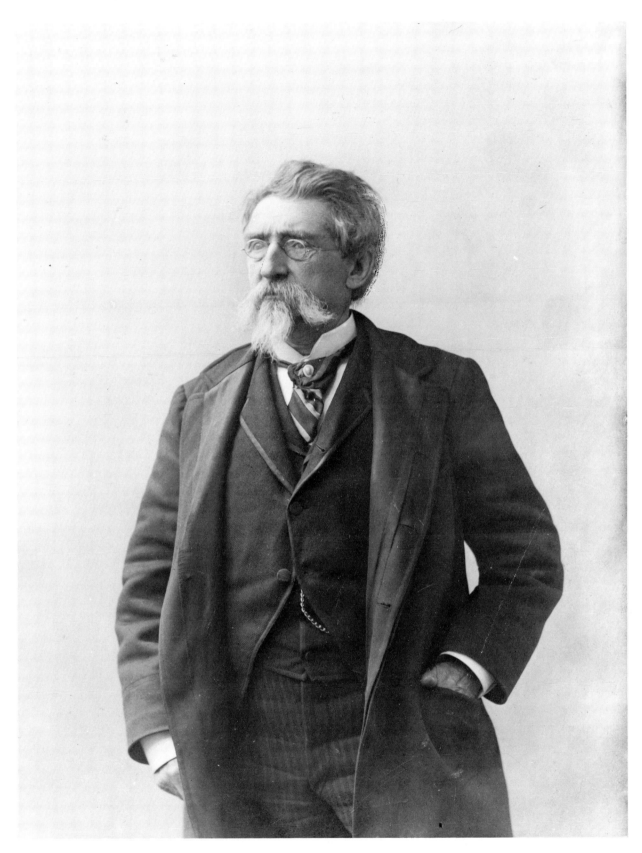

No. 135 MR. MATHEW B. BRADY
 The Veteran Photographer.

Index of Negative Numbers

Unless otherwise indicated, these negatives are in the collection of The Library of Congress. Prints can be ordered from the Chief, Photoduplication Service, The Library of Congress, Washington, D. C. 20540.

PLATE NUMBER	NEGATIVE NUMBER	PLATE NUMBER	NEGATIVE NUMBER	PLATE NUMBER	NEGATIVE NUMBER	PLATE NUMBER	NEGATIVE NUMBER
Frontispiece	BH8277-550	43	BH82-402	72	BH841-48	103 (above)	B8184-B423
1	B8171-254	44 (above left)	BH82-4639	73	B8184-4530	104 (below)	USZ62-49357
2	BH825-23	44 (above right)	BH827-4087	74	B817-7949	105 (above)	B8184-B139
4	B8184-4099	44 (below left)	BH8277-45	75 (above)	B817-7647	106	National Archives 111-B-4146
5	BH821-3084	44 (below right)	National Archives 111-B-6123	75 (below)	B811-631	107 (above)	B816-8220
6	USZ62-49326	45	BH82-137	76 (above)	BH8255-98	107 (below)	B816-8218
7	USZ62-49354	46	B8184-210	76 (below)	B8184-194	109	B815-948
8	B8184-4452	47	USZ62-5803	77 (above)	B8184-577	110 (above)	USZ62-49356
9	USA7-5044	48	USZ62-15178	77 (below)	B815-589	110 (below)	B8184-B24
10 (above)	BH835-2	49 (left)	USZ62-7992	78 (right)	BH8171-633	111 (above)	B8184-735
10 (below)	BH835-5	50	USP6-2416-A	79	B8171-3175	111 (below)	B8171-3172
11	USZ62-2188	51	BH82-100	80 (above)	USZ62-49358	112	BH831-565
12	BH824-785	52	BH82-4505	81 (above)	B8184-B-170	113	USZ62-3881
13	BH824-158	53	USZ62-5876	81 (below)	B8184-7140	114	USZ62-4901
14 (left)	BH8277-39	54 (above)	B8184-B-136	82 (above)	B815-777	115	BH831-566
14 (right)	BH834-8	54 (below)	USZ62-41338	83 (above left)	BH82-4864	116 (above)	USZ62-8389
15	USZ62-14753	55	BH83-1384	83 (above right)	USZ62-7989	116 (below)	BH823-145
17	BH8277-551	56	B8184-40477	83 (below)	BH837-207	117	BH834-40
18 (left)	BH834-9	57 (above)	National Archives 111-B-1229	84 (above)	B8161-B396	118	USZ62-8309
18 (right)	BH8277-540	57 (below left)	BH832-571	85 (above)	B8184-10396	119 (above)	B8184-7907
19 (left)	BH82-5151	57 (below right)	National Archives 111-B-1074	86 (above)	B8184-605	119 (below)	B8184-10103
19 (right)	BH824-5391	58 (above left)	BH831-1677	86 (below)	B8184-10264	120 (above)	BH831-1324
20 (above left)	BH834-14	58 (above right)	BH832-31142	87	B8184-740	120 (below)	B8184-10104
20 (above right)	BH834-34	58 (below right)	BH832-29355	88 (above)	B8184-4213	121 (above)	B8184-10701
20 (below right)	USZ62-8222	59	USZ62-49299	88 (below)	B8184-10331	121 (below)	B817-7798
22	BH824-5399	60	B815-363	89	USZ62-17216	122	BH821-6803
24	USZ62-8963	62 (above)	B8184-10669	90	USZ62-8046	123	BH82-1963
25	BH824-961	62 (below)	BH822-363	91 (above)	B817-7942	124	BH82-4671
26	BH82-4696	63	B817-7043	91 (below)	B8184-253	128	BH832-30321A
27	BH82-5220	64 (above)	B8184-B-1181	92 (above)	B8184-7964	129	USZ62-8328
28	BH82-5212	64 (below)	B8171-2485	92 (below)	B8184-268	130	BH8266-161
29 (above left)	USZ62-2889	65 (above)	B811-2486	95 (above)	BH834-66	131	USZ62-4899
29 (below left)	USZ62-28017	65 (below)	B8171-2601	95 (below)	USZ62-49300	132	BH832-2066
29 (below right)	USZ62-28113	66 (below)	B815-489	97 (above)	National Archives 111-B-5426	134	BH824-5083
30 (above left)	USZ62-3668	67 (below)	B8184-10102	97 (below)	BH8253-174	135	BH826-2602
30 (above right)	USZ62-5555	68	BH832-236	98 (above)	B8184-16	136	BH827-1584
30 (below left)	USZ62-28112	69	BH8172-1568	98 (below)	B8184-10549	139	USA7-281
30 (below right)	USZ62-28110	70 (above)	B8184-10418	99 (above)	B8184-B46	140 (above)	BH8277-41
33	USZ62-13357	70 (below)	B8184-4227	99 (below)	BH841-27	144	BH826-3704
34	BH821-743	71 (above)	B815-671	100 (above)	B8184-B620	145	USZ62-30735
37	BH824-4900A	71 (below)	B811-563	101 (above)	B8184-4999	148	BH82-5207
38	BH824-4900			101 (below)	B8171-748		
39	BH82-4023			102	B811-3293		
42	USZ62-8340						

BRADY'S LECTURE BOOK

PLATE NUMBER	NEGATIVE NUMBER	PLATE NUMBER	NEGATIVE NUMBER	PLATE NUMBER	NEGATIVE NUMBER	PLATE NUMBER	NEGATIVE NUMBER
1	B8171-221	33	B811-2557	70	B815-1174	102	BH825-47
2	B811-2295	34	B8184-B263	71	B8171-126	103	BH827-97
3	USZ62-49303	35	B811-2594	72	B8184-7971	104	BH825-13
4	B8171-520	36	B811-2597	73	B813-1999	105	B8184-B36
5	B817-7235	39	B811-3623	74	USZ62-2621	106	B8184-10212
6	B8184-562	40	B811-3671	75	BH83-1371	107	B8184-604
7	B8171-471	41	USZ62-49302	76	BH82-4080	108	B8184-10095
8	B8171-7292	42	B811-3259	77	BH831-578	109	BH825-37
9	B8184-7482	43	B811-3258	78	BH813-2208	111	BH825-26
10	B815-491	44	B8171-2646	79	USZ62-84	112	USZ62-20038
11	B817-7557	45	B811-2650	80	BH826-3711	115	B817-7117
12	B8184-899	46	B811-2718	81	B8184-10366	116	USZ62-49301
13	B811-490	47	B8171-3139	82	BH841-3	117	B8184-40484-2A
14	USZ62-25523	49	B8184-B449	83	BH832-304	118	BH83-2244
15	B8171-730	50	B8171-3158	84	B811-560	119	B8184-10461
16	B8171-3626	51	B8171-3194	85	B811-918	120	BH832-29401
18	B8184-10452	52	B8171-3195	86	B811-3182	123	B8184-10266
19	B811-2348	55	B8171-3206	87	B8184-4082	124	BH831-1152
21	B8184-B29	57	USZ62-49364	89	B811-217	125	BH82-4054A
22	BH82-1546	58	B817-7009	90	B8184-B517	126	BH83-1121
23	B813-1702	59	USZ62-49362	92	BH82-4012	127	BH826-30269
24	BH82-4157	60	B817-7035	93	B8184-1019	128	B8171-7951
25	USZ62-49360	61	USZ62-49359	94	BH83-1470	130	B8184-7303
26	USZ62-42392	62	B817-7131	95	B816-8007	131	B8184-10073
27	B817-7117	64 (above)	B811-3182	96	B811-557	132	B8184-10275
28	USZ62-45933	64 (below)	B8171-3183	97	USZ62-49355	133	B817-7604
29	B811-2448	66	B8184-10057	98	B811-482	134	USZ62-11178
30	B811-2512	67	B8184-7965	99	B811-1051	135	BH827-2102
31	B811-2529	68	B8184-7347	100	USZ62-49361		
32	B8184-40474-2A	69	B817-7383	101	B811-617		

BIBLIOGRAPHY

When I started work on this book, there came into my possession a large press clipping book containing all the newspaper reports and articles concerning Brady's activities since the opening of his first gallery in 1844. A collection of Brady's personal correspondence, manuscripts, and the correspondence that passed between his personal friends and his nephew, Levin C. Handy was also available to me which cast new light on the last few years of Brady's life. I also had access to a "lecture book," or "List Book," as it was called, that contains many homely and picturesque descriptions of the photographs, written in the language of the period. These I have quoted verbatim. In filling in the periods in Brady's life not covered by his correspondence or press book I have drawn somewhat on my imagination supported by the facts and details recorded by eye-witnesses, to cover the battlefield photographic operations; and upon General officers' accounts of conditions and actions in the battlefield areas in which Brady was known to have been consulted. For example: After examining the pictures in Gardner's *Sketchbook*, it appears that O'Sullivan worked almost exclusively with the Second Corps of the Army of the Potomac;—for the pictures for which he is given credit and the locations at which they were taken were the scenes of action of that army corps. Brady's negatives carry the initial "B" and a plate number.

Concerning Brady's home life and activities following the war, Mrs. Mary Evans, his grand niece, after exhaustive questioning, explained many things to me that she had heard her father, L. C. Handy, Brady's nephew and co-worker, say about Brady and his "comings and goings."

The Scrap Book compiled by Brady showing all his press notices will be referred to as *PB*.
Battles and Leaders of the Civil War is hereinafter cited as as *B & L*
Photographic History of the Civil War will hereinafter be referred to as *P.H.C.*

NEWSPAPERS AND PERIODICALS

The Brady Press Clippings from the newspapers listed below, and contained in the 'PressBook' (or) 'ScrapBook' date from 1844 through 1896. Some of the datelines have been cut away, but were identified by other matter appearing in them.

Baltimore Patriot
Boston Evening Transcript
Brooklyn Daily Eagle
Buffalo Courier
Cleveland Leader
Daily Chronicle
Daily Patriot
Evening Express
Evening Telegram
Evening Mirror (1849-1854)
Indianapolis Times
National Republican
National Union
New York Citizen
New York Commercial Pathfinder
New York Graphic
New York Herald
New York Sun
New York Times
New York Tribune
New York World
Old Pioneer
Philadelphia Bulletin—(Washington letter concerning Butler)
Pittsburgh Telegraph
Sunday Chronicle
Sunday Morning Telegram
Washington Chronicle
Washington Evening Star
Washington Herald
Washington Post
Washington Times
Illustrated London News, Vol. 18, p. 425—1851
Harpers Monthly Magazine, Vol. 38, Dec. 1868—May 1869
House of Representatives Report No. 46—41st Congress
Humphrey's Journal—issues from 1851-1865
National Intelligencer of 1861 and 1862
The Daguerreotype Journal of 1851, Vol. 2
The Photographic Art Journal—1852—Vol. 1
Webster and Clay—Their Daguerreotypes—T. B. Thorpe, Harpers—1851
S. F. B. Morse Papers—Library of Congress, Washington, D. C.

CORRESPONDENCE

Letter of Dr. J. W. Stone, M.D. to M. B. Brady, Pittsburgh, Feb. 24, 1892.
Letter of M. B. Brady to his nephew, April 30, 1895.
Letter of William H. Slocum to Brady's nephew, 1895.
Letter of M. B. Brady to his nephew, June 14, 1895.
Letter of William Slocum to Brady's nephew, Sept. 20, 1895.
Letter of Brady to his nephew, Oct. 1, 1895.
Letter of William Riley to Brady's nephew, Dec. 5, 1895.
Letter of William Riley to Brady's nephew, Dec. 16, 1895.
Letter of Mrs. Eliza Handy to Brady's nephew, Jan. 21, 1896.
Other correspondence not listed.

AMBROSE BIERCE QUOTATIONS

The Devil's Dictionary—or Cynic's Word Book
World Publishing Co., Cleveland, Ohio
Letter from P. Stacey to Mr. Riley, dated Saturday A.M. (no date)—account concerning Brady's death.
Letters of William Riley concerning Brady's effects—Jan. 18, 1896 to Brady's nephew.
Final letter of William Riley to Brady's nephew, mentioning a Jan. 20, 1896 work in which some of Brady's photos were poorly reproduced and written by Rossiter Johnson.
Letters of M. H. Evans to the author concerning Brady's marriage and the final sale of the F Street Gallery.
Letter of Brady to the Library of Congress giving the details of the sittings of Clay, Webster, Calhoun, and concerning the paintings which were made from his Daguerreotypes. There is also an account by artists Danby and Neagle, who were present in the Fulton Street Gallery when these Daguerreotypes of the three statesmen were made. Also published is the Library of Congress' quoted price of the paintings, which was $4,000.
Postal Telegraph Cable Co. notifying Levin Handy of Brady's death.

NOTES AND BIBLIOGRAPHY

CHAPTER 1

B. & L.—"First Battle of Bull Run," G. T. Beauregard, General, C.S.A.; "Advance to Bull Run," Major General James B. Fry.
Humphrey's Journal (1861)
The Townsend Interview — George Alfred Townsend — New York World, April 12, 1891
Stonewall Jackson, by G. F. R. Henderson, Longman's Green Co.

CHAPTER 2

Ten Years in Washington—Mary Clemmer Ames, Hartford, Conn., 1873, A. D. Worthington & Co.
The Townsend Interview—PB
"M. B. Brady and The Photographic Art," C. Edwards Lester, Jan. 1850
Account of John Plumbe—Photography and the American Scene by Robert Taft. An excellent book on the history of photography. The MacMillan Company, N. Y. 1938

Photography and the American Scene—Robert Taft—Mac-Millan Company—1938
Dictionary of American Biography—New York Public Librray
Concerning portraits of Andrew Jackson Thorpe's account—Harpers' 1868
T. B. Thorpe's account of Webster, Clay and Calhoun — Harpers Monthly, 1868, page 751
Thomas Hart Benton's sitting—*PB*

CHAPTER 3
Letter of M. H. Evans to the author
Press Book
Edgar Allen Poe—PB
James Fenimore Cooper—PB
C. Edwards Lester—"M. B. Brady and The Photographic Art"
When Brady made his Daguerreotype portraits of Clay, Webster, and Calhoun, artists John Neagle, Henry L. Darby were present. With the help of Brady's portraits they made their paintings. John Neagle made the painting of Webster, and Darby made paintings of Clay and Calhoun. The paintings came into Brady's possession, and hung in his gallery for years.
They were finally purchased from Brady in 1881 by the Joint Committee on the library. Brady received $4000.00. The Webster portrait brought $1900.00, and the portraits of Clay and Calhoun totaled $2100.00. They now hang in the main corridor of the Senate.
Brady issued a signed statement stating facts concerning the sittings, also the dates on which they were made. Clay's picture was made in the winter of 1849, another being made in 1850. Calhoun's was made in March of 1849, and Webster's in June of the same year.
Charles E. Fairman
Art Curator of the Capitol
67th Congress 1st Session
Senate Document No. 95
U. S. Government Printing Office
Page 321

CHAPTER 4
P.B.
The Handy family Bible
P. T. Barnum and Florence Nightingale—P.B.
Mrs. Alexander Hamilton—P.B.
Gallery of Illustrious Americans — circulation item — undated newspaper clipping—Press Book
Abraham Lincoln, The War Years—Harcourt Brace Company, 1939, N. Y.
Memoirs of John Quincy Adams, Edited by Allan Nevins, Longmans Green Co., N. Y., 1929
Also reproduced in Press Book News Clipping

CHAPTER 5
Brady Press Book
The Photographic Art Journal
C. Edwards Lester—M. B. Brady and The Photographic Art of 1850
James Gordon Bennet—Press Book
The Earl of Carlisle—Press Book
William Learned Marcy—Press Book
Brady's New Gallery—Complete newspaper reporter's description—Press Book
Boston Evening Transcript—P.B.—Account of "Mary Forrest" (Real name unknown—wrote under her pen name)

CHAPTER 6
Brady Press Book
Lincoln's first visit to the gallery — newspaper clipping — undated—P.B.—cites Brady's own conversation with Lincoln at the time. (Washington Letter to the Cleveland Leader.)
Prince of Wales' visit to New York—complete account including firemen's parade—P.B.
Letter of M. H. Evans to the author concerning the existence of the gold and ivory handled cane and the ebony Escritoire given to Brady and Mrs. Brady as gifts from the Prince of Wales following the sitting
Washington Irving—an account and a facsimile copy of an article in the *New York Sun* and the *New York Herald*, March 1860. Washington Irving's Daguerreotype, the one Brady copied and finished in life-size oils, was originally made by Plumbe and loaned to Brady for the purpose of copying by persons in England. The Daguerreotype is reproduced in the Fulton Edition of *The Works of Washington Irving*—N. Y., The Century Company, 1909

Humphrey's Journal—1860
Abraham Lincoln—The War Years—Harcourt Brace, New York, 1939
Six Months at the White House with Abraham Lincoln—F. B. Carpenter (Hurd and Houghton Publishers, New York 1866)

CHAPTER 7
Ten Years in Washington—Mary Clemmer Ames, 1873. A. D. Worthington & Co., Hartford, Conn.
Brady Press Book
Newspaper clipping giving complete description of the studio location in Washington, D. C.
George H. Story account of his posing President Lincoln in the Brady Gallery for his first official photograph—told to a New York World reporter
Anthony's Photographic Bulletin of 1860—Photographic Reminiscences of the Late War
B. & L.—"Washington on the Eve of the War"—Vol. No. 1, Part No. 1, Page 7—General Charles P. Stone
Senator Edward D. Baker's Speech—Lincoln Inauguration—1861
The War Years—Carl Sandburg, Harcourt Brace & Company, Copyright 1939. Volume 1

CHAPTER 8
Washington scenes—*Ten Years in Washington*, by Mary Clemmer Ames, 1873
Boots and Saddles—History of the First New York (Lincoln) Cavalry—by Major James Stevenson, copy of limited edition in the author's possession
Brady Press Book
Letter of M. H. Evans to the author
Account of the Brady-Lincoln chair—Letter of M. H. Evans to the author, after a careful search, and verified by Will H. Towles, last owner of the Brady Washington Gallery and present owner of the chair
Description of Lincoln—John G. Nicolay, President Lincoln's Secretary, 1861-65
George H. Story's personal account of the Lincoln sitting—news clipping—Press Book. Also describes an order for a painted portrait of Lincoln

CHAPTER 9
Brady Press Book
The Townsend interview—P.B.
Winfield Scott quotations. Abraham Lincoln—The War Years—Carl Sandburg, Harcourt Brace & Co. Copyright, 1939
Concerning Winfield Scott's picture—Brady's Press Book gives a complete account of the sitting and Mrs. Kemble's visit
Gardner's *Sketchbook of The War* (for the names of the photographers concerned in photographing the war)
H. W. Lanier—*P. H. C.*—The Review of Reviews, 1907. Vol. No. 1

CHAPTER 10
Brady Press Book
Gardner's *Sketchbook* — for identification of photographs — Library of Congress, Wash., D. C.
Boots and Saddles—concerning the peninsula campaign and weather conditions at the time
Letter of M. H. Evans to the author
E. B. Eaton account concerning the Prince de Joinville
Description of the battles of Williamsburg—*Boots and Saddles*, by Major James H. Stevenson. Published 1874, Phila.
Professor T. S. C. Lowe's personal account of his aerial observations, published in *P. H. C.*—"Fair Oaks and Seven Pines," Vol. 1
"Recollections of a Private," by Warren Lee Goss, *B. & L.*, Vol. III, Page 189
Brady's Lecture Book

CHAPTER 11
B. & L.—Major Gen. Wm. B. Franklin, U.S.V.—"Retreat of the Union Army during the battles of the Seven Days"— description of the field at Fair Oaks
Boots and Saddles—Major James Hunter Stevenson—Phila., July 1879
The History of Rome Hanks and Kindred Matters — Lt. Stanley Joseph Pennell — Charles Scribner, 1945 — Brady at Savage Station
Battles and Leaders—Fitzjohn Porter
Boots and Saddles—account of the New York (Lincoln) Cavalry aiding in the retreat of the Union Army to Harrison's Landing on the James River
Brady Press Book

CHAPTER 12

Letter of Mrs. M. H. Evans to the author
The Townsend Interview
Catalogue of Anthony & Co. photographic equipment, New York Public Library
Edwin M. Stanton Proclamation concerning the U. S. Military Railroads
Official records of the War of the Rebellion—George N. Barnard and photographic operations of the siege of Knoxville
Account of Sam A. Cooley operations, *P. H. C. W.*, Vol. 1

CHAPTER 13

Brady Press Book—Newspaper clipping announcing pictures on exhibition in the New York Gallery entitled "Dead at Antietam."
"The Battle of Antietam," by Major General Jacob D. Cox, U.S.V., *B. & L.*, Vol. II, Part 2
The Invasion of Maryland—by Lt. Gen. James Longstreet, C.S.A.
A Woman's Recollection of Antietam — Mary Bedinger Mitchell
"Antietam Scenes," by Chas. Carlton Coffin, *B. & L.*, Vol. II, Part 2, Page 686
Letter of M. H. Evans to the author concerning Brady photo of Lincoln at Sharpsburg and the inscription on the back of the photograph concerning Captain Derekson and reproduced in facsimile.
Sketchbook of the War, by Alexander Gardner, Phillips and Solomon, Washington, 1865; for photographers' credits and dates concerning the pictures. Other identification and pictures made by artists on the field at the same time Brady operated gives a clear description of the field immediately following the battle and which appears in Frank Leslie's "Weekly."
Bill Head and Caption Sheet of Brady reproduced in facsimile from the original in the author's possession identifying picture of signalmen on Eagle Mountain.
Concerning the routes that Brady took from Washington to Sharpsburg, he had the choice of two: The Baltimore Pike and The Hagerstown Pike. It is logical to assume that the road he would take would most certainly be the shortest one out of Washington.
As to just when the battlefield photographs were taken, according to various accounts, the dead on the battlefield were collected for burial as quickly as possible. The photographers, nine times out of ten, did their picture taking while the burial parties were at work. Frank Aretas Haskell's letter on Gettysburg mentions—rather proudly—that this work commenced almost immediately following the end of the engagement. Therefore, during these periods, which sometimes lasted anywhere from two to twenty-four hours, the pictures were made.
The Lincoln Sharpsburg Photograph—Concerning the pictures Brady made of Lincoln on his visit to McClellan's headquarters at Sharpsburg, Brady can be definitely credited with these photographs. As to the forehand knowledge of Lincoln's visit, the photographers, and particularly Brady, almost always were found at or near general field headquarters. Brady was a personal friend of Gen. George B. McClellan, and it is logical to assume that he would receive his information almost first-hand.
Illustrated History of the Civil War—F. Leslie's Weekly—F. H. Schell, special artist—Sept. 19, 1862.

CHAPTER 14

"Sedgewick at Fredericksburg and Salem Heights," by Huntington W. Jackson, Brevet Lt. Col., U.S.V.,—*B. & L.*
"In Front of the Stone Wall at Fredericksburg," by James W. Ames, Brevet Brig. Gen., U.S.V.,—*Overland Monthly*, 1869, Vol. III, Page 432, also listed in *B. & L.*
"Sumner's 'Right Grand Division'," by Darius N. Couch, Maj. Gen., U.S.V.—*B. & L.*
"Washington Scenes"—*Ten Years in Washington*, by Mary Clemmer Ames, Hartford, Conn., 1873.
The conclusion drawn on the routes taken by Brady to Fredericksburg is, that Brady had War Department passes. The easiest way for him to go would certainly be by Army Transport, for the roads from Alexandria to Fredericksburg were almost impassable for any vehicle during the Spring and Winter months.
Anthony's Photographic Bulletin mentions Captain Russell's railroad car photographic darkroom. Many times darkroom wagons were carried on flat cars commandeered for the purpose.
Concerning the weather conditions, Maj. Jas. A. Stevenson gives an adequate account of the weather in *Boots and Saddles,*

story of the First New York (Lincoln) Cavalry, a limited edition published in 1874.
Humphrey's Journal of 1862 gives a vivid account of Brady's activities during that campaign and of his almost being struck by sharpshooters' bullets.
Brady's lecture book, called "List Book," in a letter from Wm. Riley to L. C. Handy, Brady's nephew, dated Nov. 23, 1895. This gives a complete account of the derisive remarks flung at Brady by the Confederate soldiers across the river.
Light conditions at Fredericksburg: On the morning of Dec. 13 the violent opposition to the laying of the pontoons by Barksdale's "Mississippians" was under cover of the fog. According to military accounts, the fog soon lifted, giving plenty of light for camera operation. On the final capture of Fredericksburg, a description is given by Maj. Gen. Darius N. Couch of the looting and general lawlessness of the Union soldiers. During the battle many officers took observation posts in the churches and taller buildings of the town during the engagement. The photographers did the same.

CHAPTER 15

Letter of Wm. Pinkerton, son of Allan Pinkerton, Chief of the United States Secret Service.
Gardner advertisement on the opening of his gallery in the Brady Press Book.

CHAPTER 16

"Sedgewick at Fredericksburg and Salem Heights," Huntington W. Jackson, Brevet Lt. Col., U.S.V., *B. & L.*
Alexander Gardner's *Sketchbook of the War* for data on locations and concerning pictures taken on the field by O'Sullivan during Sedgewick's withdrawal across the river.
The *Sketchbook* also explains the route taken by the Second Corps, Army of the Potomac.
Letter from M. H. Evans describing the James McHenry photographic order.
Frank Aretas Haskell—*The Battle of Gettysburg*—The Wisconsin Historical Commission, owner of the original manuscript and reproduced in the Harvard Classics—Famous American Documents.
Activities of George Cook, one-time employee of Brady's, are described sketchily in *P.H.C.*, Vol. I.

CHAPTER 17

Brady Press Book—a news clipping entitled "How They Had Their Pictures Taken," which fully describes incidents involving the Union officers and their portrait sittings. There is also a complete description of the Grant incident. This is also cited in the Brady "List Book."
Concerning the Lincoln sitting, Lincoln's visit is also described by a reporter who was present, mentioning the fact that two unidentified ladies were present and watched the proceedings.
Identified photograph of Brady taken with General Potter and staff placing Brady in the vicinity of Potter's Corps on May 4th and 5th, 1864.
Grant's crossing of the North Anna River was photographed entirely by O'Sullivan. Descriptions of camp conditions and the weather are fully described in the text accompanying the photographs in the Gardner *Sketchbook*. (Library of Congress).
Letter of Lt. James Gardner describing Brady's adventure under fire at Petersburg, mentioned in *P.H.C.*, Vol. I.

CHAPTER 18

"The Worst Cases Asked To Be Photographed."
The Rise and Fall of the Confederate Government, by Jefferson Davis. Garrett and Massie Incorporated Richmond, Va. Davis devotes a full chapter concerning the photographs of prisoners made at Annapolis, though he does not mention the photographer who made them. But the logical man to make them would be Brady.
Confederate Military Prisons—"Andersonville," by John McElroy, Company L, 16th Illinois Cavalry, 1879, published by D. R. Locke. A full description is given here of the incredible conditions that existed during his internment. The pictures made at Annapolis are reproduced in this book by means of line-cut engravings made from the photographs.
Anthony's Photographic Bulletin, photographic reminiscences of the later war article No. 2 gives a full description by Captain Russell of his own and Thomas Roche's work.

CHAPTER 19

Grant's Proposal of Surrender to Lee—*B. & L.* The failure of Brady and the Army photographer to make pictures of the surrender was due to faulty communication plus the fact that the surrender meeting between Grant and Lee was of such short duration that they had no time in which to prepare. This was explained to the author in a letter of M. H. Evans and numerous consultations on the subject.

Brady Press Book:

The news story of Grant's last photograph made in the field was told to a reporter in a personal interview with Brady.

The sitting of General R. E. Lee was arranged after several refusals by Lee, by Commisssioner of Prisons Robert Ould and Mrs. Lee. The complete account, as Brady told it, is in a news clipping in the Brady Press Book. Concerning the other photographs made of General Lee by Richmond photographers, a description of them is found in *Photographic History.*

CHAPTER 20

Letter of M. H. Evans to the author concerning her father's early activities with Brady.

"Final Operations of Sherman's Army," by H. W. Slocum, Maj. Gen. U.S.V.—*B. & L.,* Vol. IV, Page 758.

Brady Press Book—on new gallery business.

Letter of M. H. Evans to the author concerning Brady's activities during the trial.

Brady news clipping concerning Grant.

"Impeachment Managers"—Brady Press Book.

Letter to the author from M. H. Evans concerning Brady's physical condition as her father, L. C. Handy, used to speak of it to her.

Press clipping in Brady Press Book concerning the New York Historical Society.

Andersonville Prisons—P. F. McElroy.

Trial of Capt. Henri Wirz.

Letter of Clara Barton to L. C. Handy, Brady's nephew.

Harpers Weekly—1866. Brady's photograph of "Relics of Andersonville."

CHAPTER 21

New York Herald—P. B.

R. E. Lee—Douglas S. Freeman. Account of what is believed to be Lee's last photographs. Vol. IV, p. 404. Bills of sale on Central Park property (reproduced in facsimile). Report of the Joint Committee of the Library of Congress. Olive Logan's column in the *Graphic,* 1869—P. B.

National Republic—P. B.

Olive Logan—"Dom Pedro"—P. B.

Beverly Robertson—P. B. Article entitled "Gossip by Roberts" Feb. 18, 1877.

Reception at Brady's gallery—P. B.

CHAPTER 22

Florida Electoral Commission—P. B.

Dublin and Cambridge Crew Race—P. B.

Photograph of the Prince—P. B.

CHAPTER 23

Bierstadt's account—E. B. Eaton, Hartford, Conn. Press book.

Brady Press Book:

Concerning John C. Taylor and Gen. Albert Ordway—P. B.

Cyrus Field—P. B.

Letter from Clara Barton to Brady's nephew, L. C. Handy.

Letter of M. H. Evans to the author concerning William Staley.

Col. Knox' description of Brady—P. B.

Brady letter to his nephew, L. C. Handy.

CHAPTER 24

Complete correspondence between persons mentioned in the text, covering a chronological period of one year.

CHAPTER 25

"Lecture Book" or "List Book" as referred to in Brady's personal correspondence.

NOTES

Brady, contrary to popular opinion, spelled his first name with one 'T'. His personal correspondence bears this out. The middle initial 'B' was supposed to represent 'Benjamin' but this is in error.

Brady had a cousin named Tom Brady who was a soldier in the Civil War. There is a Carte Des Visite of him, and one letter that has no bearing on this narrative, consequently Tom Brady does not appear in these pages. He had no sisters, or brothers.

Grant's Council of War.

The picturesque Massaponax Baptist Church of Summit, Virginia, is still standing, and its members are very proud of the distinction that the mantle of history has placed on it. On one of its walls hangs a print made by Brady of Grant's Council of War.

Ambrotypes.

This type of photographic process Brady's nephew referred to as 'weak negatives'. Prints can be made from them.